For

Jane Gaghen Wendle, John Gaghen,
Harry Gaghen, AND *Judith Gaghen Bianchi,*
WHO SHARED A CHILDHOOD WITH ME
NEAR THE MISSISSIPPI AND OHIO RIVERS,
DEEP IN AUDUBON COUNTRY.

Praise for

AUDUBON

"A scintillating biography, a richly detailed story of romance, separation, and struggle." —*Publishers Weekly*

"Streshinsky's riveting new biography . . . infuses this man's career with the same vigorous spark of real life that Audubon uniquely brought to the depiction of America's birds."
—*Los Angeles Times*

"Vividly evokes what it was like to settle in new frontier communities, to travel in America and overseas and to try to earn a living in the economically uncertain early years of the nineteenth century." —*New York Times Book Review*

"A solid narrative biography, the first popular life of the artist in a quarter century . . . The Audubon depicted here is buoyant, gifted, and vain." —*Boston Globe*

"A portrait as vivid as any of Audubon's."
—*San Francisco Chronicle*

Other books by
SHIRLEY STRESHINSKY

The Shores of Paradise

Gift of the Golden Mountain

A Time Between

Hers the Kingdom

An Atomic Love Story:
The Extraordinary Women of Robert Oppenheimer's Life

AUDUBON

A BIOGRAPHY

AUDUBON

*Life and Art in the
American Wilderness*

SHIRLEY STRESHINSKY

TURNER

200 4th Avenue North • Suite 950 Nashville, Tennessee 37219
445 Park Avenue • 9th Floor New York, New York 10022

www.turnerpublishing.com

Audubon: Life and Art in the American Wilderness

Cover design: Gina Binkley
Book design: Kym Whitley

Library of Congress Catalog-in-Publishing Data

Streshinsky, Shirley.
 Audubon : life and art in the American wilderness / Shirley Streshinsky.
 pages cm
 Reprint of: New York : Villard books, 1993.
 Includes bibliographical references and index.
 ISBN 978-1-61858-025-2 (alk. paper)
 1. Audubon, John James, 1785-1851. 2. Ornithologists--United States-
-Biography. 3. Animal painters--United States--Biography. I. Title.
QL31.A9S77 2013
598.092--dc23
[B]
2012040773

Previously published in cloth by Villard Books (1993) and in paperback by
The University of Georgia Press (1998)

Printed in the United States of America
13 14 15 16 17 18 0 9 8 7 6 5 4 3 2 1

CONTENTS

FOREWORD

In THE LIFETIME THAT SPANNED the years from 1785 to 1851, John Audubon filled endless sheets of paper with his fine, flowing script. He seemed to write continuously, pouring out letters, journals, stories of the American frontier, notes on the scientific details of the birds and animals he studied. Sometimes he used a quill; later, he said, he "drove an iron pen." Occasionally he wrote so long and so hard that his hand swelled, and for a time he would have to still his urge to spill his thoughts out onto paper. When he was away from home, he bombarded his family with letters five and six pages long, and kept up a voluminous correspondence with friends and colleagues. Such long, frequent letters probably weren't always welcome, since at the time the receiver had to pay for postage, by the page.

"I am somewhat astonished that you should not have written oftener," Audubon chided his family once, "as you well know how little I think of postages and how much I do of your letters."[1] Audubon urged his correspondents to sit right down and answer letters the day they arrived, as he himself invariably did.

It seems obvious from his continual complaints that his correspondents did not take his advice. He was always hungry for letters, always anxious to know that everything at home was all right. When he first went to England, in 1826, it could take as long as three months for a letter to reach its destination, and another three months for a reply.

The worry and suspense set off attacks of what the artist called his "blue devils."

Since he became famous in his own time, much of what he wrote in that elegant script was saved. Lucy Audubon kept her husband's letters, his journals, and a treasury of memorabilia. Had this original material been stowed away in some safe place, we who now attempt to fathom the man would have had an ocean of material to draw from. Unfortunately, Audubon's family—his wife, and particularly one granddaughter—attempted to ensure that only a sanitized version of Audubon's life history was made available.

It is difficult to say how much editing Lucy Audubon did. In the decade following her husband's death, she sifted through Audubon's papers, including all the journals, and with the help of a friend created a sizable manuscript. In 1867 a British publisher turned this mass of material over to a twenty-six-year-old writer named Robert Buchanan, who read it all and concluded that the journals—which were filled with everyday, personal matters—were not nearly so interesting as the "Episodes" already published as part of the *Ornithological Biography.*

These "Episodes" were really frontier adventure stories meant to keep the reader's interest from flagging. Audubon wrote them for a largely English audience, which couldn't get enough of the American wilderness. Some of the episodes were embellished versions of his own experiences; others were stories he had picked up from friends; most were, to some extent, a mixture of fact and fiction. "Send me stories," Audubon would beg his friends. Some of the episodes were well written and have the ring of truth to them, but even these were meant to be a marketing device, and Audubon did not take them altogether seriously—"food for the idle," he called them in a letter to a friend.[2]

Buchanan tore into Lucy Audubon's prolix manuscript and discarded four fifths of it, retaining the episodes. "I believe I have omitted nothing of real interest," Buchanan writes with infuriating arrogance. And yet, after reading all of the material put into his hands—most of it, presumably, drawn from the journals and letters—he emerged with a hugely sympathetic view of Audubon. The artist had, Buchanan declares

in his introduction, "the courage of a lion and the simplicity of a child. One scarcely knows which to admire most—the mighty determination which enabled him to carry out his great work in the face of difficulties so huge, or the gentle and guileless sweetness with which he throughout shared his thoughts and aspirations with his wife and children." Audubon was vain, Buchanan declared, and often selfish; his heart was restless, his love for nature passionate. And yet, Buchanan concludes, "his very vanity and selfishness, such as they were, were innocent and boyish —they were without malice, and savoured more of pique than gall."[3]

Buchanan may well have been the last to read all of Lucy Audubon's manuscript. Several years later—understandably annoyed with Buchanan for what she felt was his cavalier treatment of the material provided him—she decided to publish her own version of her husband's life. This edition turned out to be Buchanan's version with a few omissions—notably the parts about her husband's vanity and selfishness. Evidently, the material sent to England was never returned. The introduction to Lucy's edition states that "should Mrs. Audubon hereafter receive her manuscript, containing sufficient material for four volumes of printed matter . . . the American public may confidently look forward to other volumes, uniform with this one, of the Naturalist's writings." But there were no more volumes, and the original manuscript has never surfaced.

After Lucy Audubon's death, the journals, letters, and memorabilia were scattered among her grandchildren. One of these, Maria Rebecca Audubon, emerged with the important journals, which Audubon had kept assiduously for a good part of his working life. According to the conventions of the time, they were addressed to Lucy, but Audubon clearly expected that others would read them and probably thought they would one day be published.

Granddaughter Maria, under the impression that she had been anointed the keeper of the family flame, read them all, wrote out her own edited versions—deleting anything that she thought might reflect badly on the family—then burned the originals, not only destroying a great many of John Audubon's words but also casting doubt on those that she

let stand. Two of the journals escaped her little auto-da-fé, and happily these covered two crucial years in Audubon's life: 1821, when he left his impoverished family in Cincinnati to make his way down the Ohio and Mississippi rivers in search of birds; and 1826, when he left them again to go to England, in quest of a publisher for *The Birds of America.*

Comparing these two journals with Maria Audubon's bowdlerized versions, you can see what damage she did—not only changing words (and sometimes meanings), but cutting out long passages and even mixing up time sequences. For example: Audubon made two emotionally charged homecomings to his wife in Louisiana, one in November 1824, when he came back from a year-long trip to Philadelphia; the other in November 1829, after three years in England. Audubon's biographer Stanley Clisby Arthur, who somehow managed to get access to some of the journals before they were destroyed, quotes from the account of the first homecoming: "I was put ashore about midnight, and left to grope my way on a dark, rainy and sultry night to the village, about one mile distant."[4] Maria's account of the *second* homecoming begins: "It was dark, sultry, and I was quite alone." Both versions note that Audubon managed to get lost in the woods in the dark of night and did not reach Lucy's cabin until early morning. However, Arthur's version states that when Audubon finally arrived "it was early, but I found my beloved wife up, engaged in giving a lesson to her pupils and, holding and kissing her, I was once more happy." Maria's says, "The first glimpse of dawn set me on my road, at six o'clock I was at Mr. Johnson's house; a servant took the horse, I went at once to my wife's apartment; her door was ajar, already she was dressed and sitting by her piano, on which a young lady was playing. I pronounced her name gently, she saw me, and the next moment I held her in my arms. Her emotion was so great I feared I had acted rashly, but tears relieved our hearts, once more we were together."

Maria's rewriting is bad enough and prone to error—what piano student would make her way through the dark Louisiana woods at six on a winter morning for a lesson?—but to substitute one homecoming for the other is inexcusable.

Late in his life, Audubon made a last long journey to the American West with his old friend Edward Harris. Both men kept journals; Maria Audubon simply appropriated a section of Harris's journal in which he is chased by a buffalo, and in the Missouri River journal presented Harris's adventures as John Audubon's.

For all these reasons, I read her versions of the journals with a maximum of skepticism, discounting every phrase that seemed at all questionable. (For example, there are passages in which Audubon supposedly writes that he shot at some bird or animal, missed, and was glad to see the poor thing go free. Audubon seldom missed and was never glad when he did.) Whenever I had a choice, I went with words I knew for certain to be Audubon's own. The two journals that escaped Maria Audubon's Victorian judgment, and many of the letters Audubon wrote, were primary sources. In the decades following his death, other letters began to surface. Whole caches were found in attics and locked boxes. Eventually these found their way to safe havens in museums, university libraries, and historical societies around the country. Audubon wrote so many letters that it is possible, even today, to come upon one that scholars have managed to miss. I discovered one at the Filson Club Historical Society in Louisville, Kentucky, which describes an episode that might have been a warning of a stroke. Despite all efforts by the women of Audubon's family to sanitize his image, these letters, all in his own hand, present the man complete with human flaws.

What first comes through—even from his very earliest letters, in halting English—is an exuberant, effervescent quality. When he was eighteen and in France he wrote to Lucy's father in America, to which he hoped soon to return: "I shall on a sheep have good wind all the way and as Soon a land under My feet My compagnon of fortune Shall Carry Me Very Swiftly Toward you." He scattered capital letters randomly and threw syntax to the wind, but the meaning came shining through. Some years later, when he wrote the 1821 journal, his English had improved markedly, but his style remained intact—fresh, eager, and utterly honest. "Wearied, Muddy, Wet & hungry—the Supper was

soon calld for, and soon served, and to see 4 wolfs taring a Carcass would not give you a bad Idea of our Manners."

His French accent diminished as he grew more proficient in English. His writing, too, became more polished—but he never lost his ability to record his feelings or reactions with an intimacy that is often stunning. He became quite a good writer, though he could never entirely conquer a tendency to disregard punctuation. Lucy, whose first language was English and who was better educated than he, often copied out his writings, making corrections along the way. When working on the *Ornithological Biography* he paid William MacGillivray to edit him and add necessary scientific detail. The Scotsman succeeded in adding clarity without disturbing Audubon's style and verve.

Audubon's enormous energy allowed him to endure almost unbelievable physical trials and to work for as long as seventeen hours at a stretch. He could be intractable where credit for his *Birds of America* was concerned. He made it very clear that the title page was reserved for him, and him alone, as was the legend on each of the birds. "Drawn from nature by J. J. Audubon," it said, no matter who had painted the backgrounds or even the bird itself. He paid several assistants to do this work, as he paid MacGillivray to edit him. Not even his sons received credit on the plate, though all but one of the assistants were duly acknowledged in the text of the *Ornithological Biography.* (The one exclusion was his first assistant, thirteen-year-old Joseph Mason, who accused Audubon of reneging on a promise to give him credit on the plate itself. For that betrayal, Audubon did not mention him at all.)

Audubon was a handsome man well into his forties, and he knew it. His vanity could reach ridiculous proportions; sometimes he prattled on about his fine profile and his curly, shoulder-length locks. The way women responded to him would seem to confirm his judgment of his looks. He was emotionally and perhaps even sexually faithful to his wife, but his journals never failed to note a pretty woman and he clearly loved the intimate friendships he had with several women, most notably with Hannah Mary Rathbone in Liverpool. Although he was often socially insecure, breaking into a cold sweat if he had to speak publicly,

he must also have been lively, good company. He was in demand socially, and people went out of their way for him. His artistic talent was certainly part of the reason, but they would not have been so eager to help had he not been so likable. He was capable of intense, sustained, even passionate friendships with both men and women.

Sir Walter Scott wrote that "a great simplicity" was the thing that struck him most about Audubon. The Shakespearean actress Fanny Kemble wrote in her journal: "There is a simplicity, a total want of pretention about him that is very delightful." The word "simplicity" seems to reverberate through others' descriptions of him; I had to wonder what its users meant by it. Lack of pretension and of artifice, certainly; but I think there was more. People saw in Audubon a directness, an ability to connect, and a clarity of vision. He understood what he had to do to accomplish the enormous task he had set himself, and he was seldom deflected from his goal.

Time and place were on Audubon's side; in the early nineteenth century there was a rage in Europe for nature in all of its glory, and a fascination with the American wilderness. John Audubon, budding ornithologist and genuine backwoodsman, came along at an auspicious moment. The struggle that resulted in his masterpiece, *The Birds of America,* was epic in proportion and timeless in its theme.

———◦◦◦———

I READ EVERYTHING I COULD find by and about Audubon. The first book I happened to pick up was *On the Road with John James Audubon,* by Mary Durant and Michael Harwood, which was more a travel book than a biography, tracing Audubon's journeys through America. It offered an intimate glimpse of the bird artist by two people who obviously were as familiar as anyone could be with a man who lived in the first half of the nineteenth century—and it set a tone that I found exhilarating. I made my way carefully through the two major biographies of Audubon: Herrick's two-volume work, published in 1907,

and the 1988 edition of Alice Ford's exhaustive biography. Each author did the kind of meticulous research that pulls old, dark secrets into the light—and that explains why the Audubon women were so protective.

Herrick was particularly fascinated with Audubon's relationship, late in his life, to young Spencer Fullerton Baird, who would become a force in the Smithsonian Institution. Alice Ford's special interest in Audubon's French origins is obvious. I found myself most intrigued by the Bachmans of Charleston, South Carolina. Audubon had a deep and abiding friendship with the Reverend John Bachman; the two Audubon boys married the two eldest Bachman girls, and the three Audubon men collaborated with Bachman on *The Quadrupeds of North America,* a remarkable set of books that catalogued the continent's mammals.

In writing this book, I did not set out to break any new ground; I wanted simply to tell the full, fascinating story of an extraordinary life against the background of a young, vibrant America. The descriptions of the wilderness in the early years of the nineteenth century captivated me. The land was covered by vast primeval forests and inhabited by a wealth and variety of wildlife we will never see again. I traveled to Audubon's first home in the United States—Mill Grove Farm, near Philadelphia—then drove across Pennsylvania and Ohio to Louisville and Henderson in Kentucky, where he and Lucy lived in their early married years. This part of the Midwest was not new to me; I grew up in a Mississippi River town in southern Illinois, and spent childhood summers at my grandparents' farm on the Ohio, not many miles from Henderson. His old haunts in New Orleans and up the Mississippi to Natchez and St. Francisville, Louisiana, I visited in the springtime, when the dogwood was in bloom and the woods were filled with birds. In New York, I made my way to the site of Audubon's final home, Minniesland, and to the Trinity Cemetery at 155th Street and Riverside Drive, where he is buried. All around is concrete and high-rise now, but from inside this wooded oasis, among the old tombstones, you can look down to the river and, if you squint, almost see what the landscape must have been. Later I stopped off at the New-York Historical Society to see the original watercolor drawings exhibited there. I traveled to

London with a copy of Audubon's European journal in hand, tried to
locate buildings where he might have lived, and spent one exhausting
day following his tracks from Great Russell Street to Regent's Park, and
all the way to the top of Primrose Hill, a walk Audubon often made
as dawn was breaking. At the Royal Academy of Arts I sat at a small
desk and leafed through Audubon material, then went to Edinburgh
to check in at the Royal Society there and to explore that beautiful old
city, not all that much changed since Audubon's time. I toured a Geor-
gian house on Charlotte Square, just down George Street from where
Audubon had rented rooms. The house has been restored—its decor is
that of Audubon's period—and as I moved from room to room, from
floor to floor, I had the eerie feeling that I had walked into his life . . .
the morning light that poured through the western windows (the same
light that he awaited on all those winter mornings in Edinburgh so
he could see to draw); the drawing room with the furniture arranged
around the sides; the elegant dining room, set for one of the dinner
parties Audubon both enjoyed and dreaded. Just as Audubon had, I
wandered up the steep stairs of Holyrood Palace to the apartments
where Mary, Queen of Scots, lived; on that same windblown day, I
went on to Edinburgh Castle. One rainy day I drove out to Dalma-
hoy, the country home of the earls of Morton, where Audubon was
welcomed for elaborate weekends. The place is now a country club;
the original house is an inn. I was given a tour, and on the third floor
looked out of the yellow room described by Audubon and saw Edin-
burgh Castle in the distance. No one seemed to know anything about
Audubon's connection with the house, but one of the first-floor public
rooms was decorated with Audubon prints from *The Birds of America.*

Today, Audubon's name is synonymous with the conservation
movement. In his time, the woods and skies, the rivers and oceans
were filled with birds and animals and fish, and this bounty must have
seemed inexhaustible. Like all woodsmen of his day, Audubon used his
gun to put food on his table. He was an excellent shot; he knew how to
kill, to gut, to skin. He was proud of his prowess. Early in his gun-tot-
ing, wilderness-roaming life he went on shooting binges during which,

he boasted, he brought down as many as a hundred birds in a day. It is important to remember that his was an era with a different ethos, and that he reflected the attitudes of his times. On the long, boring voyages between Europe and England, he entertained himself by shooting sea-birds, knowing that there was no way to retrieve them. He sometimes used multiple fresh kills to study and draw a species. Like most of us, he learned as he went along: to draw, to publish and market his work—and to see the ultimate effects of so much unnecessary slaughter in America. His writing echoes with warnings; he saw the changes civilization wrought, and he was among the first to sound the alarm. One has only to look at the original drawings, or the double-elephant folio of *The Birds of America,* to know how he loved America—the birds and trees and flowers and plants; the rivers and plains and animals; the people; and, most of all, the promise.

ACKNOWLEDGMENTS

It WAS MY COLLEGE FRIEND Margaret Vest Siegert, of Slidell, Louisiana, who put me onto Audubon. A dedicated birder, she sent me the two volumes of Audubon's journals, and then traveled with me up the Mississippi from New Orleans to Natchez to St. Francisville, to trace the Audubon trail. Later, Peggy spent time at Tulane University searching out letters Audubon had written, in French, in his early years in America.

Another friend, historian Patricia Klaus, read the manuscript in progress and made valuable suggestions, in the process helping me make the transition from the writing of novels to the writing of biography.

It was both exciting and refreshing to come upon so many talented, knowledgeable people who not only made time to see me on short notice, but were wonderfully helpful. Mary LeCroy, senior scientific assistant in the department of ornithology at the American Museum of Natural History in New York, was one; Annette Blaugrund, senior curator of painting, drawings, and sculpture at the New-York Historical Society, was another. Mary Durant, who with her husband, the late Michael Harwood, has written extensively about Audubon, answered my letters in the same bright, direct style that I loved in their book *On the Road with John James Audubon*.

I was received graciously at each of the Audubon parks and monuments: at Mill Grove, the Audubon Wildlife Sanctuary near Philadelphia, by curator and director Edward Graham; at John James Audubon State Park in Henderson, Kentucky, by park manager Mary Dee Ellis; at Oak-

ley Plantation in St. Francisville, Louisiana, by curator Michael Howell. I would like to thank Audubon descendants Mary Winters, Edith Reeder, and Matilda Tyler for permission to view the Tyler Collection at the John James Audubon Museum in Henderson, Kentucky. When I arrived in Henderson, the Tyler Collection had been meticulously wrapped for storage, in anticipation of a major renovation of the museum. Mary Dee Ellis obligingly opened packages for me, and allowed me to leaf through letters, photos, and other memorabilia that make up this important collection placed with the state of Kentucky. It will once again be on public view in the fall of 1993. In St. Francisville, Elisabeth K. Dart, historian of the area, drew me a map to Bayou Sarah which took me down back roads and through woodlands that Audubon once knew.

At the Filson Club Historical Society in Louisville, Kentucky, James J. Holmberg, curator of manuscripts, was especially helpful. Beth Carroll-Horrocks, manuscripts librarian, and Tim Wilson of the American Philosophical Society in Philadelphia went to great lengths to get me the letters I needed faster than I had any right to expect. Margaret Sherry, reference librarian for rare books and special collections at the Princeton University Library, was helpful, and so was the Beinecke Rare Book and Manuscript Library at Yale.

Katy Hooper, special collections librarian at the University of Liverpool, helped track down Hannah Mary Rathbone III. Joanna Soden, of the Royal Scottish Academy in Edinburgh, and Mary Sampson, archivist at the Royal Society in London, provided information on Audubon's connections in Great Britain. I am also grateful to Catherine Althaus of the British Tourist Authority.

I spent one happy morning with Luis Baptista (chairman of the department of ornithology at the California Academy of Sciences in San Francisco) and Pennington Ahlstrand (the academy's special collections librarian), going through its copy of *Birds of America*. Jens Vindum, of the academy's department of herpetology, advised me on Audubon's rattlesnake controversy.

At the Charleston Museum Library, where the John Bachman papers are kept, archivist Sharon Bennett and assistant archivist Mary

Giles were patient with my many requests. Jay Schuler of nearby Mc-Clellansville, South Carolina, was kind enough to answer my cry for information on the Bachmans.

Anne Coffin Hanson, Samuel H. Kress professor at the National Gallery of Art in Washington, took time to write me about the research done by her mother, Annie Roulhac Coffin, on the Bachman family.

Good friends came to my aid in different ways: Andrea Moyer, with Audubon gems from her excellent art library; Monique Salgado, who, like Audubon, was born in Haiti, translated his early letters for me; Ingrid Schultheis spent hours researching yellow fever and its treatment; Sara Barry Brown did duty at the Charleston Museum Library; Suna and Rusi Kanga explored Audubon's old haunts in Edinburgh with me; David Ryan became my emergency computer consultant, saving my sanity on several occasions. Carol Kirk was backup on whatever was needed, as always.

The Kensington Library and the Contra Costa County, California, library system made my task possible by tracking down books that I needed, most of them quite beautiful and rare.

Maria Streshinsky drove with me from Philadelphia to Henderson, Kentucky, walked Audubon's woods with me, found the site of his "infernal" mill, and served as photographer. Mark Streshinsky set up my word processor in strange and amazing ways, took over the footnotes for me, and made untold copies at the university library, saving me many hours. Ted Streshinsky deserves above-and-beyond-the-call-of-duty credit for living with me and Audubon for the years it took.

And, for seeing me through, a heartfelt thank you to my longtime friend and editor, Diane Reverand, to her assistant, Alex Kuczynski, and to my literary agent, Claire Smith.

AUDUBON

BOOK ONE

THE WOODSMAN

1

*A young Man of Seventeen sent to America
to Make Money (for such was My Father's
Wish) brought up in France in easy
Circumstance who had never thought on
the Want of an article.*[1]

JOHN AUDUBON WROTE THOSE WORDS in his journal
while floating down the Mississippi River on a flatboat; by then, he
had been in America for fifteen years. His memory was not precise;
in fact, he had turned eighteen, not seventeen, in the spring of 1803,
before sailing that autumn from France to New York. He was incorrect
about his father's motives, as well. Jean Audubon did not send his only
son to America to "Make Money." He sent him there to keep him out
of harm's way.

That same year, 1803, Meriwether Lewis and William Clark were
preparing to leave on the explorations that would chart the vast, wild
continent that lay before the young man of eighteen: *America*. A land
of promise, as Saint-Domingue in the West Indies had been for Audu-
bon's father. America, a safe haven from Napoleon Bonaparte, whose
need for soldiers had become insatiable. When the American president

Thomas Jefferson convinced Napoleon to sell 828,000 square miles of French-claimed territory, this Louisiana Purchase instantly increased the size of the country by 140 percent—and worked to the young Frenchman's advantage as well, since he could claim to have been born in the United States.

It had not been easy to leave the country house in Couëron, not easy to leave France. The pain of that parting remained so vividly etched in his memory that years later he would write, "When, for the first time . . . I left my father, and all the dear friends of my youth, to cross the great ocean . . . my heart sunk within me—The lingering hours were spent in deep sorrow—My affections were with those I had left behind, and the world seemed to me a great wilderness."[2] Homesickness was compounded by *mal de mer;* the sea made him sick, and it always would. He complained that he could not draw while at sea because of a "giddiness" which seldom left him.

Unlike his father and both grandfathers, John Audubon would never be a man of the sea. He had tried his best to become a ship's officer and he had failed. His father's disappointment had not diminished his love for his only son; Jean Audubon was a resolute Frenchman who understood much about the practical duties of love. For now, the senior Audubon's more urgent duty was to see that his son escaped Napoleon's draft so he could survive to manhood.

The young man was homesick and seasick, and he could not draw on board the rolling vessel; a crossing from France to New York was a matter of six or eight weeks, often longer. He lounged on the deck, his face to the sun, and passed the long hours thinking the thoughts of an eighteen-year-old about to challenge the world on his own. A knot of self-pity formed in his stomach when he thought of those he had left behind: the mother he loved dearly; his half-sister Rose; and Papa, his natural father as well as his dearest friend in the world.

On the open ocean old memories surfaced, including one from the Nantes days of his early childhood that continued to haunt him throughout his life. He was to write:

One incident which is as perfect in my memory as if it had occurred this very day, I have thought of thousands of times since . . . My mother had several beautiful parrots and some monkeys; one of the latter was a full-grown male of a very large species. One morning, while the servants were engaged in arranging the room I was in, "Pretty Polly" asking for her breakfast as usual, *"Du pain au lait pour le perroquet Mignonne,"* the [monkey] probably thought the bird presuming upon his rights in the scale of nature; be this as it may, he certainly showed his supremacy in strength over the denizen of the air, for, walking deliberately and uprightly toward the poor bird, he at once killed it, with unnatural composure . . . I prayed the servant to beat the monkey . . . I uttered long and piercing cries, my mother rushed into the room, I was tranquillized, the monkey was forever afterward chained, and Mignonne buried with all the pomp of a cherished lost one.[3]

THE CONFLICT BETWEEN THE BIRD and the beast would become a central motif of John Audubon's life; when he arrived in the New World in the autumn of 1803, he was not aware of the impending struggle that would shape his life, a tension between self and art. He did not know he would one day have to tame the monkey beast that would threaten the joy and beauty he sought in life.

WHEN THE YOUNG MAN STEPPED ashore in New York that autumn of 1803, he presented the papers procured for him by his father, and assumed the persona they defined: He had a new name—his

father had at last given him his own—for his entry into the New World. He was Jean Jacques Audubon, soon to be John James Audubon.

His first few steps ashore were unsteady after long weeks at sea, but sweet as well for one who longed for the land. He spoke very little English. His papers asserted that he was a visitor returning to the land of his birth: the Louisiana Territory which Napoleon had so conveniently sold to the United States.

Jean Audubon had gone to extraordinary lengths to ease his son's entry into the New World. He had handed him over to a New England ship's master he knew, John Smith. Smith could be counted on to watch over young Audubon until he could be delivered into the hands of the elder Audubon's trusted American agent, a respected Quaker named Miers Fisher who lived near Philadelphia. Still, the father knew the dangers of ocean travel, from deadly storms and pirate ships to disease-breeding water barrels.

In New York, John Audubon set out to stretch his legs by walking to Greenwich Village, where his father had arranged a letter of credit. He was a prodigious walker, and should have been able to cover the two miles in little more than twenty minutes, but on this day he was feeling weak and faint. By the time he made his way back to the ship with his money, his head was aching, his back hurt, and he was having chills. Captain Smith looked at his flushed face and swollen lips and surmised it was yellow fever.

If the fever young Audubon came down with was yellow fever, as he later claimed,[4] there had almost certainly been a case of it—perhaps even a death—while the ship was at sea. Supplied with open water barrels in which to lay their eggs, and with plenty of human blood to drink, the mosquitoes on board could easily transmit disease from one passenger to another. At the time, and for a hundred years to come, the means by which the disease was transmitted would go undetected.

For all of the nineteenth century, yellow fever was the scourge of port cities around the world. Ten years earlier, in the weeks between August 1 and November 9 of 1793, four thousand Philadelphians— one out of ten of the city's residents—died of the disease. Yellow fever

started quite suddenly with aches and chills, nausea and fever. The tongue would turn a bright red; lips would swell; eyes would be inflamed. After three or four days, the patient would seem suddenly to get better, but that was only an interlude before the last, most critical phase. Now the complexion took on a dusky, yellow pallor, and bleeding might appear in tiny spots in the gums and on the skin; in the worst cases, there would be black vomit. Most of the deaths occurred on the sixth or seventh day. But if kidneys and liver survived the onslaught, the patient would recover and enjoy perfect immunity.

Had the young Frenchman been sent to the Philadelphia doctor best known for treating the disease, he would have been bled—losing as much as three quarts of blood—blistered, purged with calomel and jalap, fed a tincture of cinchona bark, and given a cold-water enema.[5] Instead, Audubon was taken to Norristown, Pennsylvania, where he was left in the care of two gentle Quaker sisters who ran a boarding house, and who simply put him to bed and insisted on absolute quiet and rest. He lay in the narrow bed for long days and nights—in a strange country, far away from the family he adored—thrashing and often delirious.

———

THERE IS NO WAY TO tell how much the son knew about his father or about the circumstances of his own birth. He knew he had been born in the New World; perhaps the elder Audubon, who had his own reasons to be vague, had encouraged his son to believe that his birthplace actually was in Louisiana.

Jean Audubon was fifty-nine the August he put his son aboard the ship that returned him to the New World. His own life at sea was over by then, his body beginning to show the lifetime of hard use. He was a short, stocky man of action, capable of withstanding punishing privations. His people were fishermen out of Les Sables-d'Olonne on the coast of the Bay of Biscay; his father's father, and his mother's as well, had been captains of the long-course fishing fleet. At thirteen, Jean had

gone to sea with his father on their boat, the *Marianne,* heading for the rich fishing waters of the New World. France was at war with England, the two countries struggling for control of the Atlantic. Little more than a year later, at Quebec, the *Marianne* and all hands were taken prisoner. For three years, young Jean and his father languished in an English prison. By the time they were released Jean, almost eighteen, was ready to seek his fortune. ("A Man of Such natural Talents and enterprise could not be confined to the common drudgery of the Money Making Animal," John Audubon would one day write about his father.)[6]

In the last half of the eighteenth century, ambitious and adventurous Europeans looked to the islands of the West Indies, where they could make quick fortunes by trafficking in slaves or in the sugar trade. It would not be many years before the gray-eyed, sandy-haired Audubon paid his first visit to the town of Les Cayes on Saint-Domingue, the island that is now Haiti.

With its oppressive heat and humidity, its tangle of jungles and sweet scents, the tropical island could cast a spell over men far away from home. African rhythms, sounds like none ever heard in France, echoed through the cane fields and in the valleys as slaves mourned the loss of home and freedom.

Frenchmen, always romantically adaptable, happily flouted rules they readily accepted at home, half a world and weeks away. Yet social lines were strictly drawn in this tropical outpost of France. A *créole*—a person born in the islands of white parents—was acceptable; anyone with even a hint of color in his or her bloodline was not. Even so, evidence that white men found the African women irresistible was obvious in the increasing numbers of mulattoes in the population. Both whites and mulattoes were outnumbered tenfold by the Africans imported as slaves to work in the cane fields, a situation destined to lead to tragedy.

The white foreigners formed liaisons with the "quadroons" and "octoroons" of the islands, installed them in their plantation homes, and fathered children by them. (Alexis de Tocqueville would try to explain the Frenchmen's position: "Spanish America was peopled by

adventurers drawn by thirst for gold, who, transplanted alone to the other side of the Atlantic, found themselves in some sort forced to contract unions with women of the people of the land where they were living.")[7] Neither the church nor the state permitted interracial marriage, and the "natural" children these relationships produced could not be baptized and had no legal rights.

When Jean Audubon arrived in Saint-Domingue, he stayed at the home of a family friend, Gabriel Bouffard, a planter in Les Cayes who chose to live openly with a woman of color named Françoise. They had several daughters: Marie-Louise, Lorimée, Bonne, Rose, and "Sanitte," a sobriquet for Catherine. By the time Audubon arrived, the eldest were already attractive young women. Sanitte and Jean Audubon began an affair.

Although polite society frowned on such practices, Audubon was far from alone. Some men managed to maintain two households, one in France and one in the islands, and divided their time between them. That idea seems not to have occurred to the bachelor Audubon until July 1772, when he found himself in France, in the river port of Paimboeuf, where he had put in to load wine into the cargo ship *Dauphine* and return with it to Les Cayes. He was twenty-eight that summer, and the fortune he was intent upon making must have seemed within reach. It was at Paimboeuf that Charles Coiron, the merchant who had hired Jean to transport wines, suggested he meet the daughter of a wine-merchant friend. She was a wealthy widow with business interests in the West Indies; perhaps Coiron thought the young man could serve as her agent in Saint-Domingue.[8]

Anne Moynet was fourteen years older than Jean Audubon. She was childless, cheerful, and practical—all qualities that would have appealed to the young man. Women could not easily do business in France; the legal state of marriage might have seemed, to Anne Moynet, the safest possible business arrangement. In August they were married—fittingly, in the Church of Saint Opportune. At Anne's age, it was unlikely that she would bear children. Perhaps Audubon told her about Sanitte. Whatever their private arrangements, he did not linger

long in the nuptial bed. By September he was on his way back to Les Cayes, without his new wife.

In the decade to come, he would travel back and forth, dividing his time between France and Anne and Saint-Domingue and Sanitte. (In all, he spent about four years with Anne, almost seven with Sanitte.) During that period he was able to buy a plantation in the settlement of Perche, near the home of his friend Bouffard, where he installed Sanitte as his *ménagère*. Jean Audubon's first child, Marie-Madeleine, was born at Perche in 1776. A year later, when he left for France, Sanitte was pregnant again, and would bear a second daughter in his absence.

How much Anne knew, at this point in their lives together, about her husband's colonial ménage cannot be determined. She understood the need for him to spend long months in the Indies, taking care of her business as well as his own. She understood, presumably, that he was dealing in slaves. (On one occasion he invested twenty thousand livres in forty slaves, then quickly sold them, making a 75 percent profit; he put up only a third of the purchase money, but took half the profits because he had done the buying and selling. His only costs were sixty livres for bananas, twenty-four for beef, and ninety-three for medical assistance to a mortally ill slave. The transaction was a textbook example of how quickly fortunes could be made.)[9] Anne would have been pleased with the steadily improving profits and with the gifts her industrious husband brought her from the tropical islands: a black slave named Elizabeth, exotic parrots and monkeys. (Among them were Mignonne and the fully grown male monkey that would haunt John Audubon.) If the success of their joint business enterprises had depended solely on the industrious Jean Audubon, the couple would have had no economic worries. But France was in the grip of political upheaval, and in the islands, the slaves were murmuring of rebellion and dreaming of a leader who would deliver them from slavery.

Jean Audubon was to witness the major upheavals of the age: the American Revolution, the French Revolution, and the slave insurrection on Saint-Domingue. He now owned not only a plantation and the

slaves to work it, but also a sugar refinery and a store; together these enterprises earned a yearly profit of some ten thousand francs. He had made his fortune and expanded Anne's; now he began to think of ways to preserve them.

In May 1779, soon after Audubon had left the West Indies for the return voyage to France as captain of the *Comte d'Artois,* he was overtaken by an English privateer. Audubon knew the drill well enough; he had once captained his own privateer. Before he could set fire to his own heavily laden ship to keep it from falling into the hands of the English, he and his crew were overwhelmed and sent off to prison in New York City, which was occupied by British troops.

Once more Audubon would languish in a British prison ship. It was more than a year before the French ambassador could arrange a grant of amnesty. A furious Audubon promptly offered his services to the Comte de Rochambeau in Philadelphia and was assigned to command the corvette *Queen Charlotte.* He had the delicious satisfaction of watching the British surrender at Yorktown on October 19, 1781.

This unexpected American interlude cost Audubon two years; now there was no time to lose. He returned to Anne in Nantes, dutifully went to Les Sables-d'Olonne to settle his mother's estate, and brought his spinster sister, the thirty-seven-year-old Marie-Anne-Claire, back with him to keep Anne company. To make certain the females of his French family were comfortable, he bought a country villa called La Gerbetière, near the village of Couëron, about nine miles down the Loire. His work on Saint-Domingue would not last forever; following tradition, Audubon would return to finish out his days in France in the rambling old country house on the river.

Anne may have been something of a matchmaker, because on his next return to France, Audubon found his spinster sister betrothed to a widower, one Jean-Baptiste Le Jeune de Vaugéon, who had three small children. Audubon attended the wedding, as did two brothers named Boure who had been pallbearers at the funeral of Le Jeune de Vaugéon's first wife, a woman of some social standing.

Almost immediately after the wedding, Audubon booked passage to return to Saint-Domingue, this time as a passenger on the ship *Conquerant*, sailing for Les Cayes on October 23, 1783. In many ways, it was to be the most fateful voyage of his life.

On the passenger list was one Jacques Pallon de la Bouverie, a retired lawyer who lived in a town in Saint-Domingue not far from Audubon's plantation. Traveling with Pallon were his wife and three daughters, aged nineteen, fifteen, and twelve, as well as a young woman of twenty-five who appeared on the passenger list as Jeanne Rabin, chambermaid.[10]

She was a country girl hired to accompany the family to the West Indies. Audubon had met some of her family connections—the brothers Boure—at his sister's wedding. Jeanne was from Les Touches, in the diocese of Nantes. Six years earlier, her aunt and uncle, Anne and Pierre Rabin, had married Joseph and Marie Boure, who were related to the first wife of Audubon's new brother-in-law. Jeanne Rabin was part of that family; though listed on the manifest as a "chambermaid," she would have been comfortable in the presence of those whose station in life was higher than her own.

After a five-year absence, Pallon de la Bouverie was returning to the West Indies, to a plantation his wife had inherited in Les Cayes. As respectable French gentry they would certainly have disapproved of Jeanne Rabin spending time in the company of Jean Audubon. But in the close quarters of the sailing ship, she could not have avoided him. He was thirty-nine, she twenty-five; in the long nights and days at sea, something happened between them.

When they reached Saint-Domingue, Jeanne went to the Pallon family home. Either she became unhappy with them or they became unhappy with her; possibly the seeds of this discontent were sown on the *Conquerant*. For whatever reason, within a few weeks Jeanne Rabin appeared at Audubon's doorstep at Perche, and he took her in.

Sanitte did not leave when the white woman moved in. She was the *ménagère* of the plantation at Perche and the mother of Audubon's daugh-

ters; her family had taken him in when he arrived in Saint-Domingue, and her father was his friend and mentor. She would not easily be displaced, nor is there any evidence that Audubon wished her to leave.

Young Jeanne Rabin did not thrive in the suffocating tropical heat; in May a doctor came to the house and treated her with medicines and mineral waters. Her ailment did not keep her from getting pregnant; by October, she was carrying Audubon's child.

It is interesting to consider what Jean Audubon's state of mind might have been at this critical juncture in his personal life. Could he have been hopelessly in love with the beautiful Jeanne? Or had he simply satisfied his sexual appetites with an attractive chambermaid and felt obligated to care for her? (On October 28, 1831, Alexis de Tocqueville, attempting to explain French sexual morals, wrote in his American journal: "A man of the upper classes who dishonored a girl of the same classes, or who, introduced into the family by the trust of the parents, debauched their daughter, that man would be lost in reputation." Debauching a girl of a lower class—a chambermaid, say—was something else entirely, Tocqueville's formulation suggests.)

Because he was a dutiful man, Audubon would have considered Jeanne's future. He had, after all, ruined her chances of making a respectable marriage. What she could not have avoided knowing was that he had an octoroon mistress and several daughters established in his Saint-Domingue house as well as a legal wife back in France who was more than twice her age.

Jeanne Rabin languished at Perche, waiting for the doctor to come with his mineral waters and medicines. The physician Laurent Sanson billed Audubon for treatment of several of his slaves, called bossals, and for care given "Mlle. Rabin."

For more than a year they lived together, with Sanitte standing by, evidently resigned. On April 24, 1785, the doctor was again summoned to Perche; he brought the surgeon Guérin to assist in the delivery of Jeanne's child. "*1785 April 24, Passe la nuit près de mlle. Rabin. en mal d'enfant. April 25 passe la nuit près de mile. Rabin. April 26, Mlle. Rabin est accouchée.*"[11] After two days and nights of labor, the exhausted

young mother delivered a boy, Jean Audubon's first and only son.

The baby would be known as "Jean Rabin, créole de Saint-Domingue": a bastard. Baptism was out of the question. And the boy was forbidden either to use his father's name or to inherit his property.

The birth of Audubon's son was in stark contrast to the celebrated birth only one month before, on March 27, of a prince royal at Versailles. That child, son of the ill-fated king of France and his queen, Marie Antoinette, was baptized Louis Charles Capet. Four years later, the child became the heir apparent to the Bourbon throne; at the age of seven he was swept away in the rages of the French Revolution. The mystery of the ultimate fate of Louis XVII, the poor little Shadow King, would absorb the world for a hundred years and more (until the mystery of Anastasia of Russia came along to replace it). There was even a rumor that the boy had been spirited out of France and sent to Saint- Domingue.[12] In years to come, the historical coincidence of their birthdates would provide "Jean Rabin, créole de Saint-Domingue," a smokescreen behind which to hide the shame of his illegitimacy. It was the sort of teasing, flamboyant fiction he could never quite resist, and which his family would not entirely relinquish.

A few weeks after the birth of her child, Jeanne Rabin's breast became infected. The doctor treated her: "May 4, 1785: Six bottles of *eau blanche* for poultices needed in an affection of the breast of Mlle. Rabin. June 19, Opened an abscess in the breast of Mlle. Rabin. August 15, A medicine for Mlle. Rabin."[13] Jeanne wilted under the onslaught of island fevers and infections; as she grew increasingly ill and weak, slaves took over the care of the child.

Jeanne Rabin died on November 11, 1785; although she had committed the sin of adultery, the father of her child somehow arranged for her to be buried in consecrated ground in the cemetery of the church of Notre-Dame de l'Assomption in Les Cayes. Six months later, Sanitte presented Audubon with another daughter.

Political turmoil was building in France; in colonial Saint-Domingue, slave rebellions had begun. Some isolated plantations were

put to the torch. As the whites who owned the great estates grew increasingly fearful, some made plans to leave. Jean Audubon decided to sell everything but his warehouse. With the proceeds he bought a cargo ship, which he used to move his stores of sugar out of the country.

On one voyage to Philadelphia, Audubon bought some property not far from the city, a farm called Mill Grove near the Schuylkill River. He bought the place sight unseen; as usual, he had the good sense to engage an honest and excellent business agent, the Quaker lawyer Miers Fisher, whom even President Washington had found reason to praise.

Some white men stayed on Saint-Domingue with their island families. Audubon did not; he did, however, make elaborate preparations to extricate his son and one of his daughters—the fair-skinned Rose Bonnitte, born in the year of Jeanne Rabin's death. On July 12, 1788, a slave (probably one who had cared for the boy) carried Jeanne Rabin's three-year-old son to the ship *Duquesclin*, whose captain was an old friend of Audubon's from Nantes. Officially, the child was listed as "Le Mr. Maison Neuve, agé de 3 ans, fils du Mr. Audubon." Young Mr. Newhouse, three years old, son of Mr. Audubon, was headed for a new home in Nantes—and a new mother as well.

A year later, a female child appeared on the passenger manifest of one of the last ships to leave Saint-Domingue before violence broke out. She was "Demoiselle Rose Bonnitte, aged four, natural daughter and orphan of Demoiselle Rabin, white." Jean Audubon had been shrewd enough to know he could best smuggle out his daughter by Sanitte by declaring her mother not only dead, but white. If the children were to grow up in France, they would have to be free of any taint of color.

Audubon spent six more months on the island, harvesting sugar, taking as many of his profits with him as he could manage, before booking passage on the *Victoire* for his last voyage home. At almost the same time that he was boarding the ship at Cap Français, on the other side of Saint-Domingue, Sanitte was bearing him yet another daughter, Louise-Françoise-Joséphine.

What would Anne Moynet—now fifty-eight—think when presented with two of her husband's illegitimate children? Jean Audubon had always proved a masterful judge of character: Anne Moynet gathered in the children with the tenderness of a woman at last presented with the miracle of motherhood. She was to embrace the two as her own for the rest of her long life, and the boy, who would become her particular pet, would always remember her with great affection. After a long and terrifying ocean voyage, he was received, he wrote, "by that Best of Women, raised and cherished by her to the utmost of her Means."[14]

Audubon installed his unique family—two children by two different mothers, neither of them his elderly wife—in his house on the rue de Crébillon in Nantes, and gave them over to the care of the good Anne while he returned to the sea, this time in the service of his country. Once more, the father would be absent for long periods.

There were drawing and music, dancing and fencing lessons, in which the boy would excel. He was less enthusiastic about mathematics, considering it "hard, dull work." Geography pleased him more, but what pleased him most was roaming the woods and fields that surrounded their country home, La Gerbetière. From an early age, he preferred an active life, in the open. His adoptive mother saw no harm in his wanderings or in his fascination with nature. Audubon later wrote: "Thus almost every day instead of going to school when I ought to have gone, I usually made for the fields, where I spent the day; my little basket went with me, filled with good eatables, and when I returned home, during either winter or summer, it was replenished with what I would call curiosities, such as birds' nests, birds' eggs, curious lichens, flowers of all sorts, and even pebbles gathered along the shore of some rivulet."

The French Revolution was swirling all about them. In May 1792, Jean Audubon became "Citizen Audubon" and was assigned the office of commissioner for the outlying communes. He saw fighting in the streets of Savenay, a village only twenty miles to the northwest. That summer, violence erupted in the islands of the West Indies too;

Audubon's eldest daughter, the sixteen-year-old Marie-Madeleine, was murdered on Saint-Domingue. In August, the French royal family was swept from power. The following January, the king and queen were executed. The seven-year-old dauphin, the heir apparent, was imprisoned in a fortress called the Temple, separated from the surviving members of his family and watched over by a shoemaker and his wife. The shoemaker reportedly built the dauphin an aviary because the boy wished to keep birds.

At the time, seven-year-old Jean Rabin was observing the birds in the skies of Nantes and climbing trees to collect their nests and their eggs.

Jean Audubon did his duty for the republicans, between time tending to such endless quotidian business as collecting rents on Anne's properties in Paimboeuf and writing letters to Miers Fisher, explaining why he had not been able to come to America to look after his farm at Mill Grove, and thanking the good Quaker for his patience and his help.

Sent to sea again, this time as commander of the *Cerbère,* Audubon managed to come once again into conflict with the British. He defended his ship in a three-hour battle with an attacking corsair, and while bleeding profusely from a thigh wound, he directed the ship's doctor to staunch the flow while he remained at his post. Finally the British broke off the fight.

In the year 1794, the Reign of Terror came to Nantes. Thousands of monarchists, real and suspected, were executed. Audubon was a well-placed citizen; but if something happened to him and his wife, the children, unable to inherit property or money, would have no protection. Early that March, the family began adoption proceedings. Since the Catholic church was outlawed, so were Christian first names. Jean Rabin was called Fougère, or Fern, and Rose Bonnitte became Muguet, Lily of the Valley. Jean and Anne went to great lengths to claim as their own the two children born in Saint-Domingue—a proof of their devotion.

During these years, the boy grew increasingly fascinated by the world he observed in the woods. His collections filled his room, and he started drawing the animals and birds he encountered on his ramblings. These early attempts at capturing the essence of birds on paper were crude. Much later he recounted how he would save the drawings, only to burn them each year on his birthday. But he was learning, and his involvement with natural history was proving more than just a boy's passing fancy.

Buffon's *Histoire Naturelle, Générale et Particulière avec la Description du Cabinet du Roi* was so popular that it had gone into several editions. Georges-Louis Leclerc de Buffon had deserted the study of mathematics—considered the foundation of the sciences—for the world of nature. His volumes presented animals posed in peculiar settings—anteaters perched on a pedestal amid ancient Roman ruins, cougars, looking like tame pussycats, lounged in front of Greek columns.

None of the creatures in the many volumes of the *Histoire Naturelle* were in the least animated. A more realistic portrayal of animal life would come with the works of Jean-Baptiste Oudry, who knew how to show animals flying, crowing, and fighting. In the latter part of the eighteenth century, in the decades just before Jean Audubon's son roamed the woods near Nantes, French artists were establishing their superiority in the art of the world of nature with works that were not only anatomically correct, but visually exquisite.[15] Books were a luxury in those days, but Jean Audubon was a reader, and he gave them to his children as gifts. Very likely, either he or Anne would have made some of these books available to a boy who seemed mesmerized by the creatures of the wild.

It was not until his son reached the age of eleven that the father decided it was time to take a hand in his education. Eleven was, after all, the age at which his own father had taken him from his mother's side to learn about ships and the sea. Long after, Jean Audubon's son would remember: "He was so pleased to see my various collections

that he complimented me on my taste for such things—But when he inquired what else I had done, and I, like a culprit, hung my head, he left me without saying another word. Dinner over, he asked my sister for some music and, on her playing for him, he was so pleased with her improvement he presented her with a beautiful book. I was next asked to play on my violin, but alas! for nearly a month I had not touched it; it was stringless: not one word was said on that subject . . . My good father looked at his wife, kissed my sister, and humming a tune left the room."[16]

Audubon took his son with him to the naval base at Rochefort, where the boy was to begin to learn all he would need to know for a life at sea. The study of nature was fine as a diversion, but now it was time to tend to the world's work.

The extreme regimentation of the naval station and the long hours of study did not appeal to a boy who had been free to observe the animals in the woods. The barracks, the artillery grounds, and the orderliness were overwhelming. Once his father's ship was sent out, the boy went over the fence and into the gardens. He was retrieved with military dispatch and kept under lock until his father returned.

Soon enough, young Jean/Fougère was paying attention to his math and learning the practical intricacies of a life at sea. He became a *mousse*—a cabin boy—one of twelve who, in the spring of 1796, went aboard the training ship *Instituteur,* captained by his father. It was the boy's first sea duty—six months of cruising the French coastal waters. Very likely he was seasick; when the *Instituteur* came back to Rochefort, mousse Jean Rabin was not among the boys sent on to their next duty. Yet, determined to please his father, he stayed on to prepare himself for the test that would qualify him to become an officer.

He was fourteen that September of 1797, when he and four other boys were tested. Only one passed; he was not Jean Rabin, son of Jean Audubon. Soon after, Jean Audubon retired, and father and son returned to Nantes; two careers at sea had ended, one before it had even begun.

Having been captain of the training ship, Jean Audubon must have known that the boy showed little promise as a seaman. Still, the son had obeyed his father's wishes and had attempted officer's training in spite of the sickness that never left him at sea.

His return delighted Anne Moynet, but now he was a teenager, at an age when her lavish praise embarrassed him. "She certainly spoiled me," he was to write, "hid my faults, boasted to everyone of my youthful merits and, worst of all, said frequently in my presence that I was the handsomest boy in France." In fact, he was a handsome boy—taller than his father, with sculpted features, curly chestnut hair, and a self-confident charm.

As the parents aged, the practical business of ensuring that the children would be the Audubons' legitimate heirs was becoming urgent. With that in mind, Jean and Anne determined to take the next, necessary step: baptism. In the perilous times—the Catholic church, it will be remembered, had been outlawed—this would require a certain discretion. Finally, an old family priest agreed to perform the ceremony, and it was duly recorded in the annals of the Catholic church that the adopted son of Jean Audubon and Anne Moynet had been baptized Fougère.

With Jean Audubon now retired, the family removed to La Gerbetière, where the boy spent the next three years roaming the countryside. "Perhaps not an hour of leisure was spent elsewhere than in the woods and fields; to examine either the eggs, nest, young, or parents of any species of birds constituted my greatest delight," he wrote years later. He began to draw even more seriously: "They were all bad enough," he said of these early efforts.

In 1802, Napoleon sent a force to Saint-Domingue to put down the slave rebellion and protect French interests in the West Indies. The expedition was an unmitigated disaster; yellow fever struck the French troops, killing more than were destroyed on the field of battle. All hope for restitution of French property was dashed.

Jean Audubon was concerned not only to recoup some of his massive losses in Saint-Domingue but also to keep his American farm work-

ing properly. Miers Fisher had found good tenant farmers, a Quaker
and his wife, but had been beseeching Audubon to come to America to
tend to his property, or to send someone in his place. Napoleon's search
for soldiers to replace those lost in places like Saint-Domingue was
beginning to cast a shadow on the Audubon hearth—Jean Rabin was
seventeen in the spring of 1802. Perhaps as a way to keep her son safe,
Anne Moynet nudged the boy toward the priesthood, but her husband
would have none of it. He had produced only one son to perpetuate
the family line; he would simply have to find some other way to keep
him safe.

That same spring of 1802, a letter arrived from Miers Fisher tell-
ing Audubon of the discovery of a rich vein of lead on the property at
Mill Grove. Enclosed was a sample of the ore. In a land where guns
were essential for protection, as well as for obtaining food, lead was a
valuable commodity. A mine could help Audubon recoup the fortune
lost in Saint-Domingue. Fisher made it clear that the tenant, William
Thomas, had discovered the ore and wanted to be included in devel-
oping the mine. There was also a question of a bond on the property
that had come due. Fisher had delayed until action was threatened;
payment had drained the account, and there was nothing left for
necessary expenditures. In the end, Fisher advised, "I cannot say, but
were [the property] mine, I would think it my duty to attend to it. I
am not conscious of having neglected it as thine, considering the feeble
powers (if powers they might be called) I had over it."[17]

Audubon lost no time. By summer he had dispatched Francis
Dacosta of Nantes, a man experienced in mineralogy and intent on
making his own fortune at Mill Grove. If Dacosta found the prospects
for a mine encouraging, papers would be drawn naming him a full
partner, in return for operating the mine. Audubon assured Dacosta
that he had his full confidence. The father did not confide these busi-
ness matters to his son, perhaps because he knew the boy's time of
wandering freely in the woods would soon be over.

As Napoleon's conscriptors began to move closer, Audubon *père*
decided to move his son out of harm's way by sending him off to the

New World. Miers Fisher was obviously a good man and had proved to be an honest friend as well. Francis Dacosta was in place in Philadelphia, near Mill Grove, and could be counted on to help guide the boy. America was at peace, and young men from all the world were gathering there to escape war and make their fortunes. The boy could learn English, the language of commerce; he could perhaps find some business to engage in, but primarily he would be safely out of Napoleon's clutches. In the meantime, the father would be looking for business opportunities for the boy.

Life in the villa had been sweet; the boy did not want to go, but understood why he must. His father explained everything, and Jean the younger trusted him implicitly. The elder Audubon probably tantalized him with stories of the vast, deep woods that covered America, of birds such as he would never see in France, of wild creatures that filled the forests and plains, and of the boundless opportunities in a world so untouched by man that there he could view nature as God had created it.

AS THE HANDSOME YOUNG FRENCHMAN struggled through the sixth, then the seventh day of the fever, the Quaker sisters in Norristown watched with alarm, not knowing if he would survive, praying that the Lord would not take such a young man. They watched until he fell into a deep and peaceful sleep. The boy survived because the sisters had administered what was, though they did not know it, the only helpful treatment for yellow fever: complete quiet and rest. When John Audubon opened his eyes and smiled at them, they thanked God for his deliverance, then did as the letter he carried with him directed, and sent for Miers Fisher.

2

*As if the world had been
made for me.*[1]

HE WOKE TO THE SOUND of birdsong and the whisper of
wind stirring through branches. He sat up, blinked, and took no-
tice; for the first time since coming down with yellow fever, he was
healthy and alert enough to feel a surge of interest in this new place,
America.

Perhaps the two Quaker sisters who ran the boardinghouse—and
who had, he understood perfectly well, saved his life—knew some
French. Did they call him "M. Audubon," with the French pronun-
ciation ("Oh-dew-*bonh*")? Or had they been the first to call him Mr.
Audubon ("*Aw*-duh-bun")? Certainly he was beginning to pick up
some English of a charming sort, scattered with the "thee" and "thou"
the Quakers used. While waiting for Miers Fisher, he made some tenta-
tive forays around the village, enough to give him an idea of this place,
tucked away into the primeval forest that America was then.

Trees, great towering forests full of them, covered a good measure of this land, though men were busy clearing them to make way for fields. Some roads had been cut to make rough passage for coaches and carriages; Indian trails offered faint paths a horse could follow through the woods. One could ride long miles under a canopy of green, seldom seeing the sun. Still, this was settled land: The Revolution had been fought and won almost twenty-five years before; Indians had been pushed west, so the frontier now was Kentucky and Illinois. President Jefferson was sending Lewis and Clark to explore the land beyond the Mississippi River; they would make the difficult journey all the way to the Pacific Ocean and return to report on the extent of the vast continent.

On this morning in the autumn of the year 1803, John Audubon stood on the road in Norristown, Pennsylvania, listened to the sounds coming from the forests all around, breathed in the air, and felt a surge of excitement. There was nothing tame about this country, nothing settled or worn. Farms had to be hacked out of the forests; trees, crowded together in seemingly impenetrable phalanxes, were always the backdrop. The land was primitive and rough, and seemed to vibrate with promise. He felt a stirring to be off, to be on his own, to see and be part of it. He was no longer Jean Rabin, no longer Fougère of France. He was John James Audubon of America.

The illusion of independence did not last long. One day Miers Fisher himself drove up in his carriage. Jean Audubon's English, learned in British prisons, was somewhat awkward, but it had not failed him. As to the care of his son, he directed: "I request you will render every service in your power . . . to procure him a good and healthy place where he might learn English. I come to point out to you Norristown, and look for a good and decent family in that place, to recommend him to her as your own son. This service from you will deserve my everlasting gratitude. I am, Sir, with consideration, your most obedient servant, Jean Audubon."[2]

Good Quaker Fisher could think of no family more good and decent than his own; he took his friend's son to his country

home near Philadelphia, where he resided with his dutiful wife (to whom he of course recommended the boy as if he were his own son) and their teenaged sons and daughters. Still, Fisher must have had some second thoughts on the long drive home.

For one thing, this young Audubon was voluble and spirited; for another, his baggage included not only a gun, but a violin, a flute, and his ever-present drawing materials. Frivolity was not acceptable in a Quaker home; sports shooting, music, and dancing were frowned upon, fishing and hunting game were necessary chores, not pleasures. Miers Fisher would have delivered a kindly lecture on appropriate behavior in a respectable Quaker home. John Audubon must have felt the long arm of his father reach out to him over the ocean; he was not free, not yet.

The stay in the Fisher household was a disaster. The eighteen-year-old Audubon took an immediate and distinct dislike to a Fisher daughter who was about his own age. She smiled at him; he turned his back. He even entertained the idea that the fathers might have some dark plot to marry the two. But the girl troubled him less than the ban on music and laughter and rambling about the woods with his gun.

The Quakers were exceptional; for most men of that early time in America, hunting was as natural and as acceptable as breathing. Animals were plentiful and men were few; the time was still decades away when thoughtful men (including Audubon) would begin to question the wisdom of the unchecked destruction of the creatures of the wild. In fact, at that early time in the country's history, the measure of a man was often taken by his skill in the hunt. At eighteen, Audubon was an accomplished sportsman, and the Pennsylvania woods were filled with creatures he had never seen before. There were birds to shoot and animals to track; to be presented with these perfect opportunities, then denied them, was too much. He knew how to be charming, certainly; but he was chafing at the bit, jumping to wild conclusions (his father, he soon discovered, thought him much too young for marriage), and making a nuisance of himself as well.

During this time, he met Francis Dacosta, who was staying in Philadelphia while making tests on the mine Jean Audubon hoped to develop. Audubon had asked Dacosta to act as guardian to his son, a responsibility he accepted without relish. Audubon *père* had arranged for his son to receive a portion of the rents from Mill Grove, with Dacosta holding the purse strings. Young Audubon put the best face on this arrangement, insisting he was "under certain restrictions which amounted to my not receiving more money per quarter than was considered sufficient to the expenditure of a young gentleman." His father would have shaken his head over the boy's pretensions, but the fact remained that now, for the first time, John would have a modest income of his own.

Within a few weeks, Dacosta and Fisher agreed that it would be best for the young man to return to Norristown and board at the house of the storekeeper there. It was only five miles—an easy walk—from the farm at Mill Grove. He would receive English lessons from the head of the Norristown Academy, the Reverend John Jones, in return for lessons in drawing. One wonders how that bargain was struck; did Jones see some of Audubon's bird drawings and ask where he had learned his art? Was it at this juncture that young Audubon, eager to impress, managed to insert the name Jacques-Louis David into the conversation? Did Jones, his French as sorry as Audubon's English, recognize the name but misunderstand the connection? David, the most famous French artist of the age, and a radical republican—he had painted Marie Antoinette on the way to the guillotine—was painter to the court of Napoleon. David once visited Nantes; perhaps Audubon saw him or even spoke to him. Possibly one of his drawing teachers did study with the master. Or there may have been no connection at all; it seems clear that there was never an opportunity for Audubon to have studied with David, but he allowed the world to believe that he had.[3]

Audubon arrived in Norristown packing his gun and fiddle and flute, along with the wardrobe of a perfect dandy: "It was one of my fancies to be ridiculously fond of dress," he would write, "to hunt in

black satin breeches, wear pumps when shooting and dress in the finest ruffled shirts I could obtain from France."[4] He was working his way toward the freedom to roam this country as he wished, unencumbered by older men who insisted he think seriously about his future.

At that time the Philadelphia road passed a short distance from Mill Grove Farm. The house is a classic two-story structure made of rubble stone, with dormer windows and a central hallway off which parlors and living rooms are arranged. A narrow staircase winds up to the second story and the bedrooms; the rooms in front look down a sloping field to the Perkiomen Creek, a wide stream with its own millpond. Audubon wrote: "My father, in his desire of proving my friend through life, gave me what Americans call a beautiful 'plantation,' refreshed during the summer heats by the waters of the Schuylkill river, and traversed by a creek named Perkioming. Its fine woodlands, its extensive acres, its fields crowned with evergreens, offered many subjects to my pencil. It was there that I commenced my simple and agreeable studies, with as little concern about the future as if the world had been made for me."[5]

His father hadn't "given" him anything, not yet. William Thomas, the tenant who worked the farm, knew that, and so did Francis Dacosta, who had considered moving into the Mill Grove house, but instead decided to stay on in Philadelphia. Still, the Thomases were friendly to young Audubon, and when he decided to move into the empty house, Mrs. Thomas agreed to take time out from her chores in the Thomas home to act as his "attendant" or housekeeper. He established himself as any eighteen-year-old on his own for the first time would—by doing exactly what he wanted to do. He spent most of his time rambling through the thick woods; he also set up one of the attic rooms as his "laboratory" and quickly filled it with specimens of all kinds— some small woodland mammals, but many more birds. (Some months later, a young neighbor boy, awestruck, saw this inner sanctum and described it: "On entering the room, I was astonished and delighted to find that it was turned into a kind of museum. The walls were festooned with all sorts of birds' eggs, carefully blown out and strung

on a thread. The chimney piece was covered with stuffed squirrels, raccoons, and opossums; and the shelves were likewise crowded with specimens, among which were fishes, frogs, snakes, lizards, and other reptiles. Besides these stuffed varieties, many paintings were arranged upon the walls, chiefly of birds.")[6]

It was the tenant, William Thomas, who had alerted Fisher and the senior Audubon to the existence of the vein of lead; for this, he made clear, he deserved a half share in what could prove to be an enormously profitable venture. Miers Fisher did not encourage him, saying only that perhaps a cash payment would be in order if the mine became productive. It is unlikely that Thomas knew any of the details of the senior Audubon's arrangement with Francis Dacosta. Thomas was not about to give up. Perhaps he thought young Audubon could be an ally, or maybe he simply liked the ebullient young man with his great enthusiasms.

At last, John Audubon was free to do as he pleased. "I had no vices," he would write in his guileless way, "but was thoughtless, pensive, loving, fond of shooting, fishing, and riding, and had a passion for raising all sorts of fowls, and which sources of interest and amusement fully occupied my time."

He spent long hours in a rock cave he had discovered on the bank of the Perkiomen, with a pair of phoebes that nested there. He was patient, and the birds finally accepted his presence so he could study their form, their coloring, their habits. He sketched them, and also caught them and tied bits of colored thread around their legs so he would know them if they returned to the cave to nest the following spring. It was the first time a bird had been banded.

By the Perkiomen he watched birds that fished for their food. It was there, he wrote, that he saw a bald eagle catch a number of redfins "by wading briskly through the water, and striking at them with his bill. I have also observed a pair scrambling over the ice of a frozen pond, to get at some fish below, but without success."[7]

He was not sentimental. To study the creatures of the wild he had to kill them. When the dead body rotted he replaced it with a new kill.

Neither he nor anyone else of the time thought of this as indiscriminate slaughter; that perception came much later, when the destruction of the forests and the wanton shooting of wildlife destroyed some species, and brought others close to extinction.

The virgin forests of America offered shelter and sustenance to countless birds. One traveler of the time wrote: "We glided down the muddy Potomac . . . cutting our way through myriads of canvasback ducks which literally blackened the surface of the water till our paddles sent them up. . . . These birds are justly esteemed a great delicacy in America."[8] The bounty seemed endless. Wildfowl were an important part of the American diet in the country's first century. A hunter would come home with bags full of birds—not just partridges, ducks, turkeys, and geese, but plovers and robins and pigeons. They were roasted over open fires and cooked in pies. Some provided only a mouthful of meat; their small bones were crunched and swallowed, the larger ones tossed away.

Audubon's struggle of the moment was to draw the bird as if it were alive. He wrote, "I betook myself to the drawing of specimens hung by a string tied to one foot, having a desire to show every portion, as the wings lay loosely spread, as well as the tail." He adds, dryly, "In this manner I made some pretty fair signs for poulterers." Then he tried suspending the birds by threads: "I raised or lowered a head, wing, or tail, and by fastening the threads securely, I had something like life before me; yet much was wanting. When I saw the living birds, I felt the blood rush to my temples, and almost in despair spent about a month without drawing."[9]

Next he tried to create the sort of manikin artists use to sketch the human figure; using wood, cork, and wires, he "formed a grotesque figure, which I cannot describe in any other words than by saying that when set up it was a tolerable-looking Dodo." When a friend saw it and burst into laughter, he "gave it a kick, broke it to atoms, walked off, and thought again."[10]

It was at Mill Grove that Audubon found the key to what became his style of drawing birds. The idea that led to what he called his

"discovery" came to him early one morning, long before daylight. He got up and headed for the village of Norristown. No shops were open when he arrived, so he used the time to bathe in the river. Then he bought some wire of different sizes and hurried back to Mill Grove. He arrived in time for breakfast but was too excited to eat.

He got his gun and was off to the creek, where he "shot the first Kingfisher I met." Back at Mill Grove, he collected some boards of soft wood, and filed sharp points on the pieces of wire. "I pierced the body of the fishing bird, and fixed it on the board; another wire passed above his upper mandible held the head in a pretty fair attitude, smaller ones fixed the feet according to my notions, and even common pins came to my assistance. The last wire proved a delightful elevator to the bird's tail, and at last—there stood before me the *real* Kingfisher."

Audubon was ecstatic. He felt neither hunger nor thirst; his mind and body were filled with his triumph: "I outlined the bird, aided by compasses and my eyes, colored it, finished it, without a thought of hunger . . . This was what I shall call my first drawing actually from nature, for even the eye of the Kingfisher was as if full of life whenever I pressed the lids aside with my finger."[11] *Drawn from nature by John James Audubon.* He had found the way; now, nothing would stop him.

His hands were rough and bloodied much of the time, as he pierced the newly dead bodies of every species of bird he would find with wire and twisted and turned them to get the effect he wished. He struggled to learn all he could from a bird. Sometimes he would gut one to preserve the skin, and he was teaching himself how to stuff birds and small animals, though he was never satisfied with using stuffed animals and birds as models for his sketches. Taxidermy was not an avocation for the queasy, but while Audubon easily succumbed to seasickness, his stomach proved strong enough to deal with the stench of animals long dead.

For many people of the time, including Audubon, the twenty-five miles into Philadelphia was an easy enough walk. Public transportation by stagecoach was very expensive, and a horse was a luxury. Audubon figured he now had enough money for such a luxury, but he didn't

know where to start looking for a good mount. An Englishman named Bakewell, the new owner of the large farm adjoining Mill Grove, had been buying stock; it was suggested that he might know who was selling horses.

Audubon's dislike of the British, inherited from his father, was not great enough to keep him from seeking information on something as important as purchasing a good riding horse. Mr. William Bakewell missed Audubon's call, but in a few days he returned the favor, and, finding his young neighbor out, left his card with an invitation to go shooting.

Audubon did not bother to respond; he was busy roaming the woods, taking specimens, and working in his attic room. Probably, too, he felt awkward in approaching this older man of obvious wealth. Bakewell's property, which he named Fatland Ford, was a larger estate than Mill Grove, and more impressive, with its wide view of Valley Forge, where Washington and his troops had spent one hard winter during the war.

Mrs. Thomas, who kept house for Audubon, passed along the neighborhood news: The Bakewells had four daughters—the eldest was about Audubon's age—and two sons. The family was gentry, descendants of the aristocratic Peveril family, who in the distant past had been joined by matrimony to one Count Bassquelle, who came from France to England as part of the court of William the Conqueror. Eventually Bassquelle became Bakewell. William Bakewell had inherited a large estate in Derbyshire from a bachelor uncle. His children had been born there and the family had lived in great comfort, but the promise of America had lured him.[12]

John Audubon's English was progressing, but his French accent was thick and he struggled for English words. He did not seek out his neighbors, but while tramping through the woods one cold day that fall, gun tucked under his arm, he happened onto William Bakewell, also out hunting, with his guns and dogs. The older man called out to Audubon, who responded with courtesy. The two continued together, the younger man watching the older aim, shoot, and bring down his

quarry almost every time. He admired the Englishman's hunting dogs; Audubon too had a knack for training dogs.[13] Bakewell, sensitive to Audubon's awkwardness, took pains to put him at ease. They shared the thrill of the hunt; the woods proved an excellent meeting ground. Before they parted that day, Bakewell invited his young neighbor to go shooting with him and his sixteen-year-old son, Tom. The well-born Englishman was probably painfully aware of how few young people were available to keep his clan company.

A few days later Audubon turned up at Fatland Ford. It was a formidable estate, with two stone barns, a washhouse and a spring-house, servant quarters, and a walled garden, all surrounded by rich farmlands (or "fatlands"). The house itself was larger and more elaborate than Mill Grove.[14] A servant led him into a parlor, where a fire blazed and where a girl about his own age was sewing. In his halting English, Audubon managed to tell her his name and why he had come. She, accomplished in entertaining her father's guests, quickly put him at ease.

He wrote about that first meeting with Lucy Bakewell: "We soon became acquainted and *I* attached to her."[15] Later, that single line would be expanded (perhaps with Lucy's help) to "And there I sat, my gaze riveted, as it were, on the young girl before me, who, half working, half talking, essayed to make the time pleasant to me."[16]

Lucy Bakewell, at seventeen, had the self-possession of an eldest child; since coming to America, her mother was often ill, and Lucy was frequently pressed into service as her father's hostess, and as lady of the house and substitute mother to the younger children, Billy, five, and Ann, nine. (Thomas, sixteen; Eliza, fourteen; and Sarah, twelve, were old enough to fend for themselves.)

Lucy was not only up to the task, but relished it; in an age when most women, and many men, could neither read nor write, she was literate. Her education had been more thorough than that of the young man who sat across from her, groping for the right English words. She chatted easily, ignoring her young brothers and sisters as they popped into view to peek at the young visitor, giggled, and disappeared.

Audubon began to relax; the company of a young woman his own age was pleasant, if being in a house filled with order and comfort and with a family of substance and education was daunting. Lucy Bakewell was not pretty; it was not until her father returned and she rose to arrange lunch that Audubon noticed her figure, which was tall and straight and very fine. It didn't matter that she was plain; she was sure of herself, and in her presence, he felt secure.

Audubon became a regular visitor to Fatland Ford. He met Lucy's mother, who had not wanted to leave her lovely mansion house in England to face the rigors and isolation of life in America.[17] The handsome young Frenchman charmed her with his music and his uncomplicated *joie de vivre*. She liked the way his presence made her plain daughter almost pretty.

The Bakewell family was a lively, animated group of young people headed by a loving and dutiful father and mother. Soon Audubon established himself as part of the family's life. As winter became spring, he learned a good deal about the Bakewells. In Derbyshire Mr. Bakewell had lived the life of a country squire, overseeing his estates and riding to hounds. A man with a liberal, intellectual bent, he had delved into scientific and philosophical studies. Two friends who came often to the Derbyshire house were Erasmus Darwin (Charles's grandfather) and Joseph Priestley, the chemist, author, and clergyman who had discovered sulfur dioxide, oxygen, and ammonia.

William Bakewell was a modern man, open to the novel idea that women should be educated. He sent Lucy off to boarding school to learn skills such as needlework, dress, and deportment. Like other young ladies of her social standing, she took music lessons and learned to sing and play the pianoforte. Outdoor activities were not ignored; she became an excellent rider, knew fine horses and fine dogs. She could swim and handle a boat, and, like the good countrywoman she was becoming, developed a fondness for gardening. But her real education—the kind most women were denied—was acquired in the hours after school, in the estate's excellent library, where a series of tutors guided her through studies of mathematics, science, and philosophy and encouraged her to

think. William Bakewell charted his children's progress, probably paying more attention to his son Thomas, but encouraging his daughters as well. He made this unorthodox decision because he believed that an educated wife would prove to be a better companion to her husband. He could not have known how important that decision would be to his daughter Lucy, and even more to the man she would marry.

In England they had been comfortable, but the French Revolution had frightened many English aristocrats, making life difficult for those among them considered to be nonconformist, a label that fit Bakewell.[18] Taxes were growing more burdensome, and tax-free America waited, offering what many European liberals saw as a promised land, full of opportunity for anyone with the courage to set out across the sea. And there was the adventure, of course. William Bakewell's brother, Benjamin—whose business had been destroyed by the French Revolution—had set out with his family to try again in America, and so had their sister, Sarah Atterbury, with her family. They wrote their brother in England: Come!

The William Bakewell family arrived in New York in the autumn, two years before John Audubon; Lucy was then fourteen. They stayed for a time in New York, where brother Benjamin had a business. Then the brothers formed a partnership in a brewery in New Haven, convinced that good English ale would be a profitable enterprise. But the brewery was lost in a fire. The episode seemed to confirm what William had already decided: Farming was his forte. The decision brought him to Fatland Ford.[19]

The months from the winter of 1803 through the spring and summer of 1804 were among the happiest of Audubon's life. The parrot Mignonne was safe from the cruel beast; life was good.

For men with a passion for hunting, for the outdoor life, this time and place in America must have seemed a paradise. Audubon spent long hours out in the woods hunting with Mr. Bakewell and Tom, and after that the other young men of the nearby farms came around. There were shooting parties; there was ice skating on the mill pond; there were balls, at which Audubon demonstrated that he had been as well

prepared for the life of the drawing room as for that of the woods. Lucy sat down at the pianoforte, Audubon took up his violin, and the two made music together, and danced, and the younger children clapped with pleasure.

The young people's parties were "noisyish," Bakewell would write, somewhat disapprovingly. He liked the young Frenchman well enough, he would tell his wife, and he would "seem to have" an acceptable background, if appearances did not deceive, but he didn't think Audubon an appropriate suitor for their daughter. He had his reasons: Like all Frenchmen, the boy had a "volatile" temperament. And while he admired the young man's fascination with nature and his skill in shooting, what, really, did they know of his family? Who were they and what were they about? The father knew that many young men would be interested in the Bakewell name and connections. He agreed that Audubon seemed not to have Lucy's inheritance in mind; he wondered how the boy expected to make his way in the world.

His wife listened, but she did not agree that they should discourage the two; the boy made Lucy glow with happiness. Bakewell's own marriage had been a love match. He had felt a certain distress about taking his wife so far from the life she enjoyed in England, and now he could not deny her, so he acquiesced on the matter of Lucy and John Audubon, for the present.

That winter, with Mrs. Thomas's help, Audubon hosted a dinner for the Bakewell family and some of their guests. After being served pheasant and partridge, the party went down to the solidly frozen Perkiomen, where the ladies were planted in sledges and the men pushed them around in large, lazy circles.

There were parties and balls, and with Lucy to steady him, Audubon was at the center of them all. His English was atrocious (Lucy was helping with that), but his neighbors were awed by his athletic skills. One of them, David Pawling, wrote in his journal: "Today I saw the swiftest skater I ever beheld; backwards and forwards he went like the wind, even leaping over large airholes fifteen feet or more across, and continuing to skate without an instant's delay. I was told he was a

young Frenchman, and this evening I met him at a ball, where I found his dancing exceeded his skating; all the ladies wished him as a partner; moreover, a more handsome man I never saw, his eyes alone command attention; his name, Audubon, is strange to me."[20]

The young Frenchman was not above showing off. Once, Tom Bakewell challenged him to shoot at his hat, tossed into the air—and to shoot while skating at full speed. Audubon took the challenge; Tom's hat was blasted through with shot. Only Mr. Bakewell was not amused.

Spring came, and then summer. From his attic window, Audubon could wave a message to Lucy at Fatland Ford; they walked together almost every day. He took her to the phoebes' cave to see the birds during what Audubon would always call the "love season." It was in the cave that he first spoke to Lucy about his feelings for her, and she told him what he already knew.

The couple soon announced that they wished to marry. Even though it was harvest season, when every member of the family was assigned chores, William Bakewell sent Lucy off on a long visit to an aunt in Baltimore. What could these two be thinking? Lucy's father wondered. The boy knew how to spend hours lying on his stomach, observing birds, but what else could he do? He didn't seem to be much of a farmer; how could he possibly hope to support a wife?

Audubon thought he understood Mr. Bakewell's caution. Only a young man with the right credentials could hope to court Lucy Bakewell. But Mill Grove was a substantial farm; it belonged to his family; and he was the only male heir. That was the one thing, Audubon surmised, that kept Lucy's father from sending him packing.

The Bakewells knew nothing about Jean Rabin, "créole de Saint-Domingue," knew nothing about Jeanne Rabin, chambermaid, or Sanitte, or Audubon's half sisters in the West Indies, or his half sister Rose, who was passing as white. Nor would he want them to know about the adoption or the baptism, or the forged papers that Jean Rabin-Jean Jacques Fougère carried with him across the Atlantic, which declared him born in the Louisiana territory and transformed him into John James Audubon.

Lucy's absence did not keep Audubon away from Fatland Ford. He turned up to help with the harvest, bringing some young French friends who were staying with him. It was a generous gesture that Bakewell could not have ignored—even if his wife had let him.

When Lucy returned, the two picked up where they had left off, with Mrs. Bakewell smiling on them. Audubon had written his father, giving a glowing account of Lucy and asking for his permission to marry. He began to tell the Bakewells more about his father, about his giving Mill Grove to him as a "gift." About the family villa in Couëron (making it seem more than the rambling country house it was) and the city house in Nantes. He talked about his father's illustrious career, fighting in the American Revolution and meeting General Washington. A portrait of the general hung in the parlor at Mill Grove. Audubon decided that Washington must have presented it to his father as a token of his appreciation for the *admiral's* substantial role in winning the victory. "Admiral" was not, he knew, the right translation. (It could be argued that, since Jean Audubon often served as captain of the vessels he sailed on, "Captain" ought to be his title. The son had spent enough time in Rochefort to know that Jean Audubon's final naval rank was *lieutenant de vaisseau,* one rank below captain.[21])

That September, both fathers had other worries on their minds. For months, Francis Dacosta had been seething with frustration, disappointment, and anger at both Audubons. The mine was tantalizing; he would follow one vein, sure it was going to be the one that would make them all rich, only to have it dissipate into nothing. The frustration was compounded by the fact that a promised contract declaring him owner of a half share in Mill Grove had never arrived. He must have asked himself what he would do, should the mine come in. What would he get in return for all his work? Could the senior Audubon be trusted, when the younger Audubon saw fit to ally himself with Thomas, who seemed to feel he had been betrayed? Most annoying, the boy was telling the world at large, and the Bakewell family particularly, that he was the sole owner of Mill Grove.

The mine was an enormous gamble, for Dacosta and for Jean Audubon as well; the former risked time and what funds he had, and the latter, in worsening financial straits with the loss of his West Indies ventures, risked half of his American investment. John, absorbed in his romance and his birds, did not know the details of the arrangement between his father and Dacosta, or if he did, he saw fit to ignore them.

Jean Audubon wrote to Dacosta, assuring him the papers had been sent, and carefully segued into the delicate subject of his son. "If you would have the kindness to inform me about his intended, as well as about her parents, their manners, their conduct, their means, and why they are in that country, whether it was in consequence of misfortunes that they left Europe, you will be doing me a signal service, and I beg you, moreover, to oppose this marriage until I may give my consent to it. Tell these good people that my son is not at all rich, and that I can give him nothing if he marries in this condition."

That message, if delivered with a certain amount of diplomacy by Dacosta, would have cheered William Bakewell. Here was a father he could understand, one with his son's best interests at heart; a father, in fact, who had a plan for the young man that included (if the mine was a success, as everyone supposed it would be) a situation that would enable him to provide for himself and perhaps eventually for a wife; a father who wanted it known that he opposed the marriage until his son was able to support himself. Bakewell might have thought, as well, that when the father said "I can give him nothing if he marries in this condition," it was obvious that there was something to give, and an intention to do so.

When Dacosta, following the elder Audubon's advice, tried to discourage the son from pursuing Lucy, John Audubon flew into a rage. Long after, he pouted: "He spoke triflingly of her and her parents, and one day said to me that for a man of my rank and expectations to marry Lucy Bakewell was out of the question."[22] Audubon managed to intimate to Lucy that Dacosta felt the French family socially superior, when what he meant was just the opposite.

Audubon continued to play the young squire of Mill Grove, embroidering the truth as he went along. Lucy listened, soaking up all

that he said, believing everything and only now and then correcting his English. He talked to her of his birds; she listened, rapt.

Dacosta continued to explore new tunnels in the mine, and made some attempt to carry out his duties as the younger man's "partner, tutor and monitor." He encouraged the studies of birds and seemed impressed with the drawings, which he said showed real talent. But with Thomas fanning the flames of rebellion, and John Audubon smarting over Dacosta's interference in his personal life, things got progressively worse.

Letters began to flow back and forth between Mill Grove and Couëron: Dacosta to Audubon about the exasperating contract, still missing; Audubon to Dacosta, assuring him that it had been sent and that he had full confidence in him and the mine; John Audubon to his father, begging permission to marry Lucy; Jean Audubon to his son, arguing that he was too young.

Summer was over, and with it came the end of the year when Audubon felt "as if the world had been made for me." Lucy's mother had been well that summer but suddenly, on September 20, she was taken ill with one of the fevers that swept through the country. Ten days later, she was dead. She was the first to be buried in the family plot in a back garden; William Bakewell, overwhelmed with grief, retreated to his rooms, absorbed with the question of what was to be carved on his wife's marble gravestone. He chose:

A LOVELY FORM, A MIND DEVOID OF ART
WITH ALL THE KIND AFFECTIONS OF THE HEART
A TENDER MOTHER AND A FAITHFUL WIFE
IN DUTY'S SACRED PATH SHE MOVED
 THROUGH LIFE
THOUGH HUSBAND, CHILDREN, FRIENDS
 IMPLORED HER STAY
HE WHO BESTOWS HATH RIGHT TO TAKE AWAY
IN HUMBLE FAITH, THIS HOME WE KEEP IN VIEW;
THE POWER THAT FORM'D US, WILL OUR
 LIVES RENEW.[23]

LUCY TOOK OVER AS MISTRESS of Fatland Ford. A pall was cast over the family; Audubon stood by, wanting to help but not knowing how, except to braid strands of Lucy's mother's hair into a ring as a remembrance.[24] Lucy was too busy now for long walks and even for talk about their future together. She was needed at home; there were servants to oversee, the older children's lessons to watch over, Ann and little Billy to comfort. Fatland Ford was a thriving farm; there was work to do, and someone had to tend it until William Bakewell could pull himself together.

Winter came; Perkiomen Creek froze; Audubon was the leader now of a group of young men who regularly went hunting. Early one December morning Audubon and young Tom Bakewell and the rest set off duck hunting; they strapped on their skates and took off, using the Perkiomen Creek as a roadway, even though the ice was full of dangerous air holes.

"On our upward journey it was easy to avoid accident," Audubon wrote, but they lost track of time and went too far. Suddenly darkness was descending, and they were in trouble. Audubon tied a white handkerchief to a stick and led the party's return homeward on the treacherous ice. "We proceeded like a flock of geese going to their feeding ground," he wrote. The darkness gathered and it became hard to see the airholes; suddenly Audubon plunged into one. He "was carried for some distance by the stream under the ice, and stunned and choking I was forced up through another air-hole farther down the stream. I clutched hold of the ice and arrested my downward progress, until my companions arrived to help me."[25]

They dragged him out, stripped him of his clothes, and rubbed him as vigorously as they could, trying to bring some color to his pale flesh. Each gave him some dry article of clothing; then they rushed him to the nearest farm, the Bakewells'.

He was bruised and chilled, and his body temperature would have been dangerously low. Lucy was there to tend to him. Doctors were called in from Philadelphia. Since the young man had no family to care for him, there was nothing to do but keep him there.

After some weeks he attempted to get up and about, but it was too early and he collapsed. For days on end Lucy and Audubon were together, with no shooting parties or forays into the woods to separate them. There was time to talk, to come to know each other at close range, to discuss a future together. It was three months before Audubon recovered.

By then, he had become utterly convinced, on the basis of Thomas's reports, that Dacosta did not know what he was doing, that he had no skills in mineralogy, that he had misrepresented himself to Jean Audubon and was working against the Audubons' best interests. Audubon, often excitable, lashed out. Dacosta, furious, responded by cutting the boy's allowance.

By March, John Audubon had made a decision. He must return to France, to warn his father against the conniving Dacosta and to convince him to allow John to marry Lucy. He discussed this decision with Lucy and her father; they did not try to dissuade him. Lucy, after all, was needed at Fatland Ford and felt that her first duty was to her father and the children. William Bakewell welcomed the chance to put an ocean between the two young lovers for a time.

Audubon walked the twenty-five miles to Philadelphia to see Dacosta and demand passage money to return to France. Dacosta obligingly sat down, wrote out a message, sealed it, and handed it over. It should be presented to his banker in New York, he said calmly; it contained the necessary instructions for making financial arrangements. Audubon, no doubt surprised at Dacosta's easy cooperation, walked back to Fatland Ford to say his good-byes. Before the young man left for New York, William Bakewell gave him a small amount of money, and a letter for his brother, Benjamin. It was arranged that Audubon would stay with Lucy's aunt; the Bakewell family had rallied around him.

He covered the ninety miles to New York in three days and presented Dacosta's sealed letter to the banker. The man read it and seemed perplexed and perhaps embarrassed. Dacosta's letter must have vented some of the anger he felt, because it directed the banker to give the boy nothing . . . to ship him off to Canton, if he could.

It was one of the few times in Audubon's life when he felt absolutely murderous. He would return to Philadelphia and kill the wretch Dacosta, he ranted to Lucy's aunt, Sarah Palmer. He wanted nothing so much as to see the man dead. She managed to quiet him (though it took some time and effort); Benjamin Bakewell stepped forward, and, following his brother's directions, offered to advance the passage money. William Bakewell must have foreseen some such problem; clearly, he wanted Audubon to make the journey home.

Soon after young Audubon's departure, Dacosta received a letter from the father pleading for his understanding, and offering a vivid glimpse into just how far the misunderstandings between the parties had progressed, and just how good a friend he was to his son. Addressed to "Mr. Dacosta, Philadelphia" and dated March 1805, the letter opened with Audubon's effusive assurances that he had every confidence in Dacosta's ability to pursue the elusive lead veins and that he supported him completely in the business. Then he went right to the heart of the matter. "I am vexed Sir," he wrote, "one cannot be more vexed at the fact that you should have reason to complain about the conduct of my son, for the whole thing, when well considered, is due only to bad advice, and lack of experience; they have goaded his self-esteem, and perhaps he has been immature enough to boast in the house to which he goes, that this plantation should fall to him, to him alone." He reminded Dacosta that it was well known in Philadelphia that they were equal partners in the venture, and said he was writing his son to give him "the rebuke that his indiscretion deserves." Then he explained, as patiently as he could, that he could neither come to America nor recall his son to France, because "the reasons which made me send him out there still remain." He pleaded with Dacosta to try to understand his son: "Only an instant is needed to make him change

from bad to good; his extreme youth and his petulance are his only faults . . . It is necessary . . . that we endeavor, by gentleness, to reclaim him to his duty. If you are indulgent with him, it will be I who should be under every obligation to you . . . This is my only son, my heir, and I am old."[26]

If Audubon's letters to Miers Fisher and William Bakewell were even half as compelling, the squire of Fatland Ford must have thought more kindly of his daughter's young suitor. But it was too late for either Dacosta or Miers Fisher to set things right; John Audubon was aboard the sailing vessel *Hope,* on his way to Nantes. He had been in the New World for two years; he had learned a great deal, but he had not learned enough.

"A few days after having lost sight of land," Audubon writes of that voyage, "we were overtaken by a violent gale, coming fairly on our quarter, and before it we scudded at an extraordinary rate, and during the dark night had the misfortune to lose a fine young sailor overboard . . . After nineteen days . . . we had entered the Loire, and anchored off Paimboeuf, the lower harbor of Nantes."[27] Late that same evening he arrived in Couëron, to the shocked surprise of his father, the delight of his mother, and the embrace of his sister Rose.[28]

3

I am here in the snears of the eagle.[1]

IN THE SPRING OF **1805,** John Audubon *fils* (as he signed him-
self now that he was back in France) wrote to William Bakewell in
irrepressible, effervescent English: "I am here in the snears of the eagle,
he will pluck Me a little and then I Shall [sail] on a sheep have good
wind all the way and as Soon a land under My feet My compagnon of
fortune Shall Carry Me Very Swiftly Toward you." In closing he added:
"Kiss all yours for me without forget Lucy."

William Bakewell was amused enough by his would-be son-in-
law's note to send it along to a cousin in England, explaining, "I en-
close you a short letter I lately reed, from Mr. Audubon who is at
his Father's near Nantes. You must make it out as you can for I can-
not exactly understand it . . . His 'companion of fortune' is an ass of
the Spanish kind which I desired him to procure for me for breeding
mules. I do not understand his snares of the eagle but suppose it is that

the government are wishing to put him in requisition for the army."[2] This was not idle speculation: Napoleon was scouring France for recruits—or conscripts—for his Russian campaign.

Or the eagle might have been Jean Audubon, who probably felt like plucking his son a little for causing so much trouble, and for not accomplishing any of the things he had sent him to America to do. He had managed to ruffle the feathers of Miers Fisher and to thoroughly antagonize Francis Dacosta, on whose diligence the success of the mine depended; he had attached himself to a young woman and announced for all the world to hear that he wished to marry, though he had shown no inclination to find a way to support her—he hadn't even learned to speak proper English. What was a father to do with such a son?

Jean Audubon was sixty-one that year; he was short (five feet, five inches), with an oval face, blue eyes, a large mouth and nose. His eyebrows were auburn and his hair and beard were gray. ("In temper," the son would say about the father, "we much resembled each other, being warm, irascible, and at times violent, but it was like the blast of a hurricane, dreadful for a time, when calm almost instantly returned.")

As usual, Audubon *père* met the problem head-on. He was robust enough to play a game of cat and mouse with the conscriptors. ("This is my only son . . . and I am old.") He kept his son hidden away in the country house, where he could maintain a close watch on him while he figured out a course of action for the boy.

"Before sailing for France," the son would write, "I had begun a series of drawings of the birds of America, and had also begun a study of their habits." When it seemed safe, Audubon *fils* was allowed to roam the woods, under the watchful eye of a young family friend who was also a keen amateur naturalist. Thus, Dr. Charles-Marie D'Orbigny entered Audubon's life at a critical moment.

"The doctor was a good fisherman," Audubon later wrote, "a good hunter, and fond of all objects in nature. Together we searched the woods, the fields and the banks of the Loire, procuring every bird we could, and I made drawings of every one of them."[3]

The two, sharing a passion for the study of birds, became close friends; before the year was out, John Audubon stood godfather to the physician's second son. In every spare minute the doctor and the draft evader were out in the woods, observing, tracking, and shooting birds. They then repaired to a makeshift laboratory to dissect and study.

D'Orbigny helped Audubon develop his skills at taxidermy; he impressed upon him a need to formulate and apply a scientific approach to his study of birds; he served as a teacher at precisely the moment when Audubon most needed direction. Had Audubon *fils* applied himself to learning English or farming or business with even half the concentration he spent on birds, he would have been a resounding success. His father must have watched as the son labored over his drawings of birds—very early in the morning at times, or late at night—but it seems not to have occurred to him (any more than it had to Lucy's learned father) that his son might have a calling, that this could be his life's work. Audubon *père* was a practical man, and so was William Bakewell. Naturalists were gentlemen with independent incomes; anyone else must pursue the study as an avocation, in leisure time. Those like D'Orbigny and Audubon, who did not understand this distinction and who could not control their obsession, were in for a difficult time, as both were to discover.

The young Audubon was aware that he could be exasperatingly different; he once wrote: "I was temperate to an intemperate degree. I lived on milk, fruits, and vegetables, with the addition of game and fish at times—The result has been my uncommon, indeed iron, constitution. This was my constant mode of life ever since my earliest recollection, and while in France it was extremely annoying to all those round me."

A letter from Lucy informed John that her tenure as mistress of Fatland Ford was soon to end. Before Christmas, her father was to marry Rebecca Smith of Philadelphia, who was thirty-eight and a spinster. William Bakewell felt that his younger children needed a mother; he had long enjoyed the companionship of a good wife, and must have wished to find that kind of relationship again. Lucy was doing a fine job with the house and the children, but she could not be expected to

continue indefinitely; she did, after all, have her heart set on marrying Audubon. And so Bakewell married the spinster, hoping to pull his family together again.

That month there was a marriage in the Audubon family as well; on December 16, 1805, John's sister Rose Bonnitte was married to Gabriel-Loyen du Puigaudeau. She was nineteen; he was thirty-five. The marriage register was forthright, stating that "Mademoiselle Rose Bouffard" was the "younger daughter of the late Catherine Bouffard,* native of Saint-Domingue, and adopted daughter of Monsieur Jean Audubon and his wife Anne Moynet."[4] Rose's half brother (Jean Rabin, "créole de Saint-Domingue") was there for the marriage ceremony, and signed the document "John Laforest James Audubon," substituting "Laforest" for "Fougère." His father sometimes addressed him as "Laforest," and Lucy would use the name when writing him.

The guiding hand of Audubon *père* can be seen in Rose's very respectable marriage: Two of the groom's brothers had served under Jean Audubon during his stint in the navy. Du Puigaudeau was not an aristocrat, though he came from a well-to-do merchant family and had properties that could support him. Following custom, Rose's father would have offered a dowry; then he would have heaved a sigh of relief: one child provided for, one to go. Du Puigaudeau proved a dutiful son-in-law; a few years later he moved his new wife and small son into a villa called Les Tourterelles—the Turtledoves—in Couëron, near his in-laws' house.

One of the guests at Rose Bonnitte's wedding was Ferdinand Rozier, the son of a family friend, Claude Rozier of Nantes. Ferdinand had finished a three-year stint in the French navy, during which he had seen a good part of the world. The previous summer he had visited America and had been a guest at Mill Grove. He had met Lucy and the Bakewells, though he had never been able to learn enough English to converse easily with them. It is likely that he attended the simple burial service for Lucy's mother, and he knew all about the younger Audubon's plan to marry.

*"Sanitte," it will be remembered, was a nickname for "Catherine."

It would take the fathers Audubon and Rozier a year to devise a plan to spirit their sons out of the country and out of danger of conscription. Rozier agreed to become an equal partner in the remaining half of Mill Grove. The cash raised would allow Audubon to send his son back to the United States, with the older (by eight years) and more business-wise Ferdinand as his partner. "Articles of Association" were drawn up which would bind the sons as partners for nine years. The document gave very specific instructions on how the young men were to proceed. They would study Dacosta's records and decide if his plan for the mine had some chance of success, and if they could work with him; if they found they could not, they were to make arrangements to divide the property. (Because of John Audubon's prickly history with Dacosta, Ferdinand was assigned to deal with him.)

In the document, the fathers tried their best to cover all eventualities, including possible rifts between the sons. Article 9 stated: "We both resolve to maintain friendship and mutual understanding, and we agree very expressly that, upon the least difficulty, we shall each select one arbitrator, who will be authorized to choose a third, and we promise upon our honor to fully accept the decision that shall be reached, without ever having it in our power to make an appeal from it before any courts."

Article 10, the last, added: "In case of the death of one or the other (which, God forbid), the survivor shall have sole charge of making a settlement . . . but the partnership cannot be dissolved until after nine years, counting from the day of the date of the present . . . Done in duplicate and in good faith between us. Nantes this 23 March 1806."

The two young men were to share equally in any profits from their half of the farm, but they were also to seek employment that would give them business experience. As a last, fatherly precaution, the two would be given a cache of gold coins to tide them over, should the farm not provide enough income to support them before they could find other work. The document gave the sons the legal right to act for their fathers, with one proviso: Before making any major decision, they must consult with Miers Fisher.

While his son was in Couëron, Jean Audubon had been corresponding with William Bakewell. Both men agreed that Lucy and John were too young for marriage. If John Audubon dreamed of returning to take Lucy as his wife and make her mistress of Mill Grove, he was disappointed. Pennsylvania was no Saint-Domingue, Lucy was no octoroon to be installed as a *ménagère,* and John would never be the Jean Audubon who could, when driven by desperation or greed, make the morally expedient decision.

Sanitte's death presented the senior Audubon with just such a decision. At a time when he was faced with dwindling resources and frustrated by the failure of the Mill Grove mine to revive his fortune, he learned that one M. Ferrière had taken legal action to be named guardian of Sanitte's children and administrator of her estate, which was rumored to be considerable. Apparently, after Audubon deserted her and all of their daughters except Rose, Sanitte had found another protector.

Jean Audubon concluded that most of Sanitte's estate was, in fact, property he had left behind in Saint-Domingue. He promptly filed papers declaring himself to be the father and legal guardian of Sanitte's children, though the only one he named was Rose. Several sea captains from the West Indies days (including the one who rescued Rose) testified that Jean was, indeed, the father of Sanitte's children. The mystery of how much Rose Bonnitte's new husband knew about his wife's mother seems to be solved by this document, which names Gabriel du Puigaudeau as "deputy guardian." His wife's share of a possible inheritance must have seemed more important than her racial background; father and son-in-law were in accord.[5]

Soon enough it was discovered that Sanitte had left no will; at the time, that news cheered Audubon and his son-in-law. Later, when the estate turned out to be a will-o'-the-wisp and Sanitte's children began to make demands on their self-proclaimed natural father and guardian (and on his deputy guardian), the men regretted their action.

Audubon's only son knew nothing about the scramble to collect from Sanitte's estate; he and Rozier had already set sail on the *Polly,* bound for New York, on a voyage destined to be a grand adventure.

Good-byes were said, and tears were wept for a future that none of them could predict. Anne Moynet, now seventy, believed that all was in the hands of God. America was far away; she knew she might never see her son again. Jean Audubon knew his might be a final parting too; he was not well, though his son refused to admit it. Only Rose, newly married to the man Audubon now called "Brother du Puigaudeau," might have felt confident they would meet again.

John Audubon's feelings were mixed. The first time he set sail for the United States, he was miserable about leaving family and friends; this time, though parting was painful, Lucy and America were waiting for him; as he had written her father, he wanted nothing so much as to be carried "Very Swiftly Toward" them.

Still, simply climbing aboard the *Polly* did not mean they were on their way; departing France was no easy matter. Jean Audubon knew all about papers, real and forged; he procured papers that declared his son to be a native of the United States. Rozier, who resisted speaking any language but French, would sail on a Dutch passport.

Almost everyone who boarded the Yankee brig *Polly* that April day was fleeing something. Some were remnants of the nobility who had lost too much to stay; two monks were hidden belowdecks; other passengers were young men like Audubon and Rozier, unwilling to risk dying for the new empire. Along with the refugees were a U.S. senator from Virginia and his pretty daughter.

The *Polly* took on cargo and passengers at Nantes. The scene at shipside would have been, as always, chaotic, with the loading of a small mountain of baggage including Audubon's fiddles, his flute, a hefty supply of the kinds of papers, pens, and pastels he preferred, and the two hundred drawings of birds he planned to present to Lucy. The hefty, sweating longshoremen lifted aboard food and water enough for the eight-week journey, not to mention all the varied goods being shipped to the New World. It would have been here, in Nantes, that the captain ordered the ballast shifted so a cache of gold could be hidden deep in the hold and spirited out of France. The two monks had been hidden below, along with the sheep and pigs and perhaps one

Spanish ass destined for Fatland Ford. And still there was room for a few contraband luxuries: good French wines and coffee. Captain Samis was an old hand at smuggling; he knew the risks and was willing to take them for the sake of the rewards.

On the morning of April 12, 1806, a Saturday, Audubon *fils* embraced his father for the last time, bending to kiss him first on one cheek, then the other. The son felt the weight of leaving a father who had proved himself a "friend through life" and who even now was intent on holding his son's hand as he made the precarious crossing into manhood and independence.

Slowly, the great ship made its way downriver toward the open ocean; they must pause at Saint-Nazaire, where French officials would, or would not, give them final clearance to sail. The French official, with a studied formality, found the ship's papers in order; next he gave a cursory glance at the American congressman's papers, and then inspected, one by one, the papers of everyone else on board. Ferdinand, always taciturn, held out his forged Dutch passport and said nothing at all; the official glanced at it, handed it back. It was Audubon's turn; the official took a hard look, glanced up in admiration, and murmured, "Would to God I had such papers." Clearly, the *Polly* had been lucky enough to draw an official who did not necessarily believe in the glory of Napoleon's empire, or begrudge a way out to those who found it.

The senator's pretty daughter provoked a story, probably apocryphal, that sheds some light on the manners and mores of the period. At first, with the *Polly* safely out to sea, the mood was almost festive. The monks climbed into the sunshine; the draft evaders took a deep breath of fresh sea air and felt, for the first time in many long months, secure.

Two young Frenchmen on board began to vie for the attention of the pretty Virginian. One afternoon a sudden wind lifted the girl's bonnet from her head and sent it sailing out over the ocean. One smitten Frenchman did not hesitate, but dove in after it. Captain Samis brought the brig into the wind and sent the yawl to collect the young

romantic. He climbed back aboard, dripping wet and clutching the bonnet, which he handed over to its owner with a bow.

At dawn the next day shots rang out. Audubon and the rest of the passengers tumbled quickly out of their berths, expecting to see a pirate ship. What they saw instead was the young man who the day before had so blithely jumped into the ocean to save a lady's bonnet; he was sprawled out on the deck, shot dead. His rival for the young lady's attention stood with pistol in hand, clearly the winner of the duel.[6]

During the 1780s, the decade of Audubon's birth, dueling was in decline and laws in most countries forbade it. Churchmen had condemned it and intellectuals pointed out the irrationality of dueling as a means of settling disputes. It was a relic of a primitive world, and seemed to be disappearing altogether until Bonaparte appeared on the world scene. It suited the diminutive emperor to encourage such a savage practice, and so dueling was reborn with a vengeance in France—not just among the upper classes, but in the ranks of the army and even in the middle class.[7] It would not have been unusual for a young Frenchman to take offense when he thought a supposed rival had taken unfair advantage, and to challenge him to a duel. Men fought, and died, over such stupid matters as a retrieved bonnet.

While the French were responsible for the revival of this barbarous practice, the Americans took it up with gusto. The practice spread north from New Orleans. In July 1804, while John Audubon was romancing Lucy at Fatland Ford, Aaron Burr killed Alexander Hamilton at a duel in Weehawken, New Jersey. (Only a year or so before that, Jean Audubon had paid off a debt to Burr, who had a lien on the Mill Grove farm.)

Duels, pirates, and privateers thrived in an age when, though laws existed, they could not be enforced or were simply ignored. National governments hired privateers—heavily armed ships, privately owned and manned—to fight or harass enemy shipping. Two weeks out of Nantes, the *Polly*, under a full sail and flying the Stars and Stripes, was overtaken by the British privateer *Leander*.[8] Captain Samis held his course; the *Leander* fired a shot across the *Polly's* bow, then quickly

moved into position to blast her with a broadside. The captain of the American ship, understanding that he could not avoid a boarding party, submitted.

As soon as Audubon saw what was happening, he raced back to his berth, dropped his gold coins into a sock, dashed back on deck, and hid his small fortune. Soon after, the boarding party climbed aboard, identified their ship (which Audubon would always refer to dramatically as the *Rattlesnake*) and asked to examine the captain's papers. Finding everything in order, the leader of the boarding party turned his attention to the *Polly's* crew. The seamen were lined up; two were impressed for duty on the British privateer. Captain Samis and the senator complained bitterly, but it did no good. The privateers carted away most of the pigs, sheep, wine, and food. But they also wanted gold.

Audubon describes the scene: "The Rattlesnake kept us under her lee, and almost within pistol-shot, for a day and a night, ransacking the ship for money, of which we had a great deal in the run under the ballast, which though partially removed, they did not go deep enough to reach the treasure. The gold belonging to Rozier and myself I put away in a woollen stocking under the ship's cable in the bows of the ship, where it remained safe until the privateers had departed."

In all, Captain Samis must have been relieved. He had lost two of his best men and the luxurious food and drink that would have made the rest of the journey more enjoyable, but his passengers had gone unharmed and the large shipment of gold had not been discovered.

Audubon and Rozier congratulated themselves on their great good luck. Because he did not drink wine or eat what he called "butcher's meat," Audubon was not even among those who bemoaned the loss of their luxuries.

Six weeks later, thirty miles off Sandy Hook, a fishing boat paused to warn the *Polly* that two British frigates lay off the entrance to New York Harbor. They had fired on an American ship, the fishermen said, and were impressing seamen. Captain Samis, wanting no more trouble, turned into Long Island Sound, where a sudden gale drove the ship onto a sand spit. At this point, Audubon—seasick and miserable—

longed for Lucy and firm ground. Fortunately, the *Polly* floated free
with the next tide and moved swiftly toward New York and a new life
for Audubon and Rozier, partners.

ROZIER, THE ELDER OF THE TWO, was stolid, purposeful, deter-
mined. His features were coarse and he had a look of melancholy about
him; he was as plain as his young partner was pretty. Rozier defied the
stereotype of a Frenchman—he was neither handsome nor charming,
his manners were far from impeccable, and he was not at all "volatile."
Audubon, on the other hand, fit the stereotype. He described himself
as he might one of his favorite birds: "I measured five feet ten and a half
inches, was of a fair mien, and quite a handsome figure; large, dark,
and rather sunken eyes, light-colored eyebrows, aquiline nose and fine
set of teeth; hair, fine texture and luxuriant, divided and passing down
behind each ear in luxuriant ringlets as far as the shoulders."[9]

They stopped in New York long enough to greet Uncle Benjamin
and collect Tom, who had been put to work in Uncle's counting house.
After that brief visit, Benjamin wrote to a cousin in England, "Mr.
Audubon (Lucy's Beau), arrived from France a few days ago to the
great satisfaction of his and her friends, as from the difficulty of leaving
France which all young men now find we were apprehensive he would
be detained. He is a very agreeable young man, but volatile as almost
all Frenchmen are."

Audubon had left during the chill of winter, and returned to Mill
Grove with the spring. The birds were back nesting in the cave where
he had proposed to Lucy, the male phoebe wearing his worn silver
thread. Audubon would write in his journal: "I saw my dear Lucy, and
was again my own master." As much as he loved his father, he loved the
freedom of America more; he could, more or less, do what he wished—
and what he wished was to find a way to marry Lucy and continue to
study and draw his birds.

Before leaving for France, Audubon had poured out to Lucy all his frustrations about Dacosta and the mine. Now it was her turn to complain. He heard about the changes that had taken place at Fatland Ford since the advent of his father's new wife. Rebecca had not opened her arms to her stepchildren, as Anne Moynet had. She was stern, watchful, and disapproving. Audubon turned on his considerable charm, but it did not work. Rebecca did not like him.

But it was summer, and Lucy and her beau picked up where they had left off, with long nature walks through the woods, little Billy sometimes in tow. They swam in the mill pond; once, Audubon swam all the way across the river with Billy on his back. At other times they pored over the bird sketches Audubon had brought with him and presented to Lucy. New attempts filled his sketchbooks: an osprey, sprays of false foxglove.[10] He was interested in everything in nature, but he was not interested in farming.

Thomas Pears, who was to marry Lucy's cousin Sally Palmer in the fall (they would be in and out of Lucy and John's life for some years to come), came out to Fatland Ford to study farming that summer. In a letter to Sally, he wrote that Lucy and John whiled away the time in doing a little weeding but mostly in teasing him. Audubon, he wrote, had said that he would rather "turn merchant" than toil away at farming. Sally wrote back to say that she thought both Audubon and Lucy "extremely unfit" for the confinement of business, both being so fond of the country. Sally wasn't the only one who didn't approve of the couple. William Bakewell wrote in his diary that while his son Tom "seems to have applied well to business and is attentive and active," he was not so well pleased with Audubon. "Don't like their being here in idleness," he wrote, "Mr. Audubon did not bring his father's permission to marry nor the $150 lent him."

Audubon may have been idle in handling business affairs, but Rozier was not. Almost immediately he began to go over Dacosta's books, and very quickly he concluded that the mine was unlikely to succeed unless the partners brought in new capital. That would mean forming a company and selling shares, or finding another partner who had

money to invest. In either case they would dilute even further every-
one's share of any future profits. Rozier was thorough and blunt. So
far, all of Dacosta's work had turned up nothing. Possibly there was
nothing to find; the mine was simply a gamble.

Dacosta took the decision out of their hands; he would have noth-
ing to do with new partners or new money. Rozier and Audubon talked
it over, conferred with William Bakewell and Miers Fisher, then pro-
ceeded to divide up Mill Grove. Rozier did his work well; Dacosta
would get an area of 113 ½ acres, including the mine and all the build-
ings. The young partners would get a total of 171 acres and a sum of
money. Dacosta could not pay them in cash, but offered a bond in-
stead. To sweeten the offer, he told them that if the mine ever produced
they would get an additional $5,000.

Rozier pored over Dacosta's accounts, listing expenses that could
be charged to Jean Audubon as the original partner, and proposing
arbitrators to settle differences that might arise. He was busy on other
fronts, as well. He canvassed enough local farmers to conclude that
Audubon and his section of Mill Grove was worth at least $8,000; then
he set about finding a tenant to farm the land. All this was dutifully
reported to the fathers, along with the young partners' decision to get
some business experience. Dacosta was now all but out of the picture.

With his usual honesty, Audubon later wrote that he was "too
young and too useless to be married . . . William Bakewell advised me
to study the mercantile business; my father approved, and to insure
this training under the best auspices I went to New York, where I
entered as a clerk for . . . Benjamin Bakewell, while Rozier went to a
French house at Philadelphia." The partners pooled their resources,
made investments when they could, and kept close track of all their
personal expenses.

Audubon was determined to remain in the United States, to make
this nation his own ("America, My Country" became his slogan); he
paused in Philadelphia long enough to apply for citizenship. The tran-
sition was almost complete; Jean Rabin, "créole de Saint-Domingue,"
also known as Jean Jacques Audubon of Nantes and Couëron, was in

the process of becoming John James Audubon, American. On the document he identified himself truthfully as "John Audubon, a free white person. . . born at Aux Cayes in the Island of St. Domingo."

John Audubon could not have found a kinder, more generous teacher than Benjamin Bakewell, who seemed to gather in all his young nieces and nephews and their cousins and friends. It was Benjamin who helped Rozier find a position with the Hurons, who were French-speaking Philadelphia importers.[11]

Soon, letters were flying back and forth between Nantes and Philadelphia, Nantes and New York. On April 24, 1807—almost a year after his return—Audubon wrote to his father in his fractured, but much improved, English a letter in which he poured out, helter-skelter, all that was on his mind and in his heart:

> I did send about a month ago a small box containing some very curious seeds and some useful ones . . . I do hope they are now in thy possession thou has been so often disappointed that it always pains me to think that they have been miscarried . . . I have seen in the newspaper that a ship called the Betzy has been in Nantz. Do make some inquiries for is there on board of her many birds and a collection of seeds from America for thee . . . I hope that Captn. Sammis has reached your port and given thee some turtles for to be eaten for soup. Mr. L. Huron did a few days ago received some wines on account of M. Rozier [which] will bring a good profit! Mr. F. Rozier the son speaks of going to France some time this summer. He is now near Mr. Huron at Philadelphia and will try while he is there to settle the business between Mr. Dacosta and thee. Mr. Rozier had chosen Mr. Huron for arbitrator, but I would not agree to it until Mr. Meirs [Fisher] was to have part in it. I am now waiting for an answer. I am always in Mr. Benjamin Bakewell store where I work as much as I can and pass my days happy. About three weeks ago I went to Mill Grove . . . and had the pleasure of seeing there my Beloved friend Lucy who

constantly loves me and make me perfectly happy. I shall wait for thy consent and the one of my good Mamma to marry her. Could thou but see her and thou would I am sure be pleased of the prudency of my Choice; Mr. B. Bakewell is always willing to oblige me and will do many things for me. Do not participate the ideas of Mr. Rozier going to France to his father. It would perhaps injure us for a while. I wish thou would write to me ofner and longuely. Think of thy self how pleasing it is to read a friend's letter. Give my love to all my friends and kiss and hug Mamma, Rosa and brother Pigaudeaux for me. I hope they continue to be all happy. Do remember to send me thy portrait in miniature dressed as an officer. It will cost thee little and will please me much. [Also send] Some of thy hair and ask my sister for the music she does not want. I wish to receive some letter from Mr. D'Orbigny to whom I have often written and sent some curiosities. He is yet to answer to my first.

When thou seest Mr. Rozier . . . try to engage him to send us some goods. Those we feel very inclined to fix up in a retail store which would do us a great deal of good. I will send him a letter by this opportunity. Goodbye, Farwell good father believe me for life thy most sincere friend, be happy, thy Son, J. J. Audubon. P.S. J'espère que tu pourra lire. Adieu, Adieu.[12]

HE HOPED HIS FATHER COULD read his English; he hoped that by writing in English he could demonstrate his progress in the language. And he wished his father to know how much he missed them all, no matter how happy Lucy made him.

Audubon was dutiful in writing the elder Rozier, too—eager to prove his diligence to both fathers. He waxed eloquent on the fascinations of ladies' gloves: The more expensive ones did not sell as well as those that were midpriced; yellow was not so good a color as bottle

green, because green did not stain and hid defects better. He lectured his friend's father: "You must know that here women's vanity equals men's circumspection—therefore any female accessory has to be beautiful and visible."[13]

The partners were coming along, in spite of some setbacks. Audubon sent off a shipment of indigo; almost at once he sensed that he and Rozier had paid too much for it, and he was right. He lost the whole investment, worth two hundred pounds. Ferdinand could hardly fault John; he had managed to make a similar blunder with hams sent to the West Indies. Still, this kind of trading was risky; even for the experienced and even in the best of economic climates, losses were to be expected.

Audubon in New York was in close contact with Rozier in Philadelphia; they agreed to go into the mercantile business. Audubon wrote Rozier's father to tell him (as if he had been the first to think of it): "Goods that have been well selected, bought at a reasonable prices, and shipped carefully are always sure of a good market." Audubon asked the elder Rozier to send him some good pastels and crayons; there were so many birds to draw in this land, so many irresistible new species flickering about in the pale-green forest light.

In 1806 Audubon could walk from one end of New York City to the other in half an hour, and in a few minutes more be in deep woods. To while away the hours without Lucy, he concentrated on his bird studies. Naturalists sought one another out, and Audubon quickly made the acquaintance of Dr. Samuel Latham Mitchill, one of the country's leading naturalists. Like D'Orbigny in Couëron, Mitchill was a physician with a passion for nature. He was also an avid supporter of Robert Fulton (who even then was proving that his steamships could navigate on the frontier, down the Ohio and on to the far Mississippi). Mitchill was a politician, serving in both houses of Congress; he advised President Jefferson on the Lewis and Clark expedition. He was a noted collector; his knowledge was encyclopedic, and his interests knew no bounds. In rooms rented by Dr. Mitchill, Audubon worked evenings preparing specimens and stuffing birds, and on his days off

he was out in the woods, stalking new birds. The connection with Mitchill, who knew everybody of importance in the scientific world, might have given the budding ornithologist the opportunity he needed to propel himself into the role of a full-time naturalist.

But in that case Audubon would have had to renounce his budding career as a merchant; he would have disappointed his father, who had gone to such lengths to help and guide him, and the Bakewell brothers as well. Most of all, he would have to give up hope of marrying Lucy anytime soon. As it was, William Bakewell had doubts about Audubon's ability to support and care for his daughter.

At twenty-two, Audubon was a dutiful son and a passionate suitor ("my Beloved friend Lucy . . . make[s] me perfectly happy"). He was intent on living a traditional life; there was never any question but that he would find a way to support Lucy, and himself, in the manner to which they were both accustomed. Keeping books and accounts in Uncle Benjamin's countinghouse was simply the first step, one that would get him some business experience.

The two novice merchants worked steadily through the winter of 1806–1807. Both young men wrote regularly to the elder Rozier, who was in a position to assist their employers, and themselves as well. On January 10, Audubon wrote: "You are giving us a lot of pleasure by introducing us to your friends in different places in France and by offering to send us merchandise . . . Mr. Bakewell has made a large profit on the shipment that you sent him shortly after our arrival. We would be flattered to receive one like it." As soon as he and Ferdinand managed to pay their expenses, he explained, they would send along an order of their own.

By spring, Ferdinand was getting restless in Philadelphia and was beginning to talk about moving west. The decision to become merchants had been mutual, but depended in part on the elder Rozier, who would, they hoped, allow them to sell his goods on consignment.

Audubon's letters to Ferdinand's father were models of decorum. On April 8, 1807, he wrote that a shipment of wines had finally arrived, that sixty crates had been sold, and that Rozier could expect

a nice profit. Then he mentioned the plan he and Ferdinand had hatched: "If we were to decide to open a variety store we could keep ourselves well employed."

On May 6, he complained in Ferdinand's name: "Your son this morning let me know that a wine of such fine quality should never be exported in barrels to America and the profit would have been greater if the whole had been in crates." And he returned to the theme of a store: "You are talking to Ferdinand in many of your letters about a variety store and . . . [Ferdinand] is asking me to tell you that certainly nothing would suit us better than if you had enough items to set up a store or a good start." He included a note to his father which ended, ingenuously, "If you find in my letter something that you deplore please forgive me. Remember that I am your son."

Audubon's May 30 letter to the elder Rozier was more forthright: "That we cannot sell the land without a great loss holds us financially tight and keeps us at the moment from working as freely as we would wish. However, your assistance and generosity in offering us what is needed to start a large store with a variety of different items will be of great help to us."[14]

By July 19, the details for the journey west had been worked out and Audubon was able to write Rozier *père:* "Soon we will go for a trip on the Ohio about which you will have more details from my father . . . I have received today a note from my friend Ferdinand who is in perfect health and is very tempted to start doing something."[15]

All the time he was in New York, John Audubon sent boxes of seeds and cages of live birds to the fathers; usually he sent some specimens to his friend D'Orbigny as well ("You will find herein a little box containing ten varieties of grain, a bottle of reptiles for Mr. D'Orbigny and also some dry plants for him"). Audubon's fascination with nature was not diminished by his days in the countinghouse; he sent box after box to France, hoping that at least some of the plants and animals would survive. In one letter to Rozier's father he commented: "You must have some strange trees in your garden now."

Audubon's English was improving rapidly. Rozier, working in a

French firm and not pressed to learn English, resisted the new language. Still, he was eager to make a move, to begin their real work. Audubon was in no particular hurry until Rozier started talking about going back to France to visit his father, who was ill. Hope that the elder Rozier would set them up in business faded. But as Audubon confided to his own father, he did not think it would bode well for their partnership if Ferdinand should return to France just then.

To convince him to stay on, Audubon declared he was ready to leave at once for the western frontier, where success beckoned. Rozier could not resist; the partnership was saved. Within a few months, with a loan from Benjamin Bakewell, they were off. They were going to Kentucky, to the very cusp of the deep wilderness, a place where fortunes were to be made.

4

Who is the stranger . . .

that can form an adequate conception of

the extent of its primeval woods—of the

glory of those columnar trunks, that for

centuries have waved in the breeze[?][1]

It was late August 1807 by the time the partners started west. Daniel Boone had blazed the trail scarcely forty years before; in the decades that followed, a steady stream of Virginians had made their way to Kentucky as people like General George Rogers Clark pushed the Indians beyond the Mississippi. The frontier was rapidly expanding; after Napoleon sold Jefferson the land between the Mississippi and the Rockies for $15 million, about a thousand wagons a year poured over the mountains and onto the plains, full of people claiming their share at two dollars an acre. "New swarms are advancing like flocks of pigeons," the president said—meaning passenger pigeons, whose migrations darkened the sky for hours on end.

Audubon stopped at Fatland Ford to say good-bye to Lucy and to promise to return for her as soon as they established their business. For all of Lucy's English reserve, it was a tender parting.

The partners set off by coach on the Lancaster Pike, planning to travel to the end of the regular stage lines at Pittsburgh. There, they would board a flatboat to go down the Ohio, along with adventurers from the world over seeking a new life in the American wilderness.

Rozier was not new to rough living; he had sailed before the mast to, for example, Cádiz, Tenerife, and Mauritius.[2] Still, this journey into the heartland of America was torturous and exhausting.[3] Rozier's bones were rattled by the rough roads; the food served in the crude taverns was barely edible—salt beef and roast fowl were staples; the beds were filthy and, usually, shared. Heavy rains caught the pair in the Alleghenies; on steep ascents they had to get out and walk or push the coach when it got stuck. It was backbreaking, bruising work, even for two strong young men. At times it took an hour to go a mile, pushing and pulling all the way.

The journey was Audubon's first foray into deep wilderness; he acknowledged the hardships and the deprivations, but he discovered something else that would forever after draw him into these primeval woods. He could not explain that something; as he wrote, no stranger could be expected to imagine the addictive allure of the American forests in all their pristine glory, filled with unimaginable numbers and species of birds, all feeding on the bountiful mast, the fruit of the forest trees. The songs of thousands of birds filled the woods and echoed from the high branches of giant oak and ash and walnut trees. As August melted into September, great flocks began to appear overhead: The fall migration had begun. Audubon was transfixed.

The differences between the partners would be exacerbated by their reaction to the wilderness. Rozier accepted it grudgingly, as a necessary evil; Audubon embraced it as a wonder, a paradise filled with marvelous creatures.

Over the mountains lay Pittsburgh, where the Monongahela and Allegheny rivers came together to become the Ohio. Now that the Indians had been subdued, the river was the easiest route west. At Pittsburgh, the partners loaded their stores onto one of the big flatboats—these ranged from thirty to a hundred feet long, and from ten

to twenty feet wide—that would carry them into the dense interior. Audubon described the scene: "This boat contained men, women and children, huddled together, with horses, cattle, hogs and poultry . . . while the remaining portion was crammed with vegetables and packages of seeds. The roof or deck of the boat was not unlike a farmyard, being covered with hay, ploughs, carts, wagons and various agricultural implements [and] spinning wheels. Even the sides were loaded with the wheels of the different vehicles, which themselves lay on the roof."

Rozier found a place on deck and settled in for the float down the wide Ohio; if he thought that he would be allowed to remain in his spot, he was mistaken. The river was full of twists and turns, and the flatboats, never easy to maneuver, frequently lodged on sandbars. Then every man aboard was expected to jump into the water and help push the boat off; it was a slow and annoying progress.

The men who worked these boats were coarse and undisciplined, given to heavy drinking, swearing, and—for sport—brawling. They gouged and kicked and raked each other with something called a devil's claw. To otherwise entertain themselves, they played cards, sang, told preposterous stories, and hunted.[4] The American frontier was no place for the timid; Rozier understood this and so did his partner. John Audubon might be mesmerized by the birds and the beasts of this wild land, but he was a good marksman, a hunter who reveled in slipping into the woods to shoot ducks, geese, turkeys, and partridges. As the partners floated down the Ohio, trying to decide where they would disembark to begin their search for a likely settlement for their store, Rozier's father died in France. For Rozier, this would mean there was no returning; for the partners, the death of Rozier *père* was a setback to their ambitious business plans.

They left the flatboat at the town of Maysville and in the following weeks made their way to the hamlets of Lexington, Frankfort, Paris, and Danville. None seemed likely to support a mercantile store. They pushed on to Louisville, perched on a limestone bluff on the south bank of the Ohio at a place where a series of falls interrupted river navigation. (One old Indian trail to the Falls of the Ohio went past Thomas

Lincoln's log cabin on Nolin's Creek, forty miles south of Louisville, where he lived with his wife, Nancy Hanks, and their firstborn, Sarah. Lincoln's father was one of the Virginians who, in 1782, brought his family over Boone's Wilderness Road to become a "Kaintuck."[5])

In 1807, Louisville had a population of a thousand and was the most important river port between Pittsburgh and New Orleans; there were thirty-six manufactories and businesses along its main street, which was half a mile long and lined by red-brick houses and storefronts. Audubon and Rozier moved into the Indian Queen, the town's best boardinghouse. Wasting no time, they established their store by renting an empty space, spreading out their wares, and opening for business.

His contemporaries and biographers routinely criticized Audubon for neglecting his business duties in favor of bird studies and sketches. Rozier did all the work, these stories go, while Audubon roamed the woods and haunted the Falls of the Ohio, which attracted birds. Later, Audubon himself recounted episodes in which he was less than attentive to the business at hand: "Once, when traveling, and driving with several horses before laden with goods and dollars, I lost sight of the pack-saddles, and the cash they bore, to watch the motions of a warbler. . . ." But how far, one wonders, could a heavily laden horse wander? And how many robbers lurked in these great empty woods, where one could travel days on end without meeting a soul? In fact, all the stories of Audubon's dereliction ignore the conscientious work he did, and they ignore his successes. Of the two, it was Audubon—more fluent in English, outgoing and charming—who would set out to meet the community and make friends for the young merchants. Rozier was content to stay behind and mind the store. (By now he had the help of a young clerk, Nathaniel Pope.)

Audubon became friendly with William Croghan, a Revolutionary War veteran who told Audubon that he had known his father, presumably during Jean's brief participation in the war. Croghan's wife, Lucy, was the sister of the heroic Indian-fighter General George Rogers Clark—and of William Clark, superintendent of Indian affairs for the

Louisiana Territory at St. Louis, who had returned the year before from exploring the Northwest Territory with Meriwether Lewis.[6] (In 1809, General Clark—then approaching sixty—was living in his log house near Clarksville when, according to an account left by local naturalist Christopher Columbus Graham, "while in an intoxicated condition fell in the fire. His relatives and friends as a matter of course not wishing to have this said against the old pioneer held that he had a paralytic stroke. His leg was taken off on South side Main St. between third and fourth Sts. by the old Dr. Ferguson . . . The drum and fife [were] brought just outside the room in which the amputation was to take place [and] when Dr. Ferguson began to cut off the limb at a signal the drum and fife started and played while the operation was going on[,] Gen. Clark keeping time with his fingers . . . to the music on the table—"[7] After that, the general went to live with the Croghans.)

In the early-morning hours, when the light was best, Audubon could often be found wiring a bird and pinning it to a board that had been scored with squares. In this way, he could draw the bird (on paper scored to match the board) life size, taking meticulous care to get each feather right. ("Drawn from Nature by J. J. Audubon," he was to declare on each of his pictures.)

Audubon's interest in birds caused Croghan to lead him to a hollow sycamore tree on his property, where the two men counted some nine thousand chimney swifts in residence. It took Audubon little time to connect with Dr. William Galt, a botanist by inclination, and Christopher Columbus Graham, only a year older than Audubon, who roamed the countryside gathering samples of rocks and plants and wild animals. (Graham sometimes stopped overnight at Tom and Nancy Lincoln's cabin on Nolin's Creek.)[8]

Audubon was quick to make the acquaintance of the influential French contingent which had settled in Shippingport, just below the Falls of the Ohio, only the year before. Louis Anastasius Tarascon was one of the wealthy (and perhaps aristocratic) Frenchmen who emigrated from France in 1794, at the height of the Revolution. He settled in Philadelphia and became a merchant, selling silks and other imported

goods. In 1799, like many new immigrants, he was seized with the idea of becoming part of the opening of the West. He sent two of his clerks to explore the Ohio and Mississippi rivers, to see if readyrigged ships could be launched at Pittsburgh to make their way down the two rivers to New Orleans, and hence to the world's ports. One of these clerks was James Berthoud, who had managed to spirit his wife, Marie-Anne-Julia, and young son out of France. The son, Nicholas, was born in 1786 (a year after Audubon); thus he too qualified for the role of the "Lost Dauphin."

The clerks returned to Pittsburgh to urge Tarascon on; the Tarascon brothers and Berthoud went into business together at Pittsburgh, building an extensive wholesale and retail store and warehouse, a shipyard, a rigging and sailing loft, and everything else needed to build seagoing vessels.

When the Falls of the Ohio at Louisville proved a major impediment to their ship traffic, the Tarascons and Berthouds simply moved their enterprises to Shippingport, just below the falls. In 1806 they set up their mercantile business and their boat-building facilities, and built as well "the Shippingport mills, the first great mills which ever existed in the western country, by means of which he [Louis Tarascon] contributed his share towards drawing the name of Kentucky flour from a mire of merited discredit, and of raising it up to a high standing."[9]

By 1810, James Berthoud's household included ten slaves, almost half of all those in Shippingport. Their home was one of the finest in the area. Audubon became a frequent visitor to the Berthouds', hunting and fishing with Nicholas. He became especially fond of the elder Berthouds, and they of him; at their comfortable home, called the White House, he chattered away in French with Madame, charming her, pleasing her. He was twenty-two, Nicholas twenty-one; the two became fast friends. The Berthouds appreciated Audubon's accomplishments in drawing, music, dance, and fencing; he reminded them of more elegant times, while they probably made him think of his own loving and attentive parents.

Audubon made the long, arduous buying trips back east, and Rozier did not complain. He disliked the rigors of travel, while Audubon loved moving through the deep, unbroken woods, occupied with his observations of bird and animal life. And if Audubon and Rozier's business did not thrive as they had hoped, the reasons had as much to do with the economic climate of the times as it did with the partners' efforts. Even while they headed for Kentucky, an international financial crisis was building. To convince the British to stop impressing American seamen, President Jefferson pushed for the Embargo Act, which would bar all American merchant vessels from sailing to any foreign port. The act, passed in December 1807, as Rozier sat behind the counter of the fledgling store in Louisville, all but ruined the American shipping industry and sent international merchants reeling. Two young partners who had gone into debt to start their store were not immune; much more experienced men found their businesses collapsing.

Benjamin Bakewell, for one, was in serious trouble. His lucrative trade with French companies (sponsored, in part, by the elder Rozier) was ruined. His creditors, sensing disaster, began to gather at his doorstep.

As the embargo became law, Bakewell's ship, the *Clyde*, loaded with French wine, was about to weigh anchor for the West Indies. Quickly, Bakewell put Lucy's brother Tom (then working in Bakewell's business office) on board as his agent, and directed him to sail straight to New Orleans, there to set up shop and sell as much wine as he could, as fast as he could.

Tom was doing fine until some of his uncle's creditors caught up with him in New Orleans and set about impounding the ship and wines. Tom, not yet twenty, turned to some of Benjamin's many friends, who saved the day by helping Tom file a countersuit.

It proved to be a short-lived victory; the boat would not bring enough to cover all of Benjamin Bakewell's debts, and he was forced into bankruptcy. The loan given Audubon and Rozier, to come due in the spring of 1808, was no longer a family affair; it fell under the scrutiny of the creditors. Pressure on the partners was building.

Through the winter, Audubon and Rozier struggled on in Louisville—learning as they went which supplies were needed on the frontier and which were not. They studied their competition, already established, and tried to find a way to get ahead.

By spring, two full years after his return from France, six months after his arrival in Kentucky, Audubon was ready to return to Fatland Ford for Lucy. He had followed his father's instructions dutifully and had been scrupulous in carrying out William Bakewell's wishes as well.

A northwester blew hard the night of April 4, 1808, and the next day dawned blustery and cold. By noon the clouds had parted, and the sun made an effort to brighten the sky. Friends and family gathered in the parlor at Fatland Ford to witness the marriage of John James Audubon and Lucy Bakewell. The Norristown *Weekly Register* gave the particulars: "Married on Tues, the 5th inst., by the Reverend Wm. Latta, Mr. J. Audubon, of Louisville, to Miss Lucy Bakewell, eldest daughter of Mr. Bakewell, of Fatland Ford, in this county."[10] Lucy was twenty-one; John was three weeks short of his twenty-third birthday.

———————

AT LAST LUCY WAS MARRIED to the handsome young man she loved dearly, and who loved her. Her mother had approved of the charming Frenchman; her father, if concerned about Audubon's ability to get ahead in life (and about Frenchmen in general), liked him well enough and was impressed with his considerable talents. Lucy was escaping a divided home, with the children in one corner, their stern stepmother in the other, and the father in the middle. Since the advent of Rebecca Smith Bakewell, life at Fatland Ford had lost its luster for the children; still, as the eldest, Lucy felt responsible for Eliza, Sarah, Ann, and particularly Billy, who was only ten. In the difficult years since their mother's death, Lucy had taken tender care of Billy; he was particularly attached to her, and his admiration of Audubon was unbounded. Eliza—the prettiest, most spirited of the girls—and Billy wished they were going west with Lucy and John.

Before the newlyweds left, William Bakewell, who was acting as agent for Audubon & Rozier, had a long business session with his new son-in-law in which they went over his assets. Bakewell had all of the numbers; he knew Audubon's financial situation to the penny. There was still the property at Mill Grove, though the mine remained an unknown quantity—it might or might not pay off. Audubon's and Rozier's debt to Benjamin, soon to be due, would have to be paid. There were, obviously, financial strains, but the young couple had resources, and Audubon was sure the store would flourish.

THE NEWLYWEDS RETRACED THE JOURNEY that the two partners had made some six months before, struggling over the Alleghenies, washed by spring rains and rough roads and jostled in coaches known to tip over sideways or tumble down steep embankments. Luckily for her husband, Lucy was not only educated and refined; she was also a countrywoman who knew the practical demands of farming, who had experience with horses and other livestock, and whose staunch courage complemented Audubon's energy and exuberance. Her admiration for her new husband spilled over in her very proper letters to her cousin Euphemia Gifford in England: "I wish you were acquainted with the partner of my destiny," she wrote. "It is useless to say more of him to you at so great a distance, than that he has a most excellent disposition which adds very much to the happiness of married life."[11]

Their fathers could not have known how well suited Lucy and John would be to each other; the older men lacked the vision to recognize either the one's talent, or the other's stubborn loyalty. Parents hope to chart a course for their children that will ensure a smooth life's journey, free of storms and turbulent seas. Jean Audubon and William Bakewell had done their very best, with considerable tolerance and wisdom. Had they been able to see into the future, they would have shuddered for their much-loved children.

There was a saying, popular on the frontier, about the kind of people who moved west: "The cowards never started and the weak died by the way."[12] The brave and the strong survived, the Audubons among them. In a letter to Euphemia Gifford, Lucy mentioned some of the trip's discomforts—the stage would "rock about most dreadfully"; Pittsburgh was "the blackest-looking place I ever saw." More often, she gave an interested traveler's report of her journey; she described the flatboat that carried them to Louisville as "a large square or rather oblong boat; but perfectly flat on all sides; and just high enough to admit a person walking upright. There are no sails made use of owing to the many turns in the river which brings the wind from every quarter in the course of an hour or two . . . Beer, bread and hams were bought at Pittsburgh, but poultry, eggs, and milk can always be had from the farm houses on the bank." She was sorry, she told her cousin, that her new husband had not brought along his sketching pads so she could send some scenes from this new American wilderness she was witnessing. Not that she was all that impressed by the view from the Ohio. "There are not many extensive prospects on the river," she wrote, "as the shores are in general bound by high rocks covered with wood."[13]

At last, the newlyweds arrived at the Indian Queen, where they could be, as Lucy would write her cousin, "as private as we please." Houses being scarce on the frontier, it was the custom for those newcomers who could afford it to stay in boardinghouses.

There was not a lot for an educated girl like Lucy, used to life on a prosperous farm, to do. Audubon introduced her around; putting the best face on matters, he wrote: "My young wife, who possessed talents far above par, was regarded as a gem, and received by them all with the greatest pleasure." He rambled on: "The matrons acted like mothers to my wife, the daughters proved agreeable associates." But Lucy couldn't go visiting all the time, and the Indian Queen was a rough-and-tumble sort of place. She complained, "I am sorry there is no library here or book store of any kind; for I have very few of my own, and as Mr. Audubon is constantly at the store I should enjoy a book very much whilst alone."[14]

Frontier folks were divided by wealth and education; there were the "pore" and there were the "eddicated."[15] Thomas and Nancy Lincoln, in their log cabin on Nolin's Creek, were "pore"; the Audubons, well-to-do enough to put up at the Indian Queen, were "eddicated." These distinctions would quickly fade; while it was true that the educated were more likely to have means, it was also true that on the American frontier in the early years of the nineteenth century, success required energy, stamina, ambition, determination, and the ability to adapt. The Lincolns and the Audubons would be tested on all counts.

In February of 1809, a "granny woman" was called to the Lincoln cabin to help with the delivery of a baby boy. The following June, Lucy gave birth to a son at the Indian Queen. The Lincolns named their boy Abraham, for Tom Lincoln's father; the Audubons' son was Victor Gifford, for Lucy's English cousins.[16]

Victor was born on June 12; on July 4, the new little family joined the throng that gathered at Beargrass Creek near the river to celebrate their second Fourth of July in Louisville. Frontier life was not without its diversions, and the Fourth of July was a particularly riotous affair. Wagons filled with families rolled in from the surrounding countryside. Veterans of the Revolutionary War appeared in numbers (only thirty-five years had passed since the Declaration of Independence). There was plenty of food, the usual hard drinking by the men, foot races and horse races, and then dancing. Audubon fiddled and danced; Lucy joined in.

The young couple's other diversions included Kentucky-style wedding celebrations, called "the infare," at which the table would be spread (according to one celebrant) "with bear-meat, venison, wild turkey and ducks, eggs wild and tame, maple sugar lumps tied on a string to bite off for coffee or whisky, syrup in big gourds, peach-and-honey; a sheep that two families barbequed whole over coals of wood burned in a pit, and covered with green boughs to keep the juices in; and a race for the whisky bottle."[17] There was always a race for the whiskey; drinking was epidemic. Audubon had been abstinent until his wedding day, when he toasted his bride; in Kentucky he learned to lift the jug with the boys.

In mid-July, Audubon had to go east to see suppliers in Pittsburgh and Philadelphia. This time, eager to return to his wife and baby as soon as possible, he went by horseback. At Pittsburgh he saw Benjamin Bakewell, who once again (with the help of some good friends) had landed on his feet and was in the process of turning a small glass factory into a profitable concern. Audubon stopped by Fatland Ford to see Lucy's family; William Bakewell wanted to hear all about his first grandson, and Billy and the girls were eager to hear about life in the wilderness.

Lucy was getting restless at the Indian Queen and wanted a place of their own. As the eldest daughter, she had been given her mother's flatware and china and a portion of the fine furniture from Fatland Ford. Eventually, her library of some 150 books arrived in Kentucky, along with her music.[18] Lucy, tall and straight and disciplined, intended to make a proper home for her family, no matter where she lived. But Audubon and Rozier, merchants, had so far failed to establish themselves, and winter was coming on. For the time being, Lucy had to be content with the Indian Queen.

IN PITTSBURGH IN THE WINTER of 1810, Benjamin Bakewell gave Audubon's name to Alexander Wilson, who was about to launch a skiff he had named the *Ornithologist,* to begin a journey that would take him down the Ohio with a stop at Louisville and on to the Mississippi, eventually to New Orleans. The gaunt, handsome Wilson was a Scotsman, a weaver, a poet, and a sometime schoolteacher, who had set himself the task of drawing and publishing a complete set of books on the birds of America. One reason for his journey was to search out new birds; another, almost as important, was to sell the subscriptions that would make publication of the books possible. "In this lonesome manner," he wrote in his journal, "with full leisure for observation and reflection, exposed to hardships all day, and hard berths

all night, I persevered from the 24th of February to Sunday evening, March 17th, when I moored my skiff safely in Bear Grass Creek, at the rapids of the Ohio, after a voyage of seven hundred and twenty miles."[19] He walked up the hill to take a bed at the Indian Queen; the Audubons did not meet him that evening, but the next day he appeared at Audubon & Rozier's store.

Wilson was forty-four that winter, Audubon only twenty-five. But Audubon had been immersed in the study and drawing of birds longer than Wilson. In the summer of 1803, when Audubon arrived in New York for the first time, Wilson had declared in a letter to his engraver, "I am most earnestly bent on pursuing my plan of making a collection of all the birds in this part of North America . . . I have been so long accustomed to the building of airy castles and brain windmills, that it has become one of my earthly comforts, a sort of rough bone, that amuses me when sated with the dull drudgery of life."[20] He had set out to teach himself to draw the birds, and to study them. By the time Wilson arrived in Louisville, Audubon was the more proficient artist, but Wilson was by far the better writer, and he had the first two volumes of his work to show for his labors. He handed them over for the younger man to inspect.

Audubon leafed through the books, his excitement hard to contain. So much of the information he longed for was right here on these pages, the work of a man who could write eloquent English. Wilson explained that Audubon would not be expected to pay for the books in advance, but only when each volume was delivered. (Miers Fisher, Audubon's old mentor, had been good enough to take five subscriptions at $120 each.[21]) In his first volumes Wilson had concentrated on the East Coast; now he wanted to work on the birds of the country's interior.

Audubon showed Wilson his work, which included drawings of two warblers that the older man had never seen. Wilson was impressed enough to note in his journal that the crayon drawings were good. The two went out for a ramble to some ponds, where they saw several sandhill cranes. All in all, it seemed to be a pleasant meeting of men

with like interests; Wilson had found some new birds, and Audubon had received an important lesson on publishing.

Years later, after all of the interminable squabbling that revolved about the two, Audubon insisted that he had been about to subscribe when Rozier stopped him, saying (in French, which he assumed Wilson could not understand) that Audubon's own pictures were far superior and that he shouldn't waste his money. What is likely is that Rozier simply stopped his partner: They had no money to spare, however much Audubon longed to read all that Wilson had written.

Within three years of that spring meeting in Louisville, Wilson was dead. Friends and associates saw to the publication of his volumes; whenever a new one appeared, Audubon would scramble to borrow a copy.

———

THE AUDUBONS WERE GREAT LETTER writers. John wrote his family in France—his correspondence included an exchange with his brother-in-law—while Lucy kept up a regular correspondence with her cousin Euphemia Gifford in England as well as with her immediate family in Pennsylvania. Audubon's letters were impetuous, colorful, full of exuberance and enthusiasms—everyone was wonderful, everything was perfect. Lucy's were more studied and careful; she weighed her words and did not complain.

The business was not doing well. William Bakewell, as agent for Audubon & Rozier, sold more of the Mill Grove land; all the money went into the store. The country was still swept by depression, and the partners worried over their next move. They decided that competition was too keen in Louisville, and made the difficult decision to go to a smaller town.

Henderson, 125 miles downriver, had been settled for only twenty-five years; before that it had been a nest of river pirates, but they had been cleared out.[22] The town amounted to a cluster of log cabins and a population of fewer than 159.[23] Lucy, never fond of Rozier, must have balked. Louisville was primitive enough, and to move even closer to the edge of the wilderness was daunting.

Still, Audubon was bound to Rozier by the agreement their fathers had carefully devised; the elder Rozier was gone, but Jean Audubon was very much alive and concerned with the welfare of his son and, now, his son's young heir. So, against his wife's wishes, Audubon decided to stay with Rozier. The group headed downriver to Henderson, where the Audubons found an abandoned log cabin with a hard dirt floor and set about making it their home. They put up Victor's cradle, chinked the holes between the logs, spread bearskins for warmth, and made a home that was both primitive and civilized.

Kentucky had turned John Audubon into an accomplished woodsman. He had long since given up the foppish clothes of his early days in the country; now he wore a leather hunting shirt and trousers. He walked in moccasins and carried a ball pouch, a buffalo horn filled with gunpowder, a butcher knife, and a tomahawk on his belt.[24] His job was to keep the table supplied with fish and game, while Rozier tried to breathe life into the store. The young clerk, Nat Pope, had come along with them, probably because he had nothing better to do. An excellent shot, he joined Audubon in the daily search for food for them all.

The partners had brought along a supply of flour and of "bacon ham," and all of them—especially Lucy, who was fond of this particular chore—worked to establish a garden. The would-be merchants set up a store of sorts, spreading out "the remainder of our stock on hand," Audubon would write later "but found the country so very new, and so thinly populated that the commonest goods only were called for."

Whiskey was one "common good" always in demand; it was, in fact, used as cash. When Tom Lincoln decided to move his family to Indiana, he sold his cabin for four hundred gallons of whiskey.[25] Sometime that fall Audubon and Rozier managed to put their hands on a shipment of three hundred gallons of Monongahela whiskey; it was Rozier's idea to head up the Mississippi to St. Louis, where they could sell it at a huge profit to the always thirsty trappers and hunters to be found in the jumping-off place to the wilds.

It was winter already, but they could not afford to put the trip off until spring. Besides, Rozier was feeling an ache to go even farther west; he wanted to take a look at the little French settlement of Ste. Genevieve, just south of St. Louis. Audubon's command of English was getting steadily better, which meant that Rozier was feeling more isolated. Lucy had never been particularly fond of Rozier; in Henderson, her displeasure increased. In Ste. Genevieve he would be back among those who spoke French.

Lucy and Victor stayed behind with the family of Dr. Adam Rankin at Meadow Brook Farm, three miles from Henderson. Lucy, as Audubon had said, was considered "a gem" by frontier families eager to see their children educated. What could be better than to bring an educated woman from an upper-class British family into the household, to demonstrate proper deportment and teach their children how to speak, read, and write? Lucy had a skill that would prove almost as marketable as whiskey: She could teach.

In the original version of his autobiography, addressed to his sons, Audubon scribbled: "Louisville did not suit our Plans and we left that place with a View to visit St Louis on the Mississippi but it is so seldom that our wishes are favored that we did not reach that Place, for My Partner not being on good terms with My Wife, I left her and you Victor at Henderson, you were then a babe." [26] It was snowing when Audubon took Lucy and Victor out to Meadow Brook farm; they said their good-byes, and then he was off on one of the great adventures of his life.

Audubon, Rozier, and Pope loaded the heavy whiskey barrels on a keelboat and pushed off in the snowstorm, drifting along at about five miles an hour. By dawn they were opposite the mouth of the Cumberland River. Winter had set in and the countryside was frozen. By the third day they reached Cash Creek, where they ran into another group of men bound for Ste. Genevieve and learned from them that the Mississippi was frozen. No boats could pass until spring. They decided to wait out the winter together at Cash Creek, which was full of fish and crowded with wild birds. The thick forest mast attracted multitudes of deer, bears, and raccoons. There would be no want of food.

Rozier was distressed by the delay, but Audubon was elated. Paroquets roosted in the hollow trunks of the large sycamore trees that fringed the creek, and a nearby encampment of Shawnee Indians provided him with hunting companions. Early the morning after their arrival at Cash Creek, Audubon joined a group of a dozen squaws and braves canoeing to a large nearby lake where immense flocks of swans gathered.

"When the lake burst on our view there were the swans by the hundreds, and white as rich cream, either dipping their black bills in the water, or stretching out one leg on its surface or gently floating along." Startled by the hunters, the swans took to the air and Indians began blasting away at them. When it was over, "we counted more than fifty of these beautiful birds, whose skins were intended for the ladies in Europe."

That night they had a soup of pecan nuts and bear fat, and the hunters stretched out with their feet close to the campfires while the squaws skinned the birds. The next morning, Audubon discovered that a squaw had delivered twins during the night; later that day he saw her tanning deerskins, her newborns in a bark cradle in which they "were wafted to and fro with a push of her hand, while from time to time she gave them the breast, and was apparently as unconcerned as if the event had not taken place." If the wanton destruction of the great, graceful swans disturbed him, he did not say. He understood that life in the wild was always a struggle; men did what they had to do to survive. He did not fault the Shawnees for supplying European women with feathers for their hats.

Soon after, Audubon went with three Indians on a bear hunt. About half a mile from camp, the tallest of the men found bear tracks and followed them to an immense decayed log. "I saw his eye sparkled with joy," Audubon wrote of the hunter, ". . . his brawny arms swelled with blood, as he drew his scalpingknife from his belt with a flourish." The man crawled into the tree; for a time, all was silent. Finally he emerged unscathed and announced that the bear was dead. The other Indians cut a long vine, crawled into the tree, and dragged the animal out.

In these early days, Audubon often stayed in Indian camps or went hunting with braves; he believed Indians to be a heroic people, and he admired their simplicity and modesty.

Soon the Shawnees packed up and moved south; this convinced Rozier that he and Audubon should be off as well, even though their destination lay north. They left Cash Creek at daylight; it was easy going downstream to the Ohio, but once they reached the Ohio's meeting with the Mississippi they were stopped short: The river churned with great chunks of ice. Even so, they gave it a try. Ropes were fastened to the boat, and the men pulled the heavy boats from the shore by "cordella" (ropes), against the current. "We made seven miles that day up the famous river," Audubon wrote. "But while I was tugging with my back at the cordella, I kept my eyes fixed on the forests or the ground, looking for birds and curious shells."

The next day they made ten miles; for two days more they labored, until the weather became numbingly cold again and they were forced to set up camp in the great bend of the Tawapatee Bottom. Rozier was greatly depressed. Audubon describes him: "Wrapped in his blanket, like a squirrel in winter quarters with his tail about his nose, he slept and dreamed away his time, being seldom seen except at meals."

Not Audubon; he had new trails to follow, new Indian camps to visit and observe. He was impressed with the robust and athletic Osages, who hunted only large game, including "the few elks and buffaloes that remained in the country." The Osages spoke neither French nor much English but were delighted when Audubon sketched portraits of them in red chalk. By comparison, the Shawnees, who "had been more in contact with the whites," seemed to him inferior—less able to withstand the cold, not so expert with bows and arrows.

In the six weeks they spent in the winter camp, Audubon hunted wolves and studied the habits of wild deer, bears, cougars, racoons, turkeys, and other animals. Every day he drew by the light of the great bonfire, which the men piled high with four or five ash trees.

After a few weeks, their bread gave out; they substituted turkey breast and used bear grease for butter until their stomachs revolted.

Then Pope and Audubon set out to find some Indian meal; they walked all day but came back to the camp empty-handed, eliciting gibes from those who had stayed behind. The next day they tried again, "suffering neither the flocks of turkeys nor the droves of deer we saw to turn us aside." The weather was "fair and frosty, the trees covered with snow and icicles, shining like jewels as the sun rose on them; and the wild turkeys seemed so dazzled by their brilliancy, that they allowed us to pass under them without flying."

The two men managed to round up a barrel of flour, some bags of Indian meal, and a few loaves of bread, all of which they dragged in sleds over the snow, back to camp.

To entertain themselves in the long afternoons, Audubon played on his flute while Pope fiddled; the men got up to dance, which made the squaws laugh, while the braves sat back and watched, serenely puffing on their pipes. Audubon never regretted a day spent there.

The breakup of the ice was startling and violent. "It split with reports like those of heavy artillery . . . The congealed mass was broken into large fragments, some of which rose nearly erect here and there, and again fell with thundering crash, as the wounded whale, when in the agonies of death springs up with furious force, and again plunges into the foaming waters."

The next day the frozen river was splintered into millions of sharp, churning fragments of ice. To save their boat from being smashed by ice, the men lashed bunches of cane to the sides, and before the ice could chew these up, the boat was afloat. Some time later, a thunderous noise was heard from about a mile away; the ice dam had broken, the Mississippi was shaking loose from a shockingly cold winter, and Rozier was at last on his way to Ste. Genevieve.

They worked feverishly, using Cordellas to pull the boat past some dangerous spots like the "Grand Tower," a large rock in the river. (There Audubon saw an immature bald eagle and, believing it to be a new species, named it the bird of Washington after the first president.[27] Later, in one of his early journals, he wrote of these birds: "Becoming very Numerous, hunt in pairs, and roost on the Tall trees above their

Nests—One this morning took up the head of a Wild Goose thrown overboard, with as much ease as a man could with the hand—they chase Ducks and if they force one from the Flock he is undoubtedly taken, carried on a Sand Bank and eat by Both Eagles—they are more shy in the afternoon than in the morning—they seldom sail high at this season. Watch from the tops of trees and Dash at any thing that comes near them—to secure a Goose, the Male & Femelle, Dive alternately after it and give it little time to breath that the poor fellow is forced in a few Minutes."[28])

Audubon and Rozier had paid twenty-five cents a gallon for the whiskey; at Ste. Genevieve they sold that amount for two dollars. Rozier found the local French Canadians to be good company and announced that he would stay. Audubon was not enchanted with the place or the French Canadians. Mostly, he wanted to get back to his wife and son and do what he could to make them happy. It was time, the partners agreed, to call it quits. "Rozier cared only for money and liked Ste. Genevieve," Audubon later said. Rozier declared, "Audubon had no taste for commerce, and was continually in the forest."[29] They divided their whiskey profits; Audubon had put more into the failed partnership than Rozier had, but he could wait to collect. He took Rozier's promissory note, said adieu, and set out across the wide Illinois prairie, heading for Henderson and home.

5

This Place saw My best days, My Happiest,
My Wife having blessed me with Your
Brother Woodhouse . . . I Calculated,
to Live and died in Comfort, Our Business
Was good of course We agreed.[1]

LEAVING STE. GENEVIEVE THAT SPRING of 1811,
Audubon "walked to Henderson in Four Days 165 Miles."[2] The
Rankins took him in, happy to have him back, in part because if her
husband stayed with them Lucy could continue to teach their chil-
dren while the Audubons decided what they were going to do. Lucy,
pleased to be free of Rozier, would bide her time in Henderson—but
she was ready for a change of place.

Spring ripened into summer; the trees were thick with katydids
droning their twilight songs. On warm evenings Lucy and John
swam together, sometimes all the way across the river. She was
twenty-four, and proving to be a hardy pioneer wife and mother.
She was also, with Rozier's departure, finally able to take her place
as full partner to her husband. From that time, they would make
decisions together.

Lucy taught the Rankin children while Audubon did his share on the farm and spent time in the woods; now he could immerse himself in his nature studies without risking Rozier's irritation. The second time he saw a "bird of Washington" was on the Rankin farm: "I saw an eagle arise not a hundred yards away where we had slaughtered some hogs . . . alight on a low tree branching over the road." Determined to have the specimen to draw, he "prepared my double-barrelled piece, which I constantly carry, and went slowly and cautiously towards him. Quite fearlessly he awaited my approach, looking upon me with undaunted eye. I fired and he fell. Before I reached him he was dead. With what delight did I survey the magnificent bird! Had the finest salmon ever pleased him as he pleased me? Never."[3] He killed the bird to capture it on paper; no woodsman of the day would have faulted him, even if he had taken it purely for sport. None of them dreamed that the mighty eagles would one day need protection.

The birds were a distraction, but soon Audubon would have to figure out how he was going to earn a living for his young family. For now they had the whiskey money to tide them over. It had been three years since Lucy had seen her family; they began to talk about paying a visit to Fatland Ford.

That summer a man appeared in Henderson with a mustang he had bought from the Osages. He swore to Audubon that he rode the mustang a steady forty miles a day for a solid month and that it fed only on prairie grasses and cane. If the man was telling the truth, the mustang's stamina and endurance were phenomenal.

Adam Rankin and Lucy, who knew a good horse when they saw one, thought the animal a bargain; Audubon bought it for fifty dollars. They named it Barro. It would carry one of them to Fatland Ford.

They were ready to leave when Tom Bakewell arrived. He was New Orleans–bound, full of news and plans: He had made arrangements to become an agent for a Liverpool firm. Now twenty-three, Tom had the self-confidence of all the Bakewell men. He was part of a family that stayed in close touch, whose members helped one another get ahead and, when they met with reverses, helped each other out. Still, despite

his confidence he knew it would be difficult for an Englishman to do business in what was essentially a French city. He thought it an excellent idea for him and his French brother-in-law to form a partnership: Audubon & Bakewell, Commission Merchants. They would deal in pork, lard, and flour, commodities always in demand.

Lucy loved the plan; with her husband and her brother working together, the business would be all in the family. If they must move to New Orleans, fine. Audubon was just as enthusiastic; he had worked in a countinghouse, he had experience as a merchant, and he had the French verve that would nicely complement Tom's English reserve. Best of all, he would take his place as part of the Bakewell family, with all the security that ensured.

Audubon's childhood memory of the parrot and the monkey did not intrude; for now, the parrot Mignonne was safe from the monkey beast. None of the three thought that the threat of war between America and England would come to anything. War talk had been going on so long, and nothing had happened. Of course, the southern states, including Kentucky, were itching for a declaration of war so they could grab more land—what became Florida, for example, and even parts of Canada. But the northern states were against any conflict, and it was clear that England didn't want one. Father Bakewell didn't think it would come to war, so Tom and the Audubons decided they shouldn't wait.

They waved Tom off on his continuing journey down the river to New Orleans; then Lucy and John set out for Fatland Ford, with a mission. Tom had asked his brother-in-law to present their plan for a partnership to William Bakewell and request a loan, in Tom's name, so they could get started.

It was November by the time the Audubons finally set out, and winter was coming on quickly. Their course took them "from Henderson through Russellville, Nashville, and Knoxville, Abingdon in Virginia, the Natural Bridge, Harrisonburg, Winchester, and Harper's Ferry, Frederick, and Lancaster, to Philadelphia."[4] John devised a little basket seat for Victor on his own horse, and Lucy rode alongside, keep-

ing up the pace as he insisted. To cover forty miles a day, they rose before dawn and traveled from fifteen to twenty miles before breakfast. After a two-hour stop, during which they cleaned and fed the horses, they would ride on until half an hour before sunset, when they either made camp for the night, or stopped at one of the infrequent inns.[5]

At forty miles a day it would take an absolute minimum of twenty days to cover the eight hundred miles, and that would be hard going even for Audubon traveling alone. Lucy was game and she was an excellent horsewoman, but the trip was grueling. Indian summer had given way to the cool drafts of November; the leaves were thick underfoot. The rivers and streams they forded were chilly. Audubon urged them on ever faster; he worried about an early snowstorm or a freeze as they moved north.

Arriving in Pittsburgh after three weeks, they spent four days resting at Uncle Benjamin's. Then they pressed on, over the Alleghenies and to Fatland Ford. Lucy recounted the moment when she felt as if she had returned to civilization: "[At] the top of the last mountain there is a most beautiful view of a level well cultivated country, and from having travelled so far through woods where the eye can scarcely see fifty yards, the scene is particularly pleasing."[6]

Homecoming was sweet; three years had made all the difference in Sarah and Ann and Eliza, who were grown-up young ladies now. Billy was a teenager, eager to be off into the woods with John, to show him birds' nests he had found. The brothers and sisters and their father crowded around, admiring Victor, chattering their news, happy to be together again. Only the stepmother held herself apart, stiff and proper, and no doubt prayed that the visit would not be a long one.

Any hope that there would be more money from Mill Grove was quickly dashed; Audubon discovered that Dacosta had given up on the lead mine altogether and had sold his share of the farm. Audubon wrote Rozier the bad news, adding succinctly: "Times are not brilliant for business." He reminded Rozier that they still owed Benjamin Bakewell $55; Audubon had paid $20 of his share. The whiskey money was going fast.

But these matters were of the past; Audubon was intent on the future. He had high hopes for Audubon & Bakewell, and was delighted that William Bakewell thought well enough of the plan to promise Thomas a substantial loan.

Audubon lingered long enough at Fatland Ford to enjoy sleeping in a proper bed with his wife, where they could hold each other and make love in warmth and privacy. His field notes hint at his romantic nature; of the mating of Carolina turtledoves, he wrote: "On the branch above, a love scene is just commencing. The female, still coy and undetermined, seems doubtful of the truth of her lover, and virgin-like resolves to put his sincerety to the test, by delaying the gratification of his wishes. She has reached the extremity of the branch, her wings and tail are already opening, and she will fly off to some more sequestered spot, where, if her lover should follow her with the same assiduous devotion, they will doubtless become . . . blessed."[7]

During this brief interlude at Fatland Ford, Audubon managed to find time for some long rambles with Billy in the familiar woods, but he was preoccupied with plans for the new business. He did not doubt its success; the Bakewells were well respected in business dealings, and he was one of them now.

In December, his business satisfactorily concluded, Audubon left his wife and son behind and mounted the mustang to return to Henderson and begin his work as the Kentucky branch of Audubon & Bakewell.

His excitement about the new partnership is confirmed by the diary of Vincent Nolte, a New Orleans merchant who would one day play a pivotal role in Audubon's life. That December, both men happened to be making their way across Pennsylvania on the way to the Ohio River. They met for the first time at a small inn between Harrisburg and Pittsburgh. Nolte described the meeting: "Here I ordered a heavy breakfast. The landlady showed me into a room and asked if I would mind eating at the same table with a strange gentleman . . . who immediately struck me as being what is commonly called an odd duck. He was sitting at a table before the fire with a Madras handkerchief wrapped around his

head in the manner of a French sailor or dockworker."[8] When Nolte asked the obvious question, Audubon confounded him by insisting—in a strong French accent—that he was not French, but English, because he had an English wife.

The breakfast conversation proved pleasant enough for the two to decide to continue on to Pittsburgh together; once there, Nolte invited Audubon to ride on the ark he had commissioned to take him downriver. Nolte explained: "As he was a good and pleasant person and, besides which, a lovely draftsman, I offered him a free berth in our cabin. He took advantage of the offer; and we left Pittsburgh in very cold weather, with the two rivers, the Monongahela and the Ohio, filled with drifting ice, on the first day of January, 1812."

One morning they stopped at the Kentucky town of Maysville (then called Limestone) to go ashore. "We had scarcely finished our breakfast," writes Nolte, ". . . when Audubon, all at once, jumped up and cried out in French, 'Now I am going to lay the basis for my business firm.' Thereupon he took a small packet of visiting cards and a hammer from his coat pocket, some nails from his vest, and began to nail one of the cards to the door of the inn . . . The card read as follows: 'Audubon & Bakewell, Commissions Merchants (Pork, lard, & flour), New Orleans.' So, I thought to myself, you have got competition before you get to the city yourself." Nolte was starting his own company as well, but he was an experienced merchant with £6,000 and a line of credit for £10,000 more, so he was not much worried about his new young friend's fledgling firm.[9] The two continued on together to Lexington, then went their separate ways.

On that journey back to Henderson, or one taken shortly after, Audubon found himself jogging along through the barrens of Kentucky when his horse suddenly began acting peculiarly. "I heard," Audubon writes, "what I imagined to be the distant rumbling of a violent tornado, on which I spurred my steed, with a wish to gallop as fast as possible to a place of shelter; but it would not do, the animal knew better than I what was forthcoming, and instead of going faster, so nearly stopped that I remarked he placed one foot after another

on the ground, with as much precaution as if walking on a smooth sheet of ice."[10] What the horse felt was the vibration of the earth beneath his feet; that winter, the Mississippi and Ohio river valleys were shaken with a series of earthquakes, some of the largest ever recorded, centered in New Madrid in the Missouri Territory. The shocks and aftershocks—thousands of them—jolted the region for months on end. The quakes were so powerful that whole islands in the rivers disappeared, and new lakes were created. Audubon continued: "I . . . was on the point of dismounting . . . when [my horse] all of a sudden fell a-groaning piteously, hung his head, spread out his four legs, as if to save himself from falling, and stood stock still, continuing to groan. I thought my horse was about to die . . . but at that instant all the shrubs and trees began to move from their very roots, the ground rose and fell in successive furrows, like the ruffled waters of a lake, and I became bewildered in my ideas, as I too plainly discovered that all this awful commotion in nature was the result of an earthquake."[11]

The earthquakes that continued throughout that winter were brutal distractions, but what concerned Audubon most was how to come up with some money to send to Tom in New Orleans. He had written Rozier from Pittsburgh, asking that he repay the money he owed; when he got no reply he wrote again, more sharply: "I wish to know if you will pay at New Orleans the bill of 1,000 dollars which I have on you, or if I shall have to go to Ste. Genevieve to get them, and, at any rate, what has become of you? We promised each other mutual correspondence and I am afraid that it is all on my side."[12]

Audubon considered going on to New Orleans to see Tom, but he delayed because war with England, which now seemed a possibility, would destroy any business that depended on commerce with the British Isles. Audubon bided his time until March, hoping for some favorable sign from Tom; when it didn't come, he said good-bye to the Rankins and rode east to rejoin his family.

When he returned to Fatland Ford in March 1812, William Bakewell was much more pessimistic about the war threat. Audubon took comfort in seeing his darling son again and in gathering his wife

into his arms once more. Lucy and John could do nothing but wait to see what developed with England. Her brothers and sisters were happy to have them, and Billy attached himself once more to John, who was as good a big brother as a boy could want.

On one of their woodland tramps that spring, they came upon a nest that Audubon couldn't identify. It belonged to either a crow or a hawk—he wasn't sure which, though a bird was sitting on the nest. He sent Billy shinnying up the tree to retrieve an egg; Billy called down that for some strange reason, the bird wouldn't budge from the nest. "Cover it with your handkerchief and bring it down," Audubon directed him.

In this way they captured the small broad-winged hawk, not much larger than a crow, and took it back to the room where Audubon was drawing. "I put the bird on a stick made fast to my table. It merely moved its feet to grasp the stick, and stood erect, but raised its feathers and drew its neck in upon its shoulders." Here was the exceptional bird that would stay immobile long enough to be drawn from life. "I passed my hand over to smooth the feathers by gentle pressure. It moved not. The plumage remained as I wished it. Its eye, directed towards mine, appeared truly sorrowful. I measured its bill with the compass, began my outlines, continued measuring part after part as I went on, and finished the drawing without the bird ever once moving. My wife sat at my side, reading to me at intervals, but our conversation had frequent reference to the singularity of the incident.

"The drawing being finished, I raised the window, laid hold of the poor bird, and launched it into the air, where it sailed off out of my sight, without uttering a single cry or deviating from its course."[13]

On June **18, 1812,** the United States declared war on England. Gloom descended on Fatland Ford; still, Audubon waited to see what Tom might report from New Orleans. He wanted to believe that all was not lost.

On July 3, Audubon made a special trip to the U.S. District Court in Philadelphia to swear his allegiance to the United States of America and become a true and legal citizen of the Republic. His accent would always be French, and he might teasingly have told Nolte that he was English, but from that day on, he was a fervent, devoted American.

While on one of his trips into Philadelphia that summer, he called on Alexander Wilson and found him working on a drawing of a white-headed eagle. Wilson greeted him cordially enough, but instead of talking about birds or drawings he took his guest to see an exhibition of Rembrandt Peale's work. Audubon thought the older man had slighted him. Very likely, Wilson was simply under mounting pressure to finish his great work; a visit from anyone meant time away from his drawing board. Yet he did interrupt his labors to take the younger man to an exhibit of one of the most important artists in the city, a member of a prominent family of artists. Wilson probably had no idea that Audubon would prefer to talk about birds, and his own work. It was the last time the two met; Wilson, who became Audubon's nemesis only posthumously, never knew the role he was to play in the younger man's life.

In August, word finally came from Tom: The New Orleans venture had failed. All was lost. There was no longer any reason to stay on at Fatland Ford; Lucy had been there for almost nine months, and the mistress of the house made it clear that as far as she was concerned the Audubons had worn out their welcome. There was nothing to do but return to Henderson for the time being, and hope that Tom could salvage something at New Orleans.

Nesting together in a comfortable bed all those nights had had the inevitable effect: Lucy was pregnant. This time the journey included no forty-mile-a-day rides; it was a leisurely trip down the Ohio. The last stretch, from just below Louisville to Henderson, which they navigated in a skiff of their own, proved almost idyllic. Audubon obtained a "large, commodious, and light boat," fitted it out with a mattress and food, and took on two slaves to row it.[14]

"It was in the month of October," he remembered years later, with

undiminished longing. "The autumnal tints already decorated the
shores of that queen of rivers, the Ohio. Every tree was hung with
long and flowing festoons of different species of vines, many loaded
with clustered fruits of varied brilliancy, their rich bronzed carmine
mingling beautifully with the yellow foliage, which now predominated
over the yet green leaves, reflecting more lively tints from the clear
stream than ever landscape painter portrayed, or poet imagined."

They approached Pigeon Creek near the Indiana shore where,
four years later, Thomas Lincoln would bring his young family as they
crossed the river from Kentucky into Indiana. That night on Pigeon
Creek the Audubons heard "a loud and strange noise . . . so like the
yells of Indian warfare, that we pulled at our oars, and made for the
opposite side as fast and as quietly as possible. The sounds increased,
we imagined we heard cries of 'murder'; and as we knew that some
depredations had lately been committed in the country by dissatisfied
parties of aborigines, we felt for a while extremely uncomfortable. Ere
long, however, our minds became more calmed, and we plainly dis-
covered that the singular uproar was produced by an enthusiastic set
of Methodists, who had wandered thus far out of the common way for
the purpose of holding one of their annual camp-meetings, under the
shade of a beech forest."

Audubon had little sympathy for pious fervor and never felt much
enthusiasm for the religious colonies that were beginning to appear on
the frontier. (Including a sect about which Lucy had written jokingly
to her English cousin: the "Shaking Quakers," later known simply as
Shakers because they jiggled up and down as part of their devotional
practice.) Audubon much preferred the Indians, with their "simple"
religious ways.

The Audubons were not afraid of the Indians, but they were wary.
One of the causes of the War of 1812 was the English practice of en-
couraging Indians to ravage the settlements along the western frontier.
Audubon had never felt threatened by any of the Indians he met and
traveled with, but he understood there was always a possibility of run-
ning into a band of braves intent on vengeance. Atrocities, committed

by white men and Native Americans alike, were part of life on the American frontier, and Audubon and his wife knew it.

They returned to the welcoming Rankin household; Lucy, though far along in her pregnancy, again took over the schooling of the children. In November a second son was born and was named John Woodhouse, for his mother's family. Much later, Audubon wrote his sons about this time in their lives: "Your mother was well, both of you were lovely darlings of our hearts, and the effects of poverty troubled us not."

That last statement wasn't quite accurate. For reasons beyond their control, the partnership with Tom Bakewell had foundered; Audubon was on his own again, with a wife and two babies to care for. Acting with a dispatch reminiscent of his father, he made a quick trip back to Louisville, where he purchased with his last remaining dollars— "half cash, half credit"—enough goods to set himself up once more as a merchant in Henderson. He opened his general merchandise store in a primitive little log house at the corner of Main and Mill streets. The town was growing; he was well known in the community, and optimistic about his chances for success. They stayed with the Rankins while he got the store solidly established and Lucy nursed the new baby through a sickly first year.

Sometime during that year, Thomas Bakewell turned up. Audubon remembered the moment perfectly: He was drawing a picture of an otter (presumably one he had caught in a trap, which became a favorite) when his brother-in-law appeared. Tom had failed miserably in New Orleans: The war had destroyed all prospects. "He remained at Dr. Rankin's a few days," Audubon remembered, "talked much to me about our misfortunes in trade, and left us for Fatland Ford." Audubon adds dryly: "My pecuniary means were now much reduced."[15] Soon enough Tom reappeared; this time, it seems, his father had been unwilling or unable to help him. Audubon graciously took him into the store, which was just beginning to prosper; they would be partners after all, though in a much less grand fashion than either had envisioned. "The little stock of goods brought from Louisville answered perfectly," Audubon wrote, "and in less than twelve months I had again risen in the world."[16]

Henderson, perched on a plateau some seventy-two feet above the Ohio, was laid out in 264 one-acre lots; the lots were grouped in squares of four and each lot fronted on two streets. Twelve acres in the center of town had been set aside for public uses. Most of the streets were a hundred feet wide—enough for an impromptu horse race—and the street fronting on the river was twice as wide, in order to handle all the commerce the town fathers expected. Audubon was able to buy the four-acre tract adjacent to his store; it included a meadow and a house.

The house was a substantial log structure of a story and a half, with a porch across the front and, scattered about the grounds, a stable, a smokehouse, a stone cool house, and, beyond that, an orchard.[17] By December 1813 the family, including Tom Bakewell, had moved the three miles into town. Thus began the years that John Audubon would always remember as the happiest of his life.

He was twenty-nine, strong and confident. Little John Woodhouse had blossomed under Lucy's care; they now had two healthy young sons. Lucy finally had a house of her own; she set out at once, in the best British tradition, to turn it into an outpost of civilization. The cherry-and-walnut pianoforte was in place, along with tables, chairs, and bedsteads that had been her dowry from Fatland Ford. She stored her mother's china, the silver candlesticks and flatware, the tea service, and her linens. Her library and her musical scores were placed in cases. Lucy believed that living in the wilderness did not preclude civility.

She watched as Audubon's stack of drawings grew; she could see his talent grow with it. His friends, especially those who could read and write, admired his drawings as well, but Audubon knew no one knowledgeable enough to discuss the real merits of his art or his ornithology. He was teaching himself, observing the birds and making notes, learning from the wilderness.

He was happy to be living a life that allowed him long hours in the woods, hunting and observing, as well as time to draw his birds. At their first meeting, Wilson had asked if he intended to publish his drawings, and Audubon's answer had been a quick no. His copy of Turton's *Linnaeus,* delineating a system for identifying and classifying

birds, was dog-eared by now; Audubon found it enormously exciting
to come upon a species unknown in Europe.

The store was doing well enough for Tom to build his own cabin:
It was time he began to think about marriage. But he let the cabin sit
empty and continued to live with his sister's family and to take his
meals at the Audubon table. As for Lucy and John, they felt established
enough to begin to buy some town lots. In 1812 they purchased four,
and the next year bought five more. These they divided and resold,
realizing a tidy profit—selling for $27,000 what they had purchased
for $4,500. Eventually, their holdings amounted to $50,000, no small
sum in those days.[18] Audubon was feeling good enough about his pros-
pects to urge his father to pick up the Audubon family and move to
Kentucky. Jean replied that he thought France a better place for a man
of means, and that they would all—especially his mother—dearly love
to have John come home with his wife and sons and settle in Couëron.
Jean Audubon had made his last sea journey; if they were ever to meet
again, his son would have to come to him.

Meanwhile, Jean Audubon and Anne Moynet continued to wrestle
with the problem of the will. Jean had done everything possible to
ensure that John and Rose, his two illegitimate children, would inherit
what wealth he had left. The four daughters of one of his brothers,
and a son of one of his sisters, had made it clear that they would chal-
lenge the will, under the French law that denied illegitimate children
the right to inherit. The elder Audubon had hired the best lawyer in
Nantes to find a way around a law that would give all he and Anne had
to a flock of greedy young relatives they scarcely knew. The plan was for
him to will everything to Anne (though she was his senior); she would
then will it all to her adopted children, Jean Rabin (now identified in
all legal papers as "husband of Lucy Bakewell") and Rose Audubon
du Puigadeau. Whatever his father wanted to do was fine with John.
France and the will were far from his mind. John Audubon was estab-
lished in Kentucky; he was an American citizen by choice. He had an
English wife, who was a citizen of America as well and had provided
him with a family and a brother who had joined him in business.

In fact, Tom was beginning to chafe at his lot as a small-town storekeeper and was thinking about how Audubon & Bakewell could move on. It was Tom's idea to build a mill right in Henderson. Naturally Audubon, as the senior partner, would have to agree. Tom had in mind not just a sawmill—which was obviously needed, there being so much timber to be cut, so many new houses to be built—but a gristmill as well. Lucy and John considered the idea. People were pouring into the region, settling down. The first steamboat had come down the Ohio in 1811; river transportation would soon be transformed, with old flatboats and arks giving way to powerful steamboats. Every family that came would need shelter and bread, two of life's basics, and a mill was one of the first signs that a frontier town was developing into an established community. This was the wave of the future, and Audubon & Bakewell decided to ride it.

The cabin was filled with the excitement of a new venture. Tom thought they might be able to convince David Prentice, an engineer who had built a threshing machine at Fatland Ford, to come west to design a mill and supervise the building. William Bakewell had helped Prentice become established in his own business in Pittsburgh, but Tom felt sure he could be enticed to come west, given the challenge of creating a state-of-the-art mill.

Other members of the family might be interested as well. Because of the war, farms were not faring well back east. William Bakewell had gone so far as to put Fatland Ford on the market, but no buyer had shown up. Thomas Pears—who was learning to farm at Fatland Ford when Lucy and John were courting—followed Bakewell's lead and put his own farm on the market as well, and his sold at once. Pears and his wife, Sally, moved to Pittsburgh. Pears had some money to invest; maybe he would bring Sally and their children west to be in on the grand plan. The partners were brimming with ideas.

They would, of course, need money. In the spring of 1813, Audubon set out for Ste. Genevieve to try to extract from Rozier the money he owed. He returned over a water-soaked prairie, without the money but with news that Rozier had found himself a wife, Constance Roy,

a woman half his age, who had already presented him with a child. (Eventually she bore ten little Roziers.)

Kentucky was a slave state. A great moral debate on the subject of slavery was raging on the world stage; the British were among the first to protest the institution. By 1803, when John Audubon first stepped ashore in New York, none of the states was importing slaves, and by 1807 the international slave trade was banned outright.[19] Even so, high birth-rates and smuggling swelled the black population; by the second decade of the century, almost half the people in Kentucky were slaves.

Thomas Jefferson argued that all blacks should be free, yet in 1822 he still owned 267 slaves. The man who followed him in the presiden-cy, James Monroe, agreed that slavery was a blight on the land, that it corrupted the whole of society, yet he too owned slaves until the end of his life. In Kentucky, many reasonably affluent families owned at least a few slaves. (The Lincolns, on Knob Creek, did not, and in a few years they crossed the river into Indiana, to start over again in a free state.)

Lucy and John Audubon took no stand against the institution of slavery; in 1814 they bought nine blacks for $10,550.[20] Lucy directed them in cleaning and cooking and working in her large garden; she felt she could not manage her growing household without help. John had slaves do the heavy manual labor of the household and store: They dug a pond by the house so he could keep the turtles for the soup he fancied, and they built cages for the animals he brought in from the woods.

The meadow about the house was filled with creatures Audubon had found in the wild and wished to study: ducks and geese with clipped wings, a wild turkey cock that he found when it was but a jake, two or three days old, and that eventually chose to return to the wild. Audubon wrote: "It became so tame that it would follow any person who called it, and was the favourite of the little village. Yet it would never roost with the tame Turkeys, but regularly betook itself at night to the roof of the house, where it remained until dawn."[21] Worried that some hunter would not recognize it for a pet, they tied a red rib-bon around its neck. Gradually, the bird began to make forays into the

woods across the river. One morning Audubon watched it sail off, and that night it did not return to its perch on the roof. Some days later he was out hunting with his dog Juno, when a "fine large gobbler" crossed the path in front of him. The dog instantly gave chase, but to Audubon's amazement, the turkey seemed unconcerned. He was even more surprised when Juno pulled up short and, instead of seizing the bird, turned to look at Audubon. He saw the red ribbon and gathered up the errant bird to take it home. He did not know what to make of this encounter between dog and turkey. "Was it," Audubon asked, "the result of instinct, or of reason,—an unconsciously revived impression, or the act of an intelligent mind?" He had questions and was hungry for answers.

It was a wonderful life. Summers John and Lucy swam in the river; they rode good horses; often, in the long, light evenings she read to him as he sketched. Henderson remained a rough frontier town, but the Audubon home was where important visitors stopped on their way upriver or down. When Senator Talbot or Judge Towles or any of the other founding families of Kentucky stayed the night, Lucy would play on the pianoforte, John would get out his fiddle, and the sounds of civilization would ring out into the tall woods of Kentucky. Occasionally someone in the family came down with a fever—usually in the hot summer months, called the sickly season in the South—but for the most part the Audubons were healthy.

Both Audubon and his friend Nicholas Berthoud from Shippingport were fond of fishing with a long trotline. Audubon described the main line as being made of cotton as thick as a girl's little finger, with perhaps a hundred smaller lines about five feet long, each with "a capital hook of Kirby and Co.'s manufacture" and baited with a live toad. The lines were set early in the morning, the fish collected in the evening, sometimes by the dozens. This was Audubon's kind of fishing. "I never could hold a line or a rod for many minutes unless I had—not a 'nibble' but a hearty bite, and could throw the fish at once over my head on the ground."[22] The best part of fishing with the trotline, in Audubon's opinion, was letting it do the waiting, so that he was free to

take his gun and notebook, call his dog, and ramble through the woods from four in the morning until breakfast. Even so, he had his share of fish stories. He liked to tell about the time when Nicholas Berthoud— "a better fisher than whom I never knew"—once pulled up from a trotline "a remarkably fine catfish, in which was found the greater part of a sucking pig."

Lucy tended the large garden and ran the busy household with her usual efficiency. She had no reason to complain; her husband—whom some people called "an original," meaning that there was something slightly eccentric about him—loved her and made her happy. "Our Business Was good of course We agreed." Had he been English, of course, her family would have been more pleased. And he did become more and more occupied in searching out new birds and drawing them. (Once when he returned from a trip to find that rats had gnawed their way into the box where he kept his drawings, and had all but destroyed some two hundred of them, he had been distraught, beside himself with bitter frustration, and then depressed at the enormous loss. Ultimately, with ferocious energy, he set out to replace them all, and to make every one of the replacements better than the original.) The men of Lucy's family thought there was something inherently childish about a grown man who put such serious effort, such energy, into the drawing of birds. This was not, after all, London or even Philadelphia—where, perhaps, men with incomes could indulge themselves in such cultured niceties. But Audubon had proven himself in this frontier town; he was admired and respected. Lucy was his stalwart wife. She knew that her only real rivals for her husband's attention were the birds and the woods; she also knew that the woodsman who was absolutely in control while roaming among the birds and the beasts of the forests, and who was gaining confidence at his drawing board, was not nearly so sure of himself in the commercial jungles being created by a generation intent on fast fortunes.

6

*This place saw My best days, My Happiest, My Wife
having blessed me with Your Brother Woodhouse
and a sweet Daughter I Calculated, to live and died in
Comfort, Our Business Was good of course We agreed, but
I was intended to meet Many Events of a disagreeable
Nature; A Third Partner Was taken in and the Building
of a Large Steam Mill, the Purchasing of Too Many goods
sold on credit of course Lost. reduced us—Divided us.*[1]

THOMAS PEARS, INTRIGUED BY THE idea of moving to the
frontier and being part of a large family project, came from Pittsburgh to
have a look at Henderson. He knew Sally was fearful about moving with
four children to a frontier town, but the mill seemed like just the sort of
opportunity a young man could not afford to miss. The American fron-
tier was beginning to boom; people were pouring in, the town was grow-
ing, and Audubon & Bakewell was prospering. Pears was convinced that
the Indians were no longer a threat, and Sally would have as a model
her cousin Lucy—who, every bit as much a gentlewoman as Sally, was
perfectly content in this rough western village. Pears pledged four thou-
sand dollars to the project, and went back to Pittsburgh to talk Sally into
moving west so he could become the third partner in the venture.

When Pears left Henderson in the summer of 1814, he was charged
as well with convincing Prentice to leave Pittsburgh to build the partners

a sixteenhorse engine for the steam mill. Pears succeeded better than anyone expected; for four thousand dollars plus free room and board for himself and his family, Prentice would build the engine "including castings, blacksmithing, and wages for hands to set the fly-wheel in motion."[2] Tom happily offered his cabin and assured Prentice that his family would be welcomed at the Audubons' bountiful table.

William Bakewell put his stamp of approval on the plan. Prentice had been his protégé, and William trusted his abilities. Besides, Audubon & Bakewell had proved itself capable of success in the mercantile business. Even then, Lucy and John were setting up a clerk in a new store in Shawneetown, Illinois, across the river, about thirty miles away. This turned out to be a good investment; Audubon & Bakewell's share of the profits for one year amounted to $6,402.[3]

Pears called on his mentor at Fatland Ford, and was dismayed to find William Bakewell's health failing; at the age of fifty-two he had suffered a stroke, and his wife, Rebecca, had become even more formidable and controlling. The girls, Pears reported, were miserable. Eliza, the prettiest and most spirited of the three, complained that their father could not give them even the smallest gift without causing problems with their stepmother.[4] Tom had arranged for Billy to come to Henderson to begin his apprenticeship as a clerk for Audubon & Bakewell. Ann and Sarah stayed, but Eliza, unwilling to live in what had become her stepmother's house, went to the family of the ever-obliging Uncle Benjamin in Pittsburgh.

This time, even the good uncle got more than he bargained for. The principal actors in the melodrama that now unfolded were Eliza and Uncle Benjamin's son, also named Thomas Bakewell. Away from the stepmother she could no longer bear, Eliza blossomed once again. Cousin Thomas had always admired her from afar; now that they were living under the same roof, he found her irresistible. She paid him such kind attention that he began to believe that she returned his interest. To Eliza's utter surprise, he got up the courage to propose marriage.

The Benjamin Bakewells were delighted and so was the rest of the family—everybody, it seems, but Eliza, who said that she had never

meant to encourage her cousin and had no intention of marrying him. Tom's mother, mortified at her son's humiliation, accused Eliza of leading him on. Eliza was distressed, but not enough to change her mind. She went to stay with friends of her uncle's and wrote Lucy, begging to come live with her. Lucy agreed, suggesting that Eliza travel with the Pears. Eliza did not want to wait even a few weeks, so John Audubon rode to Louisville to collect her.[5] He welcomed her with his usual kisses and hugs. Billy, who was going on sixteen, joined them. The Bakewells were once again gathering around the oldest sister, and John Audubon was happy to have a place in the center of this young, vibrant family.

Everything seemed to be coming together in Henderson. Thomas and Sally Pears and their four children arrived; the big Audubon log house was rearranged to make room for them. David Prentice and his family came near the end of the year. Prentice was ready to go to work but discovered that he would have to bide his time for a while, until the principal partners could get everything arranged. It was important to build at exactly the right location on the riverfront; they selected a space 200 by 220 feet on Water Street and negotiated a ninety-nine-year lease (rent: twenty dollars a year) with the town trustees, who were convinced that the mill would greatly benefit Henderson.[6] Elaborate plans for the steam engine were drawn; materials were sent for. Hours were spent poring over these plans and making decisions. Preparing to build was proving to be a long process, with many delays.

The Audubon table groaned under the several daily settings needed to feed the Pears and Prentice families, Tom Bakewell, Eliza, Billy, and the Audubons, who were four now, but soon to be five. Lucy was pregnant again.

Baby Lucy was born into a cabin that was already bursting with adults and children. Her brother Victor was seven; Johnny was three. From birth, Lucy was a frail, sickly baby, as Johnny had been. But unlike her brother, she did not become hardy as the months wore on. No matter how diligently her mother and her aunt Eliza nursed her, Lucy remained delicate and was often ill.

Work on the mill was progressing slowly; everything seemed to take twice as long as the three partners—and the engineer on whom they depended—expected. This was not going to be some little country mill; this was a grand undertaking, destined to put Henderson on the map. The Audubon & Bakewell mill would be the biggest and most efficient on this part of the Ohio.

To keep himself occupied during the inevitable long delays, Prentice began working on a steamboat. More and more steamboats were beginning to appear on the river; they were soon to replace the arks and flatboats, which could only float downriver. Prentice and Tom began to talk about steamboat-building as a side business. They formed a partnership, Prentice & Bakewell.

John Audubon had never had the least bit of trouble filling his spare time. Billy, who was clerking for Audubon & Bakewell, often accompanied him on purchasing trips for the stores, or on hunting trips to help supply the demanding table. In season, the two would head to nearby Long Pond to shoot ducks, Billy going up one side, Audubon the other, hunting as the Indians had taught him. "On these excursions," Billy wrote, "we killed a great deal of game and often when without horses had such loads to carry that less enthusiastic hunters might have thought it more toil than pleasure, but to us with all the fatigue and hardships it was the grandest enjoyment the world could afford."

One afternoon, Audubon and Billy set out for a place in the forest, about a dozen miles away, where passenger pigeons were known to roost. They got there at sundown, just as the birds were arriving in masses so great as to defy the imagination; there seemed to be billions of them. Billy wrote in his memoirs that he and Audubon "commenced firing at the clouds as they flew over us to see how many we could bring down at a shot more than from any value we set on the birds—but soon gave it up, not considering them worth the ammunition. Next morning we filled four large bags, containing nine or ten bushels, with pigeons killed by upper branches of the trees that were broken by the weight of the birds falling on those roosting below. After the passenger

pigeons left this neck of the woods the trees were so much broken and stripped of their limbs as to have the appearance produced in western and southern forests by the hurricanes they sometimes experience."[7]

Two years earlier, Audubon had had a similar encounter with passenger pigeons. He was on his way to Louisville when he saw them flying southwest. "Feeling an inclination to count the flocks that might pass . . . in one hour, I dismounted, seated myself on an eminence and began to mark with my pencil, making a dot for every flock . . . The birds poured in in countless multitudes, I rose, and counting the dots then put down, found that 163 had been made in twenty-one minutes."

Every man and boy along the river crowded in with guns and blasted away at the sky full of birds to their hearts' content. "For a week or more, the population fed on no other flesh than that of Pigeons, and talked of nothing but Pigeons."

Audubon described a roosting place on the banks of the Green River in Kentucky, "in a portion of the forests where the trees were of great magnitude." He was not the only one waiting for the arrival of the pigeons: "A great number of persons, with horses and wagons, guns and ammunition, had already established encampments on the borders. Two farmers from the vicinity of . . . [Russellville], distant more than a hundred miles, had driven upwards of three hundred hogs to be fattened on the pigeons which were to be slaughtered."

It was dark by the time the birds arrived. The noise they made "reminded me of a hard gale at sea, passing through the rigging of a close-reefed vessel." Torches of pine knots were lit; men with long poles began knocking down birds by the thousands, but the pigeons continued to pour in. "It was a scene of uproar and confusion," Audubon related. "I found it quite useless to speak, or even to shout to those persons who were nearest to me. Even the reports of the guns were seldom heard, and I was made aware of the firing only by seeing the shooters reloading."

By sunrise, Audubon says, all the birds able to fly took wing; the forest floor was piled with dead pigeons. Then "the howlings of the

wolves reached our ears, and the foxes, lynxes, cougars, bears, raccoons, opossums and polecats were seen sneaking off, whilst eagles and hawks of different species, accompanied by a crowd of vultures, came to supplant them, and enjoy their share of the spoil." At the end, when everybody had collected as many birds as he could manage, the hogs were turned loose to devour the rest.[8]

Audubon did not believe that this slaughter would put an end to the species. Only the loss of the forests, on which the birds depended for food, could do that, he said. In less than a hundred years he would be proved right; as the woods were vastly diminished, the passenger pigeon became extinct.[9]

Pigeon pie was passed around the Audubon table—for the menfolk at the first sitting, for women and children at the second. Lucy's work was never done. Her household, once small, had expanded threefold. The men busied themselves at the mill, while the women took care of the children and the cooking and the chores. She had help from her sister Eliza and her cousin Sally; slaves did the hard manual work in the garden, cleaned game and birds, and washed clothes. Lucy made time for lessons for the children and for music in the evenings. She would not let her family, or the others, forget that decorum must be maintained.

Sally had not wanted to come to Henderson; once there, she was always uneasy. She could not feel secure in a place where there was a bounty on wolf heads; she worried constantly about slave uprisings and Indian attacks. (The Shawnee chief Tecumseh, who had united the western tribes in what most whites of the time believed to be an attempt to annihilate white men, had been dead only two years.) Sally disliked almost everything about Henderson and the way they were living; she had been mistress of her own farm in Pennsylvania, and now she was a guest in another woman's house. She complained continually, while it was almost an article of faith for Lucy not to complain. When Thomas Pears began to drink more heavily than his wife liked, Sally became even more disillusioned with life on the frontier, and began talking about returning to Pittsburgh.

The partners watched as their engineer struggled to put together the steam engine that would run their grand new mill. Audubon put fifteen thousand dollars into the project—this besides Pears's four thousand and Tom Bakewell's five thousand borrowed from his father—and construction began. The mill's foundation, of stone, was four and a half feet thick; the joists were rough, unhewn logs and the weatherboarding was whipsawed yellow poplar.[10] It was the biggest structure anyone had ever seen in that part of the country, and the partners intended it to be the best. They paid two thousand dollars for the finest imported millstones, rather than settle for the two-hundred-dollar domestic variety.

Ever since the Audubons' move to Henderson, James Berthoud had regularly made the 125-mile trip downriver from Shippingport, sometimes staying with the Audubons for a week or more. A white-haired gentleman rumored to have an aristocratic French background, Berthoud enjoyed the company of John Audubon, who returned his affection.[11] Now his son, Nicholas, began paying frequent visits to his good friends the Audubons as well. Nicholas was known as a level-headed businessman with the family money to back him; he came now because he was interested in the mill, but even more because he was fascinated by Eliza. This time, the prettiest of the Bakewell girls had found a man she was happy to say yes to.

The Audubons were delighted. John admired his friend and was deeply attached to the elder Berthouds. The cultivated French couple made him feel at home in a way that the English Bakewells could not. In March 1816, Eliza and Nicholas Berthoud were married amid much celebration, and left to live in Shippingport with the elder Berthouds.

Eliza's wedding spurred Tom Bakewell to do what he had been meaning to do for some time: go east to get himself a bride. Near the end of July he returned with Elizabeth Page, the daughter of one of Uncle Benjamin's close business associates. Lucy and John were preoccupied with their little Lucy, who seemed to go from one ailment to another, but they obligingly made room in the cabin for Tom's wife.

With Eliza gone, Elizabeth and Sally formed a united front against Lucy. Sally's complaints seemed to grow as her body swelled with the

baby she was carrying. Elizabeth said that Lucy was arrogant and John Audubon was crude.[12] She disliked life on the frontier every bit as much as Sally did, and both of them resented Lucy not only for thriving as a pioneer wife, but for insisting they all maintain a degree of decorum in the midst of the wilderness—an insistence that struck them as pretentious and ridiculous.[13]

While the women squabbled, the men struggled in a sea of frustration. David Prentice knew how a steam engine should be built, but he lacked the mechanical ability either to build it himself or to oversee others in the building. "We have a very good engine put up in a very slovenly fashion which we are remedying by degrees ourselves," Tom Bakewell wrote his father, adding that Prentice "is a capital man to prescribe, but not to administer—his *advice and opinion* in matters of his profession are invaluable but his execution worthless."[14] Steam power was a new field, far from perfected, and the fine new mill in Henderson, which was to have shown the world what wonders steam could accomplish, was becoming a reality only by fits and starts.

At the same time as they were working on the mill, Tom Bakewell and Prentice had produced a modest steamboat by installing a steam engine and paddle wheels on a keelboat. Their second, more ambitious project—only the second steamboat built in Kentucky—was named the *Henderson*. The partners sold it to a group of Henderson men who planned to go into the boating business; instead of cash, which was scarce for everyone, Prentice & Bakewell accepted a promissory note for $4,250.

Just as it seemed that the mill was finally going to work, Sally Pears announced that she had had enough. She planned to return to Pittsburgh, to her uncle's house, to give birth. Her husband, dissatisfied with the mill's slow progress (and probably smarting under his wife's complaints) had been casting about for someone to blame and decided that it must be the Frenchman, with his peculiar ways. Pears let it be known that he thought Audubon spent entirely too much time in the woods looking at birds, too much time drawing his pictures, to tend to business.

Knowing that he was leaving the others with precious little cash just as the mill was finally going up, Pears demanded his money back. He got it, and left to take the job waiting for him in Uncle Benjamin's glass factory. To Tom Bakewell's credit, he wrote his uncle to let him know that whatever Pears might say, John Audubon was no more responsible for the mill's problems than anyone else was. Benjamin Bakewell kept his own counsel and remained a friend to both of his nephews by marriage.

Roads were being forged throughout Kentucky as the country grew more settled. In 1816, Tom Lincoln became a surveyor to repair the road between Nolen and Pendleton. On papers in the recorder of deeds office, he signed his name and Nancy Hanks made her mark. That Nancy could neither read nor write was not unusual in the United States of 1816; it was Lucy Audubon, with her sparkling education, who was unusual. While she taught seven-year-old Victor Audubon to read, write, and play the pianoforte, and his father gave him drawing lessons, seven-year-old Abe Lincoln was walking four miles a day to a crude log schoolhouse at Knob Creek, where he learned his letters and numbers by rote, saying them aloud over and over again in what was commonly called a "blab" school.

It was becoming harder for poor white men—those without slaves to help them work their land—to make a living for their families in Kentucky.[15] Tom Lincoln—despairing of ever making his Kentucky farm productive—now decided to move his family across the river to Indiana, which had both plenty of rich farmland and a law that declared "the holding of any part of the human creation in slavery, or involuntary servitude, can only originate in usurpation and tyranny." In Indiana, Lincoln could get government land with clear title for two dollars an acre. That fall, although he was not a drinking man, he traded his house for four hundred gallons of whiskey, built a flatboat, put all the household goods on it, and with Nancy, daughter Sarah, and seven-year-old Abe, moved to Indiana, up Little Pigeon Creek.

It was to be a difficult winter for both families. The Lincolns built a "half-faced camp" deep in the Indiana woods. Two trees about

fourteen feet apart formed the cornerposts of a three-sided cabin; the fourth side, facing south, remained open. Poles, brush, branches, dried grass, and mud covered the sides and roof; on the open side, a log fire burned continually. In the far, dry corners, beds were made by throwing blankets and bearskins over a bed of dried leaves. On warm and clear days, the camp was adequate shelter; on cold days with driving rain or snow, it was not. Tom Lincoln immediately set about chopping trees for a cabin.[16]

The Lincolns were doing what scores of other homesteaders did in Kentucky and Indiana and Illinois; in 1816, on just one Pennsylvania turnpike, sixteen thousand wagons made their way west, carrying families eager to carve new homes out of the wilderness.

By contrast, the Audubons were living a relatively comfortable and secure life as leading citizens of a growing town, respected and well liked by the people who were building houses all around them, on the lots the Audubons had subdivided and sold. Still, the mill was proving costly and business was slow in the stores. But it was young Lucy's illness that was worrying them almost to distraction. The doctors could not say what ailed her. All that summer and into the fall, Lucy languished in spite of everything her doting parents could think to do. Meanwhile, Elizabeth Bakewell was pregnant, and a new discontent settled in as she let Tom know how much she resented his sister Lucy and actively disliked his uncouth brother-in-law.

Tom Bakewell had his hands full. He was trying to placate his pregnant wife, cope with the increasingly desperate financial straits that Audubon & Bakewell found itself in, and convince his father that this was not a good time to come out to Henderson for a visit, no matter how much William Bakewell longed to see his children. Tom urged his father and stepmother not to make the trip alone but to wait until spring so that he or John Audubon could fetch them. Then he wrote words that William Bakewell would not have wanted to read: "Business is with us, as with everybody in every place just now, extremely dull." William Bakewell had loaned his son five thousand dollars; it looked as if this was going to be yet another bad investment.

They managed to get the mill running—but not without endless mechanical problems, and never with the efficiency they had expected—just as the country was poised for economic depression.

Elizabeth issued an ultimatum: She intended to leave before Christmas. Tom capitulated. He would move Elizabeth to Louisville to have the baby. Then he would dissolve his partnership with the brother-in-law his wife had dismissed as "crude," and take his losses, though he felt bound to stay on to help get the mill working properly.

Tom tried to explain his actions to his father: "This place never having had any allurements for me, and still less endearments since I was married, as Elizabeth dislikes it very much, I have dissolved partnership with Mr. A., he taking all the property and debts due to A&B and agreeing to pay all their debts, for which I take loss to about $5000, and he is to pay me $5500, after all the debts owing by A&B are paid which sum of $5500 is to bear 20 pct. per annum until paid on the above condition . . . As we are both liable for the debts due by A&B, I have agreed to remain here and give my assistance to Mr. A till 1st of July next and to let the business be carried on in the name of the firm as usual."

Later, trying to sort out the major cause of their failures, Tom wrote his brother Billy that David Prentice was good at making plans but could not execute them. Tom went on to explain that he was considered the merchant, Prentice the mechanic, and he did not presume to question. In fact, Thomas had to admit, there was ample cause to complain about Prentice's engineering skills.

Tom Bakewell and John Audubon had started the mill together; it was Tom who had brought in David Prentice as well as his cousin Thomas Pears, who had contributed little and cost them much by his ill-timed departure. And now, citing his wife's discontent, Tom was deserting as well.

Thousands of times in his life, Audubon would say, he recalled the deadly monkey who had strangled the pretty Mignonne deliberately, with unnatural composure. Now the monkey advanced. One hard day that winter, delicate young Lucy, whose two years on earth had been a struggle, died and was buried in her mother's garden. Audubon wrote,

"The Loss of My Darling Daughter affected Me Much; My Wife apparently had Lost her spirits."

Audubon was deeply in debt, but the huge mill was finally ready to receive logs and grind wheat. New banks began to sprout all over Kentucky; the fine brick structure that went up in Henderson was finished inside with lumber from the Audubon mill.

Some townsmen who knew and respected Audubon—and who believed that the mill would ultimately realize its potential—came to the rescue, as did his old friend and new brother-in-law, Nicholas Berthoud. "Men with whom I had Long been connected offered me a Partnership. I accepted and a small ray of Light reappeared in My Business but a *Revolution* occasioned by Numberless quantities of Failures, put all to an end."

They had, all of them, miscalculated the demand for a mill; there were not enough farmers growing wheat, and not enough need, yet, for lumber. To make matters worse, Audubon could not get the customers in his store to pay their bills. Then the sky began to fall: Banks all over the country failed. Times were bad, and getting worse.

By the time Tom Bakewell left Henderson in 1817, taking Prentice and Billy with him, the writing was on the wall. Creditors were beginning to clamor for payment, and John and Lucy were standing all alone to face them. The first thing to go was the real estate. They moved to a small one-story house. Little by little, the wealth they had so assiduously accumulated slipped away from them.

Even Tom Bakewell, who had been pressing Audubon to begin to repay him so that he, Prentice, and Billy could set up a foundry in Louisville, realized that he could not avoid responsibility for the debacle. He provided three thousand dollars to apply to their debts and handed over to Audubon the note for $4,250 he held on the steamboat *Henderson*. If Audubon could collect that money he could apply it to the mounting debt load as well.

John struggled to keep the mill going, working all day and all night at times. His iron constitution was a local legend, but even he had limits. And now everything he tried went sour. For a supply of timber to

turn into lumber, he spent money he did not have on a woodland near Vincennes, Indiana, and hired a group of itinerant Yankees to cut it for him, supplying them with axes, saws, and oxen. They worked well for a time, then one day disappeared down the river, taking Audubon's oxen and axes with them.

Tall stories and practical jokes were among the principal amusements of the American frontier. Across the river in Indiana, Abe Lincoln enlisted a little boy to wade around in a mud puddle, then picked him up, turned him upside down, and had him "walk" across the pristine ceiling, leaving brown footmarks. Abe's stepmother came in, took one look, and laughed, it is said, for an hour.[17] At about the same time, John Audubon got his chance to add to the local practical joke lore when Constantine Rafinesque appeared at his door with a letter of introduction from one of the Tarascons in Shippingport: "My dear Audubon, I send you an odd fish, which you may prove to be undescribed." The fish, who told Audubon that he had stopped at Henderson expressly to see his drawings, had a long beard, and his hair hung loosely to his shoulders. He was dressed in a peculiar, old-fashioned way, with a long loose coat of yellow nankeen, much the worse for wear. His waistcoat had enormous pockets that were stuffed with plants, and his pantaloons were buttoned to his shoes.

In fact, Rafinesque was a well-regarded naturalist. He had been considered for the post of botanist with the Lewis and Clark expedition; Dr. Mitchill in New York was his patron; he was a professor at Transylvania University in Lexington; and he was to publish a book on the fish of the Ohio River. He was also willful and stubborn, and as eccentric in his actions as he was in his looks. If Rafinesque had one major fault, it was that he was obsessed with the idea of discovering new species, which he tended to see everywhere. When he saw a plant in one of Audubon's drawings that he had never seen before, he insisted on seeing the original at once. Audubon obliged him, and later reported that when he pointed to the plant, Rafinesque went wild. "He plucked the plants one after another, danced, hugged me in his arms, and exultingly told me that he had got not merely a new species, but a new genus."

That night, Audubon showed Rafinesque to his bed under the rafters, and everyone went to sleep. Suddenly there was a great uproar from the guest's quarters. Audubon threw open the door: "I saw my guest running about the room naked, holding the handle of my favorite violin, the body of which he had battered to pieces against the wall in attempting to kill the bats which had entered by the open window, probably attracted by the insects flying about his candle." Once more, according to Audubon, Rafinesque was certain he had a new species. He asked Audubon to catch one of the bats for him.

Rafinesque's particular interest was fish, and Audubon simply could not resist giving him what he wanted: several new, completely fabricated species. One that Audubon drew had a head that was a fourth its length, with a blunt nose. The eccentric hung on Audubon's every word and took copious notes about the "new" fish. Audubon could scarcely conceal his glee.

Rafinesque disappeared as abruptly as he had arrived. "One evening when tea was prepared," said Audubon, "and we expected him to join the family, he was nowhere to be found. His grasses and other valuables were all removed from his room. The night was spent in searching for him in the neighborhood. No eccentric naturalist could be discovered. Whether he had perished in a swamp, or had been devoured by a bear or a gar-fish, or had taken to his heels, were matter of conjecture; nor was it until some weeks after that a letter from him, thanking us . . . assured me of his safety."

Rafinesque had the last word. His book on the fish of the Ohio included those that existed only in Audubon's imagination. The "devil-Jack Diamondfish, or *Litholepis adamantinus,*" he described as from four to ten feet long, weighing as much as four hundred pounds, with scales as hard as flint, as strong as steel and "ball proof." He had seen this fish only at a distance, he wrote. "This genus rests altogether upon the authority of Mr. Audubon, who presented me with a drawing of the only species belonging to it."[18] He generously gave Audubon credit for nine other fish discoveries described in his book; the practical joke would one day become a source of embarrassment for Audubon.

Lighthearted times were becoming rare. On February 19, 1818, the elder Audubon died in France. It was spring before the news arrived in Henderson; soon after, his brother-in-law du Puigaudeau let John know that four cousins were suing to deny Anne Moynet all inheritance rights. Anne, they charged in court, had besmirched her husband's good name by announcing for all to hear that Rose Bonnitte and "Jean Rabin, créole de Saint-Domingue" were the children of adultery. Therefore, the cousins argued, the courts should void Jean's will and declare them the true inheritors of his estate. Defending the suit was expensive, Rose's husband wrote; the family was in financial straits and could use some help from their brother in America, who seemed to be doing so well.

Audubon sent condolences and talked vaguely about wanting to visit his mother and give them all the news. After that, he refrained from writing at all. He could not help his mother; he was deeply in debt, and floundering, and there was no one he could turn to for help.

It was at this point that George Keats and his wife, Georgiana, arrived on the scene. George, the brother of the poet John Keats, was twenty-one; his wife was sixteen. Their mission in America was to make the family fortune. They had money to invest, some of which belonged to John Keats. At their first stop, the Robert Owen colony in New Harmony, Indiana, they had been discouraged by the squalor and lack of common necessities, they said, so they pressed on to Louisville. There they met Tom Bakewell; when he learned of their quest he suggested they might want to go to Henderson to see the Audubons.

The Keats became paying guests, and before long invested some of their money in a steamboat John said he owned. Audubon was beginning to grasp at straws. If he could get the steamboat *Henderson* away from Sam Bowen—the Henderson businessman who had given Tom and Prentice his note for $4,250, but had never made good on it—he thought they might have a chance to make some money on the river. Steam was, everyone knew, the coming thing.

There were problems with this proposition which Keats probably was not aware of. For one thing, Bowen was among Audubon's

creditors. For another, he was in possession of the boat—he had, in fact, spirited it down the river to New Orleans. Audubon set out in great haste to reclaim it, traveling in a skiff rowed by two slaves. He arrived too late; some of Bowen's other creditors had already seized the *Henderson*.

Audubon was furious. He hired a lawyer and went to court to prove that, by law, he was the *Henderson's* rightful owner. It was to no avail; the boat was gone, taking with it the last of Audubon's hopes and all of Keats's investment.

Audubon, filled with righteous indignation, publicly ranted against Bowen loud and long before heading back home to Henderson. James Berthoud had come for one of his regular visits, bringing Billy along; they were at the cabin when Audubon arrived. They warned him that Bowen had returned ahead of him and was breathing fire because of Audubon's angry public denunciations.

Like most woodsmen, Audubon carried a dagger. It was tucked into his belt where he could reach it with his left hand. (The right was in a sling, having been injured in an accident at the mill.) Trouble was bound to come, he knew; he was going to have to fight. It came quickly enough; Bowen was waiting for him when he walked to work early one morning. The action was fast and furious: Bowen clubbed Audubon from behind, smashing his head and shoulders again and again. Audubon drew his dagger and plunged it into the attacker's chest. Audubon was able to stagger back to his cabin; Bowen, though alive, had to be carried away on a plank.

Soon Bowen's supporters gathered, muttering, in front of the house, calling for Audubon to come out and answer to them. Lucy and the boys retreated into the bedroom with John, who could scarcely stand, while old Mr. Berthoud grabbed his gun and stood firm blocking the doorway, Billy and the slaves flanking him, knives and clubs at the ready. The white-haired old gentleman admonished Bowen's friends to leave, to let the law take its course. Grumbling, they did what he said.

James Berthoud had been magnificent in defense of his friend, but that was to be his last act of courage. A few days later, on July 18, the

old man died and was buried in Henderson. A battered John Audubon grieved over the grave of a man he had admired and loved; one day soon he would call Berthoud "the Only *Sincere* Friend of Myself and Wife We ever had." [19]

Bowen recovered from his wounds and promptly sued Audubon for assault. Pleas were taken before the Honorable Henry Brodnax at the Henderson Circuit Court on June 28, 1819. An order was issued that John J. Audubon should be held to appear before the judge of the circuit court "on the first day of our September court next."[20] The charges were "maliciously suing out and prosecuting attachment, and assault." After hearing the evidence, the judge ruled that Audubon had acted in self-defense. Later he told him, jokingly, that he ought to have killed the damned rascal Bowen.

Audubon could find little to laugh about in those dark days. The episode with Bowen had been ugly; good Mr. Berthoud had followed baby Lucy and John's father in death; and John Audubon seemed to have few friends left in the world.

After the steamboat fiasco, the Keatses left for Louisville with their baby daughter; Tom and Elizabeth Bakewell welcomed them into their home. Georgiana, no doubt prompted by Elizabeth, said she was tired of the "airs" Lucy put on. In letters to her brother-in-law, she declared that both Audubons were reprehensible and John Audubon was a perfect scoundrel and swindler. John Keats's reply was remarkably calm: "I cannot help thinking Mr. Audubon a dishonest man," he wrote to Georgiana. "Why did he make you believe that he was a man of Property? How is it his circumstances have altered so suddenly? In truth, I do not believe you fit to deal with the world, or at least the American world. But, good God!—who can avoid chances. You have done your best." Then he suggested they return to England—for, he wrote, "those Americans will, I am afraid, fleece you."[21]

The only explanation for Audubon's behavior is that he was desperate. Creditors were closing in and he had exhausted all his means. A young man with ready cash must have been a great temptation, and Audubon had always been an optimist. It was easy to see that steam-

boats were soon to be the wave of the future on the Ohio and Mississippi, taking people upriver as well as down. Audubon must have convinced himself that the *Henderson* would be their salvation.

When he lost the store, there was nothing to do but pull out altogether. At this moment, Nicholas Berthoud stepped forward and, for fourteen thousand dollars, took over Audubon's interest in the mill (which included the lease for the property); he also paid Audubon $4,450 for seven "mulatto" slaves and bought the house and all the furnishings for seven thousand dollars. In this way, Berthoud gave Audubon some cash to pay his creditors, receiving in return the property Audubon still held title to. (Soon enough, however, Tom and Billy Bakewell went to court to get an injunction to prevent Berthoud from paying Audubon, who was still in debt to Tom Bakewell. Nicholas, it would seem, had found a way to help himself while helping Audubon.)

Audubon paid as many of his creditors as he could, but he had far from enough to cover them all. Tom Bakewell, who had managed to convince himself that Audubon should be responsible for the $5,000 William Bakewell had loaned Tom for the misbegotten mill, got nothing. Neither did any of the other Henderson men who had invested in the mill. Audubon was no longer respected in the village. Lucy, he said, "gave me a Spirit such as I really Needed, to Meet the surly Looks and Cold receptions of those Who so shortly before were pleased to Call me Their Friend."

Now he had to find some way to support his wife, the boys, and the new baby who would arrive soon. For the time being Lucy could stay in Henderson, surrounded by the china, flatware, and linens that had been her mother's and that gave her a sense of who she was. Soon they, too, would be gone.

With the help of his father-in-law, Tom Bakewell was setting up a boatbuilding business in Louisville, with David Prentice and Billy to help. Eliza was living in the Berthouds' handsome White House in Shippingport; she was the wife of a leading citizen. Ann and Sarah were at home, in their father's care. But Lucy was thirty-two years old and, for the first time in her life, she had nothing. Her house and all

her possessions had been sold. One warm summer morning in July of 1819, Lucy stood with the boys, ten and seven now, watched her husband disappear into the woods, and wondered when she would see him again.

Sick at heart, Audubon set out for Louisville, where he hoped to find work. He carried with him his gun and his portfolio of bird pictures, all in the world that was left to him. He was leaving Henderson, and the life it had promised, behind forever. Never had he felt so stripped of hope; never had the monkey been so close on his heels, so threatening.

"That was the only time in my life," he would write, "when the Wild Turkeys that so often crossed my path and the thousands of lesser birds that enlivened the woods and prairies, all looked like enemies, and I turned my eyes from them, as if I could have wished that they had never existed."

7

But hopes are Shy Birds flying at a great
distance seldom reached by the
best of Guns.[1]

"**I** PAID ALL I COULD and Left Henderson, Poor & Miserable
of thoughts," Audubon wrote[2] of his three-day walk to Louisville.
Only a few years earlier he had reckoned his worth at fifty thousand
dollars; now he owed nearly as much and had no way to repay it. His
partners had been smarter, he would say; they got out in time, leaving
him to face the consequences of the mill's failure. His reputation was
gone, as were many of his friends, especially those who had invested
in the mill.

Gone as well was his idyllic existence. He had been able to live
two lives in Henderson, combining the thrill of the woods with the
comforts and pleasures of a cultivated home, surrounded by his family,
respected by his neighbors. He had to push all that out of his mind;
now the great urgency was to find a place for Lucy and the children,
and a way to feed and shelter them.

He was far from the "Young Man of *Seventeen* sent to America to *Make Money* . . . brought up in France in easy Circumstance who had never thought on the Want of an article."[3] He felt as vulnerable as the parrot Mignonne, trapped in the cage with the deadly monkey approaching. Things could not get worse, it seemed.

But when he reached Louisville that summer of 1819, he discovered they could: He was seized and thrown into jail on account of his debts. Tom Bakewell was in the city at the time; Georgiana Keats and her child were staying with the Bakewells while George returned to England to settle his brother John's estate. In fact, Tom Bakewell had loaned Keats the money for the trip.

At the courthouse, Audubon ran into an old friend, Judge Fortunatus Cosby, who showed him how to file a petition for bankruptcy.[4] This would keep him out of jail, but it would not deter creditors from seeking to collect on the debts, and many were persistent. In those days, a man was expected to meet his obligations, no matter how long it took.

Finally free to search for a way to make a living, Audubon considered finding a clerical job on a river steamer. Neither Tom nor Nicholas Berthoud would recommend him, though both were in the boat-building business and might have helped. They were concerned that he would disappear into the life of a woodsman, leaving them to take care of his family.

Not all of the Audubons' friends had forsaken them. Eliza and Nicholas offered the family a place at the Berthoud estate, the White House, and Senator Talbot, often a guest at the log house in Henderson, sent his carriage to take the very pregnant Lucy to Shippingport. She and the boys arrived without much time to spare.[5] In telling the story to his sons, Audubon wrote: "for the second time You had a sweet sister born. How I have dwelt on her Lovely features, when sucking the nutritious food from her Dear Mother." [6]

The baby was named Rose, for Audubon's sister in France. Even so, Audubon chose not to write to his family in Couëron. "For the past year I have received no news of you," Gabriel du Puigaudeau wrote in exas-

peration. "To what can I attribute this silence? What adversity has caused it? If so, let us try to devise a way to thwart this imposition that can only block our interests. What astonishes me is that since your last of July 22, 1818, none of the eight letters that I have addressed to you has arrived . . . Madame Audubon is quite well considering her age . . . very anxious for news of you, and fearing some unpleasantness has befallen you. Like us, she cannot imagine that it should be due to forgetfulness. In the name of God, reassure us."[7]

But Audubon could reassure no one. Plagued by the "blue devils," this man, who could be wonderfully high-spirited, could also sink to desperate lows. Poverty gripped him. Later, remembering this painful time, he wrote to the boys: "One morning, while all of us were sadly desponding, I took you both, Victor and John, from Shippingport to Louisville. I had purchased a loaf of bread and some apples; before we reached Louisville you were all hungry, and by the riverside we sat down and ate our scanty meal. On that day the world was to me as a blank, and my heart was sorely heavy, for scarcely had I enough to keep my dear sons alive; and yet through these dark days I was being led to the development of the talents I loved."[8]

To please Nicholas and his mother (as well as to repay them in the only way left to him), Audubon attempted a charcoal portrait of the late James Berthoud. It was so successful that he followed it with one of Madame Berthoud, who always delighted in Audubon's company, and who even now did not pass judgment on him. The two drawings seemed to capture the spirit of the old couple, and Audubon's affection for them. In doing these pictures, Audubon said, "I discovered such Talents that I was engaged to proceed and succeeded in a Few Weeks beyond my Expectations."[9] He took up work as a portraitist.

Before photography, artists provided the only likenesses of loved ones; good artists were rare on the frontier, and those who did pass through often worked in oils, which were too costly for most purses. Audubon charged only five dollars for his quick charcoal portraits; the best of these managed to capture not just the likeness, but the character of the subject.

Some of the most important people in Louisville sat for him; he was called to sickbeds as well, at times arriving only minutes before the patient died. One grieving father had his son disinterred so Audubon could do a keepsake portrait. ("I would give much now to recall . . . his name," Audubon wrote, adding that in his drawing the son was "as if still alive," to the parents' intense satisfaction.)[10]

For a time, demand was lively; Audubon, forced to work quickly and to please his customers, was honing his skills, looking hard at his technique and improving it as he went along. For the first time in his life, he was earning his living by art, and that gave him a new confidence.

But the Audubons' trials had only just begun. That winter, seven months after her birth, baby Rose died as her mother and father looked on helplessly. Before the year was up, Audubon had exhausted the market for portraits; there were only so many people in Louisville who could afford even five dollars for a likeness, no matter how good the artist.

Tom Bakewell's father-in-law, a business associate of Benjamin Bakewell, helped Tom get another start; he, in turn, took Billy under his wing. But none of Lucy's family stepped forward to help her husband find work. Early in February 1820, one of the influential Tarascons came to the rescue with news of a possible job in Cincinnati. The energetic Dr. Daniel Drake had founded a new Western Museum Society as part of Cincinnati College; it already had a curator, but was looking for a taxidermist. Letters of recommendation were quickly gathered and sent off to Dr. Drake, suggesting that Audubon was equally qualified to teach French or drawing, that he had an excellent collection of drawings of American birds, and that he "would be a great acquisition to your institution and to your Society."[11]

Audubon was offered a job stuffing fish and birds at $125 a month, a generous salary; he gladly accepted and set out for Cincinnati. It took him a month to get settled in, find a modest little house, sparsely furnished, and send for his family.

In 1819, Cincinnati was a thriving town with a population of ten thousand; it boasted a dozen doctors, seventeen taverns, and ten

churches, along with four book-and-stationery stores.[12] Still, hogs roamed free in its streets and the woods crowded in on the little houses. Audubon could easily provide game for their table.

Cincinnati had another appeal for him: The college had Alexander Wilson's books, which had made him the ultimate authority on American birds. Finally Audubon could find out which birds Wilson had that he did not—and, more important, which ones Wilson had missed.

Wilson had become Audubon's lodestar; their two brief meetings had set him on course. In Louisville, when Wilson first looked through Audubon's drawings, he had asked if the younger man planned to publish. Audubon, taken aback, had said no. But the question had stuck. If Wilson had bothered to ask, he must have thought Audubon a possible competitor. Six years had passed; much had changed for the younger man; his good life in Henderson was gone and he was now making his living as an artist and naturalist. From practical experience, he knew a great deal about American birds, perhaps even more than Wilson had.

Wilson's command of English was far superior to Audubon's, of course, since English was Wilson's native language and he had been a poet. But the words were not as important as the pictures and the knowledge. Audubon was confident that his own drawings were better, much better, than Wilson's, and he was counting on another, even greater advantage: He was living in the Mississippi River flyway, one of the greatest migration routes in the world. There were surely new species to be found.

In the museum's rooms at the college, Audubon was at last occupied in the work he loved, the study of natural history. In education, naturalists were not considered the equals of classical scholars. "Education" continued to mean a solid grasp of the Greek and Latin classics; those who studied the natural world were the avant-garde.

Still, nature seized the interest of the local people, who brought Audubon all manner of wildlife. One woman arrived in his laboratory carrying a live least bittern in her apron; the bird had fallen down her chimney and when she woke, it was perched on her bedpost watching her. Audubon performed some simple experiments with the bird; the

woodsman was beginning to evolve into the man of science, taking disciplined and detailed notes.

The situation in Cincinnati might have been excellent, had the economic situation made it possible for Dr. Drake to meet his payroll. With his gun, Audubon could put food on the table, but other needs— rent and flour and wool and linen to be spun into cloth, and, always, art supplies—required cash.

Lucy found private pupils and began to teach them along with Victor and Johnny. About the middle of March, Audubon realized that no matter how kind and sincere Dr. Drake was, he was not going to be able to pay the promised wages. Audubon continued to put in his time at the museum, hoping that eventually he would be paid. But soon an advertisement appeared in the paper: "Mr. J. J. Audubon, a French gentleman of the most extraordinary qualifications . . . contemplates opening a school . . . for lessons in Drawing and the French language."[13] The response proved that people of the frontier were hungry for learning: Twenty-five students signed up, including thirteen-year-old Joseph Mason, who had an amazing understanding of botany and could draw flowers and plants like a dream. His father, who was English, recognized the boy's gift and paid for three lessons a week.

One day that spring John bumped into his erstwhile partner Thomas Pears on the street, in town as a salesman for Benjamin Bakewell's glass factory. Audubon invited him to come to see Lucy, but he declined; he wrote to his wife that he wished to put old, bad memories behind him.[14] Audubon emerged from the encounter as by far the more magnanimous of the two.

Audubon crossed the river several times to study the cliff swallows that had built their mud nests on the walls of the army garrison at Newport. For centuries it was believed that swallows did not migrate, but instead burrowed into the mud, became torpid and went into hibernation for the winter months. Audubon, who doubted the swallow theory, observed the birds all that summer, taking careful notes about their arrivals and departures, and at times irritating the swallows enough to provoke an attack. He was in his element, spending long

hours almost motionless, watching as the swallows darted in and out of their nests. They presented a puzzle he was determined to solve.

The Long expedition—led by Major Stephen Harriman Long of the U.S. Army Corps of Engineers—stopped at Cincinnati on its return from the upper reaches of the Mississippi. Titian Peale was the expedition's official artist, Thomas Say its naturalist. The men paused long enough to meet Audubon, to study his bird pictures, and to make him acutely aware of the advantages of being part of an expedition that could penetrate into the deep heart of the country, so far unexplored by whites.

In April 1820, Drake admitted that he could not pay Audubon and let him go with regret, promising that he would be paid for the work already done. In June, during the opening ceremonies for the museum, Drake gave Audubon at least his verbal due in a lengthy oration that touched on ornithology. Of Alexander Wilson, Drake said: "To this self-taught, indefatigable and ingenious man we are indebted for most of what we know concerning the natural history of our birds. His labors may have nearly completed the ornithology of the middle Atlantic states, but must necessarily have left that of the western imperfect."

Drake went on to explain: "Most birds are migratory, and in their migrations they are not generally disposed to cross high mountains, but to follow the courses of rivers; when we contemplate the great basin of the Mississippi . . . it is reasonable to conjecture that many birds annually migrate over this country which do not visit the Atlantic states, and might, therefore, have escaped the notice of their greatest ornithologist in the single excursion he made to the Ohio."

He was expressing Audubon's feelings precisely. "As a proof," Drake continued, "it may be stated that Mr. Audubon, one of the artists attached to the museum, who has drawn from nature, in colored crayons, several hundred species of American birds, has, in his portfolio, a large number that are not figured in Mr. Wilson's work, and which do not seem to have been recognized by any naturalist."[15]

SOMETIME THAT SPRING, JOHN AND Lucy reviewed all the drawings and all the field notes, and made the decision that would change the course of their lives. Audubon was going to declare himself a naturalist and artist; he was going to answer Wilson's unspoken challenge and publish his own book, which would be bigger, and better, and include all of the birds of America. And Lucy would be his partner.

The praises now being heaped on Wilson would be lavished on Audubon. Audubon, not Wilson, would become America's greatest ornithologist. He would get his pride back; his wife would never again be called "poor Lucy" by her family; with Victor and Johnny, they would form a tight little unit, indivisible, trusting each other above all else, and they would prevail.

It was a romantic, reckless decision—born as much of wounded pride as of hope. A book of the magnitude they envisioned would require many more drawings than Audubon had, and that meant long wilderness excursions, during which Lucy would be left alone with the children. And while the Mississippi flyway was close enough, what of the birds of Florida? Or those in the vast, uncharted tracts to the west, over the Great Plains and beyond the Rocky Mountains, all the way to the Pacific? When, finally, Audubon found all of the species, who was to publish his book? Audubon knew that Alexander Wilson had been exhausted, probably unto death, by the enormous task of finding the birds, studying and drawing them, writing intelligibly about them, and then selling subscriptions to his volumes in advance of publication to get money to pay the engraver and colorists (since each copy had to be colored by hand). He would have to be naturalist, artist, writer, salesman, and collection agent—all at the same time.

On the other hand, Wilson had been forty-four when Audubon met him that first time, in Kentucky; Audubon was only thirty-four, and he had been drawing birds longer than the older man ever had. Just as important, he had his famous iron constitution, enormous energy, and, he was certain, greater skills and talent than Wilson. But he could

undertake this project only with Lucy's cooperation. She would have to manage on her own in Cincinnati with the boys for six or seven months while Audubon traveled down the Mississippi to complete his drawings. It was a great deal to expect of a wife with two growing sons and little experience of poverty. She said she could do it, and he took her at her word.

The two of them flew into action, sending off a letter to Henry Clay, their congressional representative from Kentucky, and to others, including William Henry Harrison, who would one day be president. Lucy's careful editing was evident: "After having spent the greater part of fifteen years in procuring and drawing the birds of the United States with a view of publishing them [this, of course, stretched the truth about the decision to publish], I find myself possessed of a large number of such specimens that usually resort to the Middle States only. Having a desire to complete the collection before I present it to my country in perfect order, I intend to explore the territories southwest of the Mississippi.

"I shall leave this place about the middle of September for the purpose of visiting the Red River, Ark., and the country adjacent. Well aware of the good reception that a few lines from one on whom our country looks with respectful admiration, I have taken the liberty of requesting such introductory aid, as you may deem necessary to a naturalist, while at the frontier forts and agencies of the United States."[16]

Anyone heading into new territory armed himself with as many letters of introduction as he could muster. A letter from Henry Clay would open doors, especially those of government offices and army forts. Clay obliged, though in a covering letter he cautioned Audubon about embarking on such an ambitious, expensive venture.

What Clay couldn't know was that the Audubons had no real choice; their only alternative was to struggle on as they were, never quite certain how many students they would have or which would be able to pay, always scarcely making ends meet. The time would come when Victor and Johnny needed a better education than Lucy could provide, and she intended them to have it. By now she understood that

if her husband were to succeed, it would be as a naturalist and artist. She had seen with what respect Dr. Drake and the people at the college had treated him. More than anyone, she understood his passion for the study of birds: It had been his unwavering obsession since the day she had met him, sixteen years before. For the family to flourish, she needed to believe in him, and that meant doing what she had to do to be a full partner in his work.

While he was with her, she felt strong and sure of herself. She had her students and could collect the back wages owed her husband. She was not one of those complaining wives—like her brother Tom's Elizabeth, like her cousin Sally Pears—who by using their own weaknesses could make their men bend to their will.

On October 12, 1820, Lucy and the boys said good-bye to John Audubon and his new apprentice, thirteen-year-old Joseph Mason, as their flatboat cast off from the dock at Cincinnati. Joseph's father knew Audubon well enough to trust him to care for his son while serving as his drawing master. In return for lessons, Joseph would do botanical drawings of the indigenous plants and flowers that Audubon would include in his bird pictures. With them they took paper, pencils, crayons, chalk, and a roll of the wire that Audubon always used to arrange newly killed specimens into lively attitudes. Audubon carried, as well, the scored board that allowed him to transfer his drawings to paper in actual life size, a copy of Turton's *Linnaeus* to help him identify birds, and a new journal for the trip.

Unable to pay for passage, Audubon had signed on to the flatboat's crew as a hunter; he would keep them in fresh game on the long, slow journey downriver to the Mississippi and on to New Orleans. On the first page of the journal he wrote with a beginner's bravado: "I left Cincinnati this afternoon at half past 4 o'clock, on Board Mr. Jacob Aumack's flat boat . . . Without any Money My Talents are to be My support and my Enthusiasm my Guide in My Dificulties, the whole of which I am ready to exert to keep, and to surmount."

The water was low and they proceeded at an agonizingly slow pace. "We only floated 14 miles by the break of Octobre the Day was fine.

I prayed for the health of my family—prepared Our Guns and went on shore in Kentucky." Audubon brought back "thirty Partridges— 1 Wood Cock—27 Grey Squirrels—a Barn Owl—a Young Turkey Buzzard." Audubon taught Joseph how to shoot, too; managing to kill three wild turkeys, the boy "was not a little proud when he heard 3 Chears given him from the Boats." It was one of the rare bright spots in an otherwise dismal journey.

The weather had turned cold and miserable; Audubon was plagued by headaches; the boat tended to run onto sandbars; the crew was coarse and vulgar. "Ned Kelly," Audubon wrote in his journal, is "a wag of 21. Stout Well Made, handsome if Clean, possessed of Much Low Wit, produces Mirth to the Whole even in his Braggardism— Sings, dances and feels always happy—he is a Baltimorian." Two others worked well and said little. "The Last is Much Like the Last of every-thing, the Worst Part—*Joseph Seeg.* Lazy, fond of Grog, says nothing . . . sleeps Sound, for he burns all his Cloths, while in the ashes." Audubon found Captain Samuel Cummings, an engineer who had taken passage in order to make some studies of the river, to be compatible, and considered Joseph, Cummings, and himself to be a group apart, three who "agree Well."

The men were accustomed to the hardships of living on the river. Most, including Jacob Aumack, drank heavily. Near Louisville, the sweeps that steered the boats had to be replaced; they pulled in and the men, including little Joe Mason, went ashore. They were cutting trees when a flock of wild turkeys suddenly appeared out of nowhere and began to settle among them. Aumack reacted without thinking, blazing away with his pistols. One ball grazed Joseph's skull, wounding him severely, according to Audubon.

He exaggerated, since by the time they approached Hender-son—only a hundred miles downriver—Joseph was well enough to volunteer to go with Captain Cummings to retrieve a hunting dog named Dash, which Audubon had left with one of his neighbors. Audubon would not go into town himself; his last months there had been too bitter. The two took off in the skiff, returning with Dash

long after dark. The dog did not appear to remember its old master.

At first light, with a high wind blowing hard, the boat drifted past Henderson. Audubon stood on top of the cabin, wanting to make a pencil sketch of the place, but the wind defeated him. "I can scarcely conceive that I staid there 8 Years and passed them Comfortably . . ." he wrote, and then: "I looked upon the Mill perhaps for the Last Time, and with thoughts that made my Blood almost Cold, bid it an eternal farewell."

At Henderson, the cook left the flatboat, and the onerous chore of cooking suddenly fell to the hapless Joseph. Audubon wrote: "On Board the Flat Boats We seldom eat together and very often the hungry Cooked, this I performd when in need by Plucking & Cleaning a Duck, or a Partridge and throwing it on the Hot embers; few Men have eat a Teal with better appetite than I have dressed in this manner—"

Lucy had made him promise that he would shave and clean up every Sunday: "Often have been anxious to see the day come for certainly a shirt worn one week, hunting every day and sleeping in Buffalo robes at night soon become soiled and Desagreable."

Finding, shooting, and drawing the birds was his all-consuming mission. He was focused now; the goal was set; to reach it he would have to work as hard as he ever had. He hoped to draw one bird each day, but quickly discovered that was not possible. The boatmen were keeping their own schedule and Audubon, unable to get to shore to take specimens to draw, was growing increasingly impatient: "Extremely tired of my Indolent Way of Living not having procured a thing to draw since Louisville." Captain Aumack understood the need to go to shore to hunt for food, but was less amenable to time spent tracking birds to draw. Even so, there were stretches when Audubon could spend long hours laboring over his drawings, improving them artistically, demanding more of himself and of his apprentice.

It was the seventh of November when they pulled in to the Illinois shore at Shawneetown, where Audubon once had a successful branch of his Henderson store. The men went to the grog shops, and later that night Ned Kelly and Joe Seeg had "a little Scrape at the Expense of Mr.

Seeg's Eyes & Nose." Audubon spent the day drawing a "Rusty Grakle *Gracula Ferruginea,* and made a handsome piece of it."

As the flatboats came to the place where the Ohio meets the Mississippi, Audubon—miserable about conditions on the boat and worried about the family he had left behind—fell into a profound depression. His naturally buoyant spirit, combined with a curiosity that never failed him, lifted him out of the abyss. Carefully studying the way the two great rivers met, he wrote: "Here the Traveller enters a New World, the current of the stream is about 4 miles per hour, puts the steersman on the alert and wakes him to troubles and difficulties unknown on the Ohio, the Passenger feels a different atmosphere, a very different prospect."

He understood that he was entering his own New World, with "troubles and difficulties unknown." One day his spirits would flag, then they would soar again—depending on the weather, on the birds he found to draw, on how much he was able to keep his mind off Lucy and the boys, on how often the captain and crew of the flatboat irritated and infuriated him. He hated being treated as an underling; he did not like being reminded that he was getting free passage in exchange for work. He had with him a sketch of Lucy, which he would study on Sundays, along with the drawings he had so far accomplished. Family and art were the cornerstones of his faith.

Birds swirled around the slow-moving flatboat: waves of robins—Audubon called them, rather accurately, "Red-breasted Thrushes"—and barn owls, hawks, and geese. His brass telescope was hard by, ready to extend whenever some unfamiliar bird flew into view. When he could get permission to use the skiff, he took Joseph off in hopes of finding new birds. "As soon as we had eat our *Common Breakfast* fried Bacon and Soaked Biscuits—Joseph went to his station and I to Mine, i.e., he rowed the skiff and I steering it—Went to the *Little Prairie* shot at a Brown Eagle probably 250 yards and yet cut one of its legs."

On one such outing, Audubon did bring down a bald eagle, a magnificent male; with this prize they made straightaway for the boat, where Audubon wired the bird to clutch in its talons a goose that

Joseph had killed. It took four days to complete the drawing; studying the great bird, he became convinced that the brown eagle he had seen years before, and which he called the bird of Washington, was a separate species.

He recorded with the candor of a scientist his observations of eagles mating: "I saw this afternoon Two Eagles Coatiting—the femelle was on a Very high Limb of a Tree and squated at the approach of the Male, who came Like a Torrent, alighted on her and quakled shrill until he sailed off the femelle following him and ziz zaging herself through the air—this is scarce proof I have the pleasure of witnessing of these and all the *Falco genus* breeding much Earlier than any Other Land Birds."

He was keeping the goal firmly in mind. He studied birds as often and as long as he could, and drew them, while at the same time fulfilling his obligations to Joseph by giving him lessons, and to the captain of the boat by providing fresh food.

On November 27, 1820, a Monday, everyone on board became sick after eating some bad venison. Audubon's physical misery, magnified by a dread he could not shake, sent him reeling emotionally. He confided to his journal: "While looking at My Beloved Wife's Likeness this day I thought it altered and Looked sorrowful, it produced an Immediate sensation of Dread or her being in Want—yet I cannot hear from her for Weeks to Come—but Hope she and our Children are well."

LUCY'S FAMILY DID NOT UNDERSTAND either Audubon's anguish over his wife and his "good Kentucky lads," or his fierce determination to provide for them in the only way left to him. They saw only a man who would leave his family in need while he went off on an unlikely bird-related venture.

Lucy, all alone, was caught in the middle. Unable to count on payment from her students, she haunted the college until it paid four hundred dollars of her husband's back wages. Without John to share the burden (and the humiliation of having to beg for money owed),

and overwhelmed with the responsibility of caring for the boys, she wavered. Benjamin Bakewell came to Cincinnati on business; unlike his clerk Pears, he made a point of calling on Lucy and staying for a few weeks to help her. Letters from Fatland Ford made matters worse; her father was too ill to come to her aid, and her stepmother insisted on informing her that two hundred dollars William Bakewell had paid in settlement of an old Mill Grove debt would be deducted from any inheritance due her. Uncle Benjamin, always sensitive to those around him, must have alerted the Bakewells to their sister's predicament.

AUDUBON, MEANWHILE, HAD STOPPED OFF at the Arkansas post, the military station that served as seat of the territorial government, with his letter of introduction from William Henry Harrison. He had heard that an expedition was being formed to explore the upper reaches of the Red River into Oklahoma and Texas. He hoped to be appointed naturalist on any such expedition, and—thoroughly disgusted with life on the flatboat—was ready to leave at once. Of Aumack, he wrote: "Our Commander's Looks and acting are so strange that I have become quite Sickened."

The long hike into the post proved to be another exercise in futility; Audubon and Joseph arrived to find that the territorial governor had gone off to the new site of government, "Petite Rock," a hundred and fifty miles away. Famished, they entered the only tavern in the county. "Wearied, Muddy, Wet & hungry—the Supper was soon called for, and soon served, and to see 4 Wolfs taring a Carcass would not give you a bad Idea of our Manners." That night Joseph and he climbed into one of the inn's three beds, all of which were already occupied. "Nothing but the Want of *Blankets* Kept Me from Resting Well, for I soon found a Place between the *Tugs* that Supported about 10 lbs of Wild Turkey Feathers to save My roundest Parts from the Sharp Edges of an Homespun Bedstead."

Audubon left his letter from William Henry Harrison behind to be delivered to the governor in case a Red River expedition were ever mounted; then they made their way back to the detested flatboat.

As the boat made its tortuous way downriver, flocks of mysterious new birds began to appear. Audubon could not find them in his *Linnaeus;* for want of a better name, he called them "black birds" or "Brown Pelicans." One day, as he was busy drawing a marsh hawk, several of the birds settled on a nearby sandbar. Captain Aumack, in his cups again, grabbed his gun and blasted away without touching a single bird.

As Christmas approached they found themselves opposite the Yazoo River in Mississippi, where they sighted a large flock of the mystery birds. Joseph and Audubon quickly put out in the skiff and landed on a sandbar below the birds. After crawling on his stomach for about three hundred yards, Audubon was within shooting range of three birds perched together. One dropped into the water, wounded, and led them on a mile-long chase upriver before they could get it. "I took it up with great pleasure and Anxiety," Audubon wrote, "but I could not ascertain it Genus—for I could not make it an *Albatros,* the only bird I can discover any relation to." Somehow he worked out that his mystery birds were migrating cormorants.

His journal was crowded with the details of his discoveries: "I found the Stomack of the Great footed Hawk [peregrine falcon] filled With Bones, feathers, and the Gizzard of a Teal, also the eyes of a Fish and Many Scales—it was a femelle Egg numerous and 4 of them the size of Green Peas—" With his compass he measured the bill, legs, wings, talons. He examined the eyes, the nostrils, the legs and claws, the structure of the wings and the tail; he noted the colors of the feathers; he described the flight of each bird, its mating habits, how it reared its young. He took his work seriously; he could no longer allow himself to care what others thought, no matter how painful these thoughts were to his dignity.

Only Lucy worried him; on Christmas Eve he thought of his family and longed to be with them. Most of all, he wrote, "I hope to have

some tidings of them Tomorrow—the Shores are now Lined with Green Willows the Weather much Like May—at *Henderson*—The Thermometer is allmost every day from 60 to 65."

At Natchez Audubon found two letters from Lucy, dated November 7 and 14. So relieved was he with this contact, even though it was six weeks out of date, he sat down to write a long letter in reply.

In one of her letters Lucy enclosed yet another of Gabriel du Puigaudeau's pleading missives. "Two years have passed without our having any news of you," he wrote. "In God's name give us some news about yourself, if it be but a word to set us at rest . . . Madame Audubon is coming to live with us; she found herself isolated at La Gerbetière and was very dull there . . . She does not cease to speak of you."

This letter could only have added to Audubon's load of despair. How could he explain to his family in France that he had left his wife and boys alone in a rough frontier town, that Lucy was feeling isolated and dull too, and that for the moment he could do nothing for any of them?

As soon as he finished the drawing of the great-footed hawk (peregrine falcon) that he had been working on steadily for the past several days, he cleaned up and went into Natchez town, climbing from the seamy "Under the Hill" district, which was filled with taverns and prostitutes and bad characters, to the respectable section above the riverbanks. His plan was to find "something to do in the likeness Way for our Support unfortunately Natturalists are Obliged to eat and have some sort of Garb." He did two sketches, earning enough to provide some "fine sauce for our empty stomacks."

The next day he was surprised to run into Nicholas Berthoud, who was traveling downriver with a group of Frenchmen. Nicholas, to his relief, not only "accosted Me Kindly," but invited him to make the rest of the journey to New Orleans in his keelboat and insisted that Audubon share his hotel room.

Audubon accepted this deliverance; he and Joseph had had enough of the rough life of the flatboats, enough of the men's drunkenness, fighting, and carousing, enough of the terrible food soaked in grease.

Even if Nicholas questioned his brother-in-law's new direction in life and disapproved of his leaving Lucy and the boys on their own, they were old friends as well as relatives. But Audubon could not feel easy. Not only did he owe Nicholas money but he was so penniless he couldn't pay his share of travel expenses, and he was painfully aware of how that diminished him in the eyes of former equals. Even so, Audubon and Joseph were elated to escape the flatboat; they stacked their gear on the dock for servants to load, and climbed aboard with the several French businessmen whom Nicholas was escorting. It was not until they were well downstream that Audubon discovered one of his portfolios missing. Everyone pitched in to search the boat, but the drawings were not there; they had been left behind on the dock.

Audubon was in a panic. The portfolio contained fifteen drawings; three were of birds that had not previously been described and thus might be new species. In his journal, he lashed out at himself for leaving to a servant what he should have done for himself. So many hours of work, lost. "So dull do I feel about it that I am nearly Made Sick," he wrote. Worst of all, "Should I not get it again, it may retard My return home very Considerable—"

At the first opportunity he sent off a letter to John Gamier of the Natchez Hotel, asking him to do what he could to recover the portfolio. Audubon did not hold out much hope; he thought that by now his drawings were probably ornamenting the walls of rough cabins and would never be seen again.

As the keelboat floated down the Mississippi, and he could devote all of his time to his drawing, Audubon pressed ahead in a frenzy of work. He rose early, before any of the others, and walked while waiting for enough light to work by. On one morning he strolled through a cotton field ready for picking. To the artist, it "Looked Like if a Heavy Snow had fell and frose on every Pod."

As they moved deeper into the South, he noted a distinct change: "the Woods here have a new and very romantic appearance—the Plant Called Pamitta raises promiscuously through them[,] the Moss

on every tree darkens the under growth and affords to the melancholy Mind a retreat."

The only thing that relieved his melancholy was to concentrate on his work. "I drew both my Birds, the first on a plant in full bloom that I plucked Near the Boat." He "took the Outlines of Both *the Warblers by Candle Light to afford Me time to morow to finish both.*" By daylight he noted, "the flocks of *Blackbirds* . . . pass Southwest constantly; forming a Line Like disbanded Soldiers all anxious to reach the point of destination each hurrying to pass the companion before him."

After a springlike burst of beautiful weather on New Year's Day, 1821—the temperature was a balmy sixty-eight degrees—the wind picked up and the temperature dropped dramatically. At times the wind was so strong that the keelboat was forced to take cover on shore. Audubon was always the first out of the boat, exploring the countryside, shooting birds, with Joseph at his side.

On the morning of January 5, a light snow was falling and there was a fierce wind. Audubon managed to kill a tern on the wing; when its mate wheeled back to see what had happened, he shot it as well. The wild rocking of the boat made it impossible to finish a drawing, so he set out for a long walk and came upon the home of a French Créole. He noted, as he almost always did when a pretty woman was involved, that the lady of the house was "remarkably handsome" and in the same breath remarked that their garden produced oranges, fine lettuces, green peas, and artichokes, which reminded him of happy days in France.

That night he drew the outline of the tern he had shot in the morning; he could not find the species listed in *Linnaeus,* but he would not consider it to be a new species "until I See Willson's 9th Volume." At this point, Audubon measured everything he did against Wilson.

Nicholas and the French gentlemen (at whom Audubon poked fun because they wrapped themselves in their cloaks and held their handkerchiefs to their noses) were so eager to get to New Orleans that on the morning of January 6, 1821, they pushed off from their safe harbor in spite of the wind. They were quickly blown to the opposite shore and the sugar plantation of one M. St. Armand.

Audubon and Joseph bounded out of the boat with their guns, heading for the swamps—the best place to find birds and other animals—but after about three miles they turned back, afraid that the boat might leave without them. The St. Armand plantation, Audubon wrote in his journal, was the finest he had seen; he offered a glimpse of it: "Mr. S.Ad own 70 Negroes and Makes about 400 Hogshead of Sugar—besides raising, Corn Hay, Rice &c—this Gentleman, apparently Young was Shooting Red Winged Starlings [red-winged blackbirds], on the Wing for his amusement, had a richly ornemented Doubled Barelled Gun of which he Made excellent use—the Slaves employed at Cutting the Sugar Cane—this they perform with Large heavy Knifes not unlike those used by Butchers to Chop."

That same day Joseph made his first bird drawing, of the female tern killed the day before, and Audubon announced that he was very much pleased with the effort.

The rose garden at the St. Armand plantation reminded Audubon that there was always a place for beauty, even on the wild edges of the known world. That night the wind dropped and a clear moon offered a portent of good weather, of reaching New Orleans at last.

"Tomorow perhaps May take us there," Audubon wrote in his journal that night, "yet so uncertain is this World that I should not be Surprised if I never Was to reach it—the further removed, the Stronger My anxiety to see My familly again presses on My Mind—and Nothing but the astonishing desire I have of Compleating my work Keeps My Spirits at par—"[17]

8

I waged war against my feelings[1]

O<small>N</small> S<small>UNDAY</small> <small>MORNING</small>, J<small>ANUARY</small> **7, 1821,** Audubon wrote in his journal: "at New Orleans at last." The long, tedious trip down the river was over.

The results were mixed. He had worked hard, had shot and studied new birds, and had added to his stock a wealth of new drawings, better than any he had done before. But he had managed to leave fifteen of the best on the dock at Natchez; these, he felt certain, were lost forever. Still, he couldn't quite give up on them. He sent off an advertisement to the paper in Natchez.

In New Orleans, Nicholas introduced Audubon to a young Englishman, Alexander Gordon of the firm of Gordon & Grant, who was connected through business to the Bakewell clan. (Tom Bakewell had once been apprenticed to Gordon's father.) Alexander Gordon took to the handsome and talented, if slightly ragged, John Audubon;

in the days to come, Gordon would prove helpful and encouraging.

A note and a pair of gloves from Lucy were waiting in New Orleans for Nicholas, but there was no word for John. For the moment, he was satisfied to know that she and the boys were well. Nicholas, understanding his brother-in-law's anxiety, insisted Audubon come along on his business rounds.

They made plans to join Alexander Gordon for dinner on their first Sunday night in town, but that afternoon they visited Felix Arnaud, an old friend of the Berthouds, and were persuaded to stay with their French compatriots for what turned out to be a rambunctious evening. Audubon—his head aching from too much wine and morning-after doubts—confided to his journal: "We had a good dinner and great deal of Mirth that I call *french Gayety* that really sickened me. I thought Myself in Bedlam, every body talkd Loud at once and the topics dry Jokes—yet every one appeared good, well disposed, Gentlemen, and were very polite to us—a Monkey amused the Company a good deal by his Gambols and pranks . . . After having paid a Short Visit to Mr. Gordon I retired to the Keel Boat." He had stopped to make amends to his new friend. His spirits sank again when he remembered that he could not possibly hear from Lucy the next day: The post office would be closed for the anniversary of the Battle of New Orleans, in which Andrew Jackson had defeated the British fleet. (That peculiar battle had occurred after the peace treaty had been signed in the war that gave Audubon and Tom Bakewell their first business failure.)

Audubon and Joseph regularly rose before daybreak to haunt the markets, where a variety of birds—including, they hoped, some they had not seen—were for sale. They found "many Malards, some teals, some American widgeons, Canada Geese Snow Geese, Mergansers, Robins; Blue Birds; Red wing Starlings [red-winged blackbirds]—Tell Tale Godwits [greater yellowlegs]—every thing selling extremely high $1.25 for one pare of Ducks, 1.50 for a Goose &c Much surprised and diverted on finding a Barred Owl Cleand and Exposed for sale Value 25cts."

He struggled to find birds he had not yet drawn and to improve on the ones he had. He was his own best critic, continually trying new

techniques to reproduce the subtle sheen of a feather, to capture the nuances of colors, to come as close to living reality as he could. He was beginning to experiment with combining pencil and crayon and pastels with watercolor, ink, oil, and egg white.[2] But the gnawing need for funds made him lie awake at night, worrying. He had to feed himself and Joseph, and then he had to earn money to send to Lucy.

He made his way to the studio of John Wesley Jarvis, a New Yorker then residing in New Orleans, who was both the nephew of Methodism's founder and one of the country's most accomplished portrait painters. Jarvis, eccentric in dress and manner, had spent some time with the pirate Jean Laffite, had studied anatomy, and had painted some of the country's most prominent citizens. At separate times, Thomas Sully and Henry Inman had assisted him.[3] Audubon showed Jarvis some of the bird pictures, and watched in exquisite agony as he examined them. Audubon hoped for praise and help in finding work; Jarvis was disturbingly silent. Swallowing his pride, Audubon asked straight out for work, offering to paint clothing or backgrounds in commissioned portraits. Jarvis stared at him and still said nothing; Audubon, unnerved, rattled on, his words tumbling out in torrents. He had been trained by fine masters, he declared. He himself would never turn his back on such an offer, he all but pleaded. Finally Jarvis said he would think about it; Audubon should return the next day for an answer.

With nothing better to do, Audubon found Nicholas Berthoud and fell in step beside him. They stopped at the warehouse of Roman Pamar, a crockery merchant. Pamar had been welcomed at the Audubon cabin in Henderson once, and he never forgot the kindness John and Lucy had shown him. Later, during Audubon's ill-conceived trip to New Orleans in pursuit of the steamboat *Henderson*, Pamar had served as his bondsman. Now he asked Audubon how much he would charge for one of his portrait drawings. The reply was twenty-five dollars—which surprised Nicholas, who knew that in Louisville and Natchez Audubon had drawn portraits for five dollars each. Pamar wondered how much Audubon would charge to put all three of his children in one drawing. In that case, the artist replied, his fee would be one hundred dollars.

Pamar wavered, so Nicholas suggested that Audubon make a quick sketch of one of the little girls. Audubon told his journal what happened: "A sheet of Paper was procured, My Pencil sharped and Sitting on a Crate was soon at Work and soon finished; the Likeness was Striking; the Father Smiled, the Clerks stared me emased and the servant was dispatched to shew My Success (as it Was Called) to Mistress." As for Pamar, he gave a Gallic shrug and said simply that Audubon must do his best for him, as to price. Audubon, hungry for money, wanted to start at once and get part of his fee that same day—"how I Calculated on 100 Dollars; What relief to My Dear Wife and Children"—but the eldest daughter would not be available for a few days.

Even so, Audubon's spirits lifted; in his mind's eye, Pamar was paying the full price and he was already sending the whole of the fee to Lucy. The next day the portrait artist Jarvis turned him down flat. Audubon's buffeted pride had received yet another blow; he felt the sharp sting of shame followed by a rising anger, and stalked out without a word. Later, he tried to convince himself that Jarvis probably "feared" his talents. The bankrupt thirty-five-year-old John Audubon was without prospects and almost without hope. Only the thought of a commission from Pamar kept him going.

At dark that Sunday evening, he walked over to Alexander Gordon's and from there went on to a Frenchman's home where, he wrote in a shorthand filled with innuendo, "we saw some *White Ladies* and Good Looking ones—returning on Board the Quartroon Ball attracted My View but as it cost 1$ Entrance I Merely Listened a Short time to the Noise and came Home as We are pleased to Call it."

New Orleans's polyglot exoticism fascinated him. There were white women who, fallen from grace, lived the circumscribed life of the demimondaine, much as Jeanne Rabin had on his father's plantation in Saint-Domingue. New Orleans in the 1820s was not so different from the West Indies of the 1780s; handsome "quadroons" and "octoroons" were reared to become the mistresses of wealthy white men. These racially mixed couples appeared together at gaudy "quadroon balls" of the sort Audubon had stopped to listen to. For want of a dollar, he was

outside looking in. He was the poor parrot Mignonne, trapped in its cage, afraid and vulnerable.

For the next four days he could not bring himself to write in his journal. Even the Pamar commission seemed out of reach; it turned out that Mrs. Pamar was set on having an oil painting of their daughters.

Desperate, Audubon did a two-hour sketch of an old acquaintance, John Gilly, who had shown up in New Orleans and was willing to serve as a model. Gilly's distinctive features, as translated onto paper by Audubon and shown around town, worked like a charm. There was John Gilly himself, a perfect likeness on paper—fast and cheap. That settled it for Pamar; he ordered a drawing of his eldest daughter. For the next nine days Audubon did a portrait a day, including one of the British consul and one each of Pamar's other two children. By the end of the week he had $220. His luck had turned; he had hit bottom and was bouncing back up again.

Letters from Lucy offered little comfort. One, written on the last day of 1820, was so discouraging that he wrote in his journal: "rufled My Spirits Sadly." Left alone with the boys, Lucy was struggling; without a husband to share her problems and put food on the table she became fearful, and her letters took on a forsaken tone. Poor Lucy, all alone in Cincinnati while her man was off chasing birds to draw. Her family pitied her, and she—alone and afraid—pitied herself as well.

On Sunday, January 28, 1821, Audubon wrote in his journal with a sense of relief: "fatigued, Weary of Body but in good Spirits having plenty to do at good Prices, and my Work much admired—only sorry that the Sun Sets—" By the end of January Audubon had collected something over three hundred dollars; he sent Lucy $270 and a thirty-six-piece dinner set of Queen's ware, a popular variety of earthenware made by Wedgwood for Britain's Queen Charlotte. Pamar supplied it for $36.33.[4] It was a touching, if extravagant, gesture. The Queen's ware was not as fine as the china left to Lucy by her mother, but it was good enough to show a husband's understanding of his wife's burden and to reassure her that times would get better.

On February 15, Audubon went to the docks to see Nicholas Berthoud off for home, and placed in his hands a package for Lucy containing twenty pictures, among them the bald eagle and eight "new" birds that Wilson had not described. They were meant to assure her that he was accomplishing what he had set out to do.

That same day, Lucy arrived in Shippingport to live with the Berthouds. She had given up on Cincinnati; it was too hard to be alone and in need, and Eliza had offered her sister and nephews a refuge. Immediately upon her arrival Lucy wrote yet another letter to Dr. Drake, importuning him to pay more of what he owed her husband. "Sir," she began in the complaining tone that had now begun to infuse her letters, "after an unpleasant voyage owing to the rain we arrived at Shippingport and found all our friends well . . . Relying upon your politeness and consideration for me I trust the demand I make will be as speedily attended to as possible."[5]

Some part of Lucy did remain loyal to the dream; six weeks later she wrote her cousin Euphemia Gifford in England that her Mr. Audubon planned to publish in Europe "a large work on Ornithology."

In New Orleans, Audubon and young Mason moved into a ten-dollar-a-month room on Barracks Street. It was wedged between two grocery shops, from which it was separated only by flimsy wood partitions, so they could hear whatever was going on in both shops. Orders for "likenesses," as Audubon called his sketches, kept coming in, so he hired a woman to cook for them at ten dollars a month, and a hunter to go out in the woods to seek out the specific birds Audubon needed for another twenty-five dollars. He no longer had time to do the hunting himself.

Joseph did not much like the city; following his teacher's lead, he applied himself to his art so assiduously that Audubon wrote Lucy that the boy was now drawing plants and flowers better than any man in the country.

At first, Audubon was stymied by his failure to find a copy of Wilson's *American Ornithology* to borrow; without it, he could not tell which of his birds were new species. "The high value set on that work

now, particularly lately, has rendered it extremely rare," he wrote, "and the few who possess it will not lend it." Finally, with Alexander Gordon's help, he found a copy to consult, and thrilled each time he could add to or correct Wilson's information.

Audubon was becoming well known as an artist in the city, and not only for his human portraits—which he looked upon as a means to an end—but for his birds. Sometime in mid-February 1821 he was approached on the street by a graceful, veiled woman who asked if he was the artist sent by the French Academy to draw birds. It was an understandable mistake. He was French and an artist, he explained, but he drew to please himself—in other words, he had no patron. The lady, who was handsome enough to hold his attention, came to the point: She would like him to consider a commission. She gave him her address and asked that he appear there in half an hour.

Audubon would call her an "extraordinary femelle" (and, later, "the fair incognito") but he was man of the world enough to recognize a woman who had lost her place in respectable society, probably on account of her sexual behavior. He could resist neither the temptation nor the possibility of a commission—and he told Lucy the whole story. On the letter cover he wrote, conspiratorially: "This is forwarded to my only friend and I wish her to be careful about participating [sharing] any part. If thy brother William should tell thee he will keep it snugg, show it him—no one else for some years."[6] The tale he spun for Lucy was as follows:

At the appointed time he appeared at the address, where the woman—she gave her name as Madame André—asked if he had ever drawn the whole human figure. He said yes. Would he draw her in full figure—nude? To Lucy, Audubon insisted that he had hesitated; perhaps he did, but he also started work that same day, behind bolted doors. He writes, breathing heavily: "Stranger as she was to me, I could not well reconcile all the feelings that were necessary to draw well, without mingling with them some of a very different nature." When finally he saw Madame André stretched out naked on the couch, he dropped his chalk.

He returned for several sessions—enjoying himself, it would seem, until the moment when his subject rose from her couch, walked over to look at the work, made some disparaging remarks about this "folly," and with a few deft strokes proceeded to improve upon the drawing. He professed to be annoyed in the extreme by her deception in hiding her own considerable artistic abilities, and he was worried that she would not pay him.

In his journal entry for February 21, Audubon reports acerbically on this encounter with the fascinating lady: "I Met this morning with one of those slight discouraging Incidents connected with the life of artists; I had a Likeness Spoken of in very rude terms by the fair Lady it was Made for, and perhaps will Loose My time and the reward expected for My labour,—Mrs. *André* I here mention the Name as I may Speak More of the Likeness as the occasion will require—"

The next day he reported to Lucy that he had accepted in payment from Madame André a "gift" of a $125 gun, with these words engraved on it in French: "Ne refuse pas ce don d'une amie qui est reconnaissante, puisse t'il t'egaler en bonte." ("Do not refuse this gift from a grateful friend. May it equal you in goodness.") To the gunstock he added the most fanciful version of his name: "Property of LaForest Audubon, February 22, 1821."[7]

The story involving Madame André could well be apocryphal, a cover-up for spending funds Lucy needed on a fancy gun for himself. Or Audubon may have embroidered an actual event for effect, as a way to shake Lucy up, make her think of him more as a man and a lover, less as a delinquent husband and provider. Women found him attractive; she knew that but, perhaps, needed to be reminded. He reported to Lucy that a "delightful kiss" was all that transpired between him and the mysterious woman. His wife could choose to believe him or not. Sending such an overtly naïve letter at that moment was a calculated risk. In any case he had his wonderful new gun.

During March, he did a number of portraits. No longer penniless but still poor, he convinced himself that old acquaintances from Henderson or Louisville, met by chance on the streets of New Or-

leans, were avoiding him. When William Croghan from Louisville recognized him and greeted him warmly, Audubon was almost overwhelmed with gratitude. Roman Pamar had gathered the artist into his own family, out of friendship and a real admiration of Audubon's talent. By now, he had drawn portraits of all the Pamar children and had become especially fond of the family; he felt less lonely when he was with them.

Life in New Orleans was becoming more pleasant. Birds abounded in the woods around this Deep South wintering place. Audubon was able to study the swallows at close range, and with glee concluded that the idea that they could hibernate in the mud all winter long was absolute nonsense. ("This Morning the Market was well Stocked with Green Backed Swallows *Hiroundo Veridis,* the Whole very fat and in beautiful plumage; if these Dear Litle Cherubs have preferred their coats and these flesh so fresh during the pretended Torpor Occasioned by Winter'[s] frost how much more fortunate they are than the Pork Beef & Butter of Kentucky that souers however well Salted.") He had solved the riddle of the swallow's hibernation to his own satisfaction.

He watched, and recorded, the slaughter of quantities of golden plovers. "I took a walk with my Gun this afternoon to see the Passage of Millions of *Golden Plovers* Coming from the North Est and going Nearly South—the distruction of these innocent fugitives from a Winter Storm above us was really astonishing—the Sportsmen are here more numerous and at the same time more expert at shooting on the Wing than any where in the U. States." He estimated that as many as four hundred hunters were out that day, and that each man killed about thirty dozen birds, bringing the total destroyed to 144,000. The next day, the market brimmed with golden plovers.

On March 6 Lucy's father died at Fatland Ford. The pain she felt radiates from a letter to her cousin in England: "A week or two ago we heard of the Death of my dear afflicted Father, his departure from this scene of trouble can hardly be regretted, when his infirmities are considered, particularly as he has not left his room or been sensible of any external object scarcely for the last twelvemonth, not even the knowl-

edge of Sister Ann who has been with him all the time."[8] Since Sarah had come to live with Tom and his wife in Louisville, all the Bakewell children, except Ann, were together. Billy worked in the Berthouds' countinghouse and lived with Eliza, as did Lucy. Ann had stayed behind to help nurse their father.

After William Bakewell's death, Tom wrote to his stepmother, saying that he would forgo any claim to his father's estate until the debts by the "late firm of Audubon and Bakewell" should be discharged. And he added: "I doubt not but Lucy will also relinquish all pretensions to any claim on the estate." He was prospering at the moment; Lucy was not, and for him to speak for her seems both cruel and self-serving. Tom ended disingenuously: "My individual loss by Mr. Audubon *exclusive* of the debt due to my Father is about $14,000—so that you see I have had my full share of bad luck in worldly matters."[9] Lucy might have taken him to task for those words; the mill had been Tom's idea, and he had not lost nearly as much as the Audubons had in the fiasco, nor had he suffered as much.

"The various losses and misfortunes of my husband's affairs you have probably heard of," Lucy wrote Cousin Euphemia, who kept in close touch with others in the family. She tried to defend her husband, explaining that he had supported them "by his talent in drawing and painting which he learnt from David as a recreation in better times." At that very moment, she added, he was in New Orleans on a tour in search of birds "and it will be a year before he returns." Melancholy overwhelmed her. She hoped her two dear daughters were with their grandmother "in happier regions." Plaintively, she added that not receiving a reply to her letters to Euphemia was a source of grief to her "for with my years increases my attachment to old friends and the early scenes of my youth."[10]

Yet she did not write regularly to the one person who desperately needed to hear from her. As long as he had news of Lucy and the boys, Audubon could function, but when weeks went by without word he would begin to despair: "Extremely uneasy about My Wife's health or her Children," he wrote in his journal, "done Nothing." Lucy wrote

less frequently in part because she was in mourning; the loss of her father, after all of her other misfortunes, had shaken her. But she was also affected by her family's growing disdain for her husband. Anger mixed with disappointment; the woman who had been mistress of Fatland Ford, who had welcomed her brothers and sisters to her prosperous frontier home in Henderson, was now the poor relation, and it rankled. Eliza was busy with her children, Mary, James, and William. Tom and Elizabeth had three as well: William, Benjamin, and Elizabeth. Lucy could confide in only one member of the growing clan: Billy, who never lost faith in his brother-in-law.

Friday, March 16, 1821, proved to be a fine day for John Audubon; he received word from the newspaper *Mississippi Republic* in Natchez that his portfolio was waiting for him. Tony Bodley, one of the men who manned the sweeps on Aumack's boat, had seen the advertisement, and had discovered the lost portfolio in a saloon in Natchez. Alexander Gordon wrote at once to a friend in Natchez to forward it immediately, at his expense. "The Politeness of that Gentleman is remarkable to a Man who is no more than a Stranger to him, but No doubt it would be impossible for a Good heart to act otherwise—" Audubon wrote, his gratitude spilling over into the pages of the journal. (Within three years, Gordon became Audubon's brother-in-law, marrying Ann Bakewell at Fatland Ford. And in time Audubon would discover that it was possible "for a Good heart to act otherwise.")

Even while Audubon fretted over the well-being of Lucy and the boys, he was becoming more and more aware of the demands on anyone who would publish a definitive survey of the birds of America. The more he worked, the better he became at art and ornithology, the more there was to accomplish. He was stirred by every mention of an expedition into new territory and tantalized by the prospect of becoming attached to it as a naturalist. He had not lost hope for the Red River expedition; a Pacific trek held tremendous excitement for an ornithologist. Spanish (or East) Florida, a haven for seabirds and shorebirds, was especially enticing, particularly once Spain ceded the peninsula to the United States and thus expanded the area within his purview.

On March 21, he wrote in his journal: "In reading the Papers this morning . . . I saw the Treaty between Spain and our Country, the 4th Article Speaking of an expedition . . . to leave Natchitoches during the Course of this Year; I imediatly went to Mr. Gordon to know from him What steps Would be necessary to procure an appointment as Draftsman for this so Long wished for Journey . . .

"to Join in Such an enterprise and to leave all I am attachd to, perhaps for ever, produced Many diferent sensations & thought, but all are Counterbalanced When persuaded as I am that My Labours are all for their use & benefit."

This was always to be his argument, his attempt to justify leaving Lucy and the boys on their own, the only answer he could think to give his disapproving family and friends. Perhaps he really had convinced himself that what he was doing was for his family's benefit, but whether he had or not, one thing is clear: The idea of being part of an official expedition to the Floridas, where he was certain to find new birds, thrilled him, and he was ready to go—just as he had been ready to take off on a Red River expedition a few weeks before.

He wrote to ask Nicholas Berthoud to write to people with influence, to help him get the appointment. Berthoud had been with him in Natchez and New Orleans and he had seen Audubon's resolve; a letter would cost him little to write. It did not occur to the artist that his brother-in-law, his old friend, would not help.

Meantime, he took Gordon's advice (not yet being related to Audubon by marriage, Gordon could afford to encourage him) and went to show his portfolio of bird drawings to the well-known portraitist John Vanderlyn, who was in New Orleans at the time. Audubon hoped to come away with a letter of recommendation for the Pacific expedition. Vanderlyn examined the drawings carefully and said they were handsome, but then told Audubon that he knew so little of ornithology and natural history that he didn't feel he was an adequate judge. Rather than a recommendation, Vanderlyn lamely offered, he could give Audubon a certificate saying he had inspected the drawings. Naturally, Audubon was offended. "Are all Men of Talents fools

and Rude purposely or Naturally?" he asked his journal that night.

While making forays to local government officials who might write letters for him, and (with Gordon's help) laboring over a letter to the president to request a place on one of the expeditions, he began to give lessons in drawing, first to Pamar's children, then to other students, including a fine-looking young woman named Mrs. Heerman. He bought fifteen yards of nankeen to have made into a summer suit, and began to spruce himself up to look less the wild outdoorsman and more the suave artist. His two personas were, as usual, in conflict.

By the end of April, Lucy had been silent for so long that Audubon was sick with worry and could not work. His anxiety over his family may have spilled into other areas of his life, because he seems suddenly to have offended a young acquaintance, who ceased speaking to him for reasons Audubon could not fathom, and to have begun a flirtation with pretty Mrs. Heerman, who was "well of figure and graced with acquirements." Audubon's irritability carried over to Alexander Gordon, who had ordered ten pounds of Italian chalk, six dozen black lead pencils, and two gross of pastels for Audubon, but had not advanced money to pay for them. Audubon was off balance.

The mail of Monday, May 21, brought word of the death of Joseph's father. The boy bore the news well, Audubon reported; but clearly the rooms on Barracks Street were filled with heartache. On the same day, Audubon had a letter from his wife—one that contained nothing he wanted to hear.

In Lucy's letter, the dam seemed to burst; urged by her husband to tell him her feelings, she did. The letter was full of bitter recrimination. She lectured Audubon on his duty to his sons and to her; she warned that she could not be expected to carry on alone while he seemed to want to take off on some expedition that would leave them stranded. She intimated that he should not expect a letter from Nicholas, who clearly did not wish to send his brother-in-law off on some wilderness expedition that would leave him even more responsible for the Audubon family than he already was. Once started, Lucy could not stop. Victor must be educated; Johnny was hard to handle and needed a father's firm hand. She herself was not well; she couldn't even find

pleasure in playing the piano anymore. She had lost weight. As the man of the family, she insisted, he must provide them with a better life. She could not make do without help, and she wanted him to find Celia, a slave owned in their Henderson days. As for Audubon himself, she wrote, she wanted him to return, but not if he was in need—that would be too humiliating. The Berthouds should not have to support him as well as his family. Her position was untenable; she had no one to blame but her husband. "Not Very agreable to My feelings, surprised at having Nothing from N. Berthoud—" Audubon wrote succinctly.

Three days after receiving Lucy's biting letter he wrote in his journal: "—thought to day that a Certain Gentleman to Whom I go to dayly felt *uncomfortable* While I was present, seldom before My coming to New Orleans did I think that I was Looked on so favorably by the *fair* sex as I have *Discovered* Lately—" If Lucy didn't love him, there were plenty of other women who would. Soon enough, the flirtation with Mrs. Heerman landed him in trouble with her husband, and Audubon lost about a hundred dollars in unpaid-for lessons.

Although Lucy's letter hurt him, he responded with a long and careful letter meant to reassure her. "We never will have children more. Our boys soon will be further in the world, for I am determined they shall be assured, as soon as possible, that the greatest blessing we can enjoy in Life is Independence. Then, my Lucy, we will travel by ourselves and try to keep clear of obligations . . . The kindnesses of the Family Berthoud are to be thanked for, but *somehow* I do not like this appearance of helping, like *Mendicants*. Believe me, Lucy, poverty can be better born when *quite free.*"

This was so for Audubon, perhaps, but Lucy had had a taste of abject poverty in Cincinnati and she did not want to subject the boys to it again. For the moment, she would choose dependency and security with the Berthouds in Shippingport over independence, insecurity, and loneliness in Cincinnati.

"I am very sorry that *thou* are so intent on my *not* returning to thee," Audubon wrote in response. ". . . Your great desire that I should stay away is, I must acknowledge, very unexpected . . . I cannot help

thinking Lucy would probably be better pleased should I never re-
turn—and so it may be." He had ended the letter there, but could not
bring himself to send it without a forgiving postscript: "My dearest
girl, I am sorry for the last part I wrote yesterday, but I then felt miser-
able. I hope thou wilt look upon it as a momentary incident. I love thee
so dearly, I feel it so powerfully, that I cannot bear anything from thee
that has the appearance of coolness."[11]

He told her he did not know where he would be come winter.
"Migratory birds or beasts follow the mast," he wrote, implying that he
intended to follow the birds. It was obvious, he wrote, that Nicholas
was loath to help him get an appointment with a survey expedition,
and he asked Lucy not to mention it again. Even without Berthoud's
help, he intimated, he might yet be invited on an expedition—to the
Red River, to the Pacific, or to Florida—but if that didn't happen and
he remained in New Orleans, he wanted Lucy and the boys to join
him. In short, he had many vague plans, but nothing definite. Lucy
could not have been reassured, especially when he added a postscript
that made his own preference perfectly clear: "I can scarce hope now to
go to the Pacific. My plans, my wishes, will forever be abortive. How-
ever, I now enclose what I have written for the President. You may send
it or not, as you may think best fit. But I assure you that I shall ever
remember Clark's *expedition. And feel my love for you.*"

Fate in the form of fifteen-year-old Eliza Pirrie stepped forward.
As Audubon confided to his journal, he had "one hundred Diferent
Plans," none of which had him going to Oakley Plantation near St.
Francisville, 125 miles northwest, where Eliza lived with her parents.
But: "I had attended a Miss Perrie to Enhance her Natural tallent for
Drawing, for some days When her Mother . . . asked Me to Think
about My spending the summer and fall at their farm Near Bayou
Sarah; I was glad of such an overture, but would have greatly prefered
her Living in the Floridas—" Still, it was a solid job offer which he
could not afford to ignore.

He asked for a hundred dollars a month plus room, board, and
laundry for Joseph and himself; in return he would devote half a day

to Eliza's lessons, having the rest of the time free to devote to his birds. He settled for sixty dollars a month to teach Miss Eliza "all I could in Drawing Music Dancing & On June 6, 1821, before the Pirries could change their minds, John Audubon and Joseph Mason boarded the steamboat *Columbus* for Bayou Sarah . . . and for another world.

Oakley Plantation was located at a place where the alluvial lowlands of the river valley gave way to highlands rich in plant and animal life. The large, rambling house was built in the style of the West Indies, with broad, covered galleries on the top floors whose shutters were designed to let the air flow through. Audubon and Joseph had a room on the second floor, situated near a stairway on the back porch so they could come and go without disturbing the rest of the household. The area, called Feliciana, it was as luxuriant in bird life as any Audubon had known; birdcalls filled the magnificent woods of oak and beech and poplar, of magnolia and holly and cypress. "Such entire change in so short a time appears often supernatural," Audubon wrote, "and surrounded once More by thousands of Warblers & Thrushes, I enjoyed Nature. My Eyes soon met hovering over us the Long Wished for Mississippi Kite and Swallow Tailed hawk." In the city Audubon had been starved of the mottled-green woodland paradise he craved; now, surrounded by subjects to draw, he was ravenous to get on with the work which, it now seemed, only he believed in.

Guests came and went at Oakley: Audubon met Henry Clay's brother and Governor Robertson, whom he knew from New Orleans. He also met Mr. William Brand, a wealthy man from New Orleans who had taken a young lady of the neighborhood, scarcely older than Eliza Pirrie, as his second wife.

The artist could discharge his duties to his students—for Joseph was still his student—and thus to his family, in the mornings, and have the luxury of spending the rest of the day (and often much of the night) at his own work. For the next several weeks, his journals are crammed with details of the birds he sees, shoots, captures, draws: "Mocking bird—Turdus poly[g]lottus[*] *The mockingbird's scientific name is now Mimus polyglottos polyglottos Extremely plenty—

Nestles in all sorts of situations having found Nest in the higher parts of Tall trees, in Small Bushes and even between fence rails garded only by the rail imediatly over the nest—the Egg represented by Willson very Litle Like any of the great Number I examined—these Birds Mock indiscriminately every Note of Birds—are very gentle With every thing but the Bird of Prey, these they give chase to and follow a great distance with much apparent Courage—here during Winter." He wrote about hummingbirds and buntings, about cardinals and finches, about woodpeckers and wrens and all the other birds that paused in these woods during their migrations along the great Mississippi Valley flyway. Audubon's chance meeting with Eliza Pirrie and her mother had the almost magical effect of placing him in perfect position to observe, to study, and to draw species that would one day make up about a quarter of *The Birds of America.*

The move was good for Joseph as well. He was progressing so rapidly that Audubon trusted him to do the backgrounds for many of his new drawings. When Lucy warned that Joseph might prove to be a permanent burden, he answered her, "As Long at Least as I travel I shall kepp him with me, I have a great pleasure in affording that good Young Man the means of becoming able to do well, his talent for painting if I am a Judge is fine—his expenses very moderate and his Company quite indispensable. We have heard of his Father's death and on that a/c I am more attached to him—he now *draws Flowers* better than any man probably in America, thou Knowest I do not flatter young artists much. I never said this to him, but I think so—" He penciled the boy's name, along with his own, on the bottom of pictures that included Joseph's plants and flowers. For the first time in their trip south, the two were producing pictures at breakneck speed in an atmosphere conducive to good work.

At times Audubon was out much of the night in pursuit of a bird, or he might rise before dawn to spend the early-morning hours in the woods. Once, he purposely nicked the wing of a little flycatcher so he could pick it up and take it home. He writes, "I seldom have seen a bird of Such Small size With so Large & beautifull an Eye. I . . . had

the pleasure of drawing it While a live and full of Spirit, it often Made off from My fingers by starting Suddenly and unexpectedly, and then would hop round the room as quick as a Carolina or winter Wren would have done, uttering its tweet tweet tweet all the while, and snapping every time I took it up."

He was at Oakley for seven weeks before his journal mentioned his pupil or the other people of the plantation. On August 25 he reported that he drew a five-foot-seven-inch rattlesnake that weighed six and a quarter pounds and had ten rattles. "My Drawing I Hope Will give you a good Idea of a Rattle Snake although the Heat of the weather Would not permit me to spend More than 16 hours at it—" He then adds: "My amiable Pupil Miss Eliza Perrie also drew the same Snake; it is With Much pleasure that I now Mention her Name expecting to remember often her sweet disposition and the Happy Days spent near her—"

There are no journal entries for the entire month of September.

On October 10 there is a cryptic "sent 100$ to Mrs. A—"

Then, on October 20, 1821: "This Morning about 6 o'clock We Left Mr. Perrie's Plantation for New Orleans, Which Place we Reachd on Monday the 21st at 2 o'clock but before I alight in that City, I Must Poise Myself and give you a short a/c of the Most Remarkable Incident that have taken Place With us during our Stay At Oakley."

His account of the two months between August 20 and October 20 is disjointed; filled with recriminations, accusations, and self-justifications, it attempts to explain the reasons for his abrupt departure. "Three Months out of the 4 we lived there Were Spent in peaceable tranquility; giving regular Daily Lessons to Miss P. of Drawing, Music, Dancing, Arithmetick, and Some trifling acquirements such as Working Hair Sec Hunting and Drawing My cherished birds of America; Seldom troublesome of Disposition, and not Caring for or Scarcely ever partaking or Mixing with the constant Transient Visitors at the House."

Eliza Pirrie, whom Audubon had expected to "remember often her sweet disposition and the Happy Days spent near her—" was now described differently in retrospect: "Miss P. had No Particular admirers

of her beauties but several very anxious for her fortune." Audubon added spitefully that while the girl was of "a good form of *body*, not Handsome of face, proud of her Wealth and of herself cannot well be too Much fed on Praise." His treatment of Eliza's mother, Lucy Gray Pirrie, was a little better: "Raised to opulence by Dint of Industry an Extraordinary Woman—Generous I believe but giving Way for Want of understanding at times to the Whole force of her Violent Passions— found of quizing her husband and Idolatring her Daughter Eliza."

Lucy Pirrie's first husband, Ruffin Gray, had been a prosperous planter; he left her Oakley. Her second husband, the Scot James Pirrie, Eliza's father, was "a Man of Strong Mind but extremely Weak of Habit and degenerating sometimes into a State of Intoxication, remarkable in its Kind, Never associating With any body on such occasions and Exhibiting all the madman's Actions With under its Paroxism—When Sober; truly a good Man a *Free Mason,* generous and Entertaining."

The family emerges: James Pirrie, liked by all when sober, but dreaded when drunk. His wife, the mistress of Oakley, a strong and energetic woman, who through two marriages produced seven children, only two of whom survived: a married daughter, Mary Ann Gray Smith, who lived with her husband, Jedediah, on a nearby plantation, and Eliza. Having lost five children (her much-loved son Ruffin quite recently) to the fevers that swept the Louisiana swamps, Mrs. Pirrie was understandably concerned about her younger daughter's health.

When Eliza fell seriously ill, Dr. Ira Smith was called at once. Audubon understood the mother's fears, but argued that Eliza was coddled and kept in bed long after she should have been up and about and—though he does not say this outright—continuing her studies so he could collect the fees essential to his family's survival. The doctor ordered that the lessons should be halted for several months. (Audubon assumed that the doctor had romantic designs on the girl, and was jealous of the time the artist spent with her. He may not have been far from the mark; the doctor *was* looking for a wife, Eliza was a prime candidate, and men were generally suspicious of the Frenchman's affectionate ways. Within a few years, the doctor became the second hus-

band of Eliza's half sister, Mary Ann.)[12] When Eliza rallied her mother relented, and allowed Audubon to see his pupil at appointed hours, "as if I was an Extraordinary ambassador to some Distant Court—" Then the girl had a relapse; on October 10, Mrs. Pirrie dismissed Audubon.

He was beside himself; his time at Oakley had produced drawings of birds he knew to be superior to those he had done before, and there was so much more to do. He asked Mrs. Pirrie to allow him and Joseph to stay on as visitors for eight or ten days, so they could finish their work. She agreed. Audubon and Joseph worked feverishly, "Writting every day from Morning untill Night, Correcting, arranging from My Scattered Notes All My Ideas and posted up partially all My Land Birds—the great many Errors I found in the Work of Willson astonished Me I tried to speak of them With Care and as seldom as Possible; Knowing the good Wish of that Man and the Hurry he was in and the Vast Many hear say he depended on." A plea fairly lifts off the page: Let me continue, don't make me stop now.

Not surprisingly, a coolness emanated from the ladies of the house. Mary Ann Smith took a particular dislike to Audubon, and he was sensitive to her disparaging looks. But the real trouble erupted when Audubon presented his bill. He charged for ten days of the time when Eliza was ill, and Mrs. Pirrie, offended, "in a perfect Rage fit told me that I Cheated her out of 20$."

Audubon let her rave, but stood firm. "My Coolness sufered all her vociferations to flow, I simply told her our former mutual Engagements on that score." He tallied up, to the penny, the costs of the art supplies, added his time, and presented the whole bill to Mr. Pirrie, who, unfortunately, was drunk. It came to $204.[13]

Audubon reports that James Pirrie apologized for his wife's behavior and promised to pay the bill in full. Both he and his son-in-law, Jedediah Smith, seem to have been sympathetic to the artist. Even so, the last day at Oakley was awkward. The women were scarcely speaking to Audubon, but they were kindness itself to Joseph, which clearly annoyed his mentor. Mrs. Pirrie sent for the boy and offered him a "full suit of fine clothes" that had belonged to her son Ruffin. Audu-

bon, employing his woodsman persona, had allowed his hair to grow long and his clothes to fray. If Joseph, who was as tattered as Audubon, was pleased with the unexpected gift, his pleasure was short-lived. Audubon adamantly said he could not accept the clothes, haughtily announcing: "I positively refused to acquiese, Knowing too Well how far some gifts are talked of—and Not willing that My Companion should diminish the Self Respect I think Necessary for every Man to Keep towards himself however poor, when able by *Talents*, Health and Industry to Procure his own Necessities." Thus Joseph's new suit was sacrified to Audubon's injured pride.

The two took their leave of the ladies after dinner that evening, the usually affable Audubon stiffly bowing to each and exiting, followed by Joseph who, wrote a smarting Audubon, "received a volley of farewells from the 3 Ladies of the house put after him Ridiculously to Affect Me, but the Effect Was lost and it Raised a Smile on My Lips."

They left Oakley at daylight the next day, "without a single Sigh of regret—" Audubon wrote. And, plaintively: "Not so with the sweet Woods around us, to leave them was painfull, for in them We allways enjoyed Peace and the sweetest pleasures of admiring the greatness of the Creator in all his unrivalled Works. I often felt as if anxious to retain the fill of My lungs with the purer air that Circulate through them. Looked With pleasure and sorrow on the few Virgin blooming Magnolias—the 3 Colored Vines and as We descended the Hills of St. Francisville bid that farewell of the Country, that under diferent Circumstances We Would have Willingly divided With the ladies of Oakley."

Audubon's hints concerning the doctor's jealousy leave the impression that Audubon himself had carried on a flirtation with the girl. He *was* a flirt: He gave freely of his kisses and reveled in female company, peppering instructions to his pupils with "my darling" and "sweet girl." But it is unlikely that he was anything more than his usual charming self with Eliza, or that she responded to him. For one thing, against her mother's wishes she had already set her cap for her cousin Robert Barrow, with whom she was to elope within a year. For another thing, Audubon was preoccupied with his own work and wanting to

keep the peace, so, to keep the girl and her mother mollified, he had gone so far as to do much of Eliza's work himself, letting Eliza take the credit. Piqued, he wrote: "God Knows how hard I tryed to Please her in Vain—and God Knows also that I have vowed Never to try as much again for any Pupil of Mine—as usual *I* had to do 2/3 of all *her* Work of Course her progresses Were Rapid to the Eyes of every body and truly astonishing to the eyes of some good observers."[14]

Of the day he caught the rattlesnake he reported spending sixteen hours drawing it in the extreme heat, until the stench was unbearable. He did not want to stop drawing in order to give Eliza a lesson, so he assigned her to draw the snake as well. What Eliza or her mother thought of this time-saving tactic is never mentioned, but it seems likely that neither would think well of spending several hours drawing the putrid carcass of a snake. There was no one to tell them that one day Audubon's picture of this very snake, coiled in a tree and about to strike some mockingbirds, would cause a small sensation.

Whether or not Mrs. Pirrie quarreled with Audubon about the quality of the lessons he gave her daughter (there is evidence that she did not like one of his sketches), she certainly took issue with him over money. Even so, when Audubon asked permission to stay on to finish his own work she was generous enough to agree—as she would not have been likely to do if she thought a married thirty-six-year-old artist had been romancing her precious fifteen-year-old daughter.

Audubon's accusing and at times spiteful account of the brouhaha masks his own disappointment. The months at Oakley had been a period of marvelous productivity; he felt that he was progressing rapidly, and with steady money coming in, Lucy was no longer writing him contentious letters. He hated going back to New Orleans to start over again. Having no choice, he directed Mr. Pirrie to send Lucy a draft for a hundred dollars, and with the rest of the money in hand he boarded the steamboat *Ramaso* at Bayou Sarah and headed downriver.

9

I have Now 42 Dollars, health,
and as much anxiety to pursue My Plans of
Accomplishing My collection as Ever I had
and Hope God Will Grant Me the same
Powers to proceed.[1]

IT WAS RAINING WHEN THEY arrived in New Orleans, and Audubon was depressed. The momentum he had gathered at Oakley had been interrupted; now his time must be spent finding work. At Oakley he had reverted to the woodsman, pulling his long hair back and catching it with a buckle; he was wearing a loose yellow nankeen outfit that had been bleached white in the sun and had seen better days.

His first stop was at the Pamars'. "Reception of Mr. Pamar's familly was very gratefull to My Spirits," he wrote in his journal. "I Was Looked upon as of a Son returned from a Long Painfull Voyage, the Children, the Parents the servants all hung about Me; What Pleasures for the Whole of us—" His spirits raised, he went off to the barber and tailor to do what he knew he must do if he expected to get any students.

"Dressed all new, Hair Cut, my appearance altered beyond My expectations . . . ," he groaned. "Such my situation this day—Good

God that 40 Dollars should thus be *enough* to Make a *Gentleman*—"

Having shed the woodsman, he began an earnest search for new students, contacted the best-known hunters in the city and arranged to pay them a dollar for each of the birds that he wanted, and once more began haunting the markets in search of good specimens.

He was determined on another score: He intended to have his family with him. Within three days of his return he had rented a place on Dauphine Street, "a Suitable House for My Litle Familly," for seventeen dollars a month. He wrote for Lucy and the boys to come at once. It had been a full year since he left. As Lucy had ordered, he had not returned to Shippingport "in want," but had been providing money regularly, so he could see no reason for her to hesitate.

The work done at Oakley strengthened his resolve; four months in a congenial atmosphere had sent him hurtling toward his goal. Through publication of his work he would regain what he had lost in the world: a position of respect. The first half of his life had been spent struggling for success on the world's terms; now he intended to follow his own instincts, to do what would make him a different kind of success. He believed that with Lucy's help he could do it. Her family worried that John Audubon would abandon his wife and children; his own worst fear was that they might abandon him.

October passed with no word from Lucy. Audubon discovered that James Pirrie had not paid the hundred dollars that was to be sent to her, and set about correcting the matter. He tallied up his progress since leaving Cincinnati the year before and was pleased with himself: "I have finished 62 Drawings of *Birds & Plants,* 3 quadrupeds, 2 Snakes, 50 Portraits of all sorts." The portraits had been a source of ready cash, and he did not even keep track of them; the sixty-two drawings were the real treasure.

He attempted to find work teaching in the local schools, without success. He kept busy writing his usual round of letters—including one to Rozier, asking him to return a drawing of a prairie hen that had been left with him—and he paid visits to anyone who might be able to help him find work. He called on William and Anne Brand, whom he

had met at Oakley; Anne Brand had been Anne Browder, a friend of Eliza Pirrie. In his journal, Audubon invariably addressed them as the Rich Mr. or the Rich Mrs. Brand. They received Audubon in a kindly way; William hired him to teach his son by his first wife. Anne, who had scant education, soon joined in the French and drawing lessons, bringing Audubon's total wage to three dollars an hour. The Pamar girls continued their lessons, but Audubon was having difficulty finding enough new students to cover expenses. He showed his pictures to a group of young women gathered at the home of the John Clays, expecting a few to sign up for lessons, but none did.

The search for work occupied most of his time, but on one warm day at the close of October he was pleasantly distracted by the swallows that, he noted, were "Plenty and quite as gay in their flight as in June—" He continued, exulting: "to find here those Birds in aboundance 3 Months after they have left the Middle States, and to Know that they Winter Within 40 Miles in Multitudes is one of the Gratifications the most Exquisite I ever Wishd to feel in Ornithological Subjects and that Puts compleat *Dash* over *all* the Nonsense Wrote about their Torpidity during Cold Weather; No Man could ever have enjoyed the Study of Nature in her all Femine Bosomy Wild and errd so Wide—"

On November 3 he ran into John Gwathwey, the proprietor of the Indian Queen, where he and Lucy had first stayed in Kentucky, and learned that his mother-in-law had died in Louisville while visiting Tom Bakewell. Audubon was not sorrowful. He called her his *"Constant* Enemy" before remembering to ask God to forgive her faults. (If Lucy expected anything from her father's estate, she was disappointed. Rebecca left everything to two nephews and to Lucy's sisters, Ann and Sarah. Soon, Ann married Alexander Gordon, and Sarah would eventually wed Theodore Anderson of Baltimore.)

Indian summer set in and Audubon continued his rounds; now and then his journal notes some slight he felt, some "Mortification" when he showed his bird pictures to a less than enthusiastic audience. Early in November the weather turned "Cloudy & Raw," and Audubon's temper turned to match. He had not heard from Lucy, even

though he finally managed through Alexander Gordon to send her the money. On Friday, November 9, 1821, he wrote: "My feelings Much harrassed about My Beloved Wife from Whom I have Not heard for 2 Weeks." On November 10: "No News from My Beloved Lucy nor Children, Very uneasy on their Silence." On November 11: "Saw John Gwathway early this Morning, who told me that My Wife Intended Leaving Louisville about the first Instant in a Small Steam Boat for this Place—and this News Kept me Nearly Wild all day. Yet No Boat arrived No Wife No Friend yet near— . . . The Nearer the Moment that I Expect to see My Beloved Lucy Approaches the greater My Impatience, my disapointment Dayly When evening draws on." November 12: "No News from My Wife yet." On November 14 he at last received a letter from Lucy "Which Lower My Spirits very Considerably—alas w[h]ere does Comfort Keep herself now; retired certainly on a Desolate rock unwilling to Cast even a Look on our Wretched Species."[2]

Lucy wasn't coming just yet—he now had "Little Expectations of seing My familly before the Latter Part of Winter"—and, as if that weren't bad enough, a former agent of Audubon & Bakewell turned up to present him with a ten-year-old bill. Audubon "spoke to him on that subject in Terms that astonished him."

The next morning he gave lessons at the Brands, went back to Dauphine Street to spend the rest of the day completing three bird drawings, and continued working by candlelight to finish copying a head of Ariadne by Vanderlyn, hackwork taken purely for the forty dollars it would earn him. "Weather fair but Cool," he wrote. "Very Low of Spirits Wished Myself off this Miserable Stage."

But his spirits revived somewhat when the hunters began to return with fine specimens for him to draw, and despite his depression, he continued working. "Much Talk With My good Hunter Gilbert Who Procured Me a Superb Specimen of the *Great Sand Hill Crane*—"

One warm, rainy day in late November he was shocked to receive the hundred-dollar check that was to have gone to Lucy; the House of Gordon had neglected to pay it.[3] It cost Audubon ten percent to have a check drawn on the U.S. Bank of Philadelphia, which he sent to Lucy

with a message to come quickly. Once again the weather turned windy and raw.

He continued teaching and painting and worrying, taking time out to do a likeness of Joseph as a way of thanking the boy for his patience and companionship. Audubon was fully aware that the past year had been no easier on Joseph than it had on him. Audubon's was a rough school; still, he had never neglected his protégé (once he traded a portrait for new boots for them both) and he was proud of the boy's progress.

On the first of December, Audubon received a letter from Lucy saying she was on her way; his relief was palpable. He started meeting every boat from Louisville, and was disappointed every time. To occupy himself, he traded drawing lessons for violin lessons. (Lucy was coming and they could have their musical evenings again.) Eliza Pirrie of Oakley passed him on the street without speaking; immediately assuming that the slight was intentional, he was livid, ranting to his journal that she "did not remember how beautifull I had rendered her face once by Painting it at her Request with Pastelles . . . but thanks to My humble talents I can run the gantlet throu this World without her help." A few days later he ran into her at the Brands', where she was perfectly friendly and said she would be happy to see him again. He was surprised and pleased, his anger of a few days before forgotten.

Finally, on December 15, he had word that his family would arrive in four or five days; he could breathe again. On Tuesday morning, the eighteenth, he gave a lesson to Miss Pamar and one to Mrs. Brand, then at noon went off to the docks to meet the steamboat *Rocket*. And there they were: Lucy standing at the rail, smiling; his two good Kentucky lads beside her, waving furiously. Victor was twelve, Johnny nine. After fourteen long months, they were together again; he was beside himself with joy as he scooped them up and hurried them off through the bustle of the docks to the Pamars' for a dinner, before showing them to their new home on Dauphine Street.

It was a sweet reunion; after all the catching-up, John and Lucy went through all of the pictures he had produced so far, many of which

Lucy had brought with her. Carefully, one by one, they turned over the large sheets of paper on which he had created life-size images of the birds. When they had finished, Audubon sighed. One thing was painfully obvious: His most recent pictures were in every way superior. He was going to have to do the earlier drawings over. With Lucy at his side, the additional labor did not seem insurmountable.

The weather took a sharp, cold turn. Ice formed on the water buckets and, miraculously, snow fell for Christmas. Ferdinand Rozier, now a prosperous merchant in Ste. Genevieve, turned up and was welcomed as an old friend. Lucy had encouraged the dissolution of their partnership, but she had to admit that, had Audubon stayed with Rozier as his father had wished, the family would probably have been in much better economic condition.

Lucy felt her own family to be superior to Rozier; now, no matter whose fault it was, the Audubon family was living in a small, cramped house in New Orleans without enough money to cover their most basic expenses. A canceled lesson put them at risk; their cupboard was almost always bare. Fewer and fewer people seemed to want to pay twenty-five dollars for a portrait; once more, the Audubons were living a hand-to-mouth existence, and resentment was building inside of Lucy. After much hesitation, she had left the relative security of Shippingport, believing her husband when he said he could support them. She had made a mistake, and she let him know it.

From the beginning of their acquaintance, Audubon had talked to William Brand about his exemplary, educated English wife. He knew how determined Brand was to give his son and his adored, unlettered young wife an education. Now he took Lucy to meet them. It was quickly settled that she would serve as governess to the boy and as a teacher and companion to Anne, who was by now expecting a baby. This would provide the Audubons with a steady income, though they would have to spend twelve dollars of it to send Victor and Johnny off to one of the local academies, since Lucy could no longer serve as their teacher. Suddenly the routine at the house on Dauphine Street was altered: Lucy was off early each morning to the Brands', and Victor and

Johnny made their way to their academy, leaving Audubon and Joseph
to attend to their art.

On the last day of 1821, Audubon made the boasting resolution
that he would paint ninety-nine bird pictures in the next ninety-nine
days. It was a hollow boast; he could scarcely afford a dollar to buy a
new journal for the coming year. Lucy was angry with him. It was Cin-
cinnati all over again; Audubon might prefer being free and poor, but
from Lucy's point of view she and the boys would be better off being
obliged to the Berthouds, but secure.

Summer was considered the "sick season" in the South; deadly
fevers swept through port cities. As spring approached, many of those
who could afford portraits and lessons would be moving to their coun-
try homes. Audubon decided to return to Natchez in Mississippi,
about sixty miles upriver from St. Francisville and Oakley, where both
the bird life and the opportunities for work would be better. The com-
munities growing along the Mississippi were frontier towns, very like
Henderson. The lucrative sugar and cotton plantations were produc-
ing a crop of landed rich as well. These families wanted their children
educated, so new academies were being opened. Audubon arrived in
Natchez with letters of introduction from friends. He hoped to find a
position in one of these academies and then send for his family.

Lucy and the boys stayed behind, moving in with the Brands. At
Shippingport she had been "poor Lucy" to her relatives, but an equal
nonetheless. In New Orleans she was something else, a gentlewoman-
for-hire, part friend, part servant, living in somebody else's home. She
had assumed the kind of position she would hold for the next eight years.

Audubon and Joseph left New Orleans as they had arrived more
than a year before: with only talent and their art supplies to support
them. Audubon found a steamboat captain who would give them
passage to Natchez in exchange for portraits of himself and his wife.
The artist had packed his drawings and supplies in a chest, along with
some bottles of gunpowder. Sometime during the journey he opened
the chest to discover that the gunpowder bottle had broken, spilling
over his drawings. Several were damaged beyond repair and would have

to be done over. Once again he was separated from his family, and once again fate had delivered him a sharp slap.

But it was springtime; the dogwood was in bloom, the woods were newly green, and the air was sweet. Audubon wasted no time establishing himself with the local gentry. Two important men befriended him: Dr. William Provan and Benjamin Wailes. Both were interested in promoting the intellectual life of the area, and the twenty-five-year-old Wailes was a budding naturalist. His father, Levin Wailes, helped Audubon get a position at the Elizabeth Female Academy, some three miles outside Natchez. Audubon took an ad in the local paper "to inform the Ladies and Gentlemen of Natchez and its vicinity, that with the intention of making this City his permanent residence, he will open a school for Drawing (at Mr. Davis' Seminary) in Chalks, and Painting in Water Colours, in all the various styles most fashionable in Europe and our Eastern Cities . . . [and] will also give lessons of vocal Music." Almost immediately he had enough students to make his days a race between the Elizabeth Female Academy and the rooms in which he taught at Mr. Davis's seminary. He was working full-time, and soon had a steady enough income to write for Lucy to send the boys; he had arranged a place for them at Brevost Academy in Natchez.

Lucy felt obligated to stay with Mrs. Brand until the young woman's baby was born, but the boys went to Natchez; Audubon was holding his own, so Lucy trusted him with them. In whatever free time he had, he crossed to the Louisiana side of the river, where he was welcomed at the Wailes plantation. Here Benjamin Wailes and his brother, Edmund, explored the woods with Audubon, he sparking their interest in the fauna. In April, while on a visit to the Wailes plantation, he drew his orchard oriole and a tyrant flycatcher (kingbird). Benjamin climbed a honey locust in the plantation yard to get the oriole's nest for Audubon.[4] The Wailes family supported Audubon in other ways; while at their plantation, he did charcoal drawings of Levin Wailes, his wife, and both sons. Once more Audubon found himself in the untenable position of being admired for his talents and abilities, and at the same time pitied for his poverty.

It was Dr. Provan who proved the most selfless friend to the Audubons. When John became ill and could not teach for a time, Provan cared for him and paid the boys' tuition. After Audubon's recovery, the doctor found him a position teaching in Natchez, so he did not have to make the grueling seven-mile walk to the Elizabeth Female Academy.

Now he had steady work, but no time at all for his birds. He wrote in his journal: "While work flowed upon me, the hope of completing my book upon the birds of America became less clear; and full of despair, I feared my hopes of becoming known to Europe as a naturalist were destined to be blasted." [5]

Late that summer, Joseph decided to go home to Cincinnati. He was fifteen now; he had traveled with Audubon for two years, had shared his hardships, had at times gone hungry. But he had also learned enough to set his course in life. Within two years he would have a steady job as an artist at William Bartram's botanical gardens near Philadelphia, the city that was then the center of American culture.

Audubon sent Joseph off with a gun and some art supplies; he was sorry to see him go, not only because he was fond of the boy, but because now he would have to provide his own backgrounds. He could draw plants perfectly well; the problem was finding the time, especially now, when he felt the need to learn to work in oils. Painting in oils, he believed, was more demanding than working with chalks and watercolors, and he knew that oil portraits and paintings would bring a better price. When John Stein, a portrait painter from Pennsylvania, appeared in town, Audubon convinced him to give him his first lessons in oils.

The Brand baby was born that summer and died soon after. Lucy stayed on for a few months to nurse young Anne Brand, who had been desperately ill; it was fall before she joined her family in Natchez. Now Audubon's newspaper ads also offered the services of a woman capable of teaching "manners, Literature, needlework, and embroidery." [6]

Lucy was offered a position in a local clergyman's household, but within a few weeks it became clear that the parson was unable to pay her. It was during this interlude that an educated, and evidently sophisticated, British naturalist named Leacock[7] passed through Natchez.

He was impressed by the bird portfolio and suggested that the pictures might well be published in Britain. The man was conservative; he advised Audubon to improve his skill with oils, which had higher prestige and could support him better than the pastels, and told him to count on at least four or five years abroad to establish himself. Lucy was energized by this appraisal; it revived her own badly shaken faith in her husband's prospects, and she was able to urge him on again.

Within a month of her arrival, Lucy was looking for new work, and once more Dr. Provan stepped in to help. He was courting one of the daughters of Jane Percy, a considerable widow who owned a plantation named Beech Woods on Bayou Sarah, close to St. Francisville and Oakley, some sixty miles south of Natchez, in Louisiana.

Beech Woods was 2,200 acres of woodland with a "big house" that was actually two roomy cabins connected by a dogtrot.[8] In 1819, when Robert Percy died, the house, slave quarters, outbuilding, and land were worth $20,000; the fifty slaves were valued at $14,580 and the livestock at $2,300. Jane Percy took over the running of the plantation when her husband died, leaving her with four children—Margaret, Sarah, Christine, and Robert. The mistress of Beech Woods was a sharp, outspoken woman, not known for gentleness or tact.[9] She knew what she wanted and usually got it. Right now she wanted a school on her property, for her own and any of the neighbors' children who wanted to come; the students were to learn reading, writing, arithmetic, music, and social decorum. Mrs. Percy would provide a combined schoolhouse and cabin for the teacher, along with $1,000 a year, and Lucy could keep the fees paid by the neighbor youngsters.

Lucy had no trouble at all deciding to accept Jane Percy's offer; she was thirty-five years old and, as much as she loved her husband, what she longed for was a secure livelihood for herself and the boys. Blustery Jane Percy was offering her just that, a house of her own and a life of her own. Though he may have felt a stab of regret at yet another separation, John Audubon was relieved. In the two years since he had left Cincinnati, the harshest lesson he had learned was that he could not support his family and complete his work. If Lucy could take care

of herself and the boys, he would be free to give his full attention to the birds.

Stein and Audubon decided to join forces, get a buggy, and make a tour of the plantation houses all along the river. Each artist could offer his own variety of portraits; Audubon could continue to study with Stein and search the woods along the way for birds. Victor would go with them to begin his apprenticeship. Audubon was determined that both of his boys should become proficient at drawing, and this would be a good time for him to supervise the elder.

But before many weeks had passed, Audubon and Victor were back. Perhaps Audubon and Stein had quarreled; more likely, they could not find enough commissions to keep them going. The experience had not been a total loss; Audubon had learned something about painting in oils, and Stein had helped him copy his drawing of an otter caught in a trap, a picture he was to paint and repaint in oils for quick cash in the years to come. Whatever the reason for the partnership's dissolution, the boy and his father appeared at Lucy's cabin at Beech Woods and were taken in.

At first Jane Percy did not mind; the man was, after all, an accomplished artist. Her own brother was coming from England in a few weeks to draw the flowers of the region. She offered Audubon a part-time job teaching music and drawing, so he was in the enviable position of having responsibilities for only part of the day, being free to pursue his birds for the rest of the time, and having his family with him.

Jane Percy was a contentious woman, and Audubon's impulsive personality made a clash inevitable. As part of their agreement, Audubon was to do portraits of her daughters. Mrs. Percy objected to the slight yellow "jaundice" Audubon had given the girls' complexions and asked that he lighten the skin tones. Audubon refused, insisting that he had painted the girls exactly as they were and that he would not be coerced into making changes. Lucy listened but did not take sides. Her position depended upon Jane Percy; the husband who could not support her would not even make her life easier by acceding to a stubborn woman's whim. She refused to back him in the argument.

Audubon, full of righteous indignation, would not budge. Jane Percy stormed at him; when he stormed back, she ordered him off her property and out of her sight. Furious, he left at once. A few evenings later, when he had cooled down, he slipped into Lucy's cabin to make amends. He felt that out of loyalty Lucy should have left with him, but they talked and he regretted the trouble his outburst had caused with her overbearing patron. Then he took his wife to bed, where he could hold her in his arms and reestablish their intimacy. They did not know that one of Jane Percy's slaves had hurried to his mistress to report Audubon's return. Jane Percy marched into the cabin, stood by the Audubons' bed, and ordered John Audubon to be gone, at once.

That night, seething, he walked all the way to Bayou Sarah, fueled by his fury. The following day he sent for Victor, and the two left for Natchez. For a few months Audubon floundered, continuing his experiments in oils, staying at various friends' plantations where he could hunt and paint. That Dr. William Provan, who was engaged to one of the Percy girls, continued to be his devoted friend speaks volumes about the personality of Jane Percy. Audubon's company was in demand: He was energetic and talented and thoroughly charming, attributes in short supply in the Deep South in 1822.

He and Victor were guests on the Towers plantation when both came down with one of the fevers that raged through the swampy countryside, carried by clouds of mosquitoes. Dr. Provan diagnosed the ailment as yellow fever, even though Audubon believed he had already had it as a youth newly arrived in America. The doctor sent an urgent message to Lucy: Her husband and son were in grave danger and she should come at once.

Jane Percy provided a horse and buggy; leaving Johnny at Beech Woods, Lucy set out alone for Natchez. She arrived safely and nursed husband and son to a slow recovery. Finally, Mrs. Percy relented and sent word for all of them to return to Beech Woods. She wanted her school back in session, even if it meant putting up with an erratic artist.

Audubon spent the weeks of his convalescence trying to decide on a course of action. He did not know how long Jane Percy would

tolerate his presence, and he did not want to jeopardize his wife's position. Lucy had already made one decision in which her husband had acquiesced. It concerned Victor, now fourteen and of an age to become an apprentice. Lucy had written to Nicholas Berthoud, who had agreed to take the boy into his countinghouse to learn bookkeeping and train for a career in business. As much as Audubon might have wanted Victor with him, an assistant and companion as Joseph had been, he had to admit the futility of his own situation. It was yet another bitter pill to swallow—that his own son would be better off with Lucy's wealthy relatives.

Lucy had her school, and she could still teach Johnny. The family, except for the father, had a secure future. John Audubon was penniless, but he did now have a collection of drawings good enough, he and Lucy decided, to bring to the attention of the world. That would mean a trip to Philadelphia to test the waters, to see if publication was possible.

In fact, there was nothing much else for Audubon to do. He had no money to start any kind of business, he had not been able to earn a living as a commercial artist, he had sacrificed himself and his family to do the bird pictures. Now it was time to see if the sacrifice had been worth it. One day in early October, he and Victor walked to Bayou Sarah to take a steamboat up the Mississippi. Victor would travel as far as Shippingport; Audubon would go on to Philadelphia and his first big test.

His mood was morose, judging by a letter of introduction he wrote to Rozier for a fellow French passenger, bound for Ste. Genevieve: "I am yet, my dear Rozier, on the wing and God only knows how long I may yet remain so. I am now bound to Shippingport to see if I can, through my *former* friends there, bring about some changes in my situation. I am now rather wearied of the world. I have, I believe, seen too much of it." [10]

By the time they reached the Ohio, the water was so low the boat could not continue upstream. It was 250 miles to Shippingport; the Audubons began to walk. Two other passengers went with them. Much

later, his world-weariness long forgotten, Audubon would tell the tale in an "Episode" of the *Ornithological Biography.* In "A Tough Walk for a Youth," he took obvious pride in his young son's touching struggle to keep up with his father's unrelenting pace. Eventually the Audubons left the other two passengers behind.

In this "Episode," Audubon described, in fascinating detail, how settlers then greeted travelers: "The first person we met with was a woman picking cotton in a small field. On asking her if we might stay in her cabin for the night, she answered we might, and hoped we could make shift with the fare on which she and her husband lived. While she went to the house to prepare supper, I took my son . . . to the water, knowing how much we should be refreshed by a bath . . . The sun was setting; thousands of Robins were flying southward in the calm and clear air; the Ohio was spread out before us smooth as a mirror, and into its waters we leaped with pleasure. In a short time the good man of the hut called us to supper, and in a trice we were at his heels. He was a tall, raw-boned fellow, with an honest, bronzed face. After our frugal meal we . . . lay down on a large bed, spread on the floor, while the good people went up to a loft." When the travelers left at daybreak, their host refused any payment but accepted a knife from Audubon.

When they arrived in Shippingport Audubon had thirteen dollars in his pocket; he could not go on to Philadelphia penniless, so he stayed on through the winter, taking any job he could get to save enough money to continue the journey. The "former friends" he had hoped might help him offered mostly advice. He painted the interior of a steamboat, he painted signs, he scouted for portraits. When someone suggested that landscapes might sell, he seized the idea, painting the Falls of the Ohio and resolving, in a typical burst of enthusiasm, to paint a hundred views of American scenery. Anything for money to see him through.

Victor took his place in his uncle's business while, across the Ohio River, up Little Pigeon Creek in Indiana, Abe Lincoln (who like Victor was fourteen) was growing tall, and strong enough to wield an ax like a grown man, clearing out the tall stands of timber—sugar maple,

hickory, black walnut, and elm. When he wasn't needed at home, he hired out to other farms; at night, by firelight, he read, and sometimes wrote in his copybook:

> *Abraham Lincoln*
> *his hand and pen.*
> *he will be good but*
> *god knows when.*

One friend who received Audubon with pleasure was old Madame Berthoud; perhaps because in her long life she had seen so many others suffer changes of situation, perhaps because she remembered how fond her husband had been of Audubon, or perhaps simply because his Gallic charm delighted her, she did not disparage him.

On January 20, 1824, Audubon, in anguish, wrote in his journal: "I arose this morning by the transparent light which is the effect of the moon before dawn, and saw Dr. Middleton passing at full gallop towards the white house; I followed—alas! my old friend was dead! . . . many tears fell from my eyes, accustomed to sorrow. It was impossible for me to work; my heart, restless, moved from point to point all round the compass of my life. Ah Lucy! what have I felt to-day! . . . I have spent it thinking, thinking, learning, weighing my thoughts, and quite sick of life. I wished I had been as quiet as my venerable friend, as she lay for the last time in her room."[11]

By spring, when the steamboats were again moving on the river, Audubon had saved just enough to get himself to Philadelphia and buy a new suit of clothes. It was April 5, 1824, when he arrived. After being suited and having his hair trimmed (if only to shoulder length; he could not bear to give up entirely this mark of the woodsman) he set out to call on Dr. William Mease, an old friend from Mill Grove and Fatland Ford days who was now curator of the American Philosophical Society. Dr. Mease took one look at the portfolio of birds and immediately turned Audubon over to Thomas Sully, one of the foremost painters of the day. Sully leafed through the drawings, studying

each carefully; he was full of praise. He thought Audubon's handling of pastels and watercolor especially skillful, and offered to give Audubon lessons in oils if he, in turn, would instruct one of Sully's daughters in pastels and watercolor. That quickly, Audubon was drawn into the lively, warm circle of the Sully family.

It must have seemed logical to Dr. Mease to introduce Audubon, and his astonishing pictures, to a rising young (twenty-one) star of ornithology. Charles Lucien Bonaparte's uncle, Napoleon Bonaparte, had bestowed upon him the title of Prince of Canino and Musignano. As Audubon described Charles: "Bonaparte . . . is a little set, black-eyed fellow, quite talkative, and withal interesting and companion-able." Americans, then as now fascinated by aristocracy, gave Charles Bonaparte a certain celebrity. He was hard at work on his own study of the birds of America, meant to supplement Alexander Wilson's work.

Bonaparte, like Mease and Sully, was enthusiastic about Audubon's birds. Their praise fell on him like rain on parched land. At last men of knowledge had seen his work, and they thought well of it. He was good; his work was fine; his life had not been wasted. They spoke to him as to an equal, asking about his training in both art and science. He admitted being largely self-taught, and when that didn't put them off he confided that he felt field observations preferable to the work of what he called "closet ornithologists." He grew expansive and en-larged on his theme, pointing out how, in case after case, Wilson had erred. Once started, he could not seem to stop. Though Philadelphia was Wilson's intellectual home, where he was known as the father of American ornithology, it seemed not to occur to Audubon that an at-tack on Wilson might miscarry. None of his new friends warned him.

It was Bonaparte who took Audubon to a meeting of the Acad-emy of Natural Sciences, an organization that could open a whole new world for him. Audubon, suddenly confident, exhibited some of his pictures, expecting and wanting more accolades. Now the response was much more muted, the praise less spontaneous. Audubon had been careless enough to offer a less-than-enthusiastic appraisal of the birds Titian Peale had drawn for Bonaparte's book. (In his journal, he was

blunt: "From want of knowledge of the habits of birds in a wild state, he represented them as if seated for a portrait, instead of with their own lively ways when seeking their natural food or pleasure.") Seeing Bonaparte's enthusiasm for Audubon's drawings, Peale probably was worried that he would be replaced, so it is not surprising that he should find fault with his competitor's work.

George Ord had most to lose from the success of this unknown artist who had suddenly emerged from the country's deepest forests. Ord was a well-educated, wealthy, and influential member of the Academy; he was also the self-appointed keeper of the Alexander Wilson flame. Wilson had been his protégé; when Wilson died, Ord finished his work's ninth volume, and at the time of Audubon's visit he was working on the last. Ord was also to publish Wilson's papers and write his biography; his own scientific reputation rested squarely on his ability to promote Alexander Wilson as the father of American ornithology, and he was not about to allow some outspoken upstart to get in his way.

Audubon helped Ord by speaking too highly of his own work and belittling Wilson's. With each error Audubon pointed out in Wilson's work, Ord grew more and more enraged; finally he exploded. Angry words were exchanged; Academy members who remembered Wilson with respect and friendship joined in the attack on Audubon. The evening was an unmitigated disaster for the artist and it earned him a lifelong enemy. Ord began by blocking Audubon's application for membership in the prestigious society.

George Ord, it is true, could never have been anything but an enemy to Audubon, who was too much of a threat to both Ord's reputation and the financial success of the Wilson books. But with some humility, and a more gracious approach to the memory of Wilson, Audubon might have blunted Ord's attacks, made more friends among the Academy members, and saved himself years of frustration.

Not every member rejected Audubon. Richard Harlan, a young Quaker doctor and zoologist, came to his defense, and Charles Bonaparte took a careful, neutral stance. Bonaparte continued to make the rounds with Audubon, routing the Scottish printer Alexander Law-

son out of bed to meet a man he was almost as certain to dislike as Ord had been. Lawson was probably the only engraver in America capable of producing a book of the size Audubon envisioned; he was already occupied with Bonaparte's less challenging work, and he had a vested interest in seeing Wilson's work promoted. Lawson had done the prints for all of Wilson's work; the two had been close friends as well as collaborators. When the three men sat down together to go through Audubon's pictures, the printer unleashed a volley of disapproving remarks. The drawings were too soft, he said, too much like oil paintings. In the end, he said to Bonaparte, "You may buy them, but I will not engrave them . . . Ornithology requires truth and correct lines—here are neither."

Audubon was seething: What did this man know about "truth" and "correct lines"? Bonaparte had bought, for use in his own book, one of Audubon's boat-tailed grackles (he called it a "Great Crow Blackbird"). Lawson said the bird was all wrong, and he wouldn't engrave it unless Audubon made "corrections."

Bonaparte, who admired Audubon's field lore and drawings, charted a careful course between the two camps. After the stinging rejection from Lawson, he took Audubon to another competent engraver who had no personal stake in an ornithologist's work. Gideon Fairman had just returned from a stint in England; he was quick to suggest that Audubon could do far better there, where many more proficient engravers and colorers—along with the ready supply of copper necessary for such a large endeavor—were to be found. This practical advice seemed to strengthen Audubon and reinforce his old notion that he should go back to Europe to realize his dream.

The small-town character of the new country was evident in the number of acquaintances Audubon ran into on the street. Rozier was in Philadelphia on business and sought out his old partner; Audubon was glad enough to see his old friend, but dismissed him as being essentially boring and interested only in money.

Joseph Mason was another matter; Audubon was happy to see his protégé, who was now earning sixty dollars a month as an artist

for Bartram's garden. Together, the two went through all of the bird pictures, including those they had done together. Joseph noticed that Audubon had inked in his own name, but had left Joseph's in pencil. It is not clear whether Joseph pointed this out, but they did not argue: That night Audubon wrote in his journal that the meeting had been delightful. He didn't realize that, provoked by what he saw as his teacher's intransigence in the matter of credit, Joseph would give the Ord camp fuel by complaining that Audubon was passing off his work as Audubon's own.

In fact, the matter of credit was one that Audubon had not yet come to terms with. Artists often used apprentices to do backgrounds, and the customs of the day did not entitle underlings to credit on the work itself. These assistants were, after all, working under the aegis of a master who supervised the work, sometimes rejected it, and often made changes. Joseph claimed that Audubon had promised him a credit line on the drawing itself for his botanical backgrounds; if Audubon had made such a promise, he reneged. He viewed Joseph's charges as a betrayal, and was never to credit him at all.

For all the sound and fury stirred up by Ord and Mason, Audubon did not consider Philadelphia a failure. He had met artists and naturalists of the first rank. They had recognized his work and had accepted him as an equal. The Ord camp—primarily Ord and the engraver Lawson—would not be opposing him so violently unless they saw him and his work as a threat to their own primacy.

In Philadelphia Audubon had made influential contacts who would serve him well in the years to come—not only Thomas Sully and Charles Bonaparte but also Dr. Richard Harlan, the young Quaker doctor and zoologist with naturalist ambitions who had defended Audubon against Ord, and Charles-Alexandre Lesueur, an important French naturalist. Bonaparte coveted Audubon's field notes on birds; Dr. Harlan thought the frontier artist could provide interesting specimens. But one new acquaintance had no ulterior motives, just a fascination with the world of nature and an instant appreciate of Audubon's talents. Edward Harris of Moorestown, New Jersey, was a wealthy

young man who heard of Audubon and sought him out. There was an instant rapport; the two went hunting together. Harris was thrilled by the drawings, and asked to purchase some of those not destined for publication.

Audubon, almost broke, was happy to oblige. He sold Harris several drawings, then pulled out the landscapes he had done in oil for ready cash, and offered Harris the "Falls of the Ohio" at a bargain price. Harris gracefully declined, but then pressed a hundred dollars into Audubon's hand, saying simply that "Men like you ought not to want for money."[12] Audubon was never to forget this first (but by no means last) generous gesture from Harris. He wrote: "I would have kissed him but that is not the custom in this icy city."

By August, he was bound for New York with $130 in his pocket, along with an impressive collection of letters of introduction. Most of the people to whom the letters were addressed had left town to avoid the summer heat; those he did talk to showed no interest in his grand publishing venture. He did find his old employer, Dr. Samuel Mitchill, who had hired him to stuff birds in the days when Audubon was working at Benjamin Bakewell's countinghouse. Dr. Mitchill was the driving force behind the Lyceum of Natural History, and he quickly invited Audubon to show his portfolio and speak to the group. To become a member of the Lyceum one was required to write a paper. The subject Audubon chose was dear to his heart: his explosion of the myth that swallows hibernated in the winter by burrowing into the mud. The paper was accepted for publication in the Lyceum's *Annals*, and Audubon saw print for the first time. But it was the introduction to the paper that should have alerted disciples of art and nature to the presence of a rising star: "To the learning of a naturalist he unites the skill of an artist, and his magnificent collection of drawings, representing four hundred species, excels anything of the kind in this country, and has probably never been surpassed in Europe." [13]

Audubon quickly learned that the painter John Vanderlyn, his old friend from New Orleans, had returned to New York and was working on a commissioned full-length portrait of Andrew Jackson. Audubon

called; Vanderlyn was glad to receive him; they talked; and sometime during the visit the portrait painter noticed that Audubon and Jackson had much the same build. He asked his guest to pose for him in full Jacksonian regalia, which Audubon did.

New York had accepted Audubon as a serious artist and naturalist, he was a member of the Lyceum of Natural History, and he was fast running out of money. It was time to move on, out into the woods and the wilderness where he could better make do on his own. He had considered heading for Boston, but turned instead toward Albany with a vague plan to deliver a letter of introduction to the influential DeWitt Clinton.

The steamboat he took up the Hudson River carried two dozen representatives of six Indian nations in full tribal dress; Audubon felt right at home. Albany proved to be as empty as New York: everybody of importance had either retired to country places or gone to New York, where Lafayette was beginning a triumphal return tour of America.

Audubon thought about going to Boston, but decided he had had too much of cities and instead headed for the country's greatest tourist attraction: Niagara Falls. Overwhelmed by the power and the majesty of the great falls, he decided not even to try to capture their essence in oils.

Once more he turned west, making his way across Lake Erie, sleeping on deck to save money, keeping close to him the watertight tin box that held his drawings. He worked his way from town to town, walking and drawing pictures in exchange for food and lodging. In Meadville, Pennsylvania, an amiable Dutch innkeeper, captivated by Audubon's drawings and portraits, offered him a storeroom as a makeshift studio. After carefully using cloths to arrange the light from the windows, Audubon began a series of portraits for the local folks. The innkeeper posed as well, and took the artist home for food and an evening of music. Eventually, Audubon got to Pittsburgh, where he planned to take passage on a boat heading down the Ohio River.

Pittsburgh was a Bakewell bastion; Audubon was not eager to confront Lucy's relatives, but Uncle Benjamin had been kind and generous

to his little family, and he owed him the courtesy of a call. To Audubon's surprise, he was made to feel welcome.

The Ohio was too low for steamboat passage, so Audubon was stranded. He passed the time looking for students and found enough to pay for his food and to save a little. He invited Edward Harris to join him in watching the fall migrations around the Great Lakes, but family duties kept Harris in New Jersey, so Audubon set out by himself. He was at home again, alone in the forests of America, studying the creatures that passed overhead in all their glorious variety. At some point in those solitary weeks, he crossed some invisible divide; he had been tested, and passed; the world was ready to receive his work, and *The Birds of America* would be bigger and better and more complete than anything done before.

Near the end of October, the major migration over, he bought a skiff and made his way down the Ohio. He had been away a full year; it was time to go home. Miserable weather caused him to sell the skiff and climb aboard a keelboat to Cincinnati. Tom Bakewell had recently moved there to open a boatyard, financed in part by Alexander Gordon, sister Ann's new husband. Audubon, broke again and ragged from rough living in the woods and on the river, avoided Lucy's kin. He wanted to move on as quickly as possible, especially once he ran into someone who demanded payment for art supplies ordered long ago for the Western Museum Society, which no longer existed. Dr. Drake was nowhere to be found, so Audubon decided to ask for a loan from some old acquaintances at a business concern. It took him a while, and several passes of the building, before he could get up the courage to go inside and ask. He came out with fifteen dollars, enough to purchase passage to Louisville.

Strangely, as he floated downstream a feeling of well-being infused him. He confided to his journal: "The spirit of contentment which I now feel is strange, it borders on the sublime; and, enthusiastic or lunatic, as some of my relatives will have me, I am glad to possess such a spirit."[14]

Audubon's relatives at Shippingport were shocked when they saw him. His hair and beard were long and unkempt, his clothing ragged

and torn. He stayed only long enough to make certain Victor was happy; Nicholas Berthoud praised the boy, but seemed not the least interested in what had happened to his old friend in Philadelphia, or in Audubon's plans for the future. Within a few days he moved out for Bayou Sarah, and his Lucy.

He arrived at night, in a rainstorm, and trudged slowly up the long hill from Bayou Sarah to St. Francisville. The town was deserted. He walked into the post office, roused the clerk, and discovered that almost everyone had taken to the woods to avoid a fever that had swept over the town. But Lucy and Johnny were alive, that was all Audubon needed to hear. He borrowed a horse to make the ride out to Beech Woods. The wind and the rain confused him; he lost his bearings in the woods, and it was morning before he arrived at the door to Lucy's cabin. She was at the piano, giving a lesson. He made some small sound; she turned and flew to his arms, holding him, kissing him, crying her welcome home.

Lucy understood what her family could not: Philadelphia had been the first, essential test, and Audubon had passed. While his relatives and frontier friends could neither understand nor accept what one of them called his "frivolous pastime," there was a group of highly intelligent and informed men in the East who believed in Audubon's work and who gave him back some of the self-respect he had lost. Lucy felt her husband's new resolve, the "spirit of contentment . . . which borders on the sublime." Their direction was clear: England. Lucy took up the torch; together, they were going to make *The Birds of America* happen.

Money was the big hurdle. Lucy had saved a good portion of her first year's salary; within another year, if she could collect from the other parents who had children in her school, she would have the funds to send him on his way. He would need that year to finish enough drawings to give an engraver a good start on *all* of the birds of America.

John Audubon, almost religiously committed to the task before him, made his peace with Jane Percy. While others of his neighbors could not take Audubon and his grandiose plan of action seriously, Jane Percy did. Her brother was even then visiting from England to

paint American flowers. It was agreed that Audubon should stay on at Beech Woods, giving drawing lessons in his spare time. Eventually he gave fencing lessons to some of the local boys, and taught dancing to the whole community, young and old, in the ballroom of the hotel in nearby Woodville. His account of one of the first lessons bursts with the energy and exuberance of the Frenchman, now forty but still handsome and still capable of a fine gaiety: "I placed all the gentlemen in a line reaching across the hall, thinking to give the young ladies time to compose themselves and get ready when they were called. How I toiled before I could get one graceful step or motion! The gentlemen were soon fatigued. The ladies were next placed in the same order and made to walk the steps; and then came the trial for both parties to proceed at the same time, while I pushed one here and another there, and was all the while singing myself, to assist their movements. Many of the parents were present, and were delighted. After this first lesson was over I was requested to *dance to my own music,* which I did until the whole room came down in thunders of applause, in clapping of hands and shouting, which put an end to my first lesson and to an amusing comedy. Lessons in fencing followed to the young gentlemen, and I went to bed extremely fatigued."

The year 1825 was passed in a particular, energized kind of contentment. Long hours were spent in the woods with Johnny, hunting for birds; Audubon and Lucy rode together in the mornings, and swam in the springhouse pool on hot summer evenings. He would remember with pleasure that "I watched thee bathe thy gentle form." At night they fell into each other's arms, taking care not to conceive a child.

Nathaniel Pope, Audubon's old friend and clerk from Henderson days, was now a doctor in St. Francisville. His wife, Martha, like many of the young women, was infatuated with Audubon, describing him as "one of the handsomest men I ever saw. In person he was tall and slender, his blue eyes were an eagle's in brightness, his teeth white and even, his hair a beautiful chestnut brown, very glossy and curly. His bearing was courteous and refined, simple, and unassuming. Added to these personal advantages he was a natural sportsman and natural artist . . .

He was very sociable and communicative, being the center of attraction in every circle in which he mingled."[15] Her description of Lucy is less effusive: "Mrs. Audubon was not handsome. Her face was spoiled by her nose, which was short and turned up. She had fine dark gray eyes shaded by long dark lashes. Expression was her chief attraction. She was very gentle and intelligent. Her whole appearance impressed me with respect and admiration."

In the heat of the summer, Audubon shot a fine wild turkey-cock, pinned it up, and worked for several days to capture it on paper. Young Robert Percy remembered the stench of the carcass, and what he saw as the waste of some very good eating; he had no idea the artist was bestowing immortality on the strutting bird.

Soon after his arrival at Beech Woods, Audubon started what would become a sustained correspondence with the men who had befriended him in Philadelphia and New York: Charles Bonaparte, Charles Lesueur, Dr. Richard Harlan, Thomas Sully, the good Edward Harris, and others. Many of them were clamoring for specimens from the American wilderness; Audubon obliged them, with help from Johnny, from Nathaniel Pope, and from a new French Creole friend, Augustin Bourgéat. The four scoured the woods and swamps for all manner of creatures. Barrels full of baby alligators, lizards, and snakes preserved in whiskey were shipped off to Philadelphia, along with hundreds of insects and shrubs and fruits and the skins of squirrels and other small mammals. The space around the cabin became a veritable zoo; Lucy complained when a rattlesnake refused to drown in a tub of whiskey, flinging itself out to strike at everything in sight before Audubon was able to catch it and return it to the whiskey.

He wanted to please these important people in Philadelphia; he was certain that he was going to need them in the months and years to come, and he was not above fawning. He sent some of his field notes and observations to Bonaparte, and did not react when Bonaparte wrote that the engraver Lawson had made "a few little changes" in Audubon's drawing of the grackle, which would appear in Bonaparte's new book.

He and Bourgéat and Pope studied and argued and experimented. Audubon suspected that vultures found their quarry through sight rather than smell. The three killed a deer, skinned and dried it, and stuffed it with straw, then put it in an open field as bait. They watched as the buzzards swooped down on it, ripped into the straw, and appeared puzzled.[16]

At night, Audubon's pen flew. Letters issued from the St. Francisville post office in astonishing numbers. Audubon and Lucy were collecting letters of introduction from anyone who could possibly help them, in every city in England that he might conceivably visit. Scarcely two years before, Audubon had been too shamed by his situation to attempt to see Vincent Nolte, the rich New Orleans merchant with whom he had traveled down the Ohio years before. Nolte, a man of many trades, had recently become particularly well known by financing Lafayette's triumphant tour of the country—he stepped in when the U.S. Congress could not seem to act to provide the funds. Now Audubon wrote to explain what he was about, and to ask for letters of introduction to anyone Nolte believed might be able to help him.

He would sail for Liverpool. Alexander and Ann Gordon were living there now, but Audubon did not know what to expect from his erstwhile friend. Alexander had assumed the Bakewell approach to their errant brother-in-law, his old warmth turned to ice.

By the spring of 1826, John and Lucy had saved $ 1,700, enough to finance a trip to England. On April 26, his forty-first birthday, he took a steamboat to New Orleans, where he arranged to sail on the *Delos,* bound for Liverpool under Captain John Hatch of Kennebunk, Maine; it was scheduled to leave in the middle of May. He stowed his baggage, which included two hundred drawings, an impressive selection of the birds of this new world. While in New Orleans he called on Nolte, who gave him letters of introduction to the Rathbone brothers of Liverpool, wealthy cotton merchants. Then he returned to Beech Woods, where he arrived at three in the morning, and crawled into bed with Lucy. "The moments spent afterwards," he confided to his journal with what must have been a satisfied smile, "full repaid me."

He had to know that Lucy's greatest gift to him was her willingness to let him go; had she been anything other than an independent woman, ready to stay behind and support herself and the boys while he chased their dream, he could not have left.

The family spent a last, happy few days together, celebrating at a local girl's wedding, visiting the Bourgéats and the Popes. The excitement was almost palpable; he did not want to leave, yet he was eager to begin. Finally he said his good-byes to Lucy and Johnny, and set off on the journey that would propel them all into another world, another life.

BOOK TWO

THE ARTIST AND NATURALIST

———

10

*Would it be possible that I should not in
any degree succeed? I can
scarcely think so. Ah delusive hope, how
much further wilt thou lead me?*[1]

THE COTTON PACKET **DELOS** WALLOWED in the summer doldrums
that afflicted the Gulf of Mexico and the passengers "lay strewn
about the deck and on the cotton bales, basking like Crocodiles."[2]
The slow rolling of the ship caught John Audubon up in the green
clutches of seasickness. He forced himself to eat and to walk, and in
this way finally managed to defeat the old complaint.

Other demons were not so easily banished; confined to the ship
and inaction, he was assailed by doubts, by the unknown. At times the
vastness of the task he had set for himself paralyzed him, and always he
feared for the well-being of his family. In the unexpurgated version of
his 1826 journal he described the paroxysm that overtook him when
he faced the hard fact that it would be at least four months before Lucy
and the children could hear from him, and that he had no idea when
he might return to America: "My body and face feel a sudden glow

of apprehension that I can neither describe or represent. I know only
the acuteness of the feeling that acts through my whole frame like an
electric shock. I immediately feel chilled, and suddenly throw my body
on my mattress and cast my eyes towards the azure canopy of heaven,
scarce able to hold the tears from flowing." [3]

The passage was long and tedious; it would take the *Delos* three
weeks to extricate herself from the Gulf, and then she was becalmed
once more, off Cuba. To pass the time, Audubon studied seabirds and
took extensive notes, sketched crew members at work, wrote letters to
Lucy. He was diverted by the schools of dolphins that "glided by the
side of the vessel like burnished gold during day and bright meteors
by night," [4] and he became adept at hooking them with a five-pronged
instrument called a grain. The captain taught him how to calculate
latitudes and longitudes; he recorded the ship's progress in his journal.
He swam in the warm southern waters, keeping a careful watch for
sharks; he read Byron's poems, thought of Shakespeare, Smollett, and
Sterne, whose *The Life and Opinions of Tristram Shandy* was one of his
favorites. Like much of the literate world, he was entranced with the
romantic novels of Sir Walter Scott, and dreamed of one day meeting
the great man. In the six years since he had set out on his odyssey, he
had read much in English and his writing, with Lucy's careful help, had
improved enormously, as the two journals which have survived in their
original form demonstrate.

At some point he made the decision to present himself in Europe
as an "American woodsman," with the long hair and loose clothing
of the frontier. James Fenimore Cooper's Leatherstocking Tales were
all the rage in Europe. His book The *Pioneers,* published in 1823,
had introduced the American frontiersman Natty Bumppo, an ideal
of honor and integrity who fascinated Europeans. *The Last of the Mo-
hicans,* published the year Audubon set out for England, would send
thousands of Europeans flocking to America's pristine wilderness. In
a sense, John Audubon *was* a Natty Bumppo; he had traveled into the
deep American forests wearing deerskin leather stockings and moc-
casins; he had hunted with the Indians, had witnessed the beginning

of the destruction of the wilderness. He could imitate birdcalls and do Indian war whoops. If only the wind would lift to send him sailing across the wide sea.

"My time is really dull," he wrote, "not a book on board that I have not read twice since here . . . I move from the deck here, from here to the deck; lay there a little, and down here longer. It is all alike, dull, uncomfortable . . . it is all idle time I spend here—all dreary, idle time: the most miserable, pitiful, sinful way of spending even one moment." [5]

He was forty-one years old, with no time to waste, yet he was forced to waste it. The *Delos* became his prison. His skin turned brown, his beard grew long and unkempt. To escape, he drank. John Swift, an acquaintance from St. Francisville on his way to Ireland, had brought along an ample supply of spirits, which he generously shared. After these drinking bouts Audubon, feeling voluble, would sit down to his journal. "We just emptied a bottle of American porter (which, bye the bye, is equal to any in the known world)," [6] he burbled. In one of these uninhibited outbursts, he offered an earthy glimpse of life at sea: "As I look up to see if the sun shines or not," he wrote while in his cups, "I perceive the reversed compass, and the tin lamp moves both to and fro with each motion of the ship. The bottle that contained the porter is at my right . . . Several mice are running about the floor . . . The cockroaches begin to issue from their daily retreat. My bottom is sore from sitting on the mate's hard chest . . . The last object on which my eyes rested was the captain's hammock, swinging so immediately over my bunk that it reminded me most painfully of the many hurried times I have been obliged to put my nostrils between my thumb and index, for safekeeping from winds neither from the Southwest nor Northwest but from—." [7]

At that inebriated moment, he reported being called topside to see a whale: "I ran up, and lo! there rolled most majestically the wonder of the oceans. It was of immense magnitude. Its dark auburn body fully overgrew the vessel in size. One might have thought it was the God of the Seas beckoning us to the shores of Europe. I saw it and therefore believed its existence." [8]

He needed a god as big as a whale to help him do what he had to do to restore his family, his self-respect, his life. At last, on July 21, 1826, the *Delos* anchored at Liverpool, and John Audubon—like a spring too tightly wound—exploded into action.

It was raining when he went ashore.[9] He went directly to the counting-house of Gordon & Forstall to deliver some letters to his brother-in-law and onetime friend, Alexander Gordon. If he had expected a warm reception, perhaps even an invitation to come stay with his kin, he was disappointed. At first Gordon seemed not even to recognize him; when he did, he was scarcely more cordial. After a few uncomfortable minutes, Audubon moved to take his leave and Gordon made matters worse by suggesting he call at the office again, pointedly not asking him to his home to visit Anne. Stung, Audubon went out to arrange for room and board at the nearby Commercial Inn, and that night confided to his journal, addressed to Lucy as always, "Where is that sweet sister of thine who almost grew by my side, Anne Bakewell that I knew when a child? She is here in Liverpool, and I shall not see her. It is severe, but it must be endured. Yet what have I done? Ah, that is no riddle, my friend, *I have grown poor.*"[10]

He felt miserably alone and wished that he had Victor's company. He was fast coming to the conclusion that only one's closest family could be depended on, that it was he, Lucy, and the boys against the world.

Despite the rain and hurt feelings, on that first day in England he trudged around the city, asking directions (he found the citizens remarkably kind and polite) and delivering his letters of introduction. One of these, written by Vincent Nolte, was addressed to Richard Rathbone, member of a prominent family of cotton merchants with whom Nolte did business. It read, in part:

> *Mr. J. J. Audubon, a gentleman of highly respectable Scientific requirements . . . is a native of the U.S., and has spent upwards of twenty years in all parts of them and devoted most of his time to ornithological pursuits. He carries with him a collection of up-wards of 400 Drawings, which far surpass anything of the kind*

I have yet seen, and afford the best evidence of his skill and of the perfection to which he has carried his researches. His object is to find a purchaser, at any rate a publisher for them, and if you can aid him in this, and introduce him either in person or by letters to men of distinction in arts and sciences, you will confer much of a favour on me. He has a crowd of letters for England, amongst others very particular ones from Mr. Clay, Mr. De Witt Clinton and others, which will do much for him, but your introduction to Mr. Roscoe and others may do more. His collection of ornithological drawings would prove a most valuable acquisition to any Museum, or any monied patron of the arts, and I should think convey a far better idea of American Birds than all the stuffed birds of all the museums put together.

This glowing letter came from a man to whom Richard Rathbone and his brother, William, were indebted for helping them head off a plummeting wildcat cotton market.[11] It got an immediate response. The following day, Saturday, Audubon received a note from Richard Rathbone, who had arranged a dinner with William Roscoe, a highly respected writer, historian, and art collector, as well as an attorney and banker. Roscoe and the Rathbones were at the forefront of Liverpool's cultural and intellectual life at a time when the provincial centers of England, spurred by their bankers, industrialists, and merchants, were beginning to found associations for the advancement of knowledge and learning. Liverpool had a Royal Institution, a Literary and Philosophical Society, and an Athenaeum.[12] William Roscoe was at the center of each of these societies; the Rathbones had helped to found the Royal Institution. These men were uniquely situated to draw attention to an unknown artist and naturalist from the New World.

It was a formidable beginning. Encouraged, Audubon returned to Alexander Gordon's office, ostensibly to ask some questions about clearing his portfolios through customs. This time, Gordon offered a card with his home address, a gesture that meant Audubon could, if he wished, call on Ann at home.[13]

Sunday intervened to stymie him. Except for the Gordons, who issued no invitation, he knew no one well enough to contact on this day, so he went out for a long walk, took a boat to Wales, where the weather was dreary, returned to his rooms, met John Swift (who had not yet departed for Ireland), drank himself silly, and blathered away in his journal, claiming among other things that he had seen Georgiana Keats, the wife of George, on the streets in Wales that afternoon. (If Mrs. Keats *was* in the area, she would likely have called on the Gordons, which would help explain their coolness to their kin by marriage.)

Finally he fell into bed, drunk, and did something no self-respecting woodsman would ever do: He slept until ten o'clock. And this on a morning when he should have been up early to contact Richard Rathbone. "I shaved quickly," he wrote, "was dressed in a twinkling. I bustled about briskly, locking my trunk, took my cane, my hat, my gloves—all in a hurry—ran downstairs, swallowed my breakfast without mastication, and made as directly as I could through the sinuous streets of Liverpool to *No. 87* Duke Street, where the polite English gentleman Richard Rathbone resides. My locks flew freely from under my hat, and every *lady* that I met looked at them and then at me . . . "[14]

He missed Rathbone at home, so he plunged ahead to the firm's countinghouse, where he gave his name. Richard Rathbone quickly appeared, greeting him, Audubon says, *"as a brother ought to do!"*[15] No cards from this kind gentleman; instead, he invited Audubon to call at his home that same afternoon at two.

Bolstered by Rathbone's cordial greeting, Audubon decided to seek out Ann Gordon after all, and set out to walk the mile and a half to Norton Street, where the Gordons lived. He got lost, the pebbles in the road hurt his feet, and when he finally found the house, Ann was out. Assuming that she must have been expecting him, John Audubon was once more offended. "No more," he vowed, "I did a brother's part."[16] But he didn't mean it; he could not bring himself to believe that Lucy's little sister would refuse to see him.

He made his way back to the Rathbone house on Duke Street, where he was immediately cheered by being included in a family din-

ner with Mrs. Rathbone and their children. Afterward the Rathbones took Audubon to an art exhibition; his charm emerged and he quickly made a conquest of the family.

The next morning he was up and out early, returning to a shop on Church Street where he had been contemplating two gold watches, one for himself and one for Lucy. He bought both of them, with chains and seals, handing over £120 of the £340 he had brought from America, money he and Lucy had so laboriously saved.[17] He was still wearing "American woodsman" clothes—he was eager to promote this persona—and his hair, about which he was embarrassingly vain, was still too long for polite society. But he had his gold watch, and Lucy would have hers as soon as he could find a reliable way to send it, and then she would know that though they were poor, they were not bowed. "Delusive hope," with considerable help from Vincent Nolte, had led him directly to the Rathbone family, and he felt in his bones that he had made the first, all-important connection toward his destiny.

Richard Rathbone had promised to call his family together to view the drawings of the birds, but Audubon had no idea he would act quickly. After splurging on the gold watches, he returned to his lodgings to find a note from Rathbone, which had been delivered some time before: The family was waiting for him at that very moment.

Panicked, Audubon hired a hackney, loaded on the hundred-pound portfolio, and made off for Duke Street. He arrived moments after the family carriage had left; they saw him and turned back. Once more he was saved in the nick of time.

They proceeded to the home of the family matriarch, Mrs. William Rathbone, the formidable and learned widow of William Rathbone III. Like her brilliant husband, she was a Quaker, an abolitionist, and a major influence in the artistic and cultural life of Liverpool.[18] Son William (who later became mayor of Liverpool) was there as well, with his family and several other women, including a sister, Hannah Mary Rathbone.

In such impressive company Audubon felt insecure. His *mauvaise honte*—what he called "shameful bashfulness"—flared up; Richard

Rathbone and his wife, Hannah, sensed his discomfort and dispelled it by walking him through the gardens. But it returned when he noted the fine pictures of English birds that hung inside; the elder Rathbone had been a naturalist, well versed in ornithology, and there was an impressive collection of bird books at Green Bank, the family's country house.[19]

Finally, with everyone gathered around, Audubon fumbled with the strings to the folio book, "panting like the winged pheasant."[20] Vincent Nolte's letter had gotten him here. Now he was on his own and the moment of truth was at hand.

As Audubon removed the tissue and lifted each drawing to the light, those gathered in the room were stunned. They had never seen anything like these pictures; they could not say enough in praise of the birds that appeared before them, flying, fighting, diving, wings outspread, *drawn from nature by J. J. Audubon.*

Mrs. William Rathbone did not hesitate; she had shared her late husband's interest in ornithology and she recognized that the drawings were nothing short of brilliant. She announced that the Rathbone family was at Audubon's service. They would do all in their power to help him achieve his goals—and what this wealthy, influential family could do was considerable.

Audubon all but floated back to his rooms that night to pour out both his relief and his enormous pleasure to his journal. His birds had been seen, and they had conquered. There was nothing like them, nothing at all in the world.

Now that word was out, callers began to arrive at his rooms: the American consul, the rector of Liverpool, assorted ladies. All wanted to see the drawings; everyone praised them. Something was beginning. But on July 26, without warning, the blue devils returned to plague him. He explained to Lucy, "My heart swelled and involuntarily bursted with acute sensations of unknown sorrows accumulating so mistily fast before my imagination that I could not refrain from shedding an abundance of tears. I felt as if some great misfortune was neared. I felt how much I need thee!"[21]

He forced himself up and about; he saw his drinking companion, John Swift, off to Dublin, then once more went to the post office to see if there was a letter from America. Disappointment sent him back to his room, where he cried until his eyes became so red that he worried Richard Rathbone might notice them at dinner that night. He was to meet William Roscoe, who could open many doors for an unknown American artist. William Rathbone had invited Audubon to join him for dinner the following Friday; already, the family was concentrating its efforts.

At dinner, Audubon was seated between Richard Rathbone and Roscoe, whom he described as "tall, with a good eye under a good eyebrow, all mildness."[22] In awe of the great man, Audubon could scarcely think what to say. Among those gathered at the table were a Mr. Barclay, a banker from London, and the American consul, James Maury.

After dinner the lights were arranged, a table was provided for the portfolio, and Audubon blanched as he felt all eyes in the room studying him in his rough costume. Nervously, he began what was to become an exhausting routine in the weeks ahead: One by one he held each drawing to the light and waited—for a reaction, for a question, for someone to tell him what to do next. Roscoe watched attentively and said nothing, but before leaving that night, he invited Audubon to call on him at home the next day, and to visit him at the botanical garden.

Only six days after arriving in Liverpool a virtual unknown, Audubon had an invitation from the city's foremost patron of the arts.[23] He spent the following day at Roscoe's, enjoying the man himself and paying rapt attention to his several daughters. When a daughter-in-law, an artist in her own right, asked him many questions about the drawing of flowers, he answered "with all my heart." As always, he thoroughly enjoyed the company of women; they assuaged his loneliness and confirmed his physical attractiveness. "Without female society," he wrote in his journal, "I am like a herring on a griddle."[24]

The main conquest of that day, however, was William Roscoe, who told Audubon that he wished him well, and said he would try to arrange a meeting with Lord Stanley, the fourteenth earl of Derby. Only

twenty-seven years old, Lord Stanley was a naturalist who could be an immense help to a struggling artist. "Ah, Lucy," Audubon wrote in his journal that night, "this is nearing the 'Equator' fast." [25]

Things *were* happening fast; Audubon returned from Roscoe's to find a message from the secretary of the Royal Institution announcing that he would call at eleven the next day. The man appeared and invited Audubon to exhibit his drawings for three mornings the following week in a special room at the institution. His spirits soared.

Heading out in search of pastels for a drawing to give Mrs. Rathbone as thanks for her kindness, he ran into Alexander Gordon. Audubon hesitated, then told Gordon of his attempt to see Ann, careful not to imply that they had been avoiding him. A visit was arranged for the following day.

Audubon had waited nine full days to see Lucy's sister, but he was made to cool his heels. Eventually she appeared. "I kissed her," he wrote Lucy, "I thought, more than she wished; at all events *she* did not kiss me." They began to talk and after a time Ann warmed up and *"returned to old times with more familiarity than I expected. She talked a good deal, and I did also."*[26] Ann was impressed that he was moving in the Rathbone and Roscoe circles, but embarrassed that he should be visiting the great houses in such unfashionable, such *provincial American* clothes, and with all that long hair curling down about his shoulders. She urged him to go directly to a barber and a tailor.[27] He politely declined; the dress and the hair, he was convinced, were an important part of his attraction. He was a gentleman, they had Vincent Nolte's word for that; he was urbane, respectable, well spoken; his manners could be impeccable. But he was a frontiersman as well, and they were hungry for tales of the great American wilderness. Audubon's looks, and birdcalls and Indian war cries fascinated these civilized city folk. Though the last rather embarrassed him—he had never been so much as threatened by an Indian—he had to perform, to stimulate interest in the pictures. He was not entirely comfortable as a pitchman, but he felt pitching was necessary. He did not explain all of this to Ann; one thing at a time. It was enough, for now, that she had warmed to him.

To reciprocate the kindnesses shown him, he sketched portraits of the Rathbone men, and—when he could not find the pastels he wanted in local art-supply stores—did an oil painting for Mrs. Richard Rathbone. He fell back on his trusty, and bloody, "Trapped Otter" because he had done it before and knew the subject well, never considering that the kindhearted woman might be distressed by the subject. (Much later, her son would write that it "hung on our wall for years, until my mother could no longer bear the horror of it."[28])

His second Sunday in Liverpool was spent with the Gordons; suddenly, Alexander was full of praise for his brother-in-law's work, and delighted to have him in England. Audubon understood, and accepted the Gordons' hospitality no matter the reason for it. The fact was, he craved the acceptance of Lucy's family, for his own sake as well as hers.

On July 31, the first day of the exhibit, Audubon was beside himself with nerves. At noon the doors opened "and the ladies flocked in."[29] On the third day, 413 people crowded in during one two-hour period. Audubon's birds were the talk of the town. In the midst of all this, he received an invitation to dine with Lord Stanley, which sent him into a spin. (He did well enough with the merchant class, but aristocrats were something else entirely.) More important, several of his new friends—led by Roscoe—were urging him to keep the exhibit open and charge a fee.

At first the idea pained him; he needed the money, but he feared that charging admission would make him seem mercenary, that it would rob him of some of his stature as a naturalist, a man of science. He canvassed all his new friends and found them split on the subject. But the truth was, he was going to have to find a source of income soon; Lucy's money and their savings were fast running out. William Roscoe, who had himself suffered some financial reverses, seemed to understand Audubon's quandary best, and moved to resolve it by going to the Academy's governing body to convince them to request that Audubon continue the exhibit and charge a fee, which took the matter out of the artist's hands. The exhibit eventually earned him a handsome one hundred pounds, enough to tide him over for a while.

He dreaded the coming meeting with young Lord Stanley—"I would rather have been engaged in a bear hunt," he wrote.[30] They were to meet in a country house. The aristocrat (who one day would become prime minister) galloped up on a fine hunter, fell on his knees on the rug to study the pictures, which had been spread on the floor, and pronounced them fine and beautiful. "I saw Lord Stanley on his knees, looking at my work!"[31] They dined together; on taking his leave, Lord Stanley urged Audubon to visit him on Grosvenor Street when he was "in town," meaning in London. Then he galloped off again, leaving behind a mesmerized Audubon.

Thrilled by his meteoric success and hungry for vindication, he wrote to Victor and to Nicholas Berthoud, recounting every conquest with a conceit so transparent it was certain to offend the Kentuckians. In a postscript to the letter to Nicholas, he could not resist crowing, "As you may wish to know whom I am likely to become acquainted with shortly, I will say: the Baron von Humboldt, Sir Walter Scott, Sir Thomas Lawrence, Sir Humphrey Davie; and, as the venerable Roscoe was pleased to say, 'it would not be a wonder, Mr. Audubon, if our King might wish to take a peep at the *Birds of America;* and it would do no harm.'"

To seventeen-year-old Victor he wrote: "I am in miniature in Liverpool what Lafayette was with us . . . You would be surprised to see the marked attentions paid me where ever I go by the first people of Liverpool—My exhibition attracts the *beau monde* altogether and the Lords of England look at them with wonder more so I assure thee than at my flowing curling locks that again loosely are about my shoulders." With all this swagger, however, he ended this letter to his son with a small, pathetic plea: "Remember me to all besides who are not ashamed of my being a Relation or an acquaintance."[32]

The family he could count on was far away, and he craved intimates. Very quickly he became a frequent visitor at the Bedford Street house of the elder Mrs. Rathbone, whom he would affectionately dub "the Queen Bee." William and his family lived with his mother—as did Hannah Mary, whom Audubon declared to be "handsome."

In a scattering of references to this Hannah Mary Rathbone (confusingly, her mother, her sister-in-law, and two nieces were also named Hannah Mary Rathbone) throughout the 1826 journal, Audubon calls her a "girl" and a "sweet friend." In fact she was thirty-five that year, attractive, and, like most of the ladies Audubon was meeting, every bit as educated and accomplished as his wife. (Five years later, at the age of forty, Hannah Mary married her twenty-eight-year-old cousin William Reynolds, a union like that of Anne Moynet and Jean Audubon.[33])

Audubon began to spend long hours with the mother and daughter, both at their city house and at Green Bank.

Hannah Mary's name surfaces time and again in the journal. On August 14: "I am walking most happily, bearing the quiet frame of Miss Rathbone through and across the field and along the road."[34] On September 6: "Hannah, who has undoubtedly the most brilliant and yet mild black eyes I ever beheld, with a contemplative smile over her visage . . ."[35] September 7: "Miss Hannah, hearing that I was going to Liverpool, met me with a glass of white wine. . . . I looked at her eyes, drank the wine, and thought of thee." That same night: "I have shook hands with all, rather more *brotherly* than usual with kind Hannah."[36] Two days later, at her request, he sketched his own picture and signed it "Audubon at Green Bank, Almost Happy!!" On September 10 she had planned to walk into Liverpool with him, but it was raining and blustery so they went in a carriage instead. Later still, he "breakfasted by the side of Hannah Rathbone,"[37] although he had promised to be elsewhere, and she then became "my Miss Hannah," as Lucy was "my Lucy." One night, when he admittedly had too much wine, he "enjoyed my Miss Hannah's dazzling eyes."[38] She gave him a penknife; he lost it and agonized about it so much that she gave him another. Most often, their time together was shared with others, but on occasion they were alone. "I longed for a walk with Hannah," he wrote. "I wished to talk to her alone . . ."[39]

He did not tell all to his journal, or to Lucy in letters; on the rainy September day when Hannah Mary rode with him into Liverpool, Audubon presented her with a drawing which he had made for her of a

robin perched on a mossy stone. On the back of the picture he wrote: "It was my greatest wish to have had affixed on the face of this Drawing my real thoughts of the amiable lady for whom I made it in Poetry Divine!—but an injunction from Hannah Rathbone against this wish of my Heart has put an end to it—and now I am forced to think Only of her benevolence! of her Filial love! of her Genial affections and most kind attentions and friendly Civilities to all who come to repose under this hospitable roof—to the Stranger who must now bid her farewell, who will pray for her, for her Mother and her Friends and who will be forever her most Devoted and obedient Humble Servant—John J. Audubon."[40]

He became so close to the Rathbone women that he allowed them to read the confidences written in his journal and addressed to his wife. (This would account for the fact that the Rathbones' praises are sung throughout. Although the journal was addressed to Lucy—as an earlier autobiographical sketch had been addressed to his sons—this was more or less a fictive device; it would be years before Lucy would see the journal.)

If Audubon felt romantic love for Hannah Mary, he would not have dared to act on it. Too much was at risk; he was an incorrigible romantic, but he was not a fool. And so while his journal is thick with admiring froth about lovely ladies, beautiful eyes, sweet kisses, and winsome smiles that made his heart beat faster (and full, too, of his disgust for the prostitutes who crowded around him as he walked back to his quarters late at night), he made certain that any reader of the journal understood that he was pure of heart, that the woman he most longed for was Lucy, back home in America.

Her watch had finally been sent to her, not on one of Alexander Gordon's ships bound for New Orleans, as Audubon had wished—Gordon, he wrote Lucy, had not been cooperative—but on one of the Rathbones' regular packets between Liverpool and New York.[41]

Now and then, especially after a long evening of eating and too much drinking, Audubon would pick up his pen, sharpen it with a knife, and ramble on about this and that. Occasionally he seems

about ready to make some political remark; then at the last minute he backs off, ostensibly because he and Lucy have agreed not to "discuss" politics in the pages of the journal. The Rathbones, his friends and patrons, were Quakers, outspoken in their opposition to slavery and concerned with social issues. But they were also cotton merchants, and in America cotton was produced by slave labor. Certain close Rathbone friends and family members owned mills in manufacturing towns like Manchester; on one of his early-morning walks, Audubon witnessed mothers and their young children tramping off for a day of work at the mills. He refrained from suggesting that the Rathbones and their friends might be guilty of a certain hypocrisy, but he did allow himself to observe that the lot of the child laborers was no better than that of the slaves back home.

Jean Audubon had traded in slaves, and John Audubon had owned slaves in Henderson. Even now, Lucy had one of the Henderson slaves helping her in Louisiana. Did Audubon mention this to his friends? Not likely. Did he point out the contradiction between the Rathbones' beliefs and their actions? Certainly not. He had his own hard row to hoe, and he could not afford to offend the Rathbones. He saw and hated the dreadful poverty that existed in sharp contrast to the wealthy homes he visited, he ached for the children sent out to beg each day, and was revulsed by the hordes of prostitutes who walked the streets at night. At the request of one Quaker lady, he toured a prison and was bitter in his denunciation of a treadmill on which prisoners were forced to walk interminably. He abhorred all this, but his main concern was for his own family's survival.

He had to decide what to do next. The exhibit had been such a financial success that he decided to take it on tour. His first, best hope was to publish the bird pictures, but as he wrote Lucy, he wanted a steady income: "I am trying all in my power to procure a solid place in some of the Royal Institutions here, as an Ornithologist and Artist to form a collection of Drawings for whoever may employ me—"[42]

He sent off a flood of letters to Lucy as well as to others in America, but he received no word at all in return, and by early September

this was beginning to wear on him. He stopped by the post office each day, hoping, and when there was nothing his spirits drooped. In his journal he devised conversations with Lucy. He would, for example, have her ask him what his day's expenditures were, and then he would answer: "Bed last night, one shilling; breakfast, two; dinner, three; boot, sixpence; maid, sixpence; waiter, nothing this day; wine extra, three shillings; and sixpence at the Blind Asylum Church. That makes ten shillings sixpence—within sixpence sterling of two dollars."[43] It was high living, he admitted, about the same as they would pay in a hotel in Philadelphia or New York, but not so expensive as Washington City.

It was decided. He would go to the manufacturing town of Manchester, twenty-eight miles away, to exhibit his pictures for a fee. He said his good-byes and wrangled with the innkeeper, who wouldn't give him his linens until he had paid something to each servant. He was incensed, because he had already paid the servants and could prove it. The landlady, seeing him hold his ground, apologized profusely, but the incident set Audubon on edge. He would have to be careful not to be cheated. Finally, he boarded the Manchester stage with Mr. Munro of the Royal Institution, who had been lent to him for two days to set up the exhibit.

As the stage moved out, a boy of about twelve ran beside it and turned five or six cartwheels, which astonished and delighted the morose artist, who tossed out some coins. Munro told him that the boys could be trusted to deliver messages or letters as well, which impressed Audubon. These boys were younger than his Johnny.

In Manchester—the "smokiest" place he was ever in—he rented an exhibition room for three guineas a week and hired a man to take money at the door for fifteen shillings a week. Then he went to the bank and deposited the £244 he had left. He had not spent all that much, but his shirts were beginning to show wear and he could not go into polite society with frayed collars. There were certain expenses he could not avoid without making his new friends and acquaintances uncomfortable.

Manchester was not a healthy place. Liverpool had great numbers of prostitutes, but here there were even more. "The women in the streets have none of that freshness of coloring nor the fullness of breasts that I remarked at the seaport," he wrote. "I conceive this is the result of the confinement they have to [undergo] in the manufactories."[44]

On September 16—almost four months after he left New Orleans—he had his first letters from Lucy. They had been written on May 28 and June 3, in the very first week of his voyage, but it was word from home nonetheless and he was enormously relieved. He wrote Lucy back that he planned to travel through England and Scotland slowly, exhibiting his works, and would end the journey in London on the first of March. There, he would exhibit on a large scale for a long time.

Meanwhile, he said in the same letter, she should begin to think about leaving Beech Woods when her contract was up, and going either to the Berthouds' in Shippingport or to New York City, or she should bring Johnny and come to him, "either in London or Paris where I think I may reside a long time."[45] He, Lucy, and Johnny could be together. He himself would teach Johnny. Eventually, if Victor wanted to be closer to his parents, Audubon felt sure his friends in Liverpool could find a situation for him. To prepare herself for Paris, Lucy should speak French and think in French if possible. Then, for the first but by no means the last time, he threw in a sentence almost certainly meant to nullify the invitation: "I have always afforded thee the following of thy wishes in all things, and I again entreat thee to do nought but thy pleasure respecting the offers now averted to."[46] In other words, "Come at your own risk"—a thing Lucy, from harsh experience, was not likely to do.

In this same letter Audubon also assured her that if he did return to America soon—as she must have suggested in one of her letters—he would not come anywhere near Beech Woods, but would stay with his friend Bourgéat. Apparently, almost immediately after Audubon's departure, Jane Percy decided that Lucy's husband was no longer welcome on her plantation. (Percy's brother, Charles Middlemist, had given Audubon some money to deliver to his wife in London. Audubon

delayed in his errand for far too long, earning Lucy scoldings from the contentious Percy, but that could not have been the problem at the time Lucy's first letters were written.)

Whatever the reason for Jane Percy's decision, Lucy was in a painful situation. On the one hand, her employer and patron had banned her husband from the premises; on the other, her husband was tempting her by saying "Come," and then effectively withdrawing the invitation by adding that she should do what she herself thought best.

Manchester was proving a disappointment. He did make the acquaintance of William Bentley, the museum curator, who was to become a good friend, and a bundle of letters of introduction produced some interesting invitations (at a dinner at the American consul's, boiled corn on the cob was brought out, and the guests watched in astonishment as Audubon buttered, salted, and bit into it). But not enough people were attending the exhibit to meet expenses. Audubon asked the head of the Academy of Natural History to provide an exhibition room for free; the request was granted. But he was concerned and dispirited by the lack of enthusiasm for his birds in this manufacturing center, and to make matters worse, at a concert he was distressed to find that his long hair and unfashionable dress seemed to draw disapproving looks from the ladies. No enthusiasm for the woodsman, either. He decided to return to Liverpool to consult his friends there, and to retreat to Green Bank and the Rathbone women for comfort.

Audubon's practical friends took him to see H. G. Bohn, a highly successful London bookseller then visiting Liverpool, whose warehouses had 200,000 volumes in stock. Bohn, who understood what it would take to make a commercial success, was quick with advice: Audubon's birds were exquisite and deserved to be published, but he would need to give up the idea of publishing in life size. Sales of so large—and thus expensive—a book would be limited to public institutions and perhaps a few noblemen. Instead, Bohn said, Audubon should aim for another market, "and be biased by the fact that, at present, productions of taste are purchased with delight by persons who receive company, particularly, and that to have your book be laid

on the table as a pastime piece of entertainment is the principal use made of it, and that, if in compass it needs so much room as to bring shame on other works or encumber the table, it will not be purchased by the set of people who now are the very life of the trade." In other words, Audubon should produce a coffee-table book for the middle classes. "The size," Bohn went on to say, "ought to be suitable to the *English market* [and] ought not to exceed double that of Wilson's."[47]

Audubon listened to Richard and William Rathbone politely; like Bohn, they were convinced that a hugely oversize book would be a major mistake. On this point, Audubon could not be moved. A book double the size of Wilson's was not big enough; he was determined to publish the birds exactly as they appeared in nature. This would require him to use the largest size of paper available, the so-called double elephant. One thing he did decide: For the time being, he would cease exhibiting his work in public and would concentrate on publication. He would follow Bohn's advice and issue a prospectus; then he would have several of the pictures engraved and hand-colored. This done, he would have something to show prospective subscribers—those willing to pay for the pictures upon delivery—and the engravings would be delivered in groups of four or five.

Though the book would be expensive, subscribers would pay for it over time—years, really—so they need not feel pressed. Subscription publishing was the same process that Alexander Wilson had gone through, except that in England more people were interested in natural history, and more could afford such a publication.

At Green Bank, John Audubon picked up as he had left off, breakfasting with Hannah Mary, looking through a microscope with Mrs. Richard Rathbone, offering to teach her husband how to swim—a thing that could be done in an hour, Audubon claimed. (It was too late in the season, and Rathbone declined.) He gave drawing lessons to the women and children who asked for them, and continued to produce drawings to be offered as gifts to the many who befriended him.

So many avenues were open to him, so many choices. Bohn had suggested he go to France to have the books printed. To France, he

wrote, once more to see his mother. Strangely, he seems not to have known that his mother had been dead for some three years—or he did not want to admit to his journal that he knew.

In the meantime (while Lucy was making up her mind whether to join him), he repeated a request he had made earlier, for her to send, as soon as possible, six segments of magnolia tree, one of yellow poplar, one of beech, one of bottomwood or sycamore, one of sassafras, and one of oak. Each sample should be about seven or eight inches thick, and of the largest diameters that could be procured. The samples were to go to the Liverpool Royal Institution, care of the Rathbone brothers. *"I wish thee, my dear wife, to be at some trouble and expense to bring this to a good conclusion,"* he all but ordered, suggesting she might get Dr. Pope or Judge Mathews, both good friends, to perform this considerable chore. "Recollect," he told Lucy, "that those are troubles that I give thee so as to repay troubles that I have given in exchange to others." Lucy was not only to support herself and Johnny, she was to fulfill her husband's obligations as well. It must have galled her to read, in that same letter, that he still had not sent the money to Mrs. Middlemist. He would do it when he got to London, he said, but he was vague about when that would be.

Audubon needed to return to Manchester to collect his drawings, and he hoped that the exhibit was doing better, but he lingered at Green Bank, enjoying "handsome prints, handsome ladies, good wine and good conversation," taking snuff (a habit he had recently acquired), and generally letting himself forget, for a time, the mounting pressures.[48]

The senior Mrs. Rathbone—"the Queen Bee"—made it easy for him to leave; she and her daughter Hannah Mary decided to return to Manchester with him, and from there they could all make an excursion to Matlock and Derby, where Lucy had grown up. In a letter to Lucy he promised then to head for London, where he would visit all the engravers, printers, and papermakers, discover what he could about the costs of publishing, and try *"once more* to become a *man of business."*

Lucy could hardly complain about her husband's wanting to visit the scenes of her childhood; he did not mention that the elder Mrs. Rathbone and Hannah Mary would be going along. At eleven on the morning of October 6, 1826, a Friday, the three climbed into the Rathbone carriage, Hannah Mary snug between Audubon and her mother, and were off. For part of the journey, Hannah Mary read from his journal. Along the way they picnicked from the basket brought along: "Each of us had our little table, made of our knees, each a little cloth, little plate, knives and plenty of provisions . . . our dessert, Lucy, consisted of a melon and some grapes and some pears and some apples . . . We were all gay. I never saw Miss Hannah more so. Her dark eyes were more beautiful than ever."[49] He was writing, it seems, at least as much for Hannah Mary as for Lucy.

This idyll was shattered when Audubon reached Manchester and the Academy of Natural History. The doorkeeper was too drunk to understand that he was being fired. The bird pictures were unharmed, but profits were depressingly slim.

The next day Audubon was out and about, as usual, mixing with the Rathbone family and friends. At the county seat of one relative, Robert Greg, he admired Sir Joshua Reynolds's "Laughing Girl" and some Vernet drawings. These were people who could afford to subscribe to his *Birds;* he attended their dinners, admired their wives, killed a chaffinch and pinned it to a board to show them how to draw "in his fashion," and talked about America and Indians until he was tired of it.

That same day he wrote Lucy that though some of the young women in the company wanted to read his journal, he did not allow it. "I remember well my promise to thee," he told her, ". . . and shut it quietly."[50] But Hannah Mary had been reading it the day before, and he had brought along one of Lucy's letters for both Rathbone women to share.

The bookseller Bohn happened to pass through Manchester and stopped to see Audubon's exhibit. His reaction was significant: You were right, he told the artist, they should be published at life size, and they will sell well. Go directly to London, Bohn advised; the nobility, he said, would cherish Audubon.

But first the artist was off with a party of seven, including Hannah Mary and her mother, to Matlock and Derby, where Lucy had grown up. They rode in two chaises, taking along a servant and two postilions. For four days, the party toured the area, visiting old churches, exploring caves, boating on the rivers. Each night Audubon wrote at length in his journal, once telling how he and Hannah Mary, attracted by the ancient Gothic appearance of the church, walked around it, "she leaning on my arm and I supporting her, neither very happy nor very sad."[51]

Someone offered to take them on a tour of a "curious" cave, and he and Hannah Mary walked together up a steep hill. "On turning to view the delightful scenery," he wrote in his journal, "I saw either a good husband, or a good brother, or a well compensated lover bearing in his arms either his wife, his sister, or his young mistress as heartily as I have done, myself, hundreds of times: with my wife, my sister, or my lovely mistress."[52] (What he meant by "mistress" remains a puzzle.) Later, in spite of a light rain, he rowed the Rathbone women on the Derwent. They returned to the inn to "eat and drink, and enjoyed a most lively evening. Saw my sweet friend Hannah quite happy, all about me quite happy, wished thee quite happy,"[53] he wrote in his journal to Lucy. He was having a good time, but it couldn't last. His funds were dwindling.

He had conquered Liverpool, had been lionized and fêted there; the city's intellectual and cultural leaders had been captivated by this American frontiersman with his owl calls and Indian war whoops; to them, John Audubon embodied all the romance of the New World. Now, if he could capture London's imagination as he had Liverpool's, success would be his. But Manchester had unnerved him. In this outpost he had failed, and it made him fear to take on London, at least for the moment—even with Lord Stanley's invitation to visit him "in town."

Edinburgh was a logical alternative. The cultural and intellectual center of Scotland, it was riding a wave of experimentation in the arts and sciences. Edinburgh would prepare him for London. He hurried around Manchester, gathering letters of introduction—thirteen in all—to the worthies of Edinburgh.

On the morning of October 19, 1826, a Thursday, he rose early and by six was walking toward Quarry Bank, the country home of the Rathbones' kin, twelve miles outside Manchester. He arrived, ate breakfast and found himself in the midst of a group of women—among them Hannah Mary—giving a drawing lesson. ("I longed for a walk with Hannah. I wished to talk to her alone, but the weather altered. It rained and I rambled by myself after a beautiful rose that died on her bosom.")[54] He stayed another day, and early on Saturday morning said his good-byes. Hannah Mary and her cousin walked part of the way down the road with him. After three miles, the women stopped. He shook hands with the cousin, then "turned to Hannah, met her brilliant black eyes, felt my heart swell, pressed her hand fervently, and fervently said, 'May God bless you.' We parted."[55]

He hurried back then to Manchester and packed up his birds "safe and snug." As he wrote the Queen Bee: "I . . . dressed my 'family' in their red coats, buttoned them all tightly and put over them a good slip of well oiled silk to preserve them from wet."[56] Then he ran a few more errands and wrote a note to Charles Bonaparte asking permission to list him and his uncle Joseph among his subscribers and explaining that they need not actually subscribe (unless they wanted to); the idea was to use the name Bonaparte to attract others.

His journal dwelled on his daily life, on gifts given and shirts laundered, on meals and conversations and loneliness, but all the while he was working and thinking and planning his next move. He was no longer shy about asking for help: the use of an impressive name, a letter of introduction, a hall to exhibit his drawings; at times, he asked for advice.

At five on the cold, clear morning of October 24, 1826, he left Manchester, the only passenger on a stage bound for Edinburgh. At the village of Preston, two gentlemen boarded the coach; he offered each a pinch of snuff and "the chat began." Within ten minutes, Audubon reported, "we all had travelled through America, part of India, crossed the ocean in New York packets, discussed the emancipation of slavery and the corn law, and reach the point of political starvation of the poor

in England and Ireland."[57] Looking out the window, he noticed little girls running alongside the coach, carrying nosegays of flowers fastened to long sticks. Audubon reached out to take one, tossing a sixpence to the child.

11

My plan is to publish one Number at my own expense
and risk, and travel with it under my arm—
and beg my way. If I can procure three hundred
good substantial names of persons, or bodies, or
institutions, I cannot fail [to] do well for my family,
although I must abandon my life to its success,
and undergo many sad perplexities and perhaps
never see again my own beloved America.[1]

AUDUBON ARRIVED IN EDINBURGH ON Wednesday the
twenty-fifth of October, 1826; that evening, before going to bed, he
wrote in his journal: "I thought so much of the multitude of learned
men that abound in this place that I dreaded the delivering my letters
tomorrow."[2] By the second decade of the nineteenth century, the En-
lightenment had taken root in Scotland, and in Edinburgh was gath-
ered a coterie of gifted men of substantial achievement in both public
and private life, an intelligentsia eager to explore new forms in the arts
and sciences. The Scottish Enlightenment was in full ferment that fall;
John Audubon could have chosen no better time or place in which to
pursue his quest.[3]

Daylight brought new resolve. First thing the next morning he
found rooms at 2 George Street, a respectable address. He agreed to
give the landlady, a Mrs. Dickie, a guinea a week for a bedroom and an

ample sitting room furnished nicely enough to enable him to receive even titled guests. There was a large buffet decorated with a pair of stuffed pheasants, a black horsehair sofa, some armchairs, a mirror, and even some geraniums. His front room looked out to the street, the back to the Firth; the morning light would be fine for drawing.

He scurried around that first day to deliver his letters of intro-duction, crossing the bridge from the New Town to the Old. One of these men, he hoped, would be his champion, as the Rathbones had been in Liverpool. His first stop was the home of the man at the very top of the list: the geologist Robert Jameson, an eminent professor at the University of Edinburgh, editor of the influential *Edinburgh New Philosophical Journal,* a founder of the university's learned Wernerian Society, and a member of just about every Royal Society in the British Isles and on the Continent.

Dr. Jameson was not at home. On to four others; no luck. Audubon left his cards and letters of introduction, and moved on to Surgeon's Square, where Dr. Robert Knox (a descendant of the famous religious reformer John Knox) came out of the operatory, hands still bloody, to greet him and promised to call at his rooms. Backtracking to Dr. Jame-son's, Audubon found him at home but not particularly forthcoming. The professor was a friend of Sir Walter Scott, but when Audubon con-fided to him his hero worship of Scott and his burning desire to meet the great man, Jameson was not encouraging. Scott was hard at work on a biography of Napoleon, he told Audubon, and probably would not see him. Jameson added that at the moment, he himself was too busy to call to see the birds, but he would try to get around to it in a few days.

Dejected, Audubon walked all over Edinburgh that day. He was taken with the ancient city, whose great, glowering castle hovered over all. "A high castle here," he wrote in his journal, "another there, a bridge looking at a second city below, here a rugged mountain and there beau-tiful public grounds, monuments, the sea, the landscape around, all wonderfully managed indeed."[4]

The rooms he had taken were in the New Town, to whose wide avenues many of the well-to-do had moved. (In the cramped Old

Town, damp and unhealthy alleyways and closes seemed to foster the spread of disease.) That afternoon he returned to his rooms, opened his portfolio of birds, and looked at them. "I felt very much alone again," he wrote; dark thoughts crowded in so that he was suddenly overwhelmed with fear—for Lucy, for the boys, for himself.[5] He tried to eat and the food stuck in his throat. "I forced myself out of the room to destroy this painful gloom that I dread at all times and that sometimes I fear may do more."[6]

The next day he made his way to the workplace of Patrick Neill, a printer and a naturalist, who greeted him kindly and promised to help with introductions to others. Relieved, Audubon stopped by his rooms for lunch and a "tumbler of Scotch grog" and then set out for the port of Leith, three miles away. Now and then he turned to look at Edinburgh, rising in full splendor behind him. In a letter to Victor he described the castle rising high above the city: "It looks like an eagle perched on a bold naked cypress ready to fall and crush all about below."[7] He arrived at the waterfront to find that "the wind was high. The waters beat the shores violently. The vessels pitched [at] anchor . . . All was grand!"[8]

During his long walk back to his rooms that evening, a well-dressed woman sidled up to him, told him she was poor and in need, and "offered to do anything for me for a little money."[9] The streets of Edinburgh were filled with the poor and desperate; Audubon had learned not to carry money or valuables with him. When he tried to explain his lack of funds, the woman damned him.

That evening he went to a production of *Rob Roy* which thoroughly captivated him. The American version, he said, was a burlesque by comparison; he believed that Rob Roy should always be seen in Edinburgh, *Tartuffe* in Paris, and *She Stoops to Conquer* in London. The American woodsman, the quondam Hawkeye of the Leatherstocking Tales, loved the theater, just as he loved music, the company of women, and the romantic novels of Sir Walter Scott.

The next day he was out again, trying to get somebody with influence to come to his rooms to look at his birds. He dropped off

a note to "the famous Francis Jeffrey, Esqu." As the editor and principal writer of the *Edinburgh Review,* Jeffrey was the city's most powerful critic and a man who could be of help. Jeffrey was not in, and with nothing else to do, Audubon took a tour of the royal palace of Holyrood. Like thousands of tourists before and since, he saw the historical apartments where Mary, Queen of Scots, lived, and the chamber where her secretary, David Rizzio, was murdered. Almost as fascinating to him were the poor of Edinburgh; the women, he noticed, carried their burdens in large baskets on their backs, attached to their foreheads with a leather strap—"just as our squaws do in Louisiana."

As he waited for Edinburgh to discover him, he produced a constant stream of letters: to Lucy and the boys; to the Rathbones; to the learned men of Liverpool. Writing to Victor, he reacted to family news: "I have heard that your Aunt Sarah was married. To whom, pray? At her age she would better not have done so (if I may give my allowance of advice.) Your Aunt Anne, whom I saw in Liverpool, said that my sweet sister Eliza had proved a mother again! Your Uncle T. W. Bakewell is now a citizen of Cincinnati . . . Is your Uncle the Duck Killer married yet?"[10]

He received a few letters, but none from Lucy, none from home. Roscoe wrote from Liverpool to say he had learned that Professor Jameson was collaborating with Prideaux John Selby and Sir William Jardine, both talented Scots ornithologists, on a book of British birds. Audubon supposed that might explain Jameson's tepid reception of him.[11] Roscoe suggested that Audubon work with them on the book; Audubon thought not. If he did any book at all, it would be his own, he assured his journal with a puff of bravado. But to Lucy he wrote that Jardine and Selby "are engaged in a general Ornithological Work and as I find I am a useful man that way it is most likely that I shall be connected with them with a good share of credit and a good deal of cash—they both will be in in a few days when this matter will be discussed over at length and probably arranged—"[12] He was never asked to collaborate on their book.

On Sunday, a casual acquaintance, met on the coach from Manchester, brought twelve ladies and gentlemen to see his drawings; all of them sang their praises. But except for Dr. Knox, who came to look at the drawings and pronounced them the greatest in the world, nobody of consequence turned up. By one on Monday afternoon, his fifth full day in Edinburgh, Audubon was about to explode with frustration. Needing to act, he marched out of his rooms and straight to Fish Market Close in the crowded Old Town, to the office of Patrick Neill. He stormed past the rows of printers until he reached the smiling Neill himself, when "all my pomposity evaporated and dispersed like a morning's mist before the sun."[13] He blurted out to Neill how discouraged he was that no one had come to see his birds, and said that perhaps he should simply leave the city.

Neill, remembering the glowing letter of recommendation from Liverpool, did not waste another minute, but whisked Audubon off to St. James Square to meet William Home Lizars, who was engraving the Selby and Jardine book. Neill convinced Lizars to come see the birds for himself. Reluctantly, Lizars agreed.

It had started to rain; on the walk back to Audubon's rooms, he and Lizars shared an umbrella. All the way, Lizars extolled the artistic talents of Selby and praised his exquisite British birds; Audubon's spirits sank with every step. By the time they entered his rooms, Audubon's awful insecurities had returned; beset by doubts, he was shaking with fear.

Without saying a word, he offered each of the men a chair, slowly unbuckled the straps of the portfolio, and began lifting out the drawings, one by one.

Lizars stared, thunderstruck.

"My God," he said, "I never saw anything like this before!"[14]

From that moment, William Home Lizars was to be Audubon's champion, spreading the word in Edinburgh as the Rathbones had in Liverpool. What we have here, Lizars told everyone who mattered in Edinburgh, is something new and amazing, a marvelous combination of art and science, superior to anything in existence, including the Selby and Jardine work. Those two must see Audubon's birds, Lizars

insisted. They would have much to learn from this enormously talented, eccentric American with his long hair and old-fashioned clothes.

Lizars was as determined as Mrs. Rathbone had been to spread the word, and far less reserved. His exuberance bubbling over, he advised Audubon to hold visiting hours at his rooms each day until a public exhibition could be arranged. Publicity was everything. The newspapers and the important societies must be notified; a portrait must be painted of Audubon in woodsman getup. Most important, he must meet Edinburgh's cultural elite. Lizars—a founder of the Royal Academy and a driving force in the city's cultural life—could arrange that.

Suddenly the great men and women of the city appeared in Audubon's rooms during the hours he had set aside for viewing the birds—from ten to two, when the light was best. Lizars brought Professor Jameson the very next day, and the professor was impressed but reserved. "He has a look quite above my reach," Audubon wrote in his journal that night, ". . . but I am to breakfast with him tomorrow at 9."[15]

Edinburgh set a higher standard than Liverpool; praise was more measured. Yet word spread fast. Soon, ladies and gentlemen (more of the former than the latter, which was fine with Audubon) were arriving all day long. The callers included a "respectable" actress and her brother, and several friends of the Rathbones'. Audubon's arms grew weary from holding up the drawings.

The days shortened, until finally it did not get light before nine in the morning and the gaslight was turned on again at three in the afternoon. The weather turned cold; Audubon saw his first snow in five years. The invitations began to pour in, for breakfast, for dinner. Lizars and his wife ("lively, very affable, and has fine, large eyes . . . perhaps Vandyke brown," whom Audubon ever after referred to as "Lady No. 1") made him feel at home; he returned to their house again and again for meals, for long chats, for the family support he craved.[16]

At Professor Jameson's for breakfast he found "a most splendid house, splendid everything, a good breakfast to boot."[17] The professor—along with Lizars and Patrick Neill and Dr. Knox and twenty or so other academics and scientists and naturalists—became one of his

boosters. Jameson brought a "notable baronet and perhaps a couple more gentlemen" to see the birds and, according to Audubon, "made them praise my work."[18]

It had taken only a week to set Edinburgh on its ear. Later, Sir Walter Scott said that he regretted not coming to Audubon's rooms to see the birds, and explained that he didn't like to do what everyone else was doing. It was just as well; Audubon was so in awe of Scott that he would have been overwhelmed by the great man's presence in his rooms. Even so, he asked several people who were close to Scott if they could wangle an introduction for him. Somehow, he was going to meet his idol.

In the midst of all this activity, Audubon haunted the post office; as the days wore on, he was becoming more desperate for a letter from Lucy. Since leaving America nearly five months before, he had received only the two letters that reached him in Manchester. He was filled with foreboding, and questions crowded into his mind: Had Lucy and Johnny fallen prey to the fevers that swept through the Louisiana swampland in the hot summer months? Could they be dead, and he not know? And why was there no word from Victor or Nicholas Berthoud? He had written all of them several times over, had even sent copies of some letters in case the originals should be lost at sea. The ship by which he had sent Lucy's gold watch had already returned to England—carrying Charles Bonaparte, who was now in Liverpool— and yet there had been not a word from her. Letters from the United States were sent through the postal service to shipping houses along the coast, along with enough money to pay for the ocean journey and the cost of delivery in Britain. The captain of a ship would carry the letters, for a hefty fee (as much as two days' wages).[19] It was always cheaper to send letters along with someone who was traveling to England, but that was not always possible when you lived in the backwoods of Louisiana. Lucy, always watching her pennies and having little that was new to say, did not write often, no matter how her husband chided her. Any real news would come from him. She had no money to waste simply to quell his fears. Now, however, when the blue devils crowded

in and he grew faint with worry, he had someplace to go: the Lizarses', where he was always welcomed with coffee, or a warm Scotch whiskey toddy, or a meal of sheep's head.

One day when Audubon was showing his work to a large gathering, Lizars suddenly announced that he wanted to engrave one of the birds. As Audubon lifted the hawk pouncing on partridges, Lizars said, "That's the one." The room was too crowded to talk business, but that night Audubon turned up at the Lizarses' house to discuss the work. By the end of the evening, it was agreed that Lizars would print at least one number, or the first five plates. That night they discussed only the engraver's notion that the birds should be exhibited publicly. The times were not good for publishing a major work. Great Britain was in the throes of the first modern world financial crisis; major banking houses were going under, and the resulting depression affected all of society, including publishers. Even the great Sir Walter Scott was struggling to pay debts incurred by his publishing house. (Scarcely a year before, in January 1826, Scott had written in his journal: "I will be their vassal for life and dig in the mine of my imagination to find diamonds.") In this economic climate, no publisher was giving big advances for unfinished books.[20] And the book Audubon was proposing would be wildly expensive. Lizars, understandably, did not rush in.

However, when Audubon mentioned that institutes in both Liverpool and Manchester had made rooms available to him for free, Lizars marched off to rally his troops, who saw to it that the Royal Society did likewise. ("Mr. Lizars . . . is here *mon bon cheval de bataille*," Audubon wrote in his journal.[21]) Rooms were made available from the middle of November until Christmas.

Audubon sighed with relief; he would no longer have to spend his days in his room, endlessly lifting one picture after another, watching his small reserve of money disappear. He could devote time to painting, and hope that the exhibit would bring in enough to keep him going until he could find a steady source of income. The exhibit of 139 land birds and 70 water birds opened in an impressively large room at

the Royal Society, with a man to take tickets. By penny post Audubon
sent off seventy-five free tickets to those who had helped him and to
"those also from whom I needed further assistance, and to *all the art-
ists of Edinburgh!*"²² One of the tickets went to the *Edinburgh Review's*
Francis Jeffrey, who had never returned Audubon's initial call on him;
he never used the ticket, either. Even so, from the first day, the exhibit
was a solid success with the people of Edinburgh. Almost immedi-
ately Audubon started a large oil painting of a turkey hen and chicks.
(Paintings were an appropriate gift for the institutions that exhibited
his birds, just as small drawings pleased individuals. Anyway, a paint-
ing was all he could afford by way of recompense.) He also began to
sit, wearing his wolfskin coat, for a portrait by the painter John Symes.
Lizars had convinced Audubon that a portrait was necessary, and that
he would make an engraving of it to promote the American artist.

Survival was always on Audubon's mind; as sweet and vindicating
as the praise showered upon him was, it would not pay for his room,
his board, or his art supplies, it would not provide for Lucy and the
boys to join him, and it did not ensure success. He had hoped that
some patron of the arts would materialize and offer to sponsor him, or
propose the kind of position that would give him a steady income and
allow him to bring his family to England at once. Though he had met
any number of wealthy men, some of them titled, none had seemed
interested in taking the American woodsman under his wing, nor had
any of the learned societies offered him a paying position. In fact,
princely patronage was already a thing of the past, and, given the poor
economy, the learned societies were struggling. There was not going to
be any alternative way to support himself and his family. Publication
seemed the only possibility, and he knew how difficult that was.

By November 19, he and Lizars had come to terms. The engraver
would do five plates, which would constitute a "number." Each bird
would appear life size. The first, a large bird—they finally settled on the
turkey-cock—would be followed by two medium-sized birds, then two
small ones, to give subscribers an idea of what was to come. Audubon
would travel with these as samples "under my arm—and *beg my way,*"

paying Lizars back with money collected in subscriptions.[23] As soon as the first five prints were finished, Audubon would make his way back to Liverpool *"proofs in hand"* and then on to other major cities to begin soliciting in earnest. By not demanding payment in advance, or even on delivery, Lizars was in fact subsidizing the first number. If Audubon proved as good a salesman as he was an artist, Lizars stood to make a handsome profit in the long run. Even so, in such parlous economic times, he was taking an enormous risk.

Not surprisingly, the decision to begin sent Audubon into a spin. Once started, he would be like a prisoner on a treadmill: There would be no way to stop, no way to go but forward. If he failed, he could very well end up bankrupt again, and in debtors' prison. He understood that even if he succeeded, he might have to stay in England for years. The arithmetic was simple enough: The completed book would have four hundred different folio sheets, five to a number and five numbers a year. At that rate, *Birds of America* would take sixteen years to complete.

Audubon wrote a businesslike letter to Lucy: "It is now a month since my work has been begun by Mr. W. H. Lizars of this city—it is to come out in numbers of five prints all the size of life and in the same size paper of my larger drawings that is called double eliphant—they will be brought up & finished in such superb style as to eclipse all of the kind in existence[,] the price of each number is two guineas and all individuals have the privilege of subscribing for the whole or any portion of it." Tellingly, he went on to insist that "it is not the naturalist that I wish to please altogether I assure thee it is the wealthy part of the community the first can only speak well or ill of me but the latter will fill my pockets."[24] Lucy needed to know that he was being practical, that he was paying attention to business.

November became December, and still he had had no word from his wife or sons. Had a whirlwind of activity not engulfed him, he might have been overwhelmed by worry and despair. Instead, he rose early, as always—at four or five—and wrote until it was light enough to paint. He had started a text to accompany the *Birds,* what he called

an "ornithological biography" of each species. The plan was to publish the text in separate volumes that would accompany the pictures. Then he spent the bare six hours of winter light painting. Struggling to improve his technique in oils, he had finished a painting of wild turkeys, and another of wood pigeons in watercolor and oil, as well as producing yet another otter caught in a trap. He called often on Lizars's shop to make certain his birds were being copied and colored faithfully. Everything was done by hand; he kept careful watch to make certain that each copy was true to the original. Then, when evening arrived, he donned one of his new suits and appeared at an elegant home, sometimes to dine with a small gathering of erudite men, sometimes to join a large group of men and women. Always, the dinners were long and sumptuous; there was wine—sometimes too much—and many courses. At the Antiquarian Society's dinner he was served "Scotch messes of old fashion, such as marrow bones, codfish heads stuffed with oatmeal and garlic, black puddings, sheep's heads, tracheas of the same, and I do not know what all."[25] For Audubon, the toasts were the worst part. Lord Elgin started with "The King, four times four," whereupon everyone rose, drank, and shouted "Ip, Ip, Ip" sixteen times.[26] More toasts followed, until finally someone got around to Audubon's health, which meant he had to respond. "I thought I would faint," he wrote in his journal, "and I was seated in that situation when everybody rose, and the Earl President called out, 'Mr. Audubon.' I had seen each toasted individual rise and deliver a speech. That being the case could I remain speechless like a fool? No, I summoned resolution and for the first time in my life addressed a large assembly."[27] His response was short and proper, but all the while his hands were clammy and he could feel the sweat running down his legs. Lizars, sitting next to him, saw his nervous distress, gave him a pat and a drink of wine, and said, "Bravo, take this."[28]

It was one o'clock before he got to bed that night; sometimes it was two, then he was up at five or six to start over again. Symes had finished his portrait, and it was hung along with the exhibit. Audubon didn't think it a good likeness, but he was happy to have people looking at the portrait rather than at him.[29]

He met the ornithologists Selby and Jardine, found both of them warm and interesting and not in the least resentful or envious, as if they accepted with ease Audubon's superiority in drawing birds. They asked for lessons in his method of wiring and drawing newly dead birds. Audubon, happy to oblige, welcomed them to his rooms for several long days of lessons. They in turn invited him to spend time at their country houses, should he travel from Edinburgh. Others who lived closer by had invited him as well, but unless someone offered to send a coach for him, Audubon did not go.

As the first engravings were finished and colored, Audubon hung them in the exhibit and stood back to admire them. He had been right about insisting on the double-elephant size: The engravings were stunning, the large turkey strutting through a canebrake, the delicate smaller birds centered in the middle of the large sheet. A smaller book such as Wilson's could never show the birds to such advantage. The exhibit was bringing in enough to cover expenses; almost more important, it was promoting his celebrity and, he hoped, would bring him subscribers.

Among his callers was the writer Captain Basil Hall, who had traveled the world in the Royal Navy and was planning to embark, with his wife and infant daughter, on a tour of America, after which he intended to publish an account of his travels. Audubon was enthusiastic, and offered to help the captain plot his journey.

Audubon was being encouraged to do some writing of his own. The Wernerian Society wanted him to present a paper, and he thought he would write about his experiments with the turkey buzzard. Dr. Jameson encouraged him, and promised to publish the paper in his *New Philosophical Journal.* The idea of reading a paper to the assembled society made Audubon break out in a cold sweat, but he forged ahead. Just as the paper was finished and on its way to the printers, he had a note from Professor Jameson that the University of Edinburgh would subscribe to his work. He was ecstatic; if the university subscribed, others would follow.

Just as everything seemed to be going well, a young man in a large cloak entered the exhibit and made off with the drawing of the black-

poll warbler. The attendants could describe the young suspect, and Audubon swore out a warrant against him. Hours later, upon returning to the exhibit, Audubon passed on the stairs a young beggar woman carrying a baby. She had been paid to return the drawing by the thief, a young deaf man named Inglies. He was the illegitimate son of the eminent painter Sir Henry Raeburn—and Basil Hall's ward as well. Audubon was able to withdraw the warrant in time to avoid the young man's prosecution. A grateful Captain Hall called on him twice that afternoon, once with a gift of his book of travels through South America, again with an invitation to dine the following week. The whole affair had nettled Audubon, but he was glad to do the captain a favor by hushing up the theft.

Some months later, Hall provided Audubon with his heart's desire: a meeting with Sir Walter Scott. So far this longing had been frustrated: A breathless Audubon had been told he would meet Sir Walter on several occasions—once at a meeting of the Royal Academy, another time at the Antiquarian Society's annual dinner. But each time the great man had sent his regrets at the last moment. Once, in a fit of melodramatic license, Audubon addressed Sir Walter in his journal, explaining this flight of fancy with: "Poor me—*far* from Walter Scott I could talk to him."[30] Curiously, his message was to prove prophetic: "Oh Walter Scott, where art thou? Wilt thou not come to my country? Wrestle with mankind and stop their increasing ravages on Nature, and describe her now for the sake of future ages. Neither this little stream, this swamp, this grand sheet of flowing water, nor these mountains will be seen in a century hence as I see them now. Nature will have been robbed of her brilliant charms. The currents will be tormented and turned astray from their primitive courses. The hills will be levelled with the swamp, and probably this very swamp have become covered with a fortress of a thousand guns . . . Fishes will no longer bask on the surface, the eagle scarce ever alight, and these millions of songsters will be drove away by man."[31] America was changing rapidly; the forests of great trees through which the fictional frontiersman Natty Bumppo roamed were being felled, and the Indians of the

eastern states pushed off their ancestral lands. Even now, the America experienced by the fathers of James Fenimore Cooper and John James Audubon had all but vanished. Both sons knew this, and regretted it bitterly; yet, ironically, one's books and the other's art would encourage more of Europe's people to come to America, and would hasten the process.

Letters arrived from the Rathbones, along with a seal that the elder Mrs. Rathbone had made for him as a gift. It was a miniature of his turkey-cock with the legend "America, My Country." From that time on, Audubon sealed all his letters with it. It was as if the Rathbones had become his family. Hannah Mary wrote to him, as did the Queen Bee, and even Richard and William fussed over his progress, still concerned that he was making a grave mistake by insisting on publishing in such a large format.

For the moment, all of his kin in America were deafeningly silent. He could not understand it; he had given Lucy specific directions to send letters via the Rathbones. Understanding how anxious he was to hear from her, they would pay any postage, then forward the letters to him without delay. But there were no letters.

Both the Bakewells and the Rathbones were English families of wealth, social standing, and a special interest in science and nature (Audubon had not been shy about revealing the Bakewells' connections to such luminaries as Joseph Priestley and Erasmus Darwin) but the Rathbones had supported Audubon and his work in ways the Bakewells would not. The Bakewells in America saw only their sister left to survive on her own. Hannah Mary, as lovely and sympathetic as she was, had the luxury of spending her days observing the tame robin that flew into her room at Green Bank, while Lucy struggled to raise her sons and teach her students and pay the bills while living in a rough cabin in the deep magnolia woods of Louisiana.

Lucy had also to placate the exasperating Jane Percy, and, unknown to John Audubon, she was having an increasingly difficult time with her employer. Audubon's failure to deliver with dispatch either the letters or the thirty dollars he was carrying for Mrs. Percy's sis-

ter-in-law in London was an increasing annoyance, but it is likely that it was Lucy's very self-sufficiency that set the two women at odds. Lucy Audubon was a respected member of the community, and she was a *gentlewoman*. Jane Percy had inherited her wealth from her husband, while Lucy Audubon was not only supporting her family, but spending a good part of what she earned to promote her husband's ambitions. Whatever her reasons, Jane Percy no longer tolerated John Audubon. Like a good many others, she decided that Lucy was being foolhardy; unlike the others, she felt she had a right to speak her mind.

Lucy hoped to take Johnny to London by the summer of 1827, but her husband's exultant letters—though filled with longing for her and tender professions of love—were vague about when they might come and invariably left the decision to her, which was disconcerting. He wrote, for example, that he planned to exhibit his collection all over England, Ireland, and Scotland—and then on to the Continent—"to raise the means of supporting myself well and would like most dearly to add thyself & my sons also but can I or can I not expect it. Alas it is not in my power to say it does not depend on me or it would soon be accomplished."[32] Lucy was having difficulty collecting the money owed her by the additional students she had taken on. Her good friends, not surprisingly, were those who remained loyal to her husband: the Popes, the Bourgéats, Judge Mathews.

Nathaniel Pope's wife, Martha, was the niece of William Garrett Johnson, the father of a large and happy family living on a nearby plantation called Beech Grove. When things became unbearable for Lucy, Pope interceded, and at the end of the fall school term, she moved her school from Beech Woods to the smaller, but more congenial, Beech Grove. There she would be welcomed as part of the family.

Johnson offered her $1,000 a year plus room and board for instructing his children, and agreed to collect tuition for her from the parents of the other students, taking an onerous chore off her shoulders. The offer's one drawback was that she would have to agree to stay for at least one full school year, which meant she would not be going to England in the summer of 1827. She made clear to everyone that the

delay was only temporary, that she would be joining her husband soon, and that Johnny was going to continue his studies in England.

Audubon's letters reported triumph after triumph. He was elected to the Wernerian Society and to the Society of Arts & Sciences. He was moving in rarefied circles—lords and ladies, dukes and countesses—"I have not dined at my lodgings for upwards of a fortnight one single day"—and Lucy longed to be with him.[33] He understood this; after a particularly large dinner party he wrote to her in his journal: "This very bustle thou art fond of; it suits thy lively spirits and thy acquirements, but not mine."[34] And again, speaking of how terrified he felt at the prospect of meeting Lord Morton, who had been chamberlain to Queen Charlotte, he wrote Lucy, "No, thou would not [fear it,] because thou art a well bred woman. But I do because I am a fool."[35] Their dream was coming true, and she wanted to return to England in triumph to share it; this was her world more than his, and she deserved to be a part of it.

Letters between New Orleans and Edinburgh were three, often four months in transit, depending on the vagaries of the winds that powered the great sailing ships, and on the efficiency of their captains, who usually saw to the delivery of the mail pouch they carried. Once landed, the letters would have to be forwarded through intermediaries who paid the postage and then collected from the recipient. Sometimes these letters were delayed; often their routes were circuitous. Lucy had yet to receive her promised gold watch, sent in care of the captain of one of the Rathbones' packets. It annoyed her that her husband would spend such a large sum of her money on a watch, then fail to ensure its safe delivery.

On December 21, at the very moment when Lucy was preparing to move to Beech Grove, Audubon finally received two letters she had written him the previous August.[36] They had been sent for forwarding to Mrs. Middlemist in London, which may explain the delay, since Audubon was still holding the woman's money. (He didn't get around to sending it until late in December.) In one of the August letters, Lucy said she would like to join him the following summer. Her decision

to move to Beech Grove put that out of the question but John, not realizing this, immediately wrote back: "I have felt delighted at the idea of thy probably coming to Europe some time next summer—but my Lucy we must not hurry too much." Thus the pattern was set: He wrote, in effect, "I want you, I need you, tell me when you can come," and followed that with a quick change of heart: "Wait, stay, don't hurry, not yet."

Lucy was peppered with his letters, with newspaper clippings concerning his triumphs, with boxes of charming little gifts from the Rathbones and others, with copies of letters and invitations he received from families whose names she knew well, with copies of letters others had written him, with copies of pages from his journal. Each day's entry carried lavish words of husbandly devotion, meant to dispel any notion that he had carelessly left his wife and family behind, that he could have forgotten them, that he was, in fact, a negligent husband and father.

Lucy had long since learned to read between the lines, and there she found something troubling. Johnny was fourteen; she had taught him as much as she could, and now he needed to be off to school—in England, she hoped. That had been the plan, but his father was hesitating. Still, Audubon wrote of how much he needed his son to help him, how eager he was to have Johnny come: "The young Gentlemen here have a superiority of education that bears no parallel with our young Countrymen."[37] Lucy could wait, but Johnny was eager to leave for England, to join his papa and go to school. She had disappointed her son once by deciding to move to Beech Grove instead of England. A decision would have to be made before too many more months passed; Lucy hoped, for Johnny's sake, that her husband would send for them. If not, she would discuss the matter with Victor, who had become her confidant.

Now seventeen, Victor had been with Eliza and Nicholas for three years, and tended to look at his parents from the Berthouds' point of view. His mother was "poor Lucy, left all alone to shift for herself and the boys," and his father was an embarrassment. (Victor had seen

how his Berthoud and Bakewell kin had looked at his father when he returned from Philadelphia, all shaggy and tattered and poor.) The letters from Liverpool, with all their swagger and talk of his conquests "of people of the first order" and of his beautiful long locks, did not help. His father, Victor believed, was more interested in fame than in providing for his family, so he followed his uncle Nicholas's lead and did not respond to Audubon's letters at all. What neither man understood was that Audubon was interested not so much in fame as in vindication.

On December 20, 1826, he wrote Nicholas: "That you should not answer my letters is rather strange and most painful to me." Then, as if he couldn't help himself, he gushed: "Think of Lords sending their carriages to Mr. A. with best compliments, &c., &c., to go spend days and nights at their hall to see the wonderful locks that hang about his shoulders in full abundance."[38] He assured Nicholas, as he did all his confidants including his journal, that everything he did was for his family, that they were the ones who would benefit from his labors. And then, in a hurt tone, he asked Nicholas the question that was really on his mind: "Why does not Victor write to me regularly every fortnight?"[39] What he meant was, "Why does not Victor write to me at all?" Audubon was grateful to Eliza and Nicholas for their help, but he resented them, too, because he feared he might be losing his son.

While he fretted over conditions at home, his life in Edinburgh was becoming ever more involving. The men of the Wernerian Society asked for a demonstration of his method, so he took a newly killed pigeon to a meeting, wired it, and, pinning it to the scored board in a lively pose, proceeded to sketch in its outlines.

He managed to get through a reading of his paper on the turkey buzzard, which, he contended, found its food by sight and not smell (he cited the experiments he had done with Bourgeat in Louisiana). He did a paper on passenger pigeons, another on alligators, and then he wrote one on the rattlesnake—blithely dashing it off from his memory of an event he witnessed while at Oakley—which would appear in Professor Jameson's influential *Edinburgh New Philosophical Journal.* His

English, though full of verve and sparkle, was far from polished. The papers took time and effort, and required editing by some of the literary men.

The rattlesnake paper was fascinating, and was well received by an audience that knew nothing about the subject, but in fact it was full of errors and myth, and was to bring Audubon grief when published. It started off well enough, by discounting the popular notion that snakes had the power to mesmerize their prey. Then Audubon reported on observations he had made in 1821, when he was staying with the Pirries at Oakley Plantation in Louisiana. He recounted how he was lying on his stomach observing some birds, when he heard a rustling nearby. At the moment he turned to look, a gray squirrel went bounding off with a rattlesnake in full pursuit, no more than twenty feet behind and "sliding over the ground so rapidly that . . . I was at no loss to observe the snake gain upon the squirrel." The squirrel scampered to the top of the tree, Audubon claimed, with the snake in close pursuit. When the squirrel jumped to another branch, the snake followed "by stretching out full two-thirds of its body." The chase went on, from branch to branch, until finally the squirrel, "much exhausted and terrified," took a desperate leap to the ground, landing with legs splayed wide. The snake dropped, too, wrapped itself around the squirrel, and crushed it to death. Audubon moved closer for a better view; he said he watched the snake disengage itself, then devour the dead squirrel, tail first.

Audubon also repeated a story he had heard of a farmer who was struck through the boot by a rattlesnake as he was walking through his cornfields. The man went home, became violently ill, and died in a few hours. Twelve months later, so the story went, the man's son wore his father's boots on a long walk to church one Sunday. He died that same night, in agony. When a second brother fell victim, the family finally linked the deaths to the boots, discovered a fang lodged in one, scratched the nose of a dog with it, and watched the poor animal expire on the spot. As if to confirm these facts, Audubon wrote, "I have been told by native Americans, that arrows dipt in rattlesnake venom, would carry death for ages after."[40]

The boot story was a tall tale, told and retold as stories were on the frontier until it entered the realm of myth. And while it is possible that Audubon watched a snake chase a squirrel through the trees at Oakley, finally killing it by constriction, the snake he saw could not have been the heavy, lethargic rattler. (It might have been a blacksnake, which is known to climb trees and crush its prey.[41])

In his journal, Audubon wrote contemptuously of a book called *Wanderings in South America* by Charles Waterton, who claimed to have had many wild and fantastic adventures in his travels.* Audubon was clearly skeptical, and evidently did not confine his comments to his journal: Word of the "American woodsman's" scorn for his work reached Waterton, making him an instant enemy. He would seize on the rattlesnake paper to get his revenge; eventually he teamed up with George Ord, Audubon's old nemesis in America, and the two launched a particularly venomous campaign to destroy the artist's reputation.

What came out of this imbroglio was Audubon's decision to limit his writings to the "Ornithological Biographies" he planned to publish with his pictures. He also decided not to answer his detractors; others might argue in his defense, but he had neither the time nor the inclination to become embroiled in intellectual spats. Unlike Waterton and Ord, he was not independently wealthy; he would let them foam at the mouth and pay no attention at all—publicly, at least. Privately, he was stung by their pricks at the thin veneer of his self-esteem. They triggered all his old feelings of inadequacy, all his fears that the great men who had accepted him, who had helped him so readily, would think him an impostor.

On December 21 he wrote in his journal: "Weather clear with sharp frost. I thought as I saw it what a number of wild Ducks I could have brought down from their wings with a little powder and plenty shot."[42] It had been a long time since he had roamed the woods with Billy Bakewell in Henderson, and nine months since he and Johnny

*Audubon ever after referred to him as the "alligator rider."

had hunted together in Louisiana. He could not think of those days, that life, without feeling a terrible longing, and an awful fear.

A year before, in his wildest dreams, he could not have imagined the life he was leading in Edinburgh. Everything had come together; his exhibit, which would close in a few days, had been a success, both artistically and financially. (He took in more than $770 after all expenses were paid. And with some of the money he rushed right out to buy Lucy a brooch for Christmas.) He was invited to the homes of the eminent and the noble, the distinguished and the very rich. The aristocracy no longer left him speechless, though it was still true that his main reason for never turning down an invitation was not to lose a possible subscription.

The Countess of Morton came to town, saw the birds, and invited Audubon to stay overnight at Dalmahoy, the seat of the earls of Morton, and to meet her husband. Audubon happily accepted, and two days after Christmas a marvelous carriage upholstered in purple morocco came to waft him and his portfolio of drawings off to the elegant country house, eight miles outside Edinburgh. As the carriage rolled up to the impressive entry, his old dread returned. He had imagined the earl as formidable, another Richard Coeur de Lion, but when the countess rolled her husband out in his wheelchair and presented him— " a small slender man, tottering on his feet, weaker than a new hatched Partridge, welcoming me to his hall with tears almost trickling from his eyes"—Audubon felt a certain relief. Where there was no overbearing man of the house to contend with, he could relax and enjoy himself.[43]

He was led up a curving staircase to the first floor and into a room some sixty by thirty feet, hung with paintings by Rembrandt, Claude Lorrain, Van Dyck, and Titian, among others. Amazed, he wandered around with the countess beside him. When he glanced out of a window, he was surprised to see Edinburgh in the distance, the castle and city in miniature.

His drawings were admired, as usual, after which an elaborate dinner was served by men in powdered wigs and rich red livery; when he went to the "yellow room" where he was to stay, he found his linens

already laid out and warming by the fire. He sat down at the writing table and described the room to Lucy: "All was truly yellow in this yellow chamber. It might well have been a parlour in some other countries. The bed for me this night was ornamented with crowns, and was large enough to receive four of my size. A sofa was at the foot of it, large arm chairs on each side of the fire, a table containing a writing desk with all ready, and everything that I never use." He opened one door to discover a "bathing" room, with large porcelain tables, jars of water, and linens. "I saw, but touched nothing. I was clean enough."[44] Another door led into a room with chamber pots. He was in the lap of luxury.

Audubon described the countess as being about Lucy's age, "not what men call handsome, or beautiful" but well formed (something he never failed to notice), with lovely dark eyes and a stutter.[45] She had asked him, as ladies often did, for a drawing lesson.

After breakfast, chalks and crayons were readied and the lesson, with the earl looking on, began. Audubon taught her how to shade with cork and how to prepare watercolors. At eleven they were interrupted by the falconer, come to show Audubon his hawks in full dress, complete with bells, hood, and crest. The weather prevented any hunting demonstration, for which Audubon was sorry.

During a lull in the lesson, the countess announced that she would like to subscribe to the *Birds* and with a steel pen entered her name in his subscription book (which he happened to have with him). She offered to pay for the first number in advance; Audubon was relieved that he could afford to demur. His time had been well spent: The Countess of Morton was a valuable addition to his list. She offered him letters of introduction to important people she knew. She was, in fact, so eager to help that he felt free to ask her for some fresh pheasants to draw, and she sent a hunter out to kill some for him. When he left that afternoon for the hour's drive into town, the countess asked him to spend another night the following week and give her another lesson. He agreed with pleasure; he was beginning to feel comfortable with nobility—and with the luxury of purple morocco, warm linens,

•

and private indoor "bathing rooms." Dalmahoy was a far cry from the boardinghouse in Louisville, where he and Lucy had to perform their ablutions in the yard.

On Friday the twenty-ninth he received two letters from Lucy, posted in October, only two and a half months before. These gave him the calm he needed to paint all that day and the next. His picture of two cats fighting over a dead squirrel had, he admitted, turned out about as well as a journeyman carpenter's would have. He knew his limitations as a painter in oils and was intent on improving. His charcoal portraits had once provided quick cash; now, he knew, oil paintings might serve the same purpose, if only he could achieve some proficiency.

"Captain Hall attacked me about America again," Audubon wrote in his journal.[46] Hall had become a fast friend and frequent visitor, largely because Audubon had not stinted in his efforts to help Hall plan his journey to America. The captain proposed to cover much territory that Audubon knew well; they spent long hours going over maps together; Audubon wrote long memoranda detailing sights to see and people to meet, and also provided letters of introduction. In return, Hall went to lengths to get Audubon the invitations he knew he wanted.

On New Year's Eve, Audubon went to dine with Basil Hall, his wife, and his mother-in-law, Lady Hunter.[47] Also present were assorted writers, among them the *Edinburgh Review*'s Francis Jeffrey, who had so far managed to avoid Audubon altogether. The artist felt that Jeffrey had been rude to him, and was in no mood to fawn: "If *he* was Jeffrey, *I* was Audubon." [48] Audubon was first to arrive; Jeffrey and his wife, last: "Then famous Jeffrey and his wife entered; a small (not to say little) being, with a woman under one arm and his hat in the other."[49] Audubon thought Jeffrey more cunning than shrewd, and said he talked too much. As for Mrs. Jeffrey, Audubon told his journal that she was "dressy and had a twitch of a nervous nature that, joined to her uncommon share of *plainness* (for I never called a woman ugly in my whole life) rendered *her* not extremely interesting." [50]

Hall tried his best to get the two men together, but neither was cooperating. Every time the host tried to turn the conversation to

America, to give Audubon a chance to speak, Jeffrey changed the subject. At ten o'clock, in spite of its being New Year's Eve, Audubon excused himself and walked briskly home. It was not a safe evening to be abroad, but the watch had been doubled, and more gaslight than usual lit, and he arrived safely at 2 George Street, where at midnight he joined his landlady, Mrs. Dickie, for a toddy and a toast to the New Year.

That night he wrote on the last page of his journal that the time had come to send the book home to Lucy, so that she could read it and "observe my very gradual advancement into a World yet unknown, and dangerous to be known. A World wherein I may prosper but wherein it is the easiest thing to sink into compleat oblivion." [51]

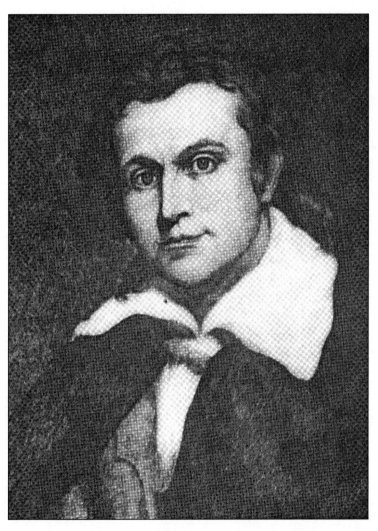

John James Audubon. Copy of one version of the miniature
portrait by Frederick Cruikshand, 1831.
*(Tyler Colleciton, John James Audubon Memorial Museum,
Henderson, Kentucky)*

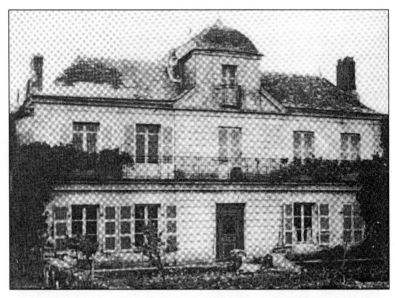

La Gerberaere, Audubon's childhood home in Couëron, France.
*(Tyler Collection, John James Audubon Memorial Museum,
Henderson, Kentucky)*

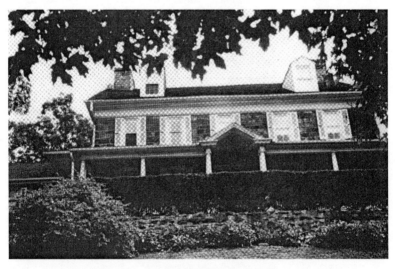

Mill Grove Farm near Philadelphia as it appears today. Now a
museum and part of the Audubon Wildlife Sanctuary, it was
Audubon's first home in America.
(Maria Streshinsky)

Remnant of the Mill Grove lead mine that caused the young
Audubon so much grief in his early years in America.
(Maria Streshinsky)

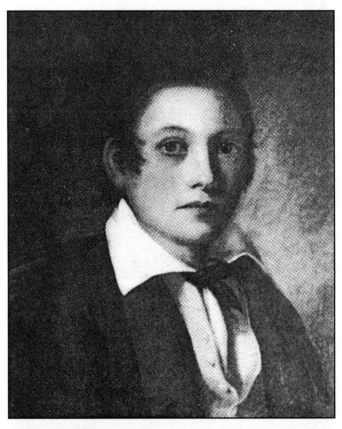

Among Audubon's first attempts to paint in oil were these portraits of his
sons, completed around 1823 when Victor Gifford Audubon (1809-1862),
ABOVE, was fourteen years old, and John Woodhouse Audubon (1812-1862),
OPPOSITE, was eleven years old.
*(Tyler Collection, John James Audubon Memorial Museum,
Henderson, Kentucky)*

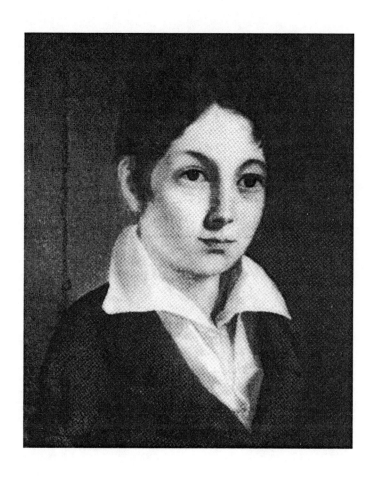

In the unhappy years after Audubon was forced in bankruptcy in
Kentucky, he scraped together a living for his family by doing black
chalk portraits. These first attempts, finished in 1819, were offered as
gifts to his very good friends the Berthouds, in Shippingport, Kentucky:
James and Marie-Anne-Julia and their son, Nicholas. The portrait of
Nicholas was presented to his wife, Eliza Bakewell Berthoud,
who was Lucy Audubon's sister.
(All three, Collection of the J.B. Speed Art Museum, Louisville, Kentucky)

The West Indies-style Oakley Plantation near St. Francisville,
Louisiana, where Audubon spent one important summer tutoring the
young mistress of the house, sixteen-year-old Eliza Pirrie.
Today it is preserved as Oakley Gardens and Audubon State Park.

On September 10, 1826, Audubon sketched "A Robin Perched on a
Mossy Stone" for Hannah Mary Rathbone at Green Bank, the Rath-
bone country home outside of Liverpool. On the back he wrote, "It was
my greatest wish to have had affixed on the face of this Drawing my real
thoughts of the amiable lady for whom I made it in Poetry Divine!—
but an injunction of Hannah Rathbone against this wish of my Heart
has put an end to it."
(Courtesy of the University of Liverpool Art Gallery)

Miniature portraits of the four Audubons drawn in London between
1834 and 1836 by their family friend Frederick Cruikshank.
(Courtesy of the Charleston Museum, Charleston, South Carolina)

LUCY BAKEWELL AUDUBON

JOHN JAMES AUDUBON

JOHN WOODHOUSE AUDUBON

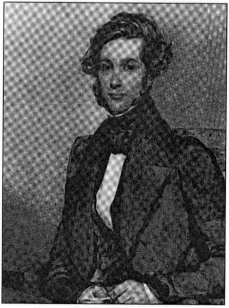

VICTOR AUDUBON

Miniature of John Audubon's half sister, Rose
Bouffard Du Puigaudeau,
who lived in Couëron, France.
*(Tyler Collection, John James Audubon
Memorial Museum, Henderson, Kentucky)*

John Bachman (1790-1874) was Audubon's great friend and collabora-
tor. A Lutheran minister in Charleston, South Carolina, Bachman was
also an avid ornithologist and naturalist. Audubon's sons married two
of the Bachmans' daughters. This portrait of the genial Bachman was
painted by John Woodhouse Audubon about 1837.
(Courtesy of the Charleston Museum, Charleston, South Carolina)

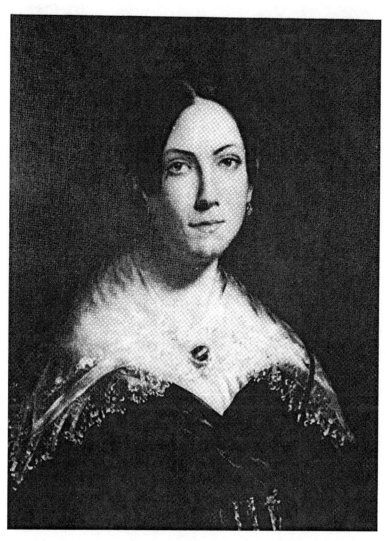

Maria Bachman Audubon (1816-1840) as painted by her husband,
John Woodhouse Audubon, in Edinburgh, Scotland, in 1838. She died
of tuberculosis two years later.
(Courtesy of the Charleston Museum, Charleston, South Carolina)

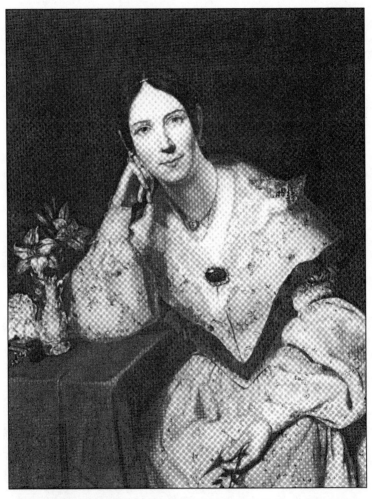

Eliza Bachman Audubon (1818-1841). Victor Audubon painted this
portrait of his young wife, Eliza Bachman Audubon, around 1840. She
succumbed to tuberculosis a year after her sister's death.
(Courtesy of Anne Coffin Hanson)

Maria Martin Bachman (1796-1863), the "Sweet Heart" of Bachman's and Audubon's letters. An artist in her own right, she provided many of the background paintings of flowers and plants in *The Birds of North America*. When John Bachman married her sister, Harriet, Maria joined the household and became a trusted friend and helper to the whole family. Two years after her sister's death in 1846, Maria and John Bachman were married.
(Courtesy of the Charleston Museum, Charleston, South Carolina)

Lucy Audubon and her granddaughters, Lucy and Harriet—
John Woodhouse's daughters by Maria Bachman. After their mother's death,
Lucy raised the girls.
*(Tyler Collection, John James Audubon Memorial Museum,
Henderson, Kentucky)*

Life mask of John James Audubon made by
Robert Havel in 1830.
*(Tyler Collection, John James Audubon Memorial Museum,
Henderson, Kentucky)*

12

I must put myself in a train of doing . . .

and thereby keep the machine

in motion.[1]

Wɪᴛʜ ᴛʜᴇ ɴᴇᴡ ʏᴇᴀʀ ᴏF 1827, Audubon stood gazing into the future and the formidable task he had set himself. In Edinburgh, with Lizars's solid support, it did not seem insurmountable. They were working on a prospectus that would detail the plan for publication. So far, five bird portraits had been printed—with 395 yet to come. The first, a wild turkey, as a purely American bird was perfect to lead off the series, and it filled the sheet of paper. Next came the yellow-billed cuckoo and prothonotary warbler, then the delicate purple finch and the Canada warbler. The choices were exquisite, and Joseph Mason's pawpaw leaves, Louisiana cane-vine berries, and magnolia seedpods added to the charm of the finished engravings. Mason's name did not appear. Audubon did not intend to share credit.

He was far from having all the drawings he would need. Since he based his reputation on always working "from nature" rather than from

stuffed birds, he knew that at some point he would have to return to the United States to observe and draw those birds he didn't have. The Far West beckoned to him, and so did Florida, with its great flights of migrating shore and land birds. He had covered the Mississippi flyway adequately, but there were birds in the Eastern forests that he did not have. He hoped to find new specimens to make the book as complete as it could be.

First things first; right now, with Lizars already planning the second number, he needed to make the money to keep them going, which meant selling subscriptions. Those rich enough to buy were concentrated in London; he could no longer delay going.

There were no new letters from Lucy; writing to her was like calling into a chasm and hearing the echo dissipate. This was not what either wanted, but there was nothing to do about it and after a time they scarcely bothered explaining, much less justifying, the decisions they were forced to make separately. ("Do write *why* thou left Mrs. P. I thought thou wert so attached to her that nothing would make you part," he wrote, more curious than concerned, long after Lucy had made her move.[2])

Occasionally he took a fatherly tone: "John may have my gun as his own if he will positively take lessons of music and Drawing and improve, but that he must pledge his word to thee that he will be industrious and a good boy to thee."[3] He blurted, "Oh to be able to write 'Lucy my love come to me.'"[4] But inevitably such words would be followed by something like "Wait there with a little patience. I hope the end of this year will see me under headway sufficient to have thee with me with comfort here and thou I need not tell thee that I long every hour of the time I am absent for thee. I conceive it best to be prudent."[5]

But most of the time, Audubon's letters to Lucy were filled with his achievements; he was always optimistic, he needed to keep her spirits up, and he could not restrain himself from dreaming of the possibilities. The first hundred subscribers, he wrote to Lucy, would pay for the engraving and the plates. After that, the only expenses would be the paper, the printing, and the coloring. Two hundred subscribers would

be enough to give them a profit of $3,902 a year, "enough to maintain us even in this Country in a style of Elegance and Comfort that I hope to see Thee enjoy." Buoyed by this thought, he worked out what five hundred subscribers would bring them: $10,754! They would be rich![6]

In the magnolia forests of Louisiana, Lucy read his letters and kept the faith—as much as she could when surrounded by doubters. Many mornings she went out horseback riding, sometimes with Johnny or one of her pupils, sometimes alone. She galloped through the great forests, then returned, put on the black dress and little white cap she invariably wore, and called her class to order. When one of her students did particularly well, she gave her a book.[7] She kept Johnny busy gathering all those things his father wrote for—boxes of acorns for Mrs. Rathbone, skins of animals, samples of wood: bits and pieces of the wonders of America. The Johnsons were much more amiable than Jane Percy; in their home Lucy was treated as a member of the family. When she could, she visited friends and showed them the newspapers that detailed her husband's successes. And she waited. It would not be long before he sent for them, she assured everyone. It was only a matter of time.

Time assailed Audubon in Edinburgh, as well. He knew he must start the round of peddling, but he found reasons to delay. He had already been elected to the Antiquarian and Wernerian societies; early in January he settled down to get himself elected to a few more. On the sixteenth he wrote John Syme, who had painted his portrait, "May I beg of you the favour to present my name to the Scottish Academy of Fine Arts as a candidate for an Associate of that Body," signing his name with the usual flourish "resembling the path of a bird in flight."[8] He promised to give the Academy a full-length picture of a covey of Highland blackcock "painted from nature."[9] The same day, Syme urged the Academy to accept Audubon, and it was done.[10] The Royal Society was to elect him in March.

Audubon was busy collecting letters of introduction—those magic keys to the doors (and, he hoped, the purses) of the influential and wealthy. He would need them in London, not to mention the lesser

cities he planned to visit on the way. Basil Hall gave him twenty letters. He paid another visit to Dalmahoy, where the countess gave him an impressive letter to the home secretary, Sir Robert Peel. At the request of the countess, the letter had been written by the lord advocate of Scotland.*

The winter was especially hard, with deep snowdrifts stopping all traffic between cities and making it difficult even to get around Edinburgh. It was at this juncture that Audubon became better acquainted with Joseph Kidd, a nineteen-year-old landscape artist who had already made a name for himself with his oils. Audubon was painfully aware that, especially at first, subscriptions might not cover the costs of publishing as well as his living expenses. He needed to be able to make fast money elsewhere, and the most logical way would be to produce oil paintings good enough to sell. For three guineas a copy, Kidd, who was dazzled by Audubon's celebrity, agreed to give him lessons in perspective, plus a copy in oils of one bird portrait.[11] If this copy turned out well, Audubon was considering having him reproduce all the birds for a traveling exhibit. Such an exhibit could bring in money to support the *Birds,* and would publicize the project as well, but Audubon had first to gauge Kidd's abilities. Each morning Kidd appeared at Audubon's rooms, where they breakfasted together and then set to work. David, Audubon's phantom master, was not mentioned, and Audubon threw himself into his studies with his usual intense concentration.

On the morning of January 22, 1827, Basil Hall suddenly appeared to tell Audubon that Sir Walter Scott was ready to receive him. At once. It was like a summons from a god; no man in the English-speaking world was better known than Scott, and Audubon was breathless with anticipation. He threw on his coat—remembering, for once, to put on his shoes (he had a habit of dashing out in his slippers), and they walked off at a good clip. Scott greeted them wearing a morning gown of light-purple silk. Audubon was so starstruck that he could scarcely speak, leaving Captain Hall to carry on the

*[The office of lord advocate is equivalent to that of attorney general.]

conversation. "I talked little, but, believe me, I listened and observed, careful if ignorant," Audubon wrote in his diary that evening.

Scott, not realizing that the American was tongue-tied in his presence, got a first impression that was not quite accurate. "He is an American by naturalization," he wrote, "a Frenchman by birth, but less of a Frenchman than I have ever seen,—no dash, no glimmer or shine about him, but great simplicity of manners and behaviour; slight in person and plainly dressed; wears long hair, which time has not yet tinged; his countenance acute, handsome, and interesting, but still simplicity is the predominant characteristic."

Scott asked Audubon to call again, which he did a few days later, this time bringing his pictures with him. Scott was more interested in the man than in his pictures; in fact, his chief interest was in the *idea* of Audubon as a hunter who roamed the wilderness with savages. He preferred the romantic American woodsman image to that of the struggling gentleman artist.

As for Audubon, he was not so much in awe that he couldn't ask a favor. After a second visit, he wrote the Great Man: "On the eve of my departure to visit all parts of the island, and afterwards the principal cities of the Continent, I feel an ardent desire to be honoured by being the bearer of a few lines from your own hand to whoever you may please to introduce me. I beg this of you with the hope that my efforts to advance ornithological studies, by the publication of my collections and manuscripts, may be thought worthy of your kind attentions, and an excuse for thus intruding on your precious moments. Should you feel the least scruple, please frankly decline it, and believe me, dear sir, that I value highly my first reception, when presented to you by my good friend Captain Basil Hall, and your subsequent civilities."[12] Scott's courteous refusal: "Dear Mr. Audubon,—I am sure you will find many persons better qualified than myself to give you a passport to foreign countries, since circumstances have prevented our oftener meeting, and my ignorance does not permit me to say anything on the branches of natural history of which you are so well possessed. But I can easily and truly say, that what I have had the pleasure of seeing,

touching your talents and manners, corresponds with all I have heard in your favour; and that I am a sincere believer in the extent of your scientific attainments, though I have not the knowledge necessary to form an accurate judgment on the subject. I sincerely wish your travels may prove agreeable, and remain, Very much your Obedient servant, Walter Scott."[13]

Scott's letter, addressed to no one in particular and making it plain that he scarcely knew Audubon, was something of an embarrassment. That didn't keep Audubon from writing Lucy: "Sir Walter Scott has also been so kind as to give me a Letter that I may exhibit wherever I may go—I have Two Letters from him very kind—all this I think will afford thee great Pleasure."[14] Lucy, at least, would get a little thrill from her husband's acquaintance with the literary giant—and it might give her something to use to counter his detractors.

Though the celebrated young artist Edwin Landseer was only in his early twenties, aristocrats were buying his works for £1,000 each.[15] (Landseer had stayed with Scott for a time to paint the author and his dogs. Scott thought the paintings of his dogs first-rate: "The most magnificent things I ever saw, leaping and grinning on the canvas.") In 1827, Landseer was working on his *The Hunting of Chevy Chase,* a celebration of blood sport. Like Scott, most of England thought Landseer's work superb. Audubon did not.

At the Royal Institution he studied Landseer's painting of the death of a stag. After giving the artist his due for technical ability, he wrote: "But nature was not there, although a stag, three dogs, and a Highlander were introduced on the canvas. The stag had his tongue out and his mouth shut! The principal dog, a greyhound, held the deer by one ear just as if a loving friend; the young hunter had laced the deer by one horn very prettily, and in the attitude of a ballet dancer was about to cast the noose over the head of the animal."[16] He was convinced that his old woodsmen friends back in Louisiana would have laughed at this depiction of the hunt, but the Scots seemed taken by Landseer's romanticized savagery. The stag was not, Audubon noted pointedly, *drawn from nature.*

If he was displeased with Landseer's effort, he was even more critical of his own blackcocks, hanging in the exhibit. The birds themselves were fine—he knew how to draw birds. But the rest of the painting! "What a difference exists between drawing one bird or a dozen and amalgamating them with a sky, a landscape, and a well adapted foreground. Who has not felt a sense of fear while trying to combine all this?"

This was the cry of an artist struggling to master a medium, to define his own style. Sometimes he was pleased with a work in progress; at other times he would look at one and think it "a miserable daub." The birds would be fine, but "the ground, the foliage, the sky, the distance are dreadful," he would comment, and put the work aside in disgust.[17] But he always came back, and with Kidd's steady help he was improving.

He spent much of February at his writing desk, turning out letters of introduction for Captain Hall's coming American journey, and— also at Basil Hall's request—a paper on wild pigeons to be read at a meeting of the Natural History Society. He wrote all day and much of the night, slept three hours, and got up again to correct the paper. Writing at such a pitch had taken him back into the woods of America so that "my ears were as if really filled with the noise of their wings; I was tired and my eyes ached."

To shake off his homesickness, he walked eight miles to the sea in weather so cold he thought his nose would drop off. His mood was not improved when Hall called; the captain had reservations about the passenger pigeon paper. He argued against ascribing human emotions to birds, against pigeons "or any other brute species" feeling affection or love. Audubon reacted explosively, at least in his journal. He ranted on about man's self-conceit and lack of humility. Exactly what he said to Hall he did not report, only: "At the exhibition rooms I put up my drawing of the Wild Pigeons and Captain Hall read my paper."

Audubon was learning by copying his bird portraits in oil; as February moved into March, there were times when he and young Kidd painted all day long. The weather turned bitterly cold and snow drifted

through the city and countryside, as high as six feet in places. No mail came through and few people so much as ventured out. Audubon did go to hear Sydney Smith preach a sermon he felt was directed at him; he attended lectures and meetings of the various learned societies and went to dinners with dancing. He even attended a fencing meet. Sometimes, he reported to his journal, he didn't get to bed until two or three in the morning, quite exhausted by all the dancing and singing.[18] Occasionally, his sense of inferiority welled up, and he recorded that the company was "all too high for me." He found Mrs. Basil Hall charming, but he couldn't help wondering what she was going to think when invited to stay in a squatter's hut in Mississippi. None of these people could imagine what it was like to be wrapped in bearskins, floating down the Mississippi on a flatboat with some of the coarsest men on the face of the earth.

As the time for Audubon's departure from Edinburgh drew near, his friends mounted a concerted campaign to get him to cut his hair. Through an intermediary, the Countess of Morton let it be known that she felt that he must get a haircut and have a fashionable coat made before appearing in London. Captain Hall added his voice to a rising chorus of pleas for Audubon to cut the long curls that he so clearly fancied. Long hair was all well and good for the provinces, they told him, but London was too sophisticated, too modish. Audubon finally capitulated. "Good God! if Thy works are hated by man it must be with Thy permission," he wrote in a page of his journal that he lined in black, to mourn the loss of his wonderful locks. He sent for a barber, and gave up the last vestige of American woodsmanhood. Now he looked like any other Englishman, as one of his subscribers, Miss Harriet Douglas, told him, though his accent corrected that mistake. Soon after being shorn, he noticed that he was taken for an officer from the Continent when, only three days before, he had been mistaken for a priest.

Finally he could delay no longer; it was settled that he would leave on April 5. In the two weeks before his departure he worked like fury, painting in oils from five in the morning until dark, determined to

improve his perspective. Then he went out to say his good-byes. All
this while he had been going to the Lizarses' home for talk and com-
fort; they were his most ardent admirers, his substitute family, and he
dreaded leaving them.

At six on a bright spring morning his coach left Edinburgh; it was
past four in the afternoon when he arrived at Twizel House, the home
of his fellow ornithologist Selby. At this great house, as at so many
others, he felt both welcome and ill at ease. It pleased him to have the
Selby children gather around, and he was generous in offering drawing
lessons to the women, who were more or less accomplished, as gentle-
women were expected to be. With the men he went on shooting par-
ties, tramping for miles over the moors with gun in hand, always ready
to blast away, proving himself a man's man (though he did not like the
war talk of military men). Evenings, Selby invited friends to come meet
Audubon, and he would show his pictures all over again.

He could never sleep much past five in the morning, so he got
up and tiptoed downstairs, carrying his shoes so as not to disturb the
family. Then he broke out into the countryside to walk, "or rather run
about, like a bird just escaped from a cage; plucked flowers, sought for
nests, watched the fishes, and came back to draw."

He remained at Selby's for a week, and left with three new sub-
scriptions. Newcastle was the next stop in the circuitous journey that
would end in London. He did not like the look of Newcastle, "all dark
and smoky" and shabby; he thought that even the people looked wan
after the rosy-cheeked Highlanders. To make matters worse, at his inn,
the Rose and Crown, breakfast had been "indifferent" and, worse,
"served on dirty plates." (This from a man who had slept on bearskins
and eaten with his hands.)

Now Audubon had the kind of letters of introduction that opened
important doors at once; besides, his reputation preceded him. The
secretary of the Literary and Philosophical Society helped him find
lodgings where he could show his work. Five people called on him the
first afternoon and, most thrilling of all to Audubon, he received an
note from the world-famous wood engraver Thomas Bewick, asking

him to tea. "I call him wonderful," Audubon explained, "because I am sincerely of the opinion that his work on wood is superior to anything ever attempted in ornithology."[19]

Bewick's son and partner, Robert Elliott Bewick, came to take Audubon to his father's house, where they found him at work. A warm rapport between the two men was instantaneous. "He came to me and welcomed me with a hearty shake of the hand," Audubon wrote, "and took off for a moment his half-dean cotton night-cap tinged with the smoke of the place. He is tall, stout, has a very large head . . . A complete Englishman, full of life and energy though now seventy-four, very witty and clever." Audubon was enthralled.

They joined the rest of Bewick's family for tea. Two of the daughters, Audubon noted, had "extremely fine figures," but it was the old man who fascinated him. "Now and then he would take off his cotton cap, but the moment he became animated with the conversation the cap was on, yet almost off, for he had stuck it on as if by magic. His eyes sparkled, his face was very expressive, and I enjoyed him." The two artists "stuck to each other," Audubon recounted. They talked admiringly of each other's work, and before he left that night, Bewick had given him a copy of his *History of Quadrupeds* to send to Johnny.

The next day a flood of people, including the whole Bewick family, came to Audubon's rooms to see the drawings. Learning for the first time the scope of Audubon's publishing plan, Thomas Bewick announced himself "perfectly astounded at the boldness of my undertaking."

Audubon stayed in Newcastle for a week, seeing Bewick almost every day. One of the Bewick daughters, Audubon confided to his journal, reminded him so much of Hannah Mary Rathbone that "I frequently felt as if Miss Hannah, with her black eyes and slender figure, were beside me." He spent time with the master in his shop, where Bewick demonstrated his technique. "But cutting wood as he did is no joke; he did it with as much ease as I can feather a bird."

Several hundred people flocked to Audubon's rooms to see the pictures. One day he happened to glance out of the window to see a groom walking three fine horses. Almost immediately, a young lady

and gentleman entered the room, "whip in hand, and spurred like fighting-cocks; the lady, with a beaver and black silk neckerchief, came in first and alone, holding up with both hands her voluminous blue riding-habit, and with a *ton* very unbecoming her fine eyes and sweet face. She bowed carelessly, and said: 'Compliments, sir;' and perceiving how much value she put on herself, I gave her the best seat in the room."

The two young people jangled him with their haughty manner and their questions, which he found insolent. Always wary of slights, especially from those of a higher class, Audubon bristled but said nothing, only confiding to his journal that he longed to be in America's dark woods. When some well-meaning man suggested that Audubon might sell even more subscriptions if he would go out to solicit members of the nobility and gentry, the artist thanked him very much but let him know that he had no intention of doing any such thing: "Although there were lords in England," he told the man, "we of American blood think ourselves their equals." The man laughed, and told Audubon that he was less of a Frenchman than he looked.

Despite these irritations, Newcastle had treated him uncommonly well. He added five new subscribers to his list, and he had made a friend of Thomas Bewick, whose daughters said it had been a long time since they had seen their father so animated as he was with Audubon. When he went to say good-bye, the old man beamed with pleasure as they shook hands. Then he gave him a letter, explaining, according to Audubon, "I could not bear the idea of your going off without telling you in written words what I think of your 'Birds of America.'" It was a generous gesture from one of England's most celebrated artists. In his journal, Audubon mused that Sir Walter Scott "will be forever the most eminent in station, being undoubtedly the most learned and most brilliant of the two; but Thomas Bewick is a son of Nature." He was also, Audubon went on to claim, *"the first wood-cutter in the world!"* It was perfectly clear which of the two men he preferred.

Audubon went from Newcastle to York, where he described his stout landlady: "In ratio with that of her husband, is as one pound

avoirdupois to one ounce apothecary! She looks like a round of beef, he like a farthing candle."[20] A late-April snow fell, it was cold and blowing and miserable, but he forced himself to go through the increasingly familiar routine: He delivered his letters, then waited in his rooms for people to come. The museum people responded first, then others—a few, then many. Almost every night he was invited to dinner at someone's home. The talk in York was of politics; Audubon broke his promise to Lucy by remarking in his journal that, in his opinion, the English would be better off reforming their laws to improve the miserable lot of the poor, rather than meddling in distant places.

Things got off to a slow start in York; there were no interesting people to meet, and he was tempted to push on. He stayed with his plan, though, and it proved worthwhile: When he left, on schedule, at the end of a week, he had ten new subscribers. Leeds, his next stop, added five more. For a man who loved action and the outdoors, this salesman's life was hard: He spent long hours in his rooms, holding up the pictures until his arms ached, answering the same questions over and over again. As a reprieve, he took long early-morning walks, and broke away whenever he could to go into the countryside. On one walk where others were about, he came upon a covey of partridges and was amused at the stir they caused. In his journal that night, he tried to imagine what these people would say if they should see "a gang of Wild Turkeys—several hundred trotting along a sand-bar of the Upper Mississippi?"

May 1, 1827, marked the first anniversary of his departure. He longed to be with Lucy in Louisiana, while she wanted nothing more than to join him in England, and hoped to join him early in the next year, 1828. Audubon hoped, too—but he knew that Bewick was right to be "perfectly astounded at the boldness of his undertaking." He and Lucy were now at odds. The gold watch he had sent her soon after his arrival had not been delivered, and it became a nagging symbol of the malaise growing between them. Neither of the Audubons could know how long it would be before they were together again. Had they known, they would have despaired.

He reached Manchester in the rain, and received a warm welcome from Mr. Bentley, who had been helpful on his first visit to the city. This was a homecoming; he was entering the sphere of Liverpool, calling on the Rathbone relatives, finding everyone happy to see him. Since his birds had been exhibited here before, he decided to show only the five pictures of the first number. This saved him a great deal of time and effort, and he quickly got five new subscribers. The one thing he couldn't find at once was suitable rooms—but a kind friend of a friend insisted he move into his home, and it was done. (His generous host also bought a drawing of doves for twenty pounds, and made an energetic effort to find new subscribers.) At the end of the week, Audubon had eighteen subscriptions—a record. He was in a fine frame of mind as the coach pulled out of York; at three that afternoon he was in Liverpool.

He did not go straight to Green Bank, thinking it best to pause and send word to the Rathbones that he had arrived. William Rathbone appeared almost immediately to tell him all the family news and say he must come out the next day.

There are no journal entries for the next four days. On Saturday he explained that he had lent the journal to Hannah Mary and her mother because "I felt great pleasure in letting my good friends the Rathbones know what I had done since I was here last . . . and left my book, as I said, with them." Caught in the act, he tried to make amends to Lucy. "*Thy* book, I should have written, for it is solely for thee." Most of those four days he spent with the Rathbone women, talking and walking.

He made time to call on the Gordons. Alexander had managed to lose a letter that Lucy had sent him to be forwarded to the Rathbones; he admitted it and apologized, but that didn't take the sting out of Audubon's disappointment. He received so few letters from his wife that Alexander's carelessness was too much to forgive easily. A letter to Lucy fairly vibrates with his annoyance with the Gordons: "I have been quite vexed at Mr. Gordon since here because although he received thy Letter to Mr. Rathbone Two months ago it never was sent here . . . and is (I am told) lost . . . Anne looks better than when I was here before, but apparently dejected and unhappy."[21]

The Gordons were in no mood to coddle Lucy's husband. Ann, who had stayed behind with a difficult stepmother and a desperately ill father, had a well-developed sense of duty. No matter how charming her brother-in-law, she could not forgive him for leaving his wife and children behind to fend for themselves. He may have convinced the Rathbones that his separation from his family was necessary; they did not know what she knew about her sister's struggles, about Audubon's bankruptcy, about how he had gotten the money to come to England in the first place.

Audubon did not intend for them to find out. About "my good Friend Lady Rathbone" he wrote: "She does not know anything of the situation but is extremely kind to me . . ."[22] He believed the Rathbones thought that he was a man of means, and that he was separated from his family by mutual choice. At the Rathbones' comfortable house, Audubon got up at four in the morning to write letters and take care of business so he would have time during the day to spend with his good friends.

He was straining Lucy's patience; even worse, he had Johnny, now almost fifteen, on tenterhooks. Audubon's letters described what father and son would do when Johnny came to England, but not when that would be. Audubon could not see the boy grow restless, did not know how eager he was to get on with school and life. But at least Johnny wrote to his father. Victor finally broke a year's silence with a polite, dutiful letter that contained some local news, and undercurrents of disapproval. Audubon's older son had been brought up in a world where a man's most important task was to provide for his family, and he was deeply embarrassed by his father's failure. Uncle Nicholas was opening a new store in a nearby village, Victor wrote; his own work as a clerk was going well. He found the newspaper articles his father had sent him interesting, but he thought it sad that the publication of the *Birds* was going to take so long before either of his parents could reap the benefits. Then he added, accusingly, "Mamma says you no longer speak of our going to Europe—or of your return to us." Victor would be eighteen in a few months; he was well on his way to becoming a

man, old enough to be his mother's defender. Clearly he thought the price his father was willing to pay for success was too high, and he did not approve of his father's willingness to make the whole family suffer.

Audubon longed to be able to sit down and explain to the boy that it was never fame he courted, but only a way to make an adequate living for his family, to have them with him. Had he succeeded in Henderson, they would be there still, his bird drawings only an avocation. He wanted to explain how hard it was for him, how tenuous everything was, how it frightened him to think of their coming and his not being able to support them. He had been bankrupt once; he could remember when the only food he could provide his boys was apples and a loaf of bread. He could not let that happen again. If he brought them to England, who would care for them if he were thrown into debtors' prison? They were safe where they were. They had no idea that the deadly monkey of his childhood memory was just behind the circle of light, waiting for the right moment to attack. He found himself in the midst of a great financial crisis; men of substance were failing all around him. His only recourse was to work harder, paint more, sell more, meet as many rich men as possible, move quickly. If Lucy knew how easily his house of cards could come tumbling down, her faith in him could be dashed and she might insist he come home to spend the rest of his life with her in the Louisiana woods, scratching out a living.

For a few days, Audubon was able to push away his family worries and indulge in a romantic respite with Hannah Mary. It gave him the courage to press on to London. "With a heavy heart I said adieu to these dear Rathbones," he wrote, and went out to challenge "the mouth of an immense monster, guarded by millions of sharp-edged teeth, from which if I escape unhurt it must be called a miracle."[23]

Of London he wrote: "Edinburgh is a mere village compared with this Vasty Capital—the duke of Bedford owns several streets himself that would cover Louisville entirely."[24]

He found rooms at 55 Great Russell Street, a block from the new British Museum. He arrived on a Sunday night; on Monday morning he was out and about, delivering his letters. This time no one put him

off; his letters were too good. One of the first to draw him in was John George Children, secretary of the Royal Society, who spirited him off that very night to a meeting of the Linnaean Society, where Audubon showed the first number to an admiring audience.

John Children proved to be the best possible champion; he was to guide the ornithologist-artist through the labyrinth of London's artistic, intellectual, and scientific world with goodwill and common sense. Audubon's luck was holding.

Audubon's cache of letters of introduction carried him through the week. "I have been about indeed like a post-boy," he wrote in his journal. He walked everywhere, crossing the city and recrossing it.

At eight-thirty one Saturday morning—far too early to be making calls, someone finally told him—he went to the home of Sir Thomas Lawrence. An eminent artist and a great favorite with the court, Lawrence was one of the last artists to be supported by princely patronage. In 1826 he had served as president of the Royal Academy. As soon as Audubon mentioned Sully's name, Lawrence put out his hand and read the letters Audubon brought. It was a brief encounter, but productive; the two agreed to meet at eight that Thursday morning to look at the *Birds*.[25] Lawrence saw the drawings, liked them, and promised to help. The promise seemed rather perfunctory to Audubon, but Lawrence was to prove as good as his word.

Audubon was operating at such high levels now that he felt certain King George IV would want to subscribe for two, three, maybe even more copies of the *Birds*. Children had put the wheels in motion by contacting Sir Walthen Waller, a palace functionary, to see how Audubon might go about getting the king's name on his subscription list. Albert Gallatin, the American ambassador, had been kept waiting six weeks before George received his credentials; he quickly disabused Audubon of any notion of seeing the king, and said quite bluntly that even if he should be admitted into George's presence, he would not enjoy the encounter very much. (George IV was not a beloved monarch; he was cranky, contentious, irascible, selfish, and lazy. As one diarist put it: "The King is such a blockhead nobody minds what he says." [26])

Audubon found that, though Gallatin "detests the English," he was charming, "a perfect gentleman." Besides, the ambassador had not minced words, but had told Audubon what he needed to know: The king was too boorish to be interested in art; he cared only for whist. Audubon showed his portfolio of birds to Gallatin, his wife, and his daughter; the artist was impressed when the diplomat was able to name nearly every one of his birds, while the two women knew all the plants.

A few days later, Audubon ran into Joseph Kidd on the street. Kidd was visiting London, and once again Audubon invited him to his rooms to paint. Audubon was working on a large oil he called "Sauve Qui Peut," of a bunch of fourteen pheasants being flushed by a fox. It was a riotous canvas, filled with action. He was striving, still, to command the medium. "Sauve Qui Peut" was to be his first real triumph in oil, but he could not seem to get it right. The birds were fine; it was the fox that was wrong. He replaced it with what he called a Spanish dog.

One evening scarcely a week after arriving in London, he took the Clapham coach five miles out in the country to the house of Sir Robert Inglis, head of the East India Company. Here he walked "through avenues of foreign trees and shrubs, amongst which were tulip-trees, larches, and cypresses from America. Many birds were here, some searching for food . . . The house itself was covered with vines, the front a mass of blooming roses exuberant with perfume." Among other guests at dinner that night was the widow of Sir Thomas Stamford Raffles, who had been an inveterate collector during long service in the Far East, and had founded the London Zoo.

Except for the fact that Audubon had arrived at the end of May, when many of the city's important people were leaving for their summer homes, everything was going as well as he could have wanted. London's size and sophistication had bolstered his enthusiasm. In fact, the city's intelligentsia were as amazed by the scope of his vision as were men like Thomas Bewick. If he could produce a book of four hundred huge double-elephant pages filled with every kind of bird known to live in the United States, they did not doubt that it would become one of the world's great books, a masterpiece.

Audubon looked at the numbers already produced by Lizars, and at the growing list of names—he had been in London only a few days when Lord Stanley sent him a note asking to be put down as a subscriber—and he began to feel more secure.

The feeling did not last. A letter from Lizars set his world to trembling violently. The colorers had gone on strike and all work was at a standstill; Lizars could not supply Audubon with the number of prints he needed to fill his orders. Lizars wrote that he had done everything he could think to do and it was not good enough. He did not see how he could continue with the work. Audubon should begin to consider finding someone in London to take it over, in the event that he could not solve the problem in Edinburgh. Otherwise, all was lost.

13

I do anything
for money now a days.[1]

THE MONKEY HAD HIM BY the throat. He depended on
Lizars; the work depended on Lizars. And the best Lizars could do was
suggest he send some engravings to London to be colored.

Lizars was Audubon's good friend; without him, the work might
not have been launched at all. Yet Audubon wondered if this was
Lizars's way of withdrawing from a difficult and demanding task. He
did not want to believe it; he did not even want to think about trying
to find another engraver.

He managed to keep his panic under control. "My thoughts
cooled," he wrote. "I concluded to keep my appointments." In
that second week of June 1827, he was in emotional turmoil,
but he dutifully showed his birds to Lord Spencer, who would
subscribe, then returned to his rooms to find a message that Charles
Bonaparte was in London. He rushed out to Bonaparte's lodgings,

found him gone, and left a note for him. Soon Bonaparte appeared at Great Russell Street. "He wished to see my drawings and I, for the first time since I had been in London, had pleasure in showing them. Charles at once subscribed, and I felt really proud of this."

He did not let on to Bonaparte, or to anyone else for the moment, of his troubles with Lizars. He was in awe not so much of Charles, but of his name, and it had long been in the back of his mind that the two might collaborate. Audubon knew he must find someone with the scientific knowledge he himself did not possess, to help with the text of his great work—if there was to be a great work, which at that moment was in doubt. As soon as Bonaparte left that day, Audubon set out to find someone to color the twenty-five copies that he had asked Lizars to send.

It was an agonizing process which took three days and sent him into London's slums, where "more misery and poverty cannot exist without absolute starvation."[2] He searched out the home of one artist whose name he had been given, found the man at table with his family eating a pathetically meager meal, watched as the young children were sent out "to work," and was horrified when he realized that the "work" was begging. The man could not help Audubon, but sent him to someone who could.

All recommendations led to Robert Havell, Sr., an artist-engraver with a shop on Newman Street, not far from Audubon's rooms. Audubon haunted the shop, returning five times, but each time found Havell away. "I am full of anxiety and greatly depressed," Audubon agonized in his journal. "Oh! how sick I am of London."

Lizars's next letter confirmed Audubon's suspicions: He must find a new engraver. He wrote Lucy a long letter which, while saying nothing at all about the crisis he was facing, fairly simmered with his anguish and frustration. She should understand, he wrote, that her life was "comparatively speaking" far more comfortable than his. She had Johnny, after all, while he was all alone and living in a style that was far less comfortable, he assumed, than she would tolerate. "It is probable that many blame me much in America for the appearance of careless-

ness and absence from my family, and the same doubtless think and say that I am pleasuring whilst thou art slaving thy life away; but can they know my situation, my intentions, my wishes, or my exertions to do well and for the best? I am sure they cannot, for they do not know me a jot. Yet I have to bear the blame and hear of these things by various channels, much to the loss of my peace."[3] His anger at the whole situation boiled over, scalding his wife.

Only a few weeks before, a letter from Lucy had announced that she was eager to come. But after receiving his angry letter, she began to feel that for all his protestations of love, he didn't want her with him. All the fine talk about sending Johnny off to the University of Edinburgh was just that: talk. She had no idea how close her husband was to utter failure, and she was not there to tell him that, at times, what seems to be failure is often fortune in disguise.

On the sixth visit, Havell was in; Audubon showed him the prospectus and the work already done by Lizars. Havell looked and was interested but in the end said, sighing, that at fifty-eight he was too old to undertake such a massive work. He did, however, have a son, Robert Havell, Jr., an artist in his own right and an engraver as well, who might take it on.

The junior Havell met Audubon; each studied the other's work and was impressed. They agreed to work together. The elder Havell was to do some of the coloring and oversee other colorers who would be hired as necessary. Not long after, Havell Junior pulled his first engraving and aquatint of the Baltimore orioles and their hanging nest; Audubon was ecstatic.[4] Havell's work was superb. When Havell Senior applied the colors, Audubon knew he had found the perfect collaborators. He erupted in a small dance and gave both father and son good Gallic kisses on both cheeks. The Havells' work was better than Lizars's—and, even more amazing, it was cheaper by twenty-five percent. Losing Lizars had proved to be providential. Pulled back from the brink of disaster, Audubon wrote Lucy in high spirits, giving her a laundered version of what had happened.[5]

The Havells worked fast, and Audubon had to meet their weekly payroll. Money was not coming in as it should from the first two num-

bers, completed and delivered by Lizars. Audubon decided that soon he must take a trip north to call on his subscribers, collect the money himself, and try to add to his list. Havell could work at a commanding pace; it would take all of Audubon's considerable energy to keep up with him. But first, he had to make some fast money, and that meant turning out oils.

He began to paint with a new resolve, working on his big oil of pheasants being attacked by a "Spanish dog," which he hoped to offer to the king in exchange for his support, and on other, more prosaic subjects. He turned out rabbits, ducks, fowl, and the tried and true "Otter Caught in a Trap"—he made seven of them—as fast as he could. They measured forty-two by twenty-eight inches; he charged twenty to thirty guineas each, and he did not sign them. "I do anything for money now a days—I positively last week made 22 pounds 10 shillings by drawing trifles in a Scotch Lady's Album," he wrote Lucy.[6] Before the paint was dry on some of the oils, he hauled them down to the London shops and sold them for whatever they would bring. "At that time I painted all day, and sold my work during the dusky hours of evening . . . never refusing the offers made me for the pictures I carried fresh from the easel," he wrote. "Without the sale of these pictures I was a bankrupt before my work was scarcely begun."[7]

He was not happy spending so much time on hackwork. On July 2 he wrote in his journal: "I am too dull, too mournful. I have finished another picture of Rabbits; that is all my consolation. I wish I was out of London." He moved to 95 Great Russell Street, where he had more room to paint, and labored through the summer months of 1827. But when Havell presented him with an unexpected bill for sixty pounds, saying that it had to be paid the following Saturday, Audubon was penniless. He had, in fact, just borrowed money for art supplies.

Sir Thomas Lawrence appeared on the scene, gauged the situation, and came to the rescue. Lawrence went through the pictures in Audubon's rooms to see what could be offered for sale, then returned with several men who quickly bought them. (One paid twenty pounds for one of the trapped otters.) Lawrence did not bother to introduce

these men, and Audubon didn't seem to mind. He carried the pictures
to their carriages for them, took their money, paid Havell, and wrote,
"Thus I passed the Rubicon!" Another time Lawrence asked to see the
picture that he had heard Audubon was painting for the king. Audu-
bon brought out "Sauve Qui Peut." Audubon tells what happened
then: "Sir Thomas pushed off my roller Heasal, bade me hold up the
picture, walked from one side of the room to the other examining
it, and then coming to me tapped me on the shoulder and said,
'Mr. Audubon, that picture is too good to be given away; his majesty
would accept it, but you never would be benefited by the gift more
than receiving a letter from his private secretary, saying it had been
placed in his collection. That picture is worth three hundred guineas;
sell it, and do not give it away!'" [8]

The smaller oils, which Audubon turned out in a matter of hours
and sold still wet, were a necessary means to an end—the publication
of *The Birds of America.* Now that Audubon had seen them emerge
in all their full double-elephant glory under the astonishingly skilled
hands of a master engraver, he could produce the oils almost, but not
quite, without shame. When William Rathbone objected to Audubon's
wasting his time on the oils, Audubon agreed with him and congratu-
lated his good taste—and went right on painting, because none of the
Rathbones knew what he was up against, how close to the financial
edge he was living, or how many people were willing to buy the pic-
tures of animals he was able to turn out in an afternoon.

All the hours when he wasn't painting or improving some of the
bird drawings in preparation for engraving, he spent at the Havells'
shop overseeing production. A perfectionist, he would not tolerate me-
diocre work. He received invitations, but for the most part sent his
regrets. He avoided the dinners and late nights that had engulfed him
in Edinburgh, but went to meetings of the learned societies because
the contacts he made there were important to the success of the *Birds.*

One guest he did receive and spend time with was his old friend
Vincent Nolte, who, by introducing him to the Rathbones, had given
Audubon's European odyssey its strong beginning. Ever since their first

meeting almost fifteen years before, Nolte had found Audubon likable and had admired his artistic abilities. Audubon trusted the older man and confided in him. Nolte was to return to New Orleans by way of Shippingport; he promised to stop off to see Victor and Nicholas and explain to them all that Audubon, in letters, could not. (He also sent a five-key flageolet to Victor, along with sheet music and directions for playing it. The gift was meant to show that even if a son was stubborn and disloyal, his father still loved him.) Audubon was convinced that if he could sit down and talk to his family, he could make them understand in an hour what no letters could explain. He hoped that Nolte could do that for him by proxy.

Soon after Nolte left for America, Audubon received word that, through Children's efforts, the king of England had become a subscriber, and had offered his "particular patronage, approbation, and protection" to the work.[9] It must have puzzled Lucy. If the king himself supported Audubon's work, how could it fail? In London, Audubon reported to his journal, "my friends all spoke as if a mountain of sovereigns had dropped in an ample purse at once, and for me." In fact, the king never got around to paying for his subscription, and in the end his patronage counted for little. Audubon, whose survival depended on collecting what he called his "dues"—the money owed him after delivery of each number—was forced to learn to distinguish between smoke and substance.

By the end of summer, the Havells had finished the third number—the "bird of Washington" (bald eagle), a snowbird (slate-colored junco) on a branch of swamp ash, the blue yellow-back warblers (parula warblers) perched on an iris, the great-footed duck hawks (peregrine falcons) tearing at the breasts of teal and gadwall, the prairie warbler, as well as the Baltimore orioles and their hang nest.[10] Audubon took them north with him in a swing that would take him first to Manchester, then on to Leeds, York, Newcastle, Edinburgh, and finally Liverpool. The agents—many of them acquaintances he had asked to make collections—had been remiss; he needed to find new subscribers and cement those he already had. The fine new Havell number gave him courage.

He left London in the middle of August, not a minute too soon. Some subscribers had changed their minds and were canceling; just as disturbing, others had not yet received their second numbers from Lizars. At York, Audubon found the coloring on one set to be "miserably poor," and later he found a copy so bad that he took it away, grumbling at Lizars. He was becoming annoyed with the shoddy work turned out by his old friend's shop.

In Manchester he collected all of the money owed him, acquired nine new subscribers, and, to his delight, saw a box of beautiful bird skins that had been sent to his friend Bentley by "my dear boy Johnny." Buoyed by this sign of family devotion, he wrote a poignant letter to Victor, telling him he hoped soon to have the means "to have your Mamma and John over with me, and the ensuing season, I will also write for you to come. I have but little doubt now of all of this being effected, but still I wish not to blunder any more; and when I do write your Mamma to come, it will be in full assurance that I can make her comfortable for life."[11] *"I wish not to blunder any more,"* he wrote his almost-grown son, hoping he would understand how sincerely his father feared failing them.

Audubon left Manchester in high spirits. On long coach rides, he appreciated good company, and on this journey he met a young man who raved about "a work on ornithology . . . being published in London by an American named Audubon." The trip passed quickly, the two talking the whole way.

Leeds, however, was not a success, and neither was York. To his chagrin, he discovered that his agents had done little, and when he called on subscribers and saw the numbers that had been sent them, he was again displeased with the colorer's work. He sent the worst to Havell to be recolored. Once, he walked a mile out of town to collect from one subscriber, only to learn that he had never received the second number.

It was not easy to explain disappointing work while convincing old subscribers to stay on, and finding new ones at the same time. "How often I thought during these visits of poor Alexander Wilson," Audu-

bon wrote. "When travelling as I am now, to procure subscribers, he as well as myself was received with rude coldness, and sometimes with that arrogance which belongs to *parvenus.*" The Scots, he groused to Lucy, "are the same as they are in all parts of the world where they go, tight dealers, and men who with great concern untie their purses."[12]

In Edinburgh the Lizars family greeted him warmly, which relieved him. While he was annoyed with the work turned out by Lizars's shop, he valued the man's friendship. He was gratified when Lizars looked at Havell's work and magnanimously declared the quality of the coloring, particularly, better than that produced by his own shop. Lizars asked to be allowed to do some part of what he could clearly see was destined to become one of the world's great books, and offered to match Havell's price. Audubon was astonished by this proposal; what kind of profits had Lizars been making, he asked his journal that night, if he could afford to cut his price so much? But he agreed to consider the idea, although he knew it probably would not work out. To take the sting out of his ultimate rejection of the idea, he appointed Lizars's brother David as his Edinburgh agent.

Havell, for his part, had finished fifty fully colored sets of the third number in less than two months, allowing Audubon to take them north with him. *The Birds of America* now had fifteen pages and was growing by the week. Audubon's remarkable drawings, and his decision to have them printed life-size on the largest paper then available, had released a genius in the young engraver: He had found his own masterwork, and he seized the opportunity with an energy and resolve that matched even Audubon's.

In his October 12 journal entry, addressed as always to Lucy, Audubon wrote: "I have set my heart on having two hundred subscribers on my list by the first of May next; should I succeed I shall feel well satisfied, and able to have thee and our sons all together." In the journal which Lucy was yet to see, he had already written that he would not be able to send for his family at the first of the year. But his letters to his wife were more ambiguous; that same October he wrote: "I still think that on the 1st of Jan.y. I will be fully able to write for thee."[13] On November

25, from Liverpool, he wrote her a long, elaborate letter filled with the details of his business, a prologue to yet another delay. He now had 114 substantial subscribers, he explained, and a business that he hoped would support them, but he wasn't ready to "run quite wild" yet.[14]

By the end of November he was back in Liverpool, not entirely cheered by the results of his first sweep. Some of his subscribers, particularly in Edinburgh, had drifted away. From others he was able to collect only part of the money due him. A sortie into Glasgow, where he was certain he would be able to pick up subscriptions from the wealthy who abounded there, had garnered only one new subscription. "No taste," he would write in disgust about places that did not rally to his cause. He had been relying on friends to collect money for him; this method was not working. He named other agents, who would take a percentage but would, he thought, better tend to business.

In London, Havell was maintaining the steady pace. By the end of November, Audubon had in hand the fourth number and was waiting for the fifth, which was already engraved and being colored under the careful supervision of the elder Havell. The goal had been to complete five numbers, twenty-five plates, by the end of the year, and the Havells were on schedule. Havell Senior was, Audubon would note, "an able man of business, and very exact as to time. I pay for the whole work done by him as it comes out and I am proud to know that, if poor, I have no debt but on the contrary have a good sum due to me which will come some time." That "some time" had a plaintive note to it; in these hard political and financial times, he was having trouble collecting all that was owed him.

In Liverpool he was gathered in by the Rathbones with their usual warmth and acceptance. He paid a visit to Lucy's sister Ann, "who looks better than I have seen her since her marriage," he wrote Lucy, "and who, I think, *is in a certain way.*" The Rathbones had tracked down the gold watch sent to Lucy more than a year before, and reported that it should be in her hands at last.

Ever since he had sent for her and the boys to come to New Orleans, and then proved unable to support them, Lucy had been

adamant about one thing: He should not send for them until he felt certain of the family finances. It was his stumbling block; he did not know, for certain, that he could support both the work and his family, and he did not want to have to choose between them. It seemed as if he was in reach of being able to support both—if only he could get a few more subscribers. In a letter to Lucy written in the early-morning hours when he could not sleep, he made excuses and explained his plan of action: He had been much too late in arriving in London last spring, and had not been able to acquire the number of subscriptions he needed. This spring would be a different matter, "being now somewhat known and determined to put the following plan in practice": With the first five plates safely published in a portfolio, he would take one to each of the scientific societies himself, so that he could exhibit and explain them. The meetings, being "crowded by Noblemen & Gentlemen," should reap "a tolerable harvest of names." He was looking to London to provide the eighty-six subscribers he needed to reach the magic figure of two hundred, which would give him the courage and security to send for his family. If only Lucy and the boys would not give up on him; if only they had the patience to wait.

He ended the long letter by telling Lucy he had been at Green Banks that morning for breakfast with Hannah Mary Rathbone and her mother. He did not tell her that he had set out in the morning's dark, arriving not long after sunrise, and rambled around the grounds admiring the birds and the flowers until someone saw him, and called him in. "After breakfast," he wrote in his journal, "Miss Hannah opened the window and her favorite little Robin hopped about the carpet, quite at home." Both Hannah Mary and her mother wished to be remembered to Lucy, and he asked that she write to each of them— "Such Ladies they are," he wrote, "so truly good & kind." Then he added a line that must have stuck in Lucy's craw: "Recollect that they know nothing of our Pecuniary standing or situation and that I do not think it fit to disclose this portion of our present situation—Indeed I believe that every one who knows me thinks that we are well off, at least independent of the World—I think it will be soon the case but

untill then *Mum.*" His last words were: "Oh what would I give to have thee with me now—but the first of Jan.y. will be soon at hand and then I will *most positively decide.*"[15]

He stayed in Liverpool the whole of December, rising early to fire off to Lucy letters filled with the details of the business: how much he had taken in, how much he had paid out, exactly what he was worth at the moment, how much was owed him. By giving her the details, he hoped to make her understand exactly what he was up against. She should be prepared to come, he wrote: "I may and probably will write for thee to come the very week I reach London."[16] At the same time, he was still dreaming that he would "stumble on a Lord or a Public Institution that will give me a good salary to form a Collection of the Birds of England." He was learning the tricks of the trade, he told her. Alexander Gordon said that as soon as the work became "Fashionable" in London, it would have a great run. Their first year together might not be as comfortable as he wished ("comfortable" had become his code word for "financially secure"), but they would be together. If Lucy read between the lines, she would have sensed his panic, his fear that the inevitable decision not to send for her in January might cost him his family.

Early in December he received a letter from Thomas Sully telling him that when the papers Audubon had read in Edinburgh were published in Philadelphia, all hell broke loose. The papers on buzzards, alligators, pigeons, and especially rattlesnakes had been viciously attacked. "The editor calls all I said . . . a pack of lies," Audubon wrote in his journal. His old nemesis George Ord was leading the attack; soon Ord would join forces with Charles Waterton in England to blast Audubon in the intellectual communities of both countries. The affair could damage Audubon's reputation as a serious naturalist. He would have to figure out an appropriate response.

As Christmas drew near, he finished a drawing of a wren for Hannah Mary, then allowed himself "that sort of laziness that occasionally feeds upon my senses unawares; it is a kind of constitutional disease with me from time to time, as if to give my body necessary rest, and enable me to recommence with fresh vigor."[17]

He wrote about how differently Christmas was celebrated in America, where it was treated as "a day of joy" and general merrymaking. At home, the boys fired off guns all night long; friends gathered; there was dancing and gaiety. In England, families gathered exclusively to have dinner and go to church and, as far as Audubon was concerned, "all is dull—silent—mournful." He joined neither the Rathbones nor the Gordons. Three days later, just after breakfast, he opened the box from Havell that contained the fifth number. It was as good a Christmas gift as he could have wished, and right on time. "The work pleased me quite," he wrote succinctly, and walked out to Green Bank to show it to the Rathbone women.

By the fifth of January, 1828, he was back in London, preparing for the new sales campaign. He started the next day at his usual early hour, striding in the dark through the streets of Bloomsbury on his way to Regent's Park, and on up Primrose Hill. He was back before anyone in the house had risen, and he tore into the task he had set himself for the day: choosing the twenty-five drawings that would make up the five numbers for the year. Havell appeared and went over the drawings with Audubon, to give himself an idea of the work he would be doing in the coming year. Since he had managed to produce three numbers in the six months since Audubon appeared in his father's shop, he should have no trouble finishing five within the year—if Audubon could meet his payrolls.

Traditionally, the first of January was the time to settle all outstanding accounts. Audubon was able to pay all that he owed—even came out ahead in funds—and the future looked promising. But other, irritating problems vexed him—a sore throat and fever, London's "thick" air, and how to handle the tempest his papers had caused.

His sensible, experienced friend John Children, who knew all about gossip and feuds in the scientific community and the toll they could take, advised Audubon to limit his writing to the "ornithological biographies" that would be published along with the *Birds,* and to refrain from becoming embroiled in a public feud. Audubon was pained by the attacks and felt them unjust, but he had neither time nor

energy to spare, so he took Children's advice and did not respond to
his detractors, except to write Sully that time would tell who was right.
About that, he was correct: Much of what he wrote was later proved
true; only his paper on the rattlesnake, filled with error and folktales,
was seriously flawed.

It was not until February 6 that he sat down to compose the letter
that he had promised Lucy, and that he dreaded writing. He began on
a positive note: He was happy she had finally received the gold watch
and that she liked it. He went on to tell her that with the two hundred
dollars she had sent through Gordon, he had bought a piano, which
was on its way to her. This was the piano, presumably, that he had so far
refrained from sending because he was so certain she would be joining
him. Its shipment would have given her a clue about what was to come:

"Now my Lucy let me talk of matters of greater importance," he
began, "—when at Liverpool . . . I thought that I would feel sufficiently
settled, after balancing my accounts, to write to thee to come directly
to England and I hoped so the more, as I am really and truly in want
not only of a *wife,* but of a kind & true friend, to consult and to help
me by dividing with me a portion of my hard labours—yet thy entire
comfort is the only principle that moves me, and fearing that thou
might expect more than I can yet afford I refrained from doing it for
the present.—however, my Love do thou not be disheartened, depend
upon it, I shall not diminish in my exertions, and I certainly have good
hopes." Having explained that it was her fault that he was not ask-
ing her to come—since she expected more than he could provide—he
went on to say, "I leave thee from my heart perfectly at liberty to do
whatever may be most agreeable to thee."[18] She was on her own, he
seemed to be saying. Creating even more confusion, he told her that
Havell was hard at work on the sixth number, and that at the rate of
five numbers a year *Birds of America* would take sixteen years to com-
plete, "so that certainly my Lucy must come to me sometime"—but he
clearly had no idea when that might be.

In the spring, after Lucy received this disheartening letter, she be-
gan to do exactly as he had suggested and made her own plans for

their younger son. She wrote her brother Billy in Louisville to ask if he would loan her the money to send the boy to school there. She had been patient as a wife, but she could no longer be patient as a mother. Johnny deserved better; he had been looking forward to going to England, but he seemed just as excited about Louisville. Billy agreed to the loan and offered to take the boy into his business when he finished school. That decided, Lucy settled back into her life on the plantation, to earn the money to pay her brother back, and perhaps even to move to Louisville herself to join the boys and her family, if her husband should never send for them. She did not lose hope entirely, but her letters became less frequent.

THE NOISE, THE SMOKE, AND the filth of London assailed Audubon's sensibilities. Unable to sleep, he would rise at four in the morning and walk to Regent's Park, which was surrounded by the plots where vegetables were grown to feed the "monster" London. "Oh!" he complained to his journal, "how dull I feel; how long am I to be confined in this immense jail?" The days were heavy, he wrote, the nights worse. The air was so thick with smoke that at times you could not see at midday. He was tormented by the contrasts between rich and poor, knowing he had a foot in each camp. Occasionally his spirits were lifted by the sight of a flock of wild ducks flying above him in the moonlight, but then he would be plunged into homesickness.

And still he worked, painting all day or superintending the elder Havell's coloring of the special set of plates Audubon had decided to present to the U.S. Congress. In his journal, he does not admit that Havell resented having him look over his shoulder, but he does say, defensively, "While I am not a colorist, and Havell is a very superior one, I *know* the birds; would to God I was among them."[19]

In January, Bentley arrived from Manchester; Audubon was pleased to offer him a place to stay, and happy to have a friend around. Bentley

reported that the subscription list was moving in fits and starts, with what seemed like a withdrawal for every addition. Audubon wondered how many of his long list would stay with him until the end.[20]

He took some time off to go about London with Bentley; they walked all around Regent's Park, which Audubon knew by heart, then went to see an exhibition of live animals. These included an elephant, on which they were given a ride. It rained; the smoke of the city caught in his throat. David Lizars wrote from Edinburgh that four more subscribers had fallen away. Audubon was "dull as a beetle."

On February 4 he carried his hundred-pound portfolio to the Linnaean Society in Soho Square, where the members looked it over carefully, admired it, and noted how sad it was that the drawings were so little known in London. Then they voted him in as a member, and he had another set of initials to place after his name. A few days later he was at the Zoological Society on Bruton Street with Lord Stanley, Lord Auckland, and "good old General Hardwicke." He was getting used to the company of aristocrats.

What did bother him was discovering that he had paid either Lizars or Havell—he didn't know which—for fifty numbers more than he or his agents could account for. The loss cost him a hundred pounds, enough to pay for Lucy and Johnny's passage to England. His trust in the honesty of both Lizars and Havell suffered. Business was business; he would simply have to keep better accounts. As if to purge himself of disappointment, he plunged into work on the drawing of what he called the white-headed eagle (the mature bald eagle). Originally the eagle had been feeding on a wild goose (the model for which had been killed by Joseph Mason). Audubon decided to substitute a catfish for the goose. He worked on the drawing from seven in the morning until dark all day, and for most of the following week. When it was finished, he looked at it with pride and wished that he could paint in oils as well as he could draw in his own style.[21]

The days were dark and gloomy and cold; even as he struggled to produce his best work, he was being lashed by some stinging rebukes.

To his shock and disappointment, he was told that it was Sir Thomas
Lawrence who had stopped the Natural History Museum from sub-
scribing, on the basis that the bird drawings were mediocre, and the
engraving and coloring inferior. Audubon did not understand; Law-
rence had told him that the birds were good and had helped him sell
oils when he desperately needed money. How could Lawrence say one
thing and believe another? (A few weeks later, when Lawrence sent yet
another customer to Audubon, he began to think that Sir Thomas's
enemies had spread the story.) At about the same time the Earl of Kin-
noul sent for Audubon, who obligingly called a coach to carry his heavy
portfolio to what he hoped would be a new subscriber. (Children had
convinced him that it would not do to lug the portfolio through the
streets on his shoulders, as had been Audubon's habit.) The earl—"a
small man, with a face like the caricature of an owl," gave the pictures
a cursory look and wasted no words. He told Audubon that all the
birds were alike and that his work was a swindle. Audubon was shaken;
being called to a man's house in order to be abused appalled him. His
response was to bow and walk away without a word to "the rudest man
I have met in this land."[22]

It was time to get out of London; he decided to make a foray to
Cambridge and Oxford to seek out new subscriptions in the univer-
sity towns, where he felt certain he would encounter civilized men,
and institutions certain to subscribe. Armed with a stack of letters of
introduction, he stormed the bastions of learning in Cambridge on a
blustery day early in March, and found himself dazzled to be in the
company of so many distinguished men. He was invited to dine in the
halls, where he noted that the students, in their floating mantles, and
their flat caps with long silk tassels ate and left the table "as vultures
leave a carcass." After dinner, he was taken to another room, where a
table was cleared to show his portfolio. The learned men admired it;
they were gay, witty, and clever, and they looked and listened and ques-
tioned him with intelligence. "Oh! My Lucy, that I also had received a
university education!" he wrote in his journal. Then: "No subscribers
to-day, but I must not despair."[23]

The fruit trees on campus had been in full bloom, but there was a hard freeze on March 7. Audubon was in the library looking through François Levaillant's *Birds of Africa* when Lord Fitzwilliam's tutor came to say that the young nobleman wanted to subscribe to Audubon's *Birds.*

Audubon's glowing account of his encounter with the young man is revealing: "I showed my drawings, and he, being full of the ardor of youth, asked where he should write his name. I gave him my list; his youth, his good looks, his courtesy, his refinement attracted me much . . . He wrote in a beautiful hand, which I wish I could equal, 'Hon. W. C. Wentworth Fitzwilliam.' He is a charming young man, and I wish him *bon voyage* through life." Young Fitzwilliam was an antidote to the abusive, owl-faced Earl of Kinnoul. More revealing, Audubon wrote that he wished that his own two "fine Kentucky lads" might recognize the value of his birds as Fitzwilliam did.

He envied all learned men their educations, and at the same time marveled at how little they knew of the New World. He answered their questions patiently and learned to laugh at them. Having been introduced to a judge on his way to court, Audubon quipped: "a monstrously ugly old man, with a wig that might make a capital bed for an osage Indian during the whole of a cold winter on the Arkansas River." [24]

He returned to London with only five new subscribers. He paused for a week, long enough to check on Havell and see the plate of the Carolina paroquets, which delighted him, to go to Covent Garden to see a "terrifyingly well performed" production of *Othello,* and to save his landlady from disaster by loaning her twenty pounds so she would not lose her house. Letters from Lucy and the boys were waiting for him; Victor had been to Louisiana for a visit, and all three had written. Audubon fired off a letter to Lucy, telling her that he was "still *imperfect* in my thoughts respecting thy coming over to me." He was also sending her some dresses "that . . . are quite the fashion. 6 in number and warranted to wash well." [25] Then he was off again to see if Oxford would produce more subscriptions than Cambridge had. Once more, he was received with hospitality, his pictures were

viewed and praised ("how tired I am of doing this"), but none of the colleges subscribed.

As soon as he returned to London at the end of March, he was approached by John Claudius Loudon to write an article for his prestigious new natural history magazine. Loudon promised to pay handsomely, which was tempting, but Audubon kept his word and declined. He would give his enemies no more ammunition. Loudon called a few days later to say that he had asked William Swainson, a naturalist and writer, to review Audubon's work for his magazine.

On April 1, he received official notice that he had been made a fellow of the Linnaean Society of London "quite fresh from the mint"; the next day he walked over to Havell's, where he saw the engravings for number seven. When it was complete, subscribers would have thirty-five pages of the book. "How slowly my immense work progresses," he wrote in his journal, "yet it goes on apace, and may God grant me life to see it accomplished and finished. Then, indeed, will I have left a landmark of my existence."[26] He was beginning to understand that—with Havell's invaluable help—the double-elephant folio of *Birds of America* would assure him a place in history. It was his landmark, his destiny. Lucy and the boys would fit into his plans at some point, but he didn't know when, and he could not let his conflicting feelings about his family deflect him from his goal.

Swainson's review was ecstatic, praising Audubon's work so wholeheartedly that the artist was filled with gratitude. It meant much to him to have a man he did not know at all, an ornithologist who was respected in scientific circles, be so utterly captivated by his birds. He immediately wrote a thank-you to Swainson, asking to meet him. In reply, Swainson invited Audubon to his home at Tittenhanger Green, near St. Albans. It was the beginning of one of those intense, satisfying attachments that Audubon acquired throughout his life, with men as well as women. This particular relationship, however, had in it the seeds of its own destruction: From the beginning, Audubon considered Swainson his superior in scientific knowledge about the birds. Swainson was a better writer as well, and so became a candidate to help

Audubon with the text of his work, but Audubon had certain strong ideas about collaborations, as Joseph Mason could attest. Audubon also had Charles Bonaparte in mind; should Charles agree to collaborate, his mere name would be a great asset. Audubon continued to write Bonaparte long, ingratiating letters, which were promptly answered. Each man had something the other wanted.

That spring, he fell into a depression in which he was plagued by premonitions. He did not hear from Liverpool, and worried that Mrs. Rathbone was ill. "The silence of a friend sometimes terrifies me," he wrote in his journal. Some days later, it seemed to him that he might never see Lucy again.

Havell was producing splendid plate after splendid plate, moving inexorably through the best drawings. Audubon had come to England with two hundred, not all of them suitable for publication. He had managed to do some over, to improve others, but at the rate Havell was working, Audubon would soon have to provide drawings of the many species he was missing. He began to think of making a trip back to America.

On May 4, 1828, a Sunday, he wrote in his journal: "I have been summing up the pros and cons respecting a voyage to America, with an absence of twelve months. The difficulties are many, but I am determined to arrange for it, if possible. I should like to renew about fifty of my drawings; I am sure that now I could make better compositions, and select better plants than when I drew merely for amusement, and without the thought of ever bringing them to public view."[27]

He could also resolve his family problems and bring Lucy back with him. He would need to leave in the spring, to be in time for the fall migration on the East Coast. It was a fine plan, he told himself that spring of 1828, but it would take a mountain of work to be able to leave behind enough drawings to keep Havell busy for a year and to arrange the deliveries and collections that would pay the engraver.

He went out to the Swainsons' modest home for a weekend. They hit it off famously: "Mrs. Swainson plays well on the piano," he wrote, "is amiable and kind; Mr. Swainson a superior man indeed; and their

children blooming with health and full of spirit. Such talks on birds we have together . . . thou wouldst think that birds were all that we cared for in this world." He had been in need of an intimate friend, and Swainson obliged.[28]

All that summer, when he wasn't painting, he was at Havell's superintending the coloring of the plates. On his return from Oxford, he had caused an uproar by demanding that one colorer be fired for doing inferior work. In the end, all the colorers went on strike and all were replaced. The elder Havell was not pleased at the artist's interference in his domain; soon Audubon was dealing almost exclusively with the son.

Some days Audubon painted from four in the morning until dark. He wrote everybody and kept a close watch on publication—and on his list of subscribers, which was shrinking steadily, name by name.

Basil Hall and his family returned from America, and Audubon was excited to hear what his friend had to say about his country. Hall had used several of the letters of introduction Audubon had given him; he had seen Sully and Dr. Harlan in Philadelphia, and Victor and the Berthouds in Shippingport. All had been wonderfully pleasant to the English family. But Hall did not bring the letter from Victor that Audubon had expected.[29] Audubon was also disturbed by what he sensed was Hall's negative reaction to his country. "He has seen much of the United States, but says he is too true an Englishman to like things there." He supposed he would have to wait for the book Captain Hall planned to write about these travels.* Hall visited one afternoon a week or so later, joining John Children and John Gray of the British Museum. After hearing Hall hold forth once more on his recent travels, Audubon labeled his judgments "superficial" and said it was too bad he could not have stayed longer in the United States.

*The book, *Travels in North America in the Years 1827, 1828,* verified Audubon's impressions: Hall found Americans boorish, travel difficult, and monarchy in every way vastly superior to democracy. Speaking of Americans, he wrote: "The nature of the monarchical form of government, with its attendant distinctions in rank, we may suppose, is nearly as repugnant to their tastes as Democracy is to ours."[30]

Audubon spent two hard months painting in oils all day, every day. He was trying to improve the two large oils he hoped would be good enough to be considered seriously for one of the important exhibitions, but most of the time he was dashing off fast pictures for a quick profit. He was able to meet Havell's payrolls; by August 8, the eighth number had been distributed. Even so, he reported to his journal: "My subscribers are yet far from enough to pay my expenses." He had borrowed a picture of a grouse he had painted for a hundred pounds in order to copy it, with the owner's permission. He needed more money, not only to pay Havell but to finance a trip to France.

He had letters of introduction to the most important men in Paris; his command of the language would be of help, he was sure; most of all, he felt that France would give him the subscribers he needed. He thought about making a trip to Couëron to visit his sister, but this no longer seemed urgent when he learned that his mother had been dead for some seven years. (It is not clear when he learned of her death; on arriving in England, he wrote that he expected to go to France to visit her.) Swainson had spoken of going to Paris to do some research at the Jardin des Plantes for his work on the second volume of his zoology of the northern parts of America.[31] He suggested they could go together.

On August 13, Audubon received an ultimatum from Lucy. She had given up all idea of coming to England, she said, and she thought he should return to his own country, where he would live a humbler but happier life. As for the boys, Lucy declared that both were against coming to England, where, they said, "neither freedom or simplicity of habits exist." [32] (Basil Hall agreed with them, but preferred England precisely because of that American "freedom and simplicity.")

Audubon wrote an anguished letter to his new friend Swainson, describing Lucy's position and saying: "I am miserable just now and you must excuse so unpleasant a letter—Would you go to *Paris* with me?"

The answer was yes, and off they went, Mrs. Swainson as well as a portrait painter named Parker whom Audubon had known in Natchez, and who had turned up on his doorstep. Swainson would do his

research, Parker would paint portraits of important men, and Audubon would try to get the subscribers he needed to continue the work and save his family. Lucy's letter spurred him on; he knew now that he would have to go back to America to get her, if their marriage was to survive. At the moment, it seemed that it would not.

The intrepid band of travelers left London on September 1, traveling in a coach that included a circus tightrope walker and a girl whose bonnet was so large and had such well-starched bows that when she took her seat on top of the coach Audubon thought she "soared aloft, like a Frigate Pelican [frigate bird] over the seas." He was in surprisingly fine fettle—they were all quite gay—as they headed for Dover. On such a bright fall day, on his way back to the country of his boyhood, he could forget for a time about filthy London, about being held hostage to his great work, even about the possibility of losing his family.

The crossing was rough and Audubon was, as usual, seasick the whole way; after three and a half hours of beating against the wind, they landed in Calais. As a diligence pulled by five horses carried them toward Paris, Audubon looked at the scenery and was disturbed. "The country seems *very poor,*" he wrote in his journal; "the cottages of the peasants are wretched mud huts." The land looked to him like "one of the old abandoned cotton plantations of the South." France was, he began to realize, not nearly so prosperous as England.

After pausing at their lodging, where Mrs. Swainson's brother joined them, the group went directly to the Jardin des Plantes, where they hoped to find Baron Georges Cuvier—perhaps the world's most famous naturalist—at the museum. He was in, they were told, but much too busy to see anyone. Swainson insisted that Cuvier be given their names. Soon they were ushered into his presence, where "Monsieur le Baron, like an excellent good man" greeted them politely. He knew Swainson's name, and while he had not heard of Audubon, he was polite and kind to him—and obviously pleased to learn that an American wren (Cuvier's kinglet) had been named for him. Before they left, Cuvier invited them to dine with him the following Saturday.

Audubon was glad to be in France, glad to be speaking French and eating French food. Instead of his usual breakfast of bread and milk, he had grapes, figs, sardines—and coffee that he thought better than anywhere else in the world. The air was not filled with smoke as it was in London. The streets were dirty, though. "Walking in Paris is disagreeable in the extreme," he wrote in his journal. "The streets are paved, but with scarcely a sidewalk, and a large gutter filled with dirty black water runs through the centre of each, and the people go about without any kind of order, in the centre, or near the houses."[33]

He and Swainson were amazed at the variety of birds, some quite rare, on sale in the markets along the quays. They noticed them as they went about delivering their letters of introduction, including one to the naturalist Étienne Geoffroy Saint-Hilaire, who had a house in the Jardin des Plantes, and who promised to take them to a meeting of the Académie Royale des Sciences the following Monday.

Audubon left Swainson at the museum and took himself to the Louvre, where he joined Parker. For the first few days he bided his time, enjoying Paris with Parker and escorting Mrs. Swanson to the Louvre. He and Parker went to a festival in St. Cloud, along with what seemed like most of Paris. Audubon described the scene in his journal: "Music began in different quarters, groups lay on the grass, enjoying their repasts; every one seemed joyous and happy." There were equestrian events with trick riding, jugglers, dancers, and target shooting with a crossbow: Anyone who hit the center automatically launched a silk goldfish—as big as a barrel—which inflated as it rose high above the crowd, its gauzy fins moving with the breeze. The two men had a bottle of Chablis with their dinner, and reluctantly made their way back to Paris, even though the merriment would go on throughout the night. The French knew how to enjoy themselves, Audubon remarked.

The very next day, when Audubon and Swainson came to call on Cuvier, he told them to be at the Académie Royale des Sciences in an hour with Audubon's portfolio. They had to sit through a boring lecture on the vision of the mole before Cuvier introduced the two visitors

from London, and Audubon rose to turn the pages of his book. That was the first step; now all he had to do was to ferret out institutions likely to become subscribers, and any man rich enough to own his own folio of *The Birds of America*.

With suggestions from Cuvier, Geoffroy Saint-Hilaire, and others he had met at the Académie, he set out on his appointed rounds. First to the Institut de France, where he gave his prospectus to the secretary of the library. At the Jardin du Roi he called on the man who stuffed birds for the Prince d'Essling; the taxidermist made an appointment for him to call on the prince that same afternoon to show the *Birds*. The young prince, the son of one of Napoleon's marshals, received Audubon with grace and courtesy, and presented his beautiful young wife. This was a treat for Audubon, as meeting beautiful women always was. When they discovered he knew Charles Bonaparte they were thrilled; Audubon must be the man of the woods Charles had told them about. But the young prince delivered the bad news: France was poor, and there were no more than six or eight people in Paris who could afford to buy Audubon's beautiful book. The couple named as many of these rich men as they could, and then the prince asked to subscribe, writing his name "next to that of the Duke of Rutland." Little Manchester, it would seem, had more rich men with an interest in art and nature than did Paris.

Audubon plodded ahead to the rue Richelieu to see the king's librarian, who told him it was out of the question to subscribe for such a work but did give him an introduction to the librarian of the king's private library at the Louvre. Only the king's *private* library could afford such a book. This man advised him to write to the Baron de la Bouillerie, of the king's household, which he did at once. "So go my days," Audubon reported laconically.

In between calls he visited the Louvre to feast on Raphaels, Correggios, Titians, and Davids. At night, often with Parker, he went to the theater or the Italian Opera. Walking home one of those nights, the clean air and clear sky of Paris reminded him of America, and he had a stab of homesickness. He wished he were there again, and while

"Europe might whistle for me," he wrote, "I, like a free bird, would sing, 'Never—no, never, will I leave America.'"[34]

He couldn't resist checking with an engraver to see what it would cost him to produce the book in France. The Prince d'Essling gave him the name of a "first-rate engraver" who came to look at the numbers, then told Audubon, with admirable frankness, that he could not produce the book as cheaply as Havell was doing, and probably could not do it as well. Audubon saw yet another engraver, who was astonished by the work's beauty and, like the other, admitted he could not do it for anywhere near the price. Audubon was convinced; he would stay with Havell.

Audubon and his *Birds* had made a conquest of Cuvier, who commanded enormous respect in the world's scientific community. Cuvier invited Audubon to exhibit his drawings at the public reception he gave every Saturday. There, the great French naturalist announced to the room at large that Audubon's work was the finest of its kind in existence. Not long after, he told Audubon that he would review it for the Académie's journal, a remarkable coup for the American artist who had arrived in France an unknown.

He celebrated by exploring the gambling houses with the son of Geoffroy Saint-Hilaire; he also toured Versailles, which he found altogether too gilded for his tastes. It was, it seems, a good thing he was not the poor little lost dauphin. At Versailles he ran into a man he had met at the Royal Academy, who gave him an introduction to the minister of the interior, whom he said had the power to order as many copies of the *Birds* as he wished. Audubon hoped he was right.

At another evening at the Académie Royale des Sciences, his book was viewed by at least a hundred people. "'Beau! bien beau!' issued from every mouth," he wrote, but what followed was "'Quel ouvrage! Quel prix!'" The French were too poor to support his grand work; only England could do that. "Poor France!" Audubon wrote, "thy fine climate, thy rich vineyards, and the wishes of the learned avail nothing; thou art a destitute beggar, and not the powerful friend thou wast represented to be."[35]

Even so, he continued his rounds, appearing at the office of the minister of the interior with his note of introduction and dragging out a letter that Sully had written five years before in Philadelphia to Pierre Redouté, the painter of exquisite flowers.

Redouté received him with kindness and courtesy, showing him some of his best works. "His flowers are grouped with peculiar taste, well drawn and precise in the outlines, and colored with a pure brilliancy that depicts nature incomparably better than I ever saw it before." Then Audubon showed his birds; Redouté admired them greatly, and wished that he could afford to subscribe. Audubon suggested an exchange, which was quickly accepted, and he went off with nine numbers of the *Belles Fleurs* and a promise that "Les Roses" would be sent. Redouté also offered to take Audubon's prospectus to the Duc d'Orléans, with whom he dined every Friday. The duke, Redouté felt sure, would want to subscribe, and perhaps the duchess would as well.

On his way to another appointment, Audubon ran into the under secretary of the king's private library, who told him that his work was being inspected by the Baron de la Bouillerie, who was empowered to subscribe on the king's behalf.

At Audubon's urging, both Cuvier and Redouté had consented to sit for Parker; Audubon sometimes kept them company. Cuvier asked Audubon to meet him at one-thirty one afternoon at the Académie, where he was to report on Audubon's work. The great man arrived an hour late, writing even as he walked toward Audubon. "I was surprised that so great a man should leave till the last moment the writing of a report to every word of which the forty critics of France would lend an attentive ear," Audubon wrote. He turned the pages of the book as Cuvier took rapid notes; both were sweating with the effort. If Audubon worried that the baron would do a slapdash job, he needn't have. Cuvier said that the *Birds* were "the greatest monument yet erected by Art to Nature" and the most magnificent bird paintings ever done. Cuvier's lavish compliments were published in the Académie Royale's *Mémoires* and in the important publication *Le Moniteur Universel*.[36] The glowing words did much to enhance Audubon's reputation in France.

But after three weeks, he had only three new subscribers; Paris was almost as bad as Glasgow, he told himself.[37] Still, he haunted the offices of functionaries who could make decisions. "To-day I have been to the King's library, a fine suite of twelve rooms, filled with elegant and most valuable copies of all the finest works," he wrote, adding sarcastically: "The King seldom reads, but he shoots well. Napoleon read, or was read to, constantly, and hardly knew how to hold a gun."

Cuvier gave him a note to take to the king's librarian to speed things up, and Redouté gave him a letter from the Duc d'Orleans, who wished to see him that same afternoon at one.

Audubon was greatly impressed, "as I do not see Dukes every day." (In two years' time the Duke would become king of France.) There was some confusion about admitting Audubon: At first a fat porter said the duke wasn't in and sent him to an antechamber, where he cooled his heels uncomfortably, attacked once more by his "strange sensation of awkwardness mingled with my original pride." People moved all about him, but nobody said a thing to him. He got up his courage, told a sergeant at arms of his appointment, and was ushered into another superbly furnished apartment. Finally, a young man came rushing up to ask if he was Audubon. "We thought that you had gone and left your portfolio," he said. "My uncle has been waiting for you for twenty minutes."[38]

Louis-Philippe, the Duc d'Orleans, was not only uncommonly handsome, but polite and disposed to like this French American. In 1796, Louis-Philippe was one of the lively young French aristocrats who visited America and, in Pittsburgh, bought a skiff from their countrymen, the Tarascons and James Berthoud. They covered it with tow linen, stocked it with provisions, and hired two men to row them all the way down the Ohio and the Mississippi to New Orleans.[39] It had been a grand adventure, which the duke remembered with pleasure. He helped Audubon untie the strings on his portfolio, and told him that he should never forget how kindly he had been treated in the United States. They opened the portfolio on the table. The future king looked at the plate of the Baltimore orioles with its swinging nest, and said he

understood now why Redouté had praised it. They talked for a time, in a mix of French and English, "of America, of Pittsburgh, the Ohio, New Orleans, the Mississippi, steamboats." And the Duc d'Orléans said with a sigh, "You are a great nation, a wonderful nation."

He added his name to the list, promised to write the emperor of Austria, the king of Sweden, and other crowned heads on Audubon's behalf, and sent him back to the minister of the interior. It was heady business, being received so graciously by so important a man. On his way out, Audubon couldn't help but ask the fat porter if he wanted to tell him again that his master was out.

The minister of the interior would see him; after waiting for half an hour, he was ushered in, showed his portfolio, and was told that if he put his terms in writing he would soon receive a reply.

The Swainsons, having run out of funds, had already returned to England, and Audubon wished to follow them as soon as he could, but the various ministers who could make decisions put him off, always promising he would receive an answer "tomorrow." He bided his time, spending three hours with Parker as he painted Redouté's portrait, studying the flower artist's drawings.

Audubon learned that the son of his old friend D'Orbigny of Couëron days was a protégé of the zoologist René-Primavère Lesson. Lesson sent word to twenty-one-year-old Charles-Henry-Marie D'Orbigny, who knew Audubon's name well, and who came at once to visit him. Audubon was delighted to see the boy, and promised to write his father, who was now living at La Rochelle. He valued his memories of the man he would always regard as his most intimate friend, other than Lucy. But other memories were better left alone, he must have decided, since he did not venture to return to the scenes of his childhood.

He grew tired of sightseeing, tired of waiting. So far, his seven weeks in Paris had reaped only four subscriptions. "What precious time I am wasting in Europe," he complained to his journal, but he did not leave.

Finally, on October 26, he received word that the minister of the interior would take six copies of *The Birds of America* for various

French towns and universities. That same day he learned that the king had subscribed for his private library. The Duc d'Orléans's secretary came to call, and told Audubon that now he could expect all the royals to subscribe because "none of them liked to be outdone or surpassed by any of the others." Encouraged, he hired a Paris agent recommended by Cuvier; the agent assured Audubon that he would be able to add to the list of subscribers. Finally, Audubon could leave France. Two months in Paris had cost him forty pounds and earned him thirteen new subscribers. When he returned to London, the names on his list numbered only 144; he could not seem to get the total up to a hundred and fifty, much less the two hundred he coveted.

The days were dismal and dark and the cold so penetrating he found it difficult to work. He wrote as much as he could on his bird biographies, painted as much as he could in oils, visited with the Swainsons, and welcomed his old friend Bentley for a visit. "The steady work and want of exercise has reduced me almost to a skeleton," he wrote in his journal. "I have not allowed myself the time even to go to the Zoological Gardens."

He was depressed, as well, by the news from home. Johnny had been sent north, to the Bardstown school near Louisville; Victor had written that he was doing well with his uncle Nicholas, and that his brother was also satisfactorily settled in. Now Lucy, like himself, was all alone. Audubon wrote Victor a long letter describing his triumphs among the French nobility and the artistic and scientific community. "France is not rich," he told his son, "it is a *beautifull waste.*" He had seen all the court, he told Victor, including the Duke of Orléans, now the wealthiest man in France. The duke had once taught French in America for a dollar a lesson, he told his son, hoping the boy would get the message. He admitted that his list of subscribers hovered at the 145 mark. Then, though he knew the boy was likely to sympathize with his mother, the father could not help but spit out his resentment. He would have to be content with the idea that his sons were happy with their lot, he wrote bitterly: "Your Mamma alone is all that I may expect to see and she is not willing to come over untill I have acquired a *great*

fortune." There was no hope that he could meet her desires, he wrote their son.[40] His message was clear: As usual, it was Lucy's fault that she was not with him, because she would not come without extraordinary assurances, which he wanted desperately to give, but could not.

The letters between husband and wife became carping and accusative. She reported that the piano was a poor thing and the dresses had been damaged by water; he felt that she was unreasonable and demanding, and had no idea how hard he was working. For the first two years of his absence, she had kept the faith. Now that faith was seriously damaged, and it would require profound effort on his part to restore it.

On January 20, 1829, he wrote Lucy to say that since every letter she had written him since his departure had been filled with "the *uncertainty* of thy *ever* joining me in Europe," he had come to the conclusion that if they were to be together he must return to America to collect her.[41] This was not his only—or even his foremost—reason for going, however; he needed additional birds for his work.

Now Audubon flew into action: The excellent John Children of the British Museum would see to his business in London, working closely with the younger Havell. Audubon wrote long memos to the two, and to his French agent as well. In his remaining three months in England he painted furiously, collecting enough money to see him through and to ensure that the work would continue. He was going home, but not as he had left. He had established himself in England and on the Continent as a brilliant bird artist and the foremost ornithologist in America, many said in the world. He would take with him a portfolio with ten completed numbers—fifty folio sheets—which was already being praised as a masterpiece, though it was scarcely an eighth of the whole. If his financial success was not as great as his popular success, it was sufficient to keep his work going, and to send him home with enough money in his pockets to travel first class. On April 1, when he took passage on the packet *Columbia* (which he chose solely for her name), no one would mistake him for anything other than a gentleman. The American woodsman who had appeared in Liverpool

three years before had long since vanished. Audubon the gentleman, at ease with great men in palaces, stately houses, and learned societies, was on his way home.

14

*To my Lucy I now offer myself with my
stock, wares and chattels and all the
devotedness of heart attached to such an
enthusiastic being as I am.*[1]

WHEN AUDUBON BOARDED THE *COLUMBIA* at Portsmouth
he had with him £150, $200, a new gun he had bought for £20, two
copies of his work, and a King Charles spaniel named Dash which
Mrs. Havell had given him.[2] The work he would show in New
York and Philadelphia, places where he might hope to get new sub-
scribers. Before returning to England, he planned to give one copy
to his brother-in-law William Bakewell as thanks for helping Johnny,
even though in his worst moments he felt as if Lucy and Billy had
conspired to take his son away from him. The other set he might give
to Nicholas Berthoud, who had taken good care of Victor, even if he
had kept a stony silence for the three years Audubon had been away,
and seemed no longer to be his friend. He hadn't decided for sure;
he might leave the set with Victor, along with the gold watch he had
brought his eldest son. He was grateful to Victor, who had finally

written him; his relief that his eldest son had not forsaken him was almost palpable.

The purpose of this trip was clear in his mind as he climbed aboard the packet and settled his things in the cabin. He was going to America to try to repair the damage his three-year absence had done to his family, but his first concern was the work. He had arrived in Liverpool with two hundred bird drawings. Of these, he was dissatisfied with at least fifty. At the rate Havell was progressing, he would soon complete the drawings Audubon felt were good enough for publication. He needed to rework the rest and, before the book could be called complete, produce at least two hundred—possibly more—new drawings.

He knew, from Alexander Wilson's work, which birds he must find on the East Coast. He would arrive in the spring—nesting season— and would stay around New Jersey and Pennsylvania through the fall migration. He planned to spend part of that time at Great Egg Harbor on the New Jersey shore, where Wilson had spent a month with his publisher, George Ord, in the spring of 1813. Audubon had written to explain this to Lucy, asking her to join him in either New York or Philadelphia, because if he went directly to see her in Louisiana he would lose his chance to include these birds, which were essential to the ultimate success of the work.

Lucy, isolated for the past three years, did not understand the changes that time and exposure to the exciting cultural life in England had wrought in his manner and demeanor, nor did she realize how fiercely determined he had become. When he left America, publishing the *Birds* had been a dream, the last resort of a man grasping for his hold on life. He had worked as hard as any man could, and against odds that would have defeated most; but now the book was a reality, it was his *"immense Work,"* supported and sustained by the nobility as well as the intelligentsia of Europe. Triumph was at his fingertips; all the promises he had made to his family were about to be kept—if only he could keep up the pace, study and hunt and shoot new birds, complete the drawings, keep those subscribers he already had and add more, collect the money they seemed loath to relinquish, pay Havell on time, carry on

the enormous correspondence with men of science and art—and in his spare time work on the text that would accompany the folio.

Traveling across the Atlantic with him was Robert Havell, Jr.'s brother Henry, who was moving to America, and a lad named Henry Ward, who had been taught by his taxidermist father how to skin birds. Swainson and another London ornithologist and artist, John Gould, had hired young Ward to find and skin the birds they would need for their separate studies and publications; Audubon had offered to watch over the feckless youth for them, an offer he would soon regret.[3]

He hoped to be able to return to London by the fall, but had prepared for a year's absence. Havell had enough work to keep him busy through the end of the year, plus drawings for the first number in 1830. Before leaving London, Audubon had written Lucy several letters to prepare her for the amount of work he faced—"Thou knowest I must *draw hard* from Nature *every day* that I am in America"—and adding, as if it were a fait accompli, "Of course Lucy will come to England with her husband &c but we will talk of that when again our lips will meet—Oh my Lucy it will have been a long absence, a great change in my manners but the same sound heart as ever and as ever devotedly attached to thee." [4]

He was attached, as well, to the idea of going into the great woods of America again with a gun, to living simply in rough cabins, to walking far beaches with the dog Dash at his heels, to shooting and making the intricate scientific studies that he needed for a credible text, then wiring and drawing the birds before skinning them. The text was a major hurdle, but there was time, still, for that.

The *Columbia* had no more than pulled out of Portsmouth harbor than he made his last notation in his journal for the whole journey: "we have hoisted the anchor, am at sea, and *sea-sick!*"[5] It was, mercifully, a short voyage. He landed in New York on the fifth day of May, 1829.[6]

He had written ahead to the newspapers, to alert them to the impending arrival of Mr. Audubon, whose immense *Birds of America* was being published to accolades by all the important people in the capitals of Europe. He had but to flash a letter from President Andrew Jackson

for the collector of the customhouse to wave him through without paying any duty.

His first stop was the Lyceum of Natural History, where he had been welcomed as a member on his otherwise discouraging trip east in 1824. Then, respected Dr. Samuel Mitchill had been his champion. Audubon was saddened to find the old man "now lost to himself and to the World. I have seen him once half dead with drunkeness."[7] Audubon looked up William Cooper, an ornithologist who was not predisposed to like him. Charles Bonaparte had named a species of hawk for Cooper; Audubon, believing the prerogative his, had named the same hawk in honor of Lord Stanley. The conflict caused a flurry in the world of ornithology, and some strain between Bonaparte and Audubon. Ultimately, the name "Cooper's hawk" prevailed.

Audubon, as a member, could exhibit his engravings in the Lyceum's rooms if he wished. Cooper was not overtly antagonistic, but he pointed out to Audubon the witlessness of failing to have skinned the birds he had used for models, so that scientists would have some way to assess the correctness of his drawings. Audubon chafed at this criticism, which others—including Swainson and Bonaparte—were making as well. That same summer, Bonaparte wrote Swainson that the reason he had always avoided collaborating with Audubon was because "I understand how difficult it would be to speak or even admit queries, on the mere authority of his drawings. Would to God he had at least the skins of his birds!"[8] Audubon recognized his mistake, and determined to avoid it in the future.

Members of the Lyceum came to see and admire the folio birds. Among the visitors were Major Long of the Long expedition, which had come through Cincinnati in what seemed a lifetime ago to Audubon, and the painter John Trumbull; all were polite but not effusive in their praise. America was not turning cartwheels over Audubon, as Liverpool and Edinburgh, and even London and Paris had. The old animosities simmered still, fueled by the papers on the rattlesnake and the vultures, which had been published in America only a few months before, to vituperative criticism. What most East Coast academics knew

about the man was not particularly favorable. They doubted someone who could mistake a blacksnake for a rattlesnake, and who believed them to climb trees as well. (One folio drawing showed a rattlesnake raiding a mockingbird's nest.) George Ord led the pack, delighted to have some reason to discredit the man who had the temerity to compare himself favorably with Alexander Wilson. Ord continued to publish Wilson's work, on which his own reputation still depended.

Audubon's reception in New York did not help his mood, and he did not look forward to Philadelphia, where most of his enemies were entrenched. Letters from Lucy had not made matters any better. He had assumed she would be on her way to meet him. She wrote that she did not have the money to come—and that she wouldn't until the end of the year, when all debts would be paid and she could collect five hundred dollars that was owed her. She also made it clear that she did not want to make the journey east alone. She was distressed that her husband had not come directly to see her. It was humiliating to have him linger in the East as if he didn't care about his wife and family. If he loved her as he continually professed, it was time for him to prove it. At the same time, it was worrisome to think of putting an ocean between herself and the boys. Victor would be twenty in June, but Johnny was only sixteen.

On May 10, 1829, Audubon, steaming, sat down and wrote a long, blustering letter to "Mrs. Audubon, Bayou Sarah, Louisiana" that was part legal brief, part rambling discourse, and, in the end, an ultimatum. He started out by telling Lucy to read this document with "due attention"; she should "believe [it] to be in its whole contents the true sentiment of thy affectionate friend and husband."

In numbered paragraphs, Audubon explained that he would stay in America only as long as he could be certain that the publication in London went on as planned; the time of his return would be left entirely to the advice of his friends there—William Rathbone, George Children, and Robert Havell.

Paragraph 2 was explicit: "I wish to employ and devote every moment of my sojourn in America at Drawing such Birds and Plants as I

think necessary to enable me to give my publication *throughout* the degree of perfection that *I am told* exists in that portion already published and now before the Public." This was to be a secret between them, he wrote, evidently worried that admitting he needed to improve some drawings might damage his reputation.

Meticulously he documented his financial situation so that she would know exactly how he stood. He was worth a total of £2,565—not counting the money he carried with him, his clothes, his gun, or his gold watch. He summed up: "The above my dear Lucy is the present stock of thy husband, raised in the 2 first years of my Publication, the two most difficult years to be encountered, with a stock of *Fame* not likely I hope to decrease but to support me and enable me to live decently but not in affluence but respectably."

He pledged himself to her then, in romantic legalese: "To my Lucy I now offer myself with my stock, wares and chattels and all the devotedness of heart attached to such an enthusiastic being as I am—to which I proffer to add my Industry and humble Talents as long as able through health and our God's will, to render her days as comfortable as such means may best afford with caution and prudence." He followed this declaration with a blunt question: Did she plan on returning to England with him, yes or no? Then came the ultimatum: "If a 'no' comes *I never will put the questions again* and we *probably* never will meet again."

He might be willing to go to Louisville or even to Wheeling to meet her, he said, but he could not go as far as Louisiana. And while he was speaking his mind, he had something to say about Johnny. Paragraph 5: He did not want the boy to come with them to England unless he planned to work with his father and "follow my profession." Otherwise, "settle him in Louisville with whomever thou may like best."

He warned Lucy that he expected a prompt answer. If she intended to come with him it should be before the first of October, because he might be recalled to England if some problem developed with the publication.

When he learned that ships were arriving from New Orleans in as little as twelve days, he added: "The news . . . shook my frame as if

electrified; to know that in so short a time I might again see my Lucy and press her to my heart is a blessing beyond anything I have felt since three years."[9]

Then he packed up his portfolios, consulted his gold watch, and took a stage for Philadelphia. He had written ahead to the artist Thomas Sully, asking him to find him a room in a boardinghouse. He was looking forward to seeing Sully and Harlan, who had kept up a lively correspondence with Audubon in the five years since coming to the artist's aid during that first ugly encounter with George Ord and his friends. Harlan, eager to publish his own writings—which, some said, were too ambitious and not well researched—had pressed Audubon for an exchange of information and specimens, and Audubon had complied.[10] Still, he did not look forward to entering the fray in Philadelphia, and he had little hope of getting any subscribers there. It seemed he was right; seven hundred dollars was rather high for a book on birds, even if they were the birds of America.

Harlan arranged to have the prints shown at the Academy of Natural Sciences; but not even the Academy chose to subscribe. Audubon set about the work at hand, removing himself to Camden, New Jersey, just at the season when migratory warblers arrived in great numbers from the south. He spent three weeks studying their habits during this breeding season, and drawing at a prodigious rate such birds as the wood pewee and the black-poll warbler.[11]

After that, he pressed on to Great Egg Harbor and the seashore, with its wealth of sea and land birds: bay-winged buntings (Vesper sparrows), seaside sparrows, yellow-breasted chats, and golden-crowned thrushes (ovenbirds), among many others.[12] It was June; the weather was fine; Audubon had his gun on his shoulder and his dog at his heels, walking at sunrise through the deep woods of New Jersey, listening to the "loud and mellow notes" of the meadowlark, on his way to Great Egg Harbor. There, he stayed in the home of a man he described as a "thoroughbred fisherman-gunner" who had an extra cot for him. The man, his excellent wife, and "a little daughter as playful as a kitten, though as wild as a Sea-Gull" took him into their family and lives.[13]

At daybreak, he wrote, "I shouldered my double-barrelled gun, and my host carried with him a long fowling-piece, a pair of oars, and a pair of oyster-tongs, while the wife and daughter brought along a seine. The boat was good, the breeze gentle, and along the inlets we sailed for parts well known to my companions."

It was the perfect antidote to all those smoky days locked in his London rooms, all those predawn walks through Regent's Park. In one important sense, Audubon was home again—in the deep woods of America, hunting and shooting birds, searching out the plants to draw with them, threading his way through a vast marsh, finding specific birds and their nests. When they were hungry, they caught fish and cooked them. Or they picked oysters fresh from their beds and ate them on the spot. If Lucy's silence disturbed Audubon, he had the woods and quantities of birds overhead to comfort him.[14]

He left Great Egg Harbor with a treasury of new drawings, twenty in all; he was fulfilling the goal he had set himself, with the help of "thoroughbred" hunters who knew where to find the birds he needed.[15]

Back in Philadelphia, he found the landscape artist George Lehman, whom he had met on his way home from Niagara five years before. The two had been companions then, each scrambling to earn a living with his art. Now Audubon hired the Swiss for thirty days' work painting backgrounds for the drawings he had just completed.[16] Lehman was an established artist—his landscapes had been exhibited at the Pennsylvania Academy of Fine Arts—yet he did not demand that his name appear on the folio pages. He was, it seemed, still scrambling. Audubon could have found no better collaborator.[17]

In Philadelphia, letters from England were waiting for him. They showed the work progressing more or less according to plan: The fourteenth number had been engraved and the book had grown to seventy double-elephant pages. There were a few problems—the French agent, Pitois, had remained ominously silent, which meant he had not collected the thousand dollars due from subscriptions, and Charles Bonaparte's bankers were not being cooperative about paying the whole amount owed. But the work itself was going along smoothly.

Audubon faced other irritations: Young Henry Ward had not joined him in Camden to collect bird skins for Swainson and others, according to plan, but instead had returned to New York and spent the money advanced him to marry a girl whom Audubon dismissed as "the lowest cast[e]" of Londoner. Audubon sent off an apologetic letter to Swainson. He also had to report that "you are, as well as I, accused of publishing species as new that are *long since* described, &c." [18]

Swainson replied rather mildly about Ward, saying he was "at the best negligent, and somewhat ungrateful"—and once more emphasized that Audubon must preserve the skins of every bird he drew "on which there is the least doubt whether the bird is young or old . . . If you are to give scientific descriptions and definitions of the species this precaution is absolutely necessary." He prodded Audubon once more to send the "cartload" of seashells from the Ohio and the Mississippi that he had promised for nearly a year. [19]

The most annoying letters came from Lucy. She would not budge; he would have to come to her; she did not know if she wanted to give up her secure position for what seemed a precarious future. "Convince me," she seemed to be saying. "Prove that you love me."

His anger spilled over onto their elder son, on whom he had counted for help. By July 18, Audubon had been in the country for two months and thirteen days and had not yet heard from Victor. He fired off a letter that was as close as he could come to a visit to the woodshed, on paper: "It is neither kind as a man or dutifull as a son to keep such an extraordinary silence. Have you thought as your Mother that *although* I wrote that I could not go Westerly or Southerly that I would undoutedly do so?—if you have undeceive yourself and believe me I cannot go either to Kentucky or to Louisiana." Audubon's own good father had been absent from his mother for three years and more, in search of his fortune. Men of substance the world over left their families for long periods for the good of them all; he was not alone, and he had never abandoned his family.

He had explained several times over why he could not come directly to them, he went on to say; he had pleaded with Lucy to join

him, but she would not. Her letters "are full of doubt & fear . . . " he
went on. "She complains of my want of affection; of the coolness of my
style of writing &c—and thinks that my not going to Louisiana for her
is quite sufficient proof for all these her doubts and fears."

He asked Victor to intercede to convince Lucy to settle her busi-
ness and join him as soon as possible. He didn't understand why she
should be afraid to travel alone; he remembered her sister Ann getting
on a steamboat to join her husband in New Orleans. Anger surging,
he lashed out bitterly at Lucy's relations: "What is my former partner
Mr. Thomas W. Bakewell doing? or M. Berthoud and their increased
families? upon my word it is wondrous to live a long life and see the
movements, thoughts, and different actions of our poor degenerated
species—good only through interest; forgetfull, envious, or hatefull
through the same medium—well my Dear Boy so goes the world and
with it we must move the best way we can."[20] He wanted to remove his
boys from the Bakewell nest, where he was not welcome; his wish had
always been for the four of them to stand together, trusting each other
absolutely and letting the rest of the world go by.

He packed up and moved out again at four in the morning, to
what was called the Great Pine Swamp in Northampton County,
Pennsylvania. Victor's response caught up with him a month later. He
had negotiated a truce of sorts; Lucy would meet his father in Louis-
ville. Audubon replied immediately: *I will be at Louisville to meet your
Mamma as soon as I hear from her saying that she will have left Bayou
Sarah to join me never to part again!*[21] As it happened, he would not
be able to leave before the end of October; Lucy replied that she must
finish the year at her school, and that at any rate, she would not be
able to collect the money owed her until January 1, when the cotton
crops were sold.[22] He was uneasy about her remaining in Louisiana,
not least because there had been an especially bad siege of yellow fever,
which was moving north along the river from New Orleans toward
St. Francisville.[23]

Audubon declared the Great Pine Swamp to be no swamp at all,
but really a pine forest, still filled with deer and bear and with streams

full of trout just waiting to be caught by anyone dangling a grasshopper on a line. Winding up and over the mountains in a fierce summer storm, he was thoroughly drenched when he arrived at the cabin of Jedediah Irish, who had been given the job of clearing the forest for the mills. Irish was not at home, but his wife welcomed Audubon and said he could stay with the family. She called in a nephew to answer the visitor's questions about birds and to help him settle in.

Audubon unpacked the wooden box with his journal and supplies—linen, drawing paper, colors, and pencils, as well as the twenty-five pounds of shot he had brought along, some flints, and his gun, which he had named Tear-jacket. The next morning dawned bright and clear, with drops of the previous day's rain sparkling on the leaves, and sunlight streaking into the deep pine green. With what he called "a heart as true to Nature as ever" he set out with Irish's nephew to search for the birds he required.

They had been gone only a short time before he spotted a hemlock warbler (Blackburnian warbler); he could scarcely believe his luck. The warbler—which he called a "lovely Sylvia"—had eluded him for years. He stood silent for a long moment, thinking to himself that the Great Pine Swamp must be rich in the birds he needed. The young man offered to push on with him, showing him the way through the depths of the forest, but Audubon was too excited. He returned to the cabin to wire the bird and draw it that same day, taking a twig of blooming laurel with him. The next few days proved no different; a ramble quickly reaped a bird he needed for the book, and he spent the better part of his time inside, drawing—Irish's "sweet children" bobbing happily around him.

Their father returned in a few days. He was in charge of cutting the virgin forests which covered the steep mountains, an idea which Audubon deplored, but Irish was "young, robust, active, industrious, persevering, and energetic." He was an American woodsman poet; he was Audubon, twenty years before. Irish was quick to offer help in Audubon's search for birds, and in the weeks to come the two were together for "long walks and long talks" during which they pursued,

shot, and admired many beautiful birds. Irish read Robert Burns's poems aloud while Audubon drew; he told logging stories, some of them tall, and demonstrated the methods used to clear the forest. Even as they talked in the cold, healthy woods, thirty people a day were dying of yellow fever in New Orleans.

When Audubon left after ten weeks, Jedediah Irish hiked out with him; they took the direct route, straight over the mountain to the town of Mauch Chunk.[24] Irish stayed the night and the two parted the next day, the one to go back into the woods, the other headed, on a cool and crisp day in September, to Philadelphia. Audubon was sorry to see Irish go, sorry that his idyll had come to an end.

"Left to my thoughts," Audubon wrote, "I felt amazed that such a place as the Great Pine Forest should be so little known to the Philadelphians." Here was prime territory for a naturalist, brimming over with forest creatures, and yet few city people knew where it was. He was proud that at the age of forty-four he had been able to rough it with a strong young woodsman like Irish, and that he had found the outdoor living and the simple fare—venison and bear meat and trout cooked over an open fire—agreeable after all the years away. He could not help but let himself gloat a little, and he wrote a small sermon on how all the young dandies in Philadelphia, those he called "closet" naturalists, would be better off spending their time in such wild retreats instead of sitting around drawing rooms "in full dress, intent on displaying the make of their legs . . . enjoying their wines." He sincerely doubted if any of these young gentlemen would appreciate the Jedediah Irishes of the world, and the kind of wilderness hospitality they offered.[25]

Lehman labored to finish the backgrounds of the Great Pine Swamp birds. "I wish I had eight pairs of hands," Audubon wrote, "and another body to shoot the specimens, still I am delighted at what I have accumulated in drawings this season." He went on: "I live alone, see scarcely any one . . . I rise long before day, and work til night-fall, when I take a walk, and to bed." By October, he and Lehman had completed forty-two drawings—eleven large, eleven middle-sized, and twenty small ones, along with the plants, nests, and flowers.[26] A few

weeks later, Audubon shipped the pictures—which included ninety-five species in all, as well as drawings of sixty kinds of birds' eggs—to Havell. Along with this cargo went three boxes of insects, about thirteen hundred specimens, that Audubon had managed to collect for Children—his reward for diligently watching over Audubon's business while he was away. As Children must have his insects, Swainson must have his shells, and a veritable forest of seedling trees. Audubon's friends did not hesitate to ask him to scour the great forests and river-banks of the new country, and he knew he must not disappoint them. Friends were a necessity in the complex world of science and the arts; even now, friends in Philadelphia were beginning to answer Audubon's critics. He hoped the tide would turn for him in his own country.

His work done, he set out early in November to see his family. He wanted them to come to him, partly because he did not relish confronting Lucy's family. He felt that the Bakewells had turned away from him when he most needed their support and kindness, that they had frozen him out and disparaged him to his sons. He might have expected that from Thomas Bakewell, but he didn't from Nicholas Berthoud, whom he had thought a friend, or from Eliza, whom he had taken into his home when she was in need. Even Billy Bakewell, who had been like a little brother to him, seemed to be conspiring with the others to deny Audubon the respect he craved, and felt he deserved, as a husband and father and as a member of the family. But he had managed without them; he was returning a changed man, self-assured, confident, and, yes, polished. And they would already have read in the *National Intelligencer* an account of the great success of *The Birds of America*.

He made his way to Pittsburgh by coach—"the Roads, the coaches, horses Drivers and Inns all much improved and yet needing a great deal to make the traveller *quite comfortable*," he wrote, probably thinking of Basil Hall's reports of these same coaches and roads. "The slowness of the stages is yet a great bore to a man in a hurry," he added.[27]

He booked passage on a steamboat to Louisville, then walked the two miles to Shippingport. When he entered Nicholas Berthoud's countinghouse he did not at first recognize the tall, good-looking boy

who was his elder son. Victor had his mother's straight, slender build and his father's handsome face. In an instant, Audubon did what he had dreamed of doing for the five long years they had been apart: He clasped the boy to his heart, and let his tears flow. Then father and son went to find Johnny, and the scene was repeated. Audubon could not get over how his sons had changed, how they had grown, how tall they were: Both were taller than he, now.

He was not the same Audubon who had passed through on his way down the Mississippi, shaggy and longhaired and poor. He was not the same man Lucy had said should not return to her in Shippingport if he was "in want"; he was not a father to be ashamed of. This Audubon looked the London gentleman, with his tailored suits and social ease. They knew from the newspaper accounts, those sent from London as well as those in the American papers, that he was fast becoming famous. It was hard to believe, but their father seemed to have done what he set out to do.

Audubon, never one to hold a grudge, thanked Nicholas and Billy for being of service to his sons. They responded with praise for the boys, and Billy—whom Audubon had playfully called "the Duck Killer"— once more became his devotee. Audubon met Billy's wife of a year, Alicia Matthews, and commiserated with her on the recent death of their first baby.[28] Always happy among children, he became acquainted with the Berthouds' growing tribe and, in a few days at Shippingport, began to achieve a rapprochement with the family.

It was Lucy he needed to see, and since it would be almost two months before she could leave Louisiana there seemed nothing to do but catch a steamboat and go to her. After a few days with the boys, he paid twenty-five dollars for passage to Bayou Sarah. When he left Philadelphia, the trees were already bare and the country spare and cold, but as he moved south, the trees grew green again and the air soft.

He arrived in the morning and made his way to Beech Grove, where he found Lucy, straight as ever in her black dress and white cap and her little glasses perched on her nose. It was just as he believed it would be: A few hours together dissolved the years of bickering and

wrangling and writing letters that passed each other in the middle of the ocean, all the long months of simmering resentments and accusations and ultimatums. They were together again; she could see by looking at him, by listening to him, that everything had changed. She was forty-two years old; the struggle of the past ten years had been more than any gentlewoman should have to bear, yet she had borne it, and now she would share in his success. They put the huge double-elephant folio on a table; he turned each new page, she looked at it and then at him; and finally she understood. They had done it; they had triumphed over the poverty, the humiliations, the long difficult separations. Lucy and John were together, and this time she believed him when he told her they would never again need to be apart.

On New Year's Day, 1830, John and Lucy Audubon said good-bye to their friends in St. Francisville and boarded a steamer for New Orleans, taking with them the three slaves Lucy owned—Celia, who had been with them in Henderson so long ago, and her two sons, Reuben and Lewis. (The slaves would be sold to the Audubons' old friends the Brands.) After a week in New Orleans, the couple boarded the steamer *Philadelphia* as first-class passengers, paying sixty dollars to arrive in style in Louisville.[29] Scarcely two years before, Captain Basil Hall, with his wife and infant daughter, had boarded this same boat—"one of the largest . . . on the river"—for the passage from New Orleans to Louisville, some 1,430 miles. The backwoodsmen filled the upper deck, while the ladies and gentlemen took the saloons belowstairs, Hall had written.[30] Audubon had once talked of returning to Louisville in a fine coach to lord it over his doubters; the steamer *Philadelphia* was almost as good.

Both Johnny and Victor were staying with their Uncle William and his wife; Audubon once more found himself in the enviable position of having his family gathered around him, of once more finding himself valued as a father and a friend. The Audubons lingered in Louisville for a month with their sons and Lucy's family, becoming reacquainted and making plans for the future. He explained to Lucy and the boys, in detail, all that he must do—the juggling act so great an

effort demanded—so they could see how essential their help could be. He could not afford to bring them with him now, but just as soon as he could enlarge his subscription list sufficiently he would send for them. In the meantime, he found time to skin twenty Carolina paroquets and some ivory-billed and pileated woodpeckers to take back with him.

In appreciation of Billy's hospitality—and probably, as well, of the genuineness of his welcome—Audubon painted a still life in oils of dead game. All the while he reminded Johnny to pay attention to painting in oils, above everything.

Lucy left part of her savings with Billy, in case the boys should need money, and Audubon drew up a will, naming Lucy and his sons as his heirs. (He always feared dying at sea.) The document was witnessed by Nicholas and Billy.

The parents lingered with their sons through February. On the twelfth of that month, across the Ohio in Indiana, Abraham Lincoln marked his twenty-first birthday and reached his majority. He could now vote, and he was law fully free from his father's commands; he could come and go as he pleased. Three days later, on February 15, he led the ox team which pulled a wagon loaded with his family's scarce belongings. Tom Lincoln was taking them north to Illinois, to the Grand Prairie, to start over once more, and Abe went with them, to his destiny.

Audubon spoke to Victor and Johnny about their futures. He made it clear that he wanted both of them to work with him, that his dream had always been to establish a family enterprise that would ensure their independence against anyone who might try to control their fate. He urged them to make good use of the coming months by honing their talents in drawing and painting. Johnny was the more promising artist, he could see; Victor was the businessman. Victor was within four months of his twenty-first birthday; soon he, like Abe Lincoln, would be free to go his own way and, like Lincoln, he would choose to stay with his father.

Early in March, Lucy and John waved good-bye to their sons and began the long journey back to England. At Cincinnati they stopped

to pay what amounted to a courtesy call on Lucy's brother Thomas, and they paused again at Wheeling to see her sister Sarah. These family duties accomplished, the husband and wife climbed on the mail coach bound for the nation's capital.[31]

Audubon had letters of introduction to President Andrew Jackson and to Edward Everett of Massachusetts, then a leader in the House of Representatives. The Audubons were greeted cordially by the president—it was an age when public figures were generally available to constituents who came calling—but it was Everett, the onetime publisher, who looked at the folio, recognized its excellence, and decided to help the artist. "Congress was then in session," Audubon wrote, "and I exhibited my drawings to the House of Representatives, and received their subscription as a body." (Everett had a gift for recognizing greatness; thirty-three years later he would share the podium at Gettysburg with President Abraham Lincoln, listen to his short address, and declare it a masterpiece.)

At Baltimore they paused long enough to collect three new subscriptions; but once more, those in Philadelphia who might have subscribed—notably the Academy—turned away from him. Ord had managed to keep Audubon's reputation clouded, and the Academy continued to deny him membership.

Audubon, with Lucy beside him now, refused to be distracted by this pettiness and, with a new supply of saplings and a menagerie that included squirrels and blue jays, the couple boarded the packet *Pacific* on the first of April, 1830, bound for Liverpool.

15

I feel fully decided that we should all go
to Europe together and to work as if an
established Partnership for Life consisting
of Husband Wife and Children.[1]

THE PACKET *PACIFIC* MADE ITS regular run in a fast twenty-five
days, depositing the Audubons in Liverpool near the end of April
1830. They went directly to the Gordons', where Lucy found her
sister gravely ill and immediately assumed the role of caretaker. Only
when she could be spared from the Gordon household was Audubon
able, at long last, to introduce his Lucy to the Rathbones, who had
heard so much about her.

Her effervescent husband presented Lucy with pride; the Rath-
bones were pleased to meet her and were as polite as they could be.
But there would be no more long, rambling walks alone with Han-
nah Mary, no more confidences, no more exchanges of long, tender
glances. Lucy had arrived to assuage her husband's aching loneliness;
if the Rathbone women were surprised at Mrs. Audubon's appearance
or her temperament, in comparison with her husband's, they spoke of

it only among themselves. And if Lucy took exception to her husband bringing some snakeskins from America to have a pair of shoes made for Hannah Mary, she did not speak out.

It was not only companionship that Audubon expected from his wife: There was an enormous amount of work to be done, more than enough for both of them. She was as eager to share the work as he was to have her; once more they would be making decisions together, she would be part of his life. He was eager to be off at once to Manchester, where his solid base of subscribers was eroding and needed urgent attention. Lucy felt she must stay with Ann; Audubon, disappointed but understanding, pushed on alone, first to Manchester and then to London.

He threw himself into a frenzy of salesmanship, visiting his subscribers, looking at the numbers already sent them, listening to their complaints. For the past year, Havell had been solely responsible for the quality of the folio. Now, in his swings through the countryside, whenever Audubon heard a complaint about a plate, he readily promised that it would be replaced; if that meant replacing nine, Havell would replace nine. Audubon talked hard to regain the confidence of subscribers who had fallen away, and to find new ones to take the place of those who could not be coaxed back into the fold.

He went on to London to check in with Havell, and now learned that at last he had been elected to membership in the Royal Society. It was the culminating honor; how could his own country continue to ignore and deny him, now that he was a fellow of the Royal Society of London? He had but to paint a few quick oils and rush them to the shops to get the money for the fifty-pound entrance fee, so he could take his seat on the sixth of May.[2]

Meanwhile, Lucy stood sentinel over her sister's sickroom, writing to warn Audubon that Ann, who feared she was going to die, was asking Lucy to take over the care of her small son. On June 23, Audubon replied from Birmingham, telling her to stay as long as was necessary and adding—correctly but guardedly: "I assure thee that was she to die to see thee the guardian of Dear Willie would add to my comfort and I

do not well see why thou shouldst [not] at least for a time take charge
of him."[3] He hoped, however, that Ann would recuperate so that "I will
then no longer be confined to my dull thoughts alone."

He did not try to spare Lucy's feelings in reporting on another
branch of the family, the very wealthy Giffords, whose favor Lucy had
always curried. Lucy had written her father's cousin to see when they
might meet. Audubon wrote that he would not bother to send Mrs.
Gifford a reply because "She merely says she cannot see thee for the
Lord knows when!"

He, however, ached to be with his wife; the months together since
their reunion in Louisiana had given him a sense of security, as well as
resolve. When Lucy was with him, he was not so plagued by doubt. He
wrote her about a disturbing dream that took him back to Henderson:
"I was shooting Ducks with William in the Pond Settlement and that
we had so many killed that our Horses were scarcely able to walk under
the load and that it was so pitchy Dark when we returned that every
tree came in contact with my own noble Nose!"[4] The burden of the
Birds was becoming almost too much to bear, all alone.

By the end of June, after Audubon had gone to London and re-
turned to Birmingham to try to sell subscriptions, Ann was well enough
to release her sister. However, Lucy was afraid to travel on her own to
Birmingham. Her years alone in the woods had made her fearful of the
world; her husband would have to come get her. "I will find it rather
inconvenient to go to Liverpool for thee," he wrote, not concealing his
exasperation. "But if I cannot get thee without, I must do so."[5]

Since his return to Great Britain he had been pelted with prob-
lems—the loss of subscribers, complaints from the likes of Charles
Bonaparte about inferior coloring. Audubon took Havell severely to
task, going so far as to threaten somewhat hysterically to give up on the
whole business and return to America if Havell couldn't maintain an
even, excellent quality. It was a calculated threat; he was putting Havell
on notice. They had an excellent business going, but Audubon wanted
Havell to know that unless he agreed to supervise the coloring person-
ally, it was within the artist's power to call a stop to the whole enter-

prise. He was looking ahead; the folio was not even a quarter done, and years of work still lay ahead of them. He had to know he could depend on Havell for consistent workmanship.

Havell responded to the outburst with restraint, remarking that he had heard no complaints from London clients but promising to replace all the numbers in question, and to keep a closer watch. His reputation was soaring with the publication of the *Birds;* as demanding as the work was, Havell understood its significance to his own place in history—besides which, Audubon was keeping dozens of workmen occupied. Havell could afford to be conciliatory.

As important as it was to maintain the cash flow from the subscribers, Audubon also felt mounting pressure to find someone to work with him on the text. He had already decided to publish the *Ornithological Biography*—so called because it would give detailed scientific information about each of the birds pictured—in separate volumes, which could be sold with the *Birds of America* folio. To make the rather dry material more interesting, he planned to include anecdotes about the birds and his own observations, as well as what he called "Episodes": stories of America intended to intrigue and entertain. He knew, from the past three years, just what the British longed to know about America, what titillated and fascinated them—stories about Indians, about derring-do, and most of all, about life on the wild frontier. He had tales to tell from his own experience, though he would embellish some of them for dramatic effect. Friends told him their stories, and he could include tall tales that circulated on the frontier or that he simply invented. All of them had one purpose: to encourage brisk sales.

Audubon was a good storyteller with an animated, colorful way of expressing himself. In the twenty-seven years since his arrival in America he had never lost his French accent, but his English had improved tremendously. The 1821 journal, written on that first, miserable journey down the Mississippi in search of birds, was vibrant and crude, filled with misspellings, punctuation gone wild, and ideas only partially expressed. But the 1826 journal, covering his first year in Great

Britain, was literate and even stylish, with ideas fully articulated. Once committed to publishing his work, he had taken up his pen with a vengeance, writing letters and journals and notes on the birds. Much of this material he made copies of, sending two letters (and sometimes three) by various ships to ensure that at least one would arrive, sending Lucy copies of letters he had received, writing everybody and anybody who could possibly be of help. All this practice had its effect: Audubon had become an effective practitioner of the English language. But he was not as good a writer as Alexander Wilson; he needed an editor to polish his English. More than that, he needed someone with formal training in ornithology to help him describe the species in a way acceptable to the scientific community.

Swainson, an ornithologist and writer as well as a good friend, was the obvious choice. Audubon knew that Swainson considered him an intimate. After their French trip, he had written Audubon to ask for a loan of eighty pounds, adding disingenuously, "If you were aware of the peculiar feelings which we Englishmen have on such occasions, perhaps you would smile, but so it is that we never ask anyone, from whom we have the least idea of a refusal." [6] Swainson had generously offered to include an announcement of Audubon's *Birds* in one of his own books, and he had come to Audubon's defense when some members of the Royal Society, influenced by Ord's and Waterton's accusations, expressed doubts about Audubon's character and wondered if he deserved to be elected.

Audubon dashed off a letter to Swainson, asking him to help make the *Ornithological Biography* acceptable for publication and suggesting that if Swainson agreed to the collaboration, he and Lucy should come to live with the Swainsons as paying guests.

Swainson's answer set out his conditions for taking on the job and stating what he would charge for each page, as well as for such extras as proofreading. He did not see his role as simply editing Audubon's work; he would expect to work independently, "not consulting with each other at every page" and with his own work distinct from Audubon's, "in the form of Scientific Notes." He took it as a matter of

course, he added, that his name would appear on the title page, giving him full credit for his part in the publication.

Audubon did not intend to share the title page with anyone. What he wanted was someone to fill in the background of the text for him, just as Mason and Lehman had filled in the drawings. Swainson would be paid for this work, as the background artists had been paid. Acknowledgment of his participation would be given, at the proper time and the proper place—both of which Audubon would choose. This was a classic publishing dispute involving reputations and egos, control and credit.

Swainson refused Audubon's terms. He considered himself every bit Audubon's equal, and more. He had his reputation to protect, and he was incensed that Audubon was not willing to treat him with the respect he felt he deserved. In a stinging rebuke, he gave his erstwhile friend to understand that the name Swainson on the title page would add value to the book, and he accused Audubon of wanting to pass off another's work as his own. He added, to give the French-American upstart his due, "As to boarding with us, you do not know, probably, that this is never done in England, except as a matter of necessity or profession, in which case the domestic establishment is framed accordingly." His last bit of information was meant to be the coup de grace: He had accepted Sir William Jardine's offer to work on a new edition of Alexander Wilson's book, so he wasn't available at any rate. (What he did not know was that the editorship of a new edition of Wilson's *American Ornithology* had been offered to Audubon. "I refused 200 pounds," Audubon wrote Havel, " . . . and advised the gentleman to apply to Mr. Swainson."[7])

John Audubon had no time to fret over the row with Swainson. He and Lucy were moving at a frantic pace, traveling from London to Leeds to York; Audubon was exhibiting when he could, writing while it was light, doing everything within reason to recoup the losses incurred during the year in America and to move ahead. From the beginning, Audubon had wondered if Lucy could adapt to this life, living in boardinghouses and rented rooms, working from dawn until dark.

Now he had his answer; she stayed with him, sharing the work and the worry, but the pace was clearly wearing.

In Edinburgh they went straightaway to Mrs. Dickie's boarding-house on George Street; there Lucy took to bed with rheumatism in her writing arm.[8] The city proved a tonic for them both; Audubon had always loved it, and he had many friends there who made Lucy feel comfortable.

As always, Edinburgh was filled with talent. After a few inquiries, Audubon was introduced to William MacGillivray, a modest young Scots naturalist who was familiar with Audubon's work. "He agreed to assist me, and correct my manuscripts for two guineas per sheet of sixteen pages," Audubon wrote.[9] It was one-sixth of what Swainson had asked.

The very next day they began working on the bird biographies. Audubon's routine had him waking at four in the morning and working until ten or eleven at night; MacGillivray did not start until about ten, but would work until the early-morning hours. "Writing now became the order of the day. I sat at it as soon as I awoke in the morning, and continued the whole long day, and so full was my mind of birds and their habits, that in my sleep I continually dreamed of birds," Audubon reported. And so the manuscript grew, "like the rising of a stream after abundant rains."

Luck had found him once more; MacGillivray proved to be the perfect collaborator. He was bright and talented, just starting out and with no established reputation to protect; best of all, he was full of admiration for Audubon. Lucy did her part, editing and copying and taking care of details.

Unable to find a publisher for the *Ornithological Biography*, Audubon went to his old friend Patrick Neill, who urged him to publish the book himself. Then Lucy and he fussed over the proper way to ensure the American copyright. While Lucy set about making a copy of the book to send to America, Audubon wrote Dr. Harlan and others for advice. When it came, they learned that Lucy's labors were for nothing. To keep the English version from being pirated and published

in America, they had to withhold English distribution until a printed copy could be sent to America to secure the copyright there. The American copyright would be in Victor's name, to prevent the indefatigable Henderson creditors from snapping at Audubon's heels.

He had spent the summer and fall pushing Havell to perform at peak and the winter in Edinburgh writing the book and, with Lucy's help, attending to the dozens of publishing and bookkeeping details his work spawned. Audubon, always on the lookout for a new source of income, searched out his friend Joseph Kidd, the landscape artist who had given him lessons in oils. From the beginning, Audubon had had it in mind to hire Kidd to copy the *Bird* drawings in oils for a traveling show or perhaps an ornithological museum. The entry fees could help supply the cash needed to keep Havell and the printers working. Kidd agreed to the plan, and Audubon quickly sent away to London for canvases to get him started. Havell, meanwhile, was plunging ahead, transferring more and more of the finished drawings to the engraving stone.

Working at a frenetic pace, Audubon and MacGillivray completed the first volume of the *Ornithological Biography* in four months. By the end of February, Audubon sent copies off to Dr. Harlan in Philadelphia, who was in charge of securing the copyright and seeing to the printing of the American edition. In April, the first volume of the *Ornithological Biography* appeared in England and *Blackwood's Magazine* gave it a rousing two-part review. Audubon didn't write as well as Wilson, the review conceded, but as a bird artist, there was no one in the world to equal him. Audubon was, the reviewer said, quite simply one of the world's great ornithologists.

The words were sweet. On April 10, 1831, Audubon wrote Havell: "We are quite well and a happier time have seldom enjoyed since in Europe than we have experienced in this fairest of Cities." Lucy was especially pleased when her cousin Euphemia Gifford of Duffield Bank, Derby, became a subscriber to *The Birds of America*.

John and Lucy Audubon had accomplished much in their year together in Great Britain. Never mind that his goal had always been to sell at least two hundred subscriptions, while the most he ever had

was a hundred and eighty, fifty of which had fallen away despite "all my constant exertions, fatigues, and vexations." He seemed unable to find any new subscribers in England, and France was in political turmoil. Although Audubon was thrilled to learn that the Duc d'Orléans had now mounted the throne of France, he realized that the change of government would probably cost him many hard-won subscriptions. Audubon decided to secure his English subscribers before tackling France, and he and Lucy made a quick sweep of the northern towns—Newcastle, York, Leeds, Manchester, and Liverpool—to reassure subscribers and see old friends and Lucy's family, before returning to London "on that extraordinary road, called the railway, at the rate of 24 miles an hour."[10] Then Audubon made a fast trip across the Channel to collect what he could from his French subscribers.

Everything seemed to be going well; it was time to return to America. The Audubons booked passage on the *Columbia,* set to sail on July 31, 1831, from Portsmouth to New York. On July 27, Edward Harris— the wealthy young man from Moorestown, New Jersey, who had come to Audubon's financial rescue on his first Philadelphia sojourn—arrived in London. Audubon sent him a note: "Come to meet me *tomorrow, precisely* at *twelve* o'clock, at our lodgings, 121 Great Portland street."[11] Audubon had liked Harris from the beginning, and considered him to be a personal friend. Since Harris was also a subscriber, Audubon agreed to carry the last three numbers back to America for him.

At this point, Havell had finished and delivered 115 double-elephant folio pages, and was hard at work on the next five. Soon he would require the bird drawings Audubon did not yet have. Audubon felt a sense of urgency; he wanted to be in Florida by November, to find the birds he needed, and some new species. Once more, a chastened Henry Ward was with him, hired to prepare the bird skins Audubon drew. Ward also intended to get a supply for himself to sell in the London market. Audubon had written ahead to Lehman, asking him to go south with him in search of sea and land birds.

At Portsmouth harbor at nine on the morning of August 1, a bright clear summer day, the *Columbia* raised her sails and was off for

America, carrying the Audubons, who hoped to find both the birds and the subscribers critical to the continued success of the great work.

———————

THAT SAME JULY OF 1831, Audubon's French countryman Alexis de Tocqueville was traveling through the deep woods of America. Of a visit to a log cabin he wrote: "We enter a room filling the whole extent of the house. Fire in a corner, tools of all sorts, an excellent bed in another corner, the man and woman lying in bed, the woman dressed like a lady. Strange mixture of prosperity and poverty. The Americans in their log houses have the air of rich folk who have temporarily gone to spend a season in a hunting lodge."[12]

The American couple that Tocqueville came upon might have been the Audubons in their Henderson or St. Francisville days. But that time was over for them now; for the most part, they lived in boardinghouses or rented rooms, always with a sitting room to entertain their many callers. On their arrival in New York in the opening days of September, they made their way to the comfortable house that Nicholas and Eliza Berthoud had taken when they came east to open a business. Nicholas, like most American businessmen, was having his ups and downs; he hoped that business would be better in New York, which was turning into the commercial hub of the country.

Berthoud was no longer indifferent to Audubon, who was fast becoming famous; the papers were full of praise for the first volume of the *Ornithological Biography.* John and Lucy Audubon spent a week with the Berthouds "in great comfort." During that time, it was agreed that Nicholas would become his old friend's New York agent.

A letter was waiting from Victor, who proposed to meet them in Philadelphia so he could escort his mother back to Kentucky, where she could visit the boys and her brother Billy while Audubon was off chasing birds in Florida. Victor and Johnny were no longer content with their lives in Kentucky. Their mother's very practical letters gave

them a glimpse of a different and exciting world. Though Audubon was not yet aware of it, Victor and Johnny were considering assuming the roles he had proposed for them long ago.

The parents had arrived in Philadelphia before Victor, and welcomed him with open arms. Times had changed for all of them. Audubon's obvious accomplishments could no longer be ignored. The Philosophical Society and the Academy of Natural Sciences subscribed to the *Birds,* and so did John Wetherill of the family that now owned Mill Grove. Dr. Richard Harlan, Audubon's prolific correspondent and Philadelphia agent, added his name to the growing list of American subscribers. "My Enemies are going down hill very fast and fine reviews of the Work coming forth," Audubon wrote Havell gleefully.

At Baltimore, Lucy and Victor said good-bye to John and headed over the mountains to Kentucky. Audubon, Lehman, and Ward pushed on, working together for the first time. Friction between the slovenly Ward (who was a good worker, Audubon admitted, but lacking in most other virtues) and the fastidious Lehman developed almost immediately, and Audubon lost no time in making them understand that squabbling would not be allowed, that he expected them to be respectful of each other.[13]

The U.S. Congress, thanks to the efforts of Edward Everett, was about to pass legislation allowing the *Birds* to come into the country duty-free. This would help Audubon's sales effort, but he wanted more; he wanted the government to help him find the birds he needed to complete his great work. He stormed Washington with two hundred letters of recommendation, and came away with letters from the secretaries of the navy and treasury to the commanding officers of military vessels and those of the revenue service, directing them to give Audubon all possible assistance.[14] He was hoping that the government would provide transportation to Florida and perhaps beyond—to Mexico, to California, and even north to the Columbia River. The American Far West loomed large in Audubon's mind. New species were there; he wanted—and needed—them, but a journey so far west would mean an absence of two years, during which he would be completely out of

touch not only with Havell and England, but with Lucy and the boys. For the time being, he would concentrate on the United States' southeastern shores. He, Lehman, and young Ward headed for Charleston, South Carolina.

Three years before, Basil Hall and his family had made this same journey between Columbia and Charleston. "The road led us sometimes across enormous swamps, and sometimes through extensive pine forests . . . " Hall wrote. "Charleston is a pretty-looking city, . . . with the sea in front, and two noble rivers, the Ashley and the Cooper, enclosing it on a wide peninsula called the Neck. This space of flat ground is covered with the villas of the wealthy planters, many of which were almost hid in the rich foliage . . . In the streets, a row of trees is planted on each side, along the outer edge of the foot pavement, a fashion common to most of the southern towns of America. This tree is generally called the Pride of India."

To the former British naval officer, Charleston seemed a tropical port, its wharves filled with ships from all parts of the world, cargoes of bananas and coconuts and cotton bales piled high by sweating black men with French West Indian accents. The city reminded Basil Hall of Java, of Bermuda, of Ceylon. He stood for a time and observed "the dripping forehead of the poor negro, the cotton sails of the schooners, the luxuriant fruits of the Caribee Islands, and the blue heavens of a perpetual summer." Then he wandered back into the center of town to the Exchange, near which a slave auction was under way. He watched for a time, both intrigued and repelled. Families were sold as units, displayed on a table for all to see. The children were terrified, he noticed, especially two little boys, twins, "who kept their eyes fixed steadily on their mother's face."[15] The boys, their parents, and their baby sister were sold for $1,450, or $290 each.

In October 1831, Audubon and his two "companions de voyage" crossed the Cooper River to Charleston in a canoe. They put up at a boardinghouse that charged them what Audubon felt was the outrageous sum of $10.50 for three meals and two nights' rest.[16] He went about his usual routine of delivering his letters; one of these introduced

him to the Unitarian minister, Mr. Gilman, who obligingly offered to help him find cheaper accommodations. After securing the new rooms, Gilman and Audubon were walking through the streets again when a man on horseback hailed the minister. As soon as Audubon's name was mentioned, the man sprang from his horse and pumped his hand with pleasure, a wide, infectious smile on his face. He was John Bachman, a Lutheran minister whose enthusiasm for life and for all things living rivaled Audubon's.

Bachman did not hesitate: Nothing would do but that Audubon and his two helpers should come to stay at his home. "He would have us to make free there as if we were at our own encampment at the headwaters of some unknown Rivers—," Audubon wrote Lucy, scattering capitals and punctuation in his excitement, "he would not suffer us to proceed farther South for 3 weeks—he talked—he looked as if his heart had been purposely made of the most benevolent materials granted to man by the Creator to render all about him most happy—Could I have refused his kind invitation?"[17] The three men moved to Bachman's "in a crack"—and found a room already prepared for Henry to skin birds, and another room for Audubon and Lehman to draw in, and a separate bedroom for Audubon.

The sprawling three-story house on Rutledge Avenue, with its verandahs and spacious gardens, was home to a large, rambunctious family that included John; his wife, Harriet; and their nine living children (five others had died in infancy), as well as thirty-six-year-old Maria Martin, who ran the household during her sister Harriet's frequent confinements, and both grandmothers. Spreading out about the house were vegetable gardens. (The horticultural society had once given John Bachman a silver medal for the best cauliflower; Harriet had received another, for the best indigenous plant.)[18] There were flower gardens with bowers of lilies and roses, gardens spilling over with verbena, quince, orange trees, and azaleas, not to mention dogwood brought from the country. There were wisteria and trumpet vines and crape myrtles and magnolias. There were poultry yards and a duck pond, beehives and a pigeon cote. A saltwater pond produced minnows and

eels to feed the ducks. The naturalist-minister was fascinated by all sorts of animals and birds; pets wandered everywhere. Cats, a New-foundland named Beauregard and an anhinga "battled with the dogs or the cooks for the most comfortable place on the hearth," and now and then a raccoon or a porcupine could be found in Bachman's study.[19] Once there had been a pet bear, but it was dispatched after attempting to embrace one of the Bachman girls in a death-grip.[20, 21]

Bachman was a thoroughly congenial man, but inviting Audubon and his entourage into his home wasn't entirely selfless. As Audubon explained, "he was an old friend of Alexander Wilson . . . an orni-thologist, a philosophical naturalist." And he could shoot well, too.[22] Audubon was to rekindle Bachman's dormant interest in nature. The two sat up nights talking and spent their days together, roaming the countryside in search of birds. Bachman's carriages and slaves were at Audubon's command; his sister-in-law, Maria Martin—not in the least pretty, but intelligent and an accomplished artist—joined their circle. The two pretty older daughters, Maria and Eliza, added the feminine charm and sparkle that Audubon so adored. He was happy at the Bach-man hearth, excited in the first sweet flush of a friendship that was to last a lifetime. (Some weeks later, when Audubon wrote to thank Bach-man, the minister would reply: "Look here, my friend, before I forget it, why are you always talking of 'a load of gratitude'—now suppose we say no more about this. Your visit to me gave me new life, induced me to go carefully over my favorite study, and made me and my fam-ily happy." [23]) At about this same time, Tocqueville was writing that "Americans are a people with very little feeling for the pleasures of the mind." [24] That was decidedly not the case at the Bachman home, where the two men sat and talked into the night.

About this interlude, Audubon reported: "I jumped at once into my wood-hunting habits. All hands of us were up before day-break, and soon at work, either in the way of shooting, taking views, or draw-ing birds." In spite of the "shockingly hot" weather they were able to prepare some three hundred specimens, including sixty land and water birds, which they sent to Dr. Harlan in Philadelphia for safekeeping.

Invitations came from all around; Lehman and Ward were always included, and went along when their work permitted. Bachman's neighbors were generous with their help. When Audubon said he wanted to go to Cole's Island to look for some marine birds, he was offered a boat, four slaves to man it, and a pilot for as long as he needed them. (The island was covered with birds, but no new species were sighted.)

He was having a fine time in Charleston, "out shooting every Day—Skinning, Drawing, Talking Ornithology The whole evening, noon and morning." [25] As for Bachman, he "is . . . full of Life & Spirits; we Laugh & talk as if we had known each other for Twenty Years." [26]

Bachman, recognizing that only a very few people in Charleston could afford a subscription to *The Birds of America,* had taken it upon himself to get six groups of twelve people together, each group to share a subscription. Audubon was overwhelmed by his new friend's generosity. As a cap to this happiness, word arrived that at long last he had been elected a member of the Society of Natural Sciences of Philadelphia—unanimously. [27]

In Charleston, he managed to complete five drawings of fifteen birds. "The ground Dove of which I have drawn 5 on a Wild Orange branch is one of the sweetest birds I have ever seen." Lehman had finished the backgrounds, with admirable results, and Henry had managed to skin and preserve 220 specimens of sixty species of birds. [28]

But Audubon had miscalculated the season: He should have stayed in Pennsylvania another month or six weeks. As he wrote to Lucy, "We have passed the Birds of the North and not overtaken those of the South therefore I have lost time both ways." [29] The only thing to do was push on south. He said good-bye to the Bachman family, promising to stop in Charleston on his way back, and with Lehman and Ward sailed off to St. Augustine on the schooner *Agnes.*

On November 15, only hours after Audubon's departure, Bachman sat down to write Lucy: "The last has been one of the happiest months of my life. I was an enthusiastic admirer of nature from my boyhood and fond of every branch of natural History. Ornithology is, as a science, pursued by very few persons—and by no one in this

city . . . For the short month he remained with my family, we were inseparable. We were engaged in talking about ornithology—in collecting birds—in seeing them prepared, and in laying plans for the accomplishment of that great work which he has undertaken. Mr. Audubon has promised frequently to write to me, and I shall feel as much interested in all of his movements, as if he were a brother, or the dearest friend on earth . . . There seems quite a blank in my house since he has gone, for we looked on him as one of our family. He taught my sister Maria to draw birds; and she has now such a passion for it, that whilst I am writing, she is drawing a Bittern, put up for her at daylight by Mr. Audubon."[30]

This letter's recipient was having none too good a time of it with her brothers' families in Louisville and Cincinnati. She had never been on good terms with Thomas's wife, and Billy's wife was guilty of being a poor housekeeper. The truth was, after England, Lucy found her Kentucky kin rather coarse. It did not help to learn that her husband was made to feel so wonderfully welcome in Charleston—and by perfect strangers. John Bachman was one more formidable person she would have to share her husband with.

———

AUDUBON AND HIS COMPANIONS ARRIVED in Florida during a lull in the ongoing Seminole Indian wars. He was in uncharted country again, a frontier not of great towering forests but of vast expanses of blowing sand and sultry heat, of scrub oak and palmetto. Indian trails crossed and recrossed the sandy wastelands. "It seemed to us that we were approaching the end of the world. The country was perfectly flat, and, so far as we could survey it, presented the same wild and scraggy aspect."[31] Near the ocean, the sky was filled with cormorants and fish crows, herons moved in the low swamps while "alligators swam in sluggish sullenness," and shells could be scooped up by the shovelful. At night, great swarms of "blind mosquitos" covered every-

thing in the cabin and even put out their candles; the tiny insects did not bite, but drove them to despair.[32]

St. Augustine proved to be "the poorest hole in the Creation," reminding Audubon of some old French village "and doubtless the poorest village I have seen in America—The Inhabitants principally poor Fishermen . . . The streets about 10 feet wide and deeply sanded—backed by some thousands of orange Trees loaded with fruit at 2 cents apiece."[33] The trio settled in, taking desultory rooms, with "little more in sight than the Breaking Sea Surf in our Front and extensive Orange Groves in our rear" and hoping that a government cutter would come along to take them into the interior.[34]

Their rooms overlooked the entrance to the harbor, where clouds of gulls and brown pelicans by the hundreds swirled through the air, "but the Rascals are so wary and so shy that there is no coming near them—further South where no gunners are I am told they are as aboundant and quite Gentle." The sultry heat of the day was followed by frosty nights; the three men lingered for a month, hunting birds to skin for the lucrative London market and drawing only a few, mostly waterbirds. Lehman, as always, was industrious and helpful and Henry, as always, was inclined to sloth, as far as his employer was concerned.[35] But Audubon rousted Henry out of bed early each day, even if there wasn't much for him to do.

St. Augustine was the end of the line for mail delivery. Audubon was beside himself at learning that the friend in Savannah who had volunteered to send his mail along had not. Worried about the hefty postage Audubon would have to pay, the friend decided he could just as well pick it up on his return to Savannah. Audubon learned that one letter, from England, was marked "Urgent," and he allowed his imagination to run wild. He convinced himself that the letter carried news that Havell was dead. "I hope to God it is not so," he wrote Lucy. "Such an event would stop my Journey at once and force me back to Europe in a very unprepared state."[36]

When a whole slew of letters finally arrived early in December, Audubon was delighted to learn that "Havell was going on *well!!!!*" and

that new subscribers, many from America, were slowly being added to the list.[37] There were several letters from Havell, and others from Nicholas Berthoud, from the prolific Dr. Harlan, and from Bachman.

The only disturbing news came from Lucy. The boys were unsettled; Victor was working with his Uncle William, but he did not want to continue unless he was offered a full partnership, and he did not know if that would be forthcoming. Audubon was annoyed with both his wife and son for a lack of candor. "Had Victor spoken to me at Baltimore as thy letter now expresses neither thou nor him should have gone to Kentucky—I certainly would have taken him with me." Johnny was without work at the moment and had been accused of carelessness. He was keen to work on a steamboat, but his Uncle William evidently disapproved. Audubon wrote in answer to Lucy, "I am quite of thy opinion respecting our Dear John, I think that it is merely to his great flow of spirits that his carelessness can be attributed to and therefore hope that a very few years will correct all that.—I am not averse to his going on Board a good Steam Boat under a good Commander; far from it I think it will prove to him the necessity of acting for himself . . . as to the Pride of William on that Score care not a Jot."

Johnny was proving, once more, to be hard to handle, and he had, evidently, earned his uncle's displeasure by wanting to pursue an adventurous life on the river. Lucy would have preferred that Johnny join his father in Florida, but Audubon wrote that he could not afford to take him at the moment. Once again, Johnny should be patient and wait. As soon as he could, Audubon planned to have them all together—"I feel fully decided that we should all go to Europe together and to work as if an established Partnership for Life consisting of Husband Wife and Children."[38] And yet Audubon let his wife know that if some good work opportunity for either son should present itself, he should feel free to take it. This was not particularly encouraging. The best the father could do was to suggest that if Victor should decide against staying on with his uncle, he should plan to meet Audubon in New Orleans on the first of June. Lucy should come as well; that would give them some time together to catch up and confide in each other.

It was clear to Audubon that Lucy had not found her family—
Billy in Louisville or Thomas in Cincinnati—as congenial as she had
expected. She was depressed and disappointed and, when the Gordons
arrived with little Willie for a short visit on their way back to Eng-
land, she considered returning with them. Her husband did not mince
words; he wrote that under no account was she to return without
either him or one of the boys. "I expect that Thou would find Ken-
tucky rather rough after returning from Europe," he wrote, trying to
soothe her. And while she might complain of Billy's "rough bark," he
knew his brother-in-law well enough to know he had a good heart.
Billy was the one Bakewell who had kept the faith with Audubon.

Lucy became so upset and annoyed that her letters to her husband
were lists of complaints. She was not sure that Audubon should have
trusted Nicholas Berthoud to handle his affairs in New York—what if
he should decide to keep all the money he collected, in payment for
the old Henderson debt? She had heard that Dr. Harlan was not a good
businessman. And how could Audubon consider a lengthy trip into the
interior of the country, much less to the Far West? Once more, Lucy
was panicked about being deserted, and she did not disguise her grow-
ing fears for herself and for the boys.

To placate her, he promised to keep a "bright eye" on Nicholas, but
Lucy's discontent was corrosive to his own spirits, especially since after
a month he had exhausted his supply of birds to draw.[39] So far, he had
done twenty-nine drawings, only eighteen of which were complete.
The others needed either a male or female of the species.

No revenue cutter had come into St. Augustine, but a naval schoo-
ner called the *Spark* had arrived. When her commanding officer, one
Lieutenant Pearcy, heard about Audubon's mission, he let it be known
that he did not think much of hauling a naturalist and his party around
Florida. Armed with a letter from the secretary of the treasury that
directed all commanding officers to receive Audubon and his party
and take them where they wanted to go, Audubon presented himself
to Lieutenant Pearcy. The sailor, while rough and blunt, knew an order
when he saw it. It was agreed that the *Spark* would take them up the

St. Johns River as far as she could go, a journey of about four or five weeks. After that, she would return to Norfolk for a few days to be out-fitted with new sails; then she would turn back for a closer inspection of the Florida coast and the Keys. Eventually, Audubon hoped to be taken as far as Cape Sable; from there, he could reach New Orleans by the first of June. Like most of Audubon's optimistic, ambitious plans, this one was not to work out quite as expected. Still, he could not keep himself from crowing to Lucy, "I begin to be proud of myself when I see that my Industry, perseverance and honesty has thus brought me So high from So Low as I was in 1820 when I could not even procure through my Relations and former Partners the Situation of a Clerk on Board an Ohio Steamer.—now they Prize me—nay wish me well." His past still rankled; he could not quite forgive her family, and neither could she.

He was deeply tanned from the sun and had a five-week growth of beard; at times it was like the old days, living in the open, braving gales and sandstorms, shooting alligators and eagles. But he was finding very few new species, and in general the country seemed to him dreary and desolate. Great stretches of sand were broken by the occasional swamp, the only possible habitat here for birds.

For the most part it was a miserable, mosquito-infested existence; the heads of fish floated in the murky water, the bodies they belonged to having been snapped off by alligators. He could not even allow their Newfoundland, Plato, into the water.

When they were about a hundred miles up the river, one of the sailors accidentally shot himself in the head, and Lieutenant Pearcy decided to turn back to St. Augustine so he could be treated by a doc-tor. Then the *Spark* would continue on to Norfolk for repairs. Audu-bon was disgusted with the country, with the lack of birds, and with Lieutenant Pearcy, who seemed to change his mind with the gusting winds. He decided that his party would hire a boat to take them south to where the St. Johns River paralleled St. Augustine; at that place they would hire a wagon to carry them cross-country.

It was four in the afternoon by the time they arrived, and there was no wagon to be had. Leaving Henry Ward on the river bank with all

their baggage, Audubon and Lehman set out walking, with Plato lead-
ing the way at a good clip. When they arrived in St. Augustine, they
would send a wagon back for Henry.

Everything was fine until a breeze sprang up and the sky became
ominously dark. "The air felt hot and oppressive, and we knew that a
tempest was approaching," Audubon wrote. Soon, they could scarcely
see. Lightning flashed, a fierce wind blew, and solid sheets of rain lashed
them. They pressed on, sinking into the water-soaked earth, marvel-
ing at the occasional lightning-struck pine that burned like some great
candle against the dark. When finally they sighted the St. Augustine
light, Plato leaped briskly around and led them straight into town
and to their hotel. "Drenched with rain, steaming with perspiration,
and covered to the knees with mud, you may imagine what figures we
cut in the eyes of the good people whom we found snugly enjoying
themselves in the sitting-room," Audubon wrote. The next day, the
army commander sent two soldiers with a wagon and mules to pick up
Henry and the luggage.[40]

It was March; Audubon had wasted too much time and money
for too little return. The trio boarded the *Agnes* once more and headed
north to Charleston. Along the way, they met the *Spark,* and Pearcy
came aboard to present Audubon with a fine pair of swans he had cap-
tured. They were as much a bribe, to keep him from complaining to
his superiors, as a peace offering. In Charleston, Audubon planned to
regroup at the Bachmans' and find another government cutter to take
him south along the Florida coast, to the Keys, and on to New Orleans.
He knew the birds he needed were there; he would simply have to find
a way to get to them.

A storm at sea changed the course of his journey—in this case,
providentially. Forced ashore at Savannah, Georgia, forty miles south
of Charleston, he decided to make the best of the situation and deliver
some letters of introduction he carried for that city. His first call was
on William Gaston, who proved to be hospitality itself, immediately
gathering a group of interested men to see the drawings. There were
all the usual gasps of admiration, but Gaston let Audubon know right

away that he wouldn't find a subscriber in the area and that, much as he himself might like to have a copy of the *Birds,* he could not afford it. As always, Audubon murmured that he understood. The conversation was spirited; there was talk about the Philadelphians' shoddy treatment of Audubon, and before he knew it Gaston had subscribed. Two hours later two more men had signed up. By the time Audubon left on the mail coach, he had not only the three new subscriptions but also the promise of more. Gaston had become a believer; he promised to find even more names, and he would prove to be as good as his word. Audubon left Savannah with six hundred dollars in his pocket, and in a few days received two hundred more.

He now had twenty-two subscribers in America, and most of them had come easily, almost unexpectedly. In high spirits he wrote Lucy: "Should *this run continue Victor Audubon* will have to sail for England instanter *to push the Printing Coloring & Delivery* of the Work to our Subscribers—More of this *when we meet at New Orleans* on the 1st of June Next."[41]

Back at the Bachmans' in Charleston, Audubon exchanged letters with his wife—a correspondence that was crammed with business details and possibilities. He told her that John Bachman thought as many as a hundred subscribers might be found in the United States; if that happened, they would need someone in this country to attend to the delivery and collections, and who better to do the job than the artist's elder son? Better yet, why not send Victor through the country, to every town and city, "with a Volume & thousands of letters of introduction to receive subscriptions & take charge of the business in America"?[42] It was all very exciting; when he and Bachman, two optimists, got together, the sky seemed to be the limit.

Selling subscriptions was one thing, getting the birds he needed to complete the work was another. So far, this trip had been disappointing. Meeting Lucy in New Orleans was no longer possible; neither (she would be glad to hear) was his plan to push on to the Pacific coast. Instead, he and his "lads," as he called his two young assistants, were to sail on the U.S. schooner *Marion,* which the government had put

at his disposal for two months. They would sail down the coast of
Florida and to the Keys, and then return. "I go in her in most excellent
spirits," he wrote Lucy, "for it will be an opportunity of doing what
no naturalist has ever done." [43] Exactly when he would meet Lucy, he
could not say. The best he could do was tell her not to be "vexed at
thy relations business" and to assure her that sometime after his return
from the Keys they would all meet again. Meanwhile, he was leaving
all his new drawings in the care of Maria Martin, Bachman's smart and
artistic sister-in-law, who soon would be adding flowers and butterflies
to some of them.

Audubon did get some work done in the five weeks he lingered
at the Bachmans': He added to his inventory five fine new drawings,
including the snowy egret, which would become plate number 242.
(The egrets came flying in by the thousands while Audubon was there,
settling in the rice fields and saltwater marshes, where they fed on the
abundant shrimp.[44]) Maria, intent upon advancing her own skills, cop-
ied the egret in watercolor, with Audubon looking on to offer advice.[45]

One day in the middle of April, Audubon and his helpers
boarded the *Marion* and once more headed south, past
St. Augustine and on to Indian Key. Here, at last, Audubon began to
find the birds he wanted, because he found a man who could take
him to them.

He was a pilot named Egan, and "not a cormorant or pelican, a
flamingo, an ibis, or heron had ever in his days formed its nest with-
out his having marked the spot . . . In a word, he positively knew
every channel that led to these islands, and every cranny along their
shores."[46] With Egan's invaluable help, Audubon found quantities of
pelicans, and then hundreds of cormorants' nests, egrets, herons, gulls,
and terns. At a place called Sandy Island, he was amazed to find birds
covering the beaches. The first time the group fired into a beach full
of great godwits (marbled godwits), they killed sixty-five birds. "Rose-
colored Curlews [curlew sandpipers] stalked gracefully beneath the
mangroves," Audubon wrote, "Purple Herons [Louisiana herons] rose
at almost every step we took, and each cactus supported the nest of a

White Ibis. The air was darkened by whistling wings, while, on the waters, floated Gallinules and other interesting birds." This was what he had come for; this was the Florida of his dreams.

One morning at low tide, he sat on the beach and watched the birds probe the beaches for crabs and fish caught in tide pools. "Frigate Pelicans [magnificent frigate birds] chased the Jager [jaeger], which himself had just robbed a poor Gull of its prize, and all the Gallinules, ran with spread wings from the mud-banks of the thickets of the island, so timorous had they become when they perceived us." Hungry, the group trudged over the sand to a thicket, where on every bush they found several ibis nests, each containing three large eggs. Omelets were the order of the day; as soon as they had breakfasted, Egan guided them back to the beach for "some fun." As the tide washed in, it drove ahead of it great masses of birds. The men, hidden behind bushes, blasted away with their guns; before long they had a tall stack of dead birds and everyone busied himself with the skinning.[47]

The *Marion's* last stop before turning back was the Dry Tortugas, seventy-five miles out from Key West. There Audubon went ashore to watch as the sea turtles—some weighing seven hundred pounds—lumbered onto the beach to lay their eggs. He watched in amazement as each giant scratched out a hole in the sand in which to deposit and bury as many as two hundred eggs. Audubon kept careful notes; this was the kind of story that would enliven the *Ornithological Biography.*

He arrived in Charleston a third time, with, according to Bachman, a two-month old beard that was "as gray as a Badger's. I think a grizzly-bear, forty-seven years old, would have claimed you as *par nobile fratum.*"[48] Ward stayed on in Charleston to work for the Natural History Museum, and Lehman went home to Philadelphia. Audubon did not tarry; he had written directing Lucy and Victor to join him in Philadelphia in June. It was time, he had finally decided, to begin to mobilize the family alliance.

16

How strangely our Bark is tossed—
Poor as Job yesterday—rich as Croesus
Tomorrow!—and who could not wish to
live to enjoy this Life of pleasurable
anxiety? Not I believe me.[1]

As John Audubon made his way north to Philadelphia in the early summer of 1832, the residue of his hard months in the Florida wilds fell away from him. His beard was shaved, his hair trimmed, a neat suit replaced the rough, worn clothes that had seen him through the tangled swamps and sandy wastes.

Letters that waited for him in Philadelphia pulled him into the machinations of civilization. Waterton in England had published yet another vitriolic attack on Audubon's buzzard paper, now five years old. Waterton insisted that Audubon was wrong about buzzards finding their food by sight; he said they used scent. The scientific community was fascinated by the controversy, and so the argument was kept alive. Waterton also took issue, once more, with the folio sheet showing a rattlesnake in a mockingbird's nest. It was common knowledge, he said, that rattlesnakes did not climb trees or anything else. Ord in

Philadelphia was cheering Waterton on. The two seemed to entertain each other by maligning Audubon—Ord out of self-interest, Waterton from sheer bile. At the very moment when the American scientific and literary establishment was accepting Audubon, along came the two spoilers to dredge up old complaints.

Worse still, Lucy and Victor were not in Philadelphia waiting for him. All winter long, Lucy had complained about having to stay in Louisville, yet now she tarried; he waited with mounting exasperation. On July 1 he wrote Bachman a chatty, affectionate letter, telling him about the Waterton-Ord attack, and then blurted, "I hope my good Wife & son will arrive soon for I feel almost crazed and quite at a Loss in this City."[2]

When they did arrive, Johnny was with them and he looked pale and weak. He had been terribly ill, Lucy explained; she would not leave him behind, and they could not leave until he was strong enough to travel. They had stopped in Pittsburgh on the way; Uncle Benjamin Bakewell had been full of praise for Audubon, Lucy reported.[3]

On her own she had made the decision that Johnny should come, and there they were, all of them together at last. Encouraged by the unexpected spate of new American subscribers, the father gathered them in. From that point they were his "little alliance"—which he thought to be as "good as 'the Holy' at least."[4] Victor had just turned twenty-three; he was, Audubon thought, like his mother—thoughtful, dependable, careful. He would make a fine business agent. John, nineteen, was more like his father. He had taken his turn on a riverboat, where he had been taken to task for being more interested in playing music and having fun than doing his chores.[5] He was spirited, wild, an adventure seeker—and he was better at drawing than his father had expected. He could work in the field, where Audubon could keep an eye on him and help him refine his drawing skills. The boys—who had been away from him for the better part of nine years—were about to learn what life with Father was all about.

During his journey across America that same year Alexis de Tocqueville was to observe about the national character of Americans:

"Howsoever powerful and impetuous the course of history is here, imagination always goes in advance of it, and the picture is never large enough. There is not a country in the world where man more confidently takes charge of the future, or where he feels with more pride that he can fashion the universe to please himself." [6] He might have been talking about John Audubon.

At Lucy's urging, the family moved to a cheaper boardinghouse in Camden, New Jersey, and the new pattern of work began to evolve: Victor was briefed on all of the business details and was lectured on the *Birds* and how a properly engraved and colored folio sheet should appear. Johnny went out with his father on shooting forays and took on the job of bird skinner. All the while, Lucy's knitting needles were flying, keeping three active men in socks. She also supervised their deportment. (Bachman had written in his usual wry style to remind Audubon to watch his language, which at times could be foul.) Everyone had a duty to perform. Johnny would have no chance to be careless now; his father would see to that. The boys had made their choice; they would follow in their father's footsteps—into art and publishing.

The family went north to Boston, which welcomed them without reserve. Audubon was both astonished and delighted. Boston was another Edinburgh—a city filled with learned men who understood at once the contribution he was making to art and to science. These important, influential men embraced him, showed that they were serious by the number of subscriptions that began to come in. Leading citizens came to call: Dr. George Parkman; Dr. George Shattuck; Thomas Perkins, president of the Boston Athenaeum; Harvard president Josiah Quincy, who subscribed for the university.[7] The ornithologist Thomas Nuttall was in Boston; Nuttall was publishing his own book on North American birds, *A Manual of the Ornithology of the United States and Canada.* Audubon declared him to be "a gem . . . after our own heart," and liked him even better when he dismissed his fellow Yorkshireman Waterton as a man not to be taken seriously.[8] Audubon was enthralled. He wrote his friend Harris, "Allow me to say that with my work . . . the Bostonians have proved themselves the best supporters of a good cause

in the country." Later he would add, *"I have faith in the Bostonians!"*[9]

That summer the family went north, traveling by steamboat and stage, by horseback and by foot, up the coast to Maine and into Canada. Along the way Audubon and his sons went on long forays into the countryside to search out birds. At Dennisville, they were befriended by Judge Lincoln and his family, who made their visit an event. His son Tom went with them into the woods.

People who were familiar with birds in this north country urged Audubon to consider a trip up the rugged and little-known coast of Labrador. In those wild, cold regions summer lasted scarcely a month; if he went then, he was certain to get great numbers of waterbirds and of the new species he craved. It was an alternative to the Far West, which money and time pressures made all but impossible. Audubon began to consider the idea.

It was autumn by the time the family wended its way south again; fields of corn stood ready for harvest, "the fruits of the forests and orchards hung clustering around us, and as we came in view of the Penobscot River, our hearts thrilled with joy— Canoes filled with Indians glided swiftly in every direction, raising before them the timorous waterfowl that had already flocked in from the north."[10] Some rare birds were found, some new friends made in the villages where they stayed.

It was a cohesive family interlude, but it could not last. Along the way, Audubon had decided that he needed another year—better yet, two—in America to complete his masterwork. Since he could not leave the business unsupervised for so long, Victor must go to London in his place. On October 10, soon after the family returned to Boston, the young man boarded the packet *South America,* bound for Liverpool, to take over as business manager for what was now a family enterprise.

Bachman had urged them all to come south to Charleston and use his home as their winter headquarters, but Audubon thought it best to stay in Boston, where he might gain subscribers and could keep in closer touch with Victor (the fast Yankee packets now crossed the ocean in as few as twenty days).

John, Lucy, and Johnny settled into their boardinghouse for the cold Boston winter, John drawing birds—including a species of water-bird that John Bachman had sent, which Audubon believed to be new—and working steadily on his first draft of the second volume of the *Ornithological Biography*.[11] Lucy cleaned up and copied the manuscript and sent it along to MacGillivray in Edinburgh for editing. The Audubons received guests, among them Senator Daniel Webster, who brought a brace of ducks. Johnny was given the job of drawing these and performed so well his father put him to work on the *Birds*.[12] He was also sent out to pay social calls on his parents' behalf, so as to polish his rough edges and prepare him for England.

All winter long Audubon wrote, drew, gave lessons to Johnny, received visitors, and kept up an incessant correspondence: with Victor, with John Bachman, with Dr. Harlan, with the Rathbones and Edward Harris and all the good friends he had made over the years. He courted them all; he urged them on; he needed them all. To Harlan he wrote, "Money is wanted money must be had and money shall be had as long as my fingers will not be Palsied."[13] Harlan, who was off in Europe, had neglected his duties as agent for the American edition of the bird biographies, and the book was not paying its way. Other annoyances surfaced: Charles Bonaparte let it be known that he was not amused at finding his name so far down in Audubon's list of acknowledgments; Lucy fretted that, because of business reverses, Nicholas Berthoud might claim as payment for old debts the funds they had left with him. Audubon sent an apologetic letter to Bonaparte, and (while he didn't believe Nicholas would claim their money) he sought to head off any financial conflict, and calm Lucy, by giving Nicholas a bound volume of the *Birds*. He also offered to share a forty-year-old debt owed his own father, if Berthoud wanted to try to collect it; Berthoud did. (Americans were stubborn about collecting old debts, as Audubon well knew.) His attention was splintered, but he could not break his momentum, not for a instant.

Bachman, his ornithological passions rekindled by Audubon, was working steadily for his new friend, sending him skins and writing him

long, witty, informative letters: "You say new birds are scarce," he wrote. "So they are, and yet, in my opinion, we will occasionally find them for half a century to come. I will tell you the plan I have adopted. I try to interest every fellow that has a little brains to look out for new birds. I take him to the Museum—show him our birds and my skins, and then beg him to procure the skin of every rare bird, and if not, at least to send me his wings and tail, head and feet. Be patient, friend, for two years more, and you shall hear what the South and West can produce."[14]

In February Audubon was given a golden eagle found in a fox trap; the bird was an absolutely superb specimen, which thrilled the artist. He hated to mar its beauty by killing it in the usual way, so he put a blanket over its cage and put it in a closet with a lighted pot of coal, thinking to suffocate it. When that didn't work, he put a quarter pound of powdered sulfur into the closet. This affected Audubon more than the eagle. Finally he resorted to killing the bird by piercing its heart with a long pin. Then he wired it and for the next thirteen days worked steadily at the drawing.[15] He had not labored so long or so hard since his drawing of the turkey, and it took its toll.

On March 20, 1833, Audubon wrote Dr. Harlan: "The hand which now drives my pen was Paralised on Saturday last for about one hour. The attack seized on my mouth and particularly my lips, so much so that I neither could articulate or hold anything. My good Dear Wife was terribly frightened . . . Dr. Warren came in with our *very worthy Friend* Parkman and administered me a dose which kept me 'a going' for 24 hours. Now much debility is all that ails me—moderate exercise and a *cesation of Work* will remove this and I hope soon to be myself again."[16]

He was forty-eight; he had had what doctors today call a transient ischemic attack, which could be a warning of strokes to come. He sensed that his body was beginning to betray him, and that he would have to hurry. The plan now was to leave for Labrador early in the spring. His illness delayed their departure, and it was the end of March before they arrived in New York, where business had to be attended to before he could be off on another wilderness exploration for birds.

Victor was doing well in England, and his father cheered him on in letter after letter: "Go on my Dear son—keep a strong band of *good Spirits* . . . suffer not your Spirits to droop."[17] He included long lists of accounts and plenty of blunt advice on how to deal with this one or that: "Poole & B——— are scamps take care of them—I cannot promise any live Birds to anybody. . . . Push Joseph Kidd if he *can* be pushed."[18] Directives flew: Victor should watch to make certain Havell maintained quality; he should go north to visit subscribers and collect money; he should prod Kidd to turn out more oils of the birds; he should see if the French government, which had purchased Cuvier's library,* would continue to pay for his subscription; and he should write to du Puigaudeau in Couëron to see what he meant by writing about "wishing to settle with me . . . I know no more about the matter than the man of the moon."[19]

Occasionally he delivered a pompous and revealing fatherly lecture as well: "Your soirees at the Duke of Sussex will be of great interest to you, and us all—there you will meet with the Elite of Science . . . persons of profound learning from all quarters of the World—persons endowed with that suavity of manners which is so necessary to render any one welcome and sought after in the best of Society . . . Even to him, who like your Father has not received the wonderful advantages of a Classical Education."

Audubon was in his forties and had had a fair amount of experience in society when he first approached England with his birds; even then, he was often ill at ease socially, to the point of being dumbstruck. Victor was still in his early twenties, had been educated by his mother, and knew little of the world beyond Louisville. Still, that didn't stop Audubon from urging his son to giddy social heights: "When you see the Duke of Sussex next or Lord Stanley," he wrote, "ask them for letters to the continent—and when at Paris, call on Geoffrey St. Hillaire he will introduce you to the Citizen King of the French—Should you go to Rome Charles Bonaparte will I feel confident be your friend as he

*[Cuvier died in 1832.]

is mine—in Vienna you may meet the Great [historian and economist Jean-Charles-Léonard Simonde de] Sismondi—call upon him that is sufficient with your name."[20]

Now and then Victor wondered about the meaning of the work he was doing. His father didn't hesitate to tell him: "Do not think that the time you are now spending in Europe is a loss to you—no matter at what you may be employed here after, depend upon it; this will prove beneficial to you—but when we meet I hope we will be able to live together and do well."[21]

Victor had heard that before. His father *hoped;* the fact was, his father simply did not know—had never known, from day to day or year to year—how long he could keep everything going. At least, at the moment, with new subscriptions coming in at a regular clip in America, things looked good. Add two new names, Audubon told Victor in a letter dated April 15, 1833: P. G. Stuyvesant and General Stephen Van Rensselaer.

In the meantime, Johnny was far from being neglected; his art had progressed to the point where he was drawing birds for publication. "My Youngest Son *draws Well*—Can you tell what is his or mine's work in the last Drawings you saw?" Audubon wrote Havell with obvious pride.[22]

With Lucy safely in New York, again with the Berthouds, Audubon and Johnny left on May 1 for the trip they had been planning all winter: going where "No White Man has ever tramped," where they would be out of reach throughout the summer because there were no post offices in the frozen wilderness of Labrador.[23]

They reached Eastport, Maine, on the seventh of May, and found it "shockingly cold." Snow was on the ground, great chunks of ice floated in the harbor, and they could see that their clothes were not warm enough for the voyage north. Audubon put local tailors to work to outfit them for the extreme chill. He had commissioned a schooner, the *Ripley,* to take them to Labrador, and she was on her way to meet them. There was no hurry; they had to wait for the ice farther north to break. Until then, the government revenue cutter was put at Audubon's

disposal for some short runs. On one of these, up the Bay of Fundy, he found four rare birds. He found only one or two others he needed; but it had been a long, hard winter, and spring was slow in coming.

While aboard the revenue cutter one day in a rough sea, they watched as a schooner under full sail capsized. Audubon was sickened and frightened by the sight, while at the same time he was thrilled by the performance of the cutter's Yankee crew, who rescued the schooner's three men and towed the ship to shore. "Depend upon it the Yankees are the Lads for the Ocean," he wrote Lucy. "They are firm, cool, considerate, human & generous when ever these qualities are called for . . . Our John behaved like one of them and worked the ropes & sails to my astonishment extremely well."

Audubon liked energetic, spirited young men—a good thing, since several sons of his friends and supporters had signed on for the journey north: Judge Lincoln's son, Tom, from Dennisville, and George Shattuck and William Ingalls, both medical students from Boston. Audubon called them "the Young Gentlemen."[24] Wild tales of the country they were about to enter floated around Eastport and, Audubon confided to Lucy, "all these say so have rendered John & the Young Gentlemen almost wild with anxiety—they talk of bringing Mothers bed of Eider down—Bears and White Wolf Skins for marts and eggs in salt with thousands of other curious things as if they had these already in their possession." As for Audubon, he was feeling fine: "My health has much improved I am fast recovering my habitual activity, and strange as it would appear a hard life is the one best suited to my Constitution.—No snuff—no Grog—and plenty of exercise." His only disappointment was that Edward Harris was not going with them. The more he knew of Harris, the better he liked him, and he wanted to share this adventure with the friend who had been steady in his support from the day they had met, at the very beginning of the quest for *The Birds of America*.

At last the schooner arrived, the intrepid group donned their new outfits, which transformed them into the strange-looking creatures he described to Lucy: "Fishermen Boots, the sowls [soles] of which are all

nailed to enable us to stand erect on the sea weeds—Pantaloons of Fear-
nought so coarse that our legs look more like bear's legs than anything
else; Oil Jackets & Overtrowsers for Rainy weather and Round White
wool Hats with a piece of oil cloth dangling on our shoulders to prevent
the wet running down our necks.—a coarse bag strapped on the shoul-
der . . . hunting knife at our sides and Guns on the back—add to these
the full grown beard which thy Friend will have on his return."[25]

The *Ripley's* captain, Henry Emery, had been a schoolmate of Tom
Lincoln; he brought with him a twenty-one-year-old named Joseph
Coolidge, who had been "bred to the sea" and, they were to discover,
seemed seldom to get seasick. Audubon liked both men immediately
and they melded easily with his group. By journey's end three months
later, he would think of them as a family. Add to this group a pilot
(who struck the only sour note; Audubon called him an "ignorant
ass"), two extra sailors, and a majordomo to clean their guns and do
other odd jobs.

Eastport gave them a rousing sendoff on the afternoon of June 6,
and the *Ripley* in full sail began to make her way up the coast. Thus
began a three-month ordeal of cold and wind, of rain mixed with sleet
or snow, and fog so thick you could drive a nail through it, as the locals
said. Interminable gales blew over a land so desolate and wild that it de-
fied imagination. Much of the time they were wet; often they were sea-
sick. Audubon worked below decks at a large table that had been secured
to the floor, directly under a hatch. At the Magdalen Islands, Audubon
wrote: "At four this morning we were seated at breakfast around our
great drawing-table; the thermomenter was at 44; we blew our fingers
and drank our coffee, feeling as if in the very heart of winter."

Summer was short but the days were long, which delighted
Audubon, who always hated waiting for the morning light. Now he
could roust his son out of bed and put him to work. "John," he wrote,
". . . is overcoming his habit of sleeping late, as I call him every morn-
ing at four, and we have famous long days."

Those long days were spent trying to wrestle the ship into the
rockbound harbors so they could scramble ashore to get birds. Their

pilot, whose job it was to guide them safely past the perilous rocks and into harbors, proved inept. Squalls and storms seemed to catch them every other day, tossing them about; much of the time they were wet and sick and miserable: "June 15. All our party except Coolidge were deadly sick. The thermometer was down to 43, and every sailor complained of the cold."

And yet they kept to their purpose: birds. Approaching the great "Bird Rock," they observed long files of gannets in the air. At first the rock appeared to be covered with snow; with his spyglass, Audubon saw that the snow was in fact gannets, thousands of them, "a mass of birds of such a size as I never before cast my eyes on." Even more remarkable, the air above the rock was filled with birds, hovering like a snow cloud. The men of the *Ripley* stood "astounded and amazed." As they came close, they could see that the rock's surface was covered with nests, the birds almost touching each other, "in such regular order that you may look through the lines as you would look through those of a planted patch of sweet potatoes or cabbages."

A whaleboat was launched with Tom Lincoln and John, the most adventurous of the young men, aboard, but the sea was too rough and they could not land. Fishermen regularly climbed the great rock and clubbed hundreds of birds at a time to use for codfish bait. "Five hundred and forty have been thus murdered in one hour by six men," Audubon notes in his journal, the word "murdered" hinting at his disapproval.

A fresh wind blew them north, toward Labrador, where no ornithologist had ventured. He was on deck at three on the morning of June 17; it was not yet light, but he could not sleep for thinking of Labrador. "The sea was literally covered with Foolish Guillemots [common murres]," he wrote, "playing in the very spray of the bow of our vessel, plunging under it, as if in fun, and rising like spirits close under our rudder."

Soon they were at the mouth of the Natashquan River, where the Hudson's Bay Company had a fishing business. Here they went ashore, and discovered that traveling by land was as difficult as traveling by

sea. Once past the beach, "we sank nearly up to our knees in mosses of various sorts, producing as we moved through them a curious sensation. These mosses, which at a distance look like hard rocks are, under foot, like a velvet cushion." Land was not land at all, but rocks covered over, in places, with a moss at times so deep it was, in Audubon's words, "boggy up to a man's waist." The "cushion" made hard going; they slipped and slid and fell; occasionally someone sank and had to be pulled out.

Millions of birds filled the air: White-winged scoters, common murres, razorbills, geese, loons, and common eiders. They saw red-breasted mergansers, black ducks, common scoters, and least sandpipers—but new and rare birds were not making an appearance. Lincoln and Johnny usually went off in one direction, the two medical students and Coolidge in another to spread out and look for the species Audubon needed. He worried when the young men took off in rough waters, and fretted until they returned to the ship before dark. "The Young gents under my care all proved to be excellent and usefull companions and I frequently felt as if all belonged to one Family. Yet . . . my anxiety was truly great and often raised to great pitch when we encountered a Storm out of Harbour."[26]

With their courage and tenacity, the young men were more than paying their way. "At three a.m. I had all the young men up," Audubon wrote on June 19, "and they left by four for some islands where the Larus marinus [great black-backed gull] breeds." Johnny came back with eight specimens of razor-billed auks, and four eggs. Five live chicks were brought back as well, and were clicking around the deck, crying "hack, hac, hac, wheet, wheet, wheet" and eating the bits of food given them.

Johnny, Tom, and the others kept Audubon's spirits up. Always ready for sport, they could catch a hundred codfish in half an hour; on shore they would "toll" loons by running toward them, shouting and waving a handkerchief, which for some reason so confused the birds that they ran at them, rather than away. In the evenings, the men passed the time in playing music—Johnny on the violin, Tom on the

flute—in telling stories and jokes, in comparing notes for their journals, and in just generally being jolly.

A British surveying schooner, the *Gulnare,* appeared and Audubon was invited to dine with the captain and the ship's doctor, who turned out to be a naturalist, interested in botany and conchology.[27] The first lieutenant, he discovered, studied ornithology. These were valuable men to meet off the Labrador coast, especially since the *Gulnare* would travel the same route as the *Ripley.* Though Audubon was obliged to shave and dress for dinners aboard—"quite a bore on the coast of Labrador"—the conversation proved stimulating, ranging "from botany to politics, from the Established Church of England to the hatching of eggs by steam."

Now and then, feeling stiff from so much time spent drawing at his desk, Audubon would go ashore for a walk, but a few miles of trudging through the marshes was exhausting. Even so, the experience was often worth it. On July 5, he wrote: "This afternoon I thought the country looked more terrifyingly wild than ever; the dark clouds, casting their shadows on the stupendous masses of rugged rock, lead the imagination into regions impossible to describe . . . I am much fatigued and wet to the very skin, but, oh! we found the nest of a Peregrine Falcon on a tremendous cliff, with a young one about a week old, quite white with down; the parents flew fiercely at our eyes."

Little by little, under the onslaught of the Young Gentlemen, the rugged country was giving up its riches: Lincoln had come upon a new species of finch, which Audubon named Lincoln's finch (now Lincoln's sparrow) in his honor. Coolidge brought him eight redpolls, young and old. Audubon was at his table for as much as seventeen hours a day, sometimes starting at three in the morning. By four in the afternoon, his fingers no longer worked and he was so weary that he had not even the energy to write in his sacrosanct journal, but fell into his bed and went to sleep. And in the morning, "my body seemed to beg my mind to suffer it to rest a while longer." The young men worried about him; they thought it wasn't good for him to work in wet clothing, but he wouldn't hear it. He had worn wet clothes all his life, and it hadn't hurt

him. "No! No!" he cried out to his journal. "It is that I am no longer young." His vaunted energy was failing him, and there was so much yet to do.

At noon on the first of August, they sighted an iceberg, which he described as "like a large man-of-war dressed in light green muslin, instead of canvas, and when the sun strikes it, it glitters with intense brilliancy." By the second week in August, a full two months since the *Ripley* had left Eastport, he was ready to go home. He had twenty-three drawings, most of them completed. He wished he had more, but as he wrote Lucy, "all hands have ransacked this Wonderful rocky & Mossy desert—To do more I need to stay at least a Winter, and I must say I would rather spend it with thee.—I have collected a good deal of most valuable information . . . which no one else possesses either in America or in Europe."[28]

For the Young Gentlemen, it was an adventure remembered with pleasure for the rest of their lives; each came away with feelings of respect and affection for the man who led the expedition. As for Audubon, he considered Labrador wild and grand in its "wonderful dreariness," but all he had to say as the ship turned south was "Seldom in my life have I left a country with as little regret."

The *Ripley* was at St. Georges Bay in Newfoundland on August 13, where they all tumbled ashore to search for birds, plants, and shells until a squall sent them back to the ship, drenched to the skin. Above, vast flocks of birds were traveling south, and Audubon could hardly wait to join them.

That same day, a group of village people came aboard to invite Audubon and his party to a ball in their honor, and asked that they bring along their musical instruments. At ten o'clock, the Young Gentlemen and their leader followed the gay paper lanterns to the dance-hall, which turned out to be the ground floor of a fisherman's house. Johnny had his violin; Tom had his flute; Audubon took a flageolet tucked into his waistcoat. The local girls arrived, and Audubon described them as "flourishing in all the rosy fatness produced by an invigorating northern climate, and in decoration vying with the noblest

Indian queen of the West. Their stays seemed ready to burst open, and their shoes were equally pressed. Around their necks, brilliant beads mingled with ebony tresses, and their naked arms might have inspired apprehension had they not been constantly employed in arranging flowing ribbons, gaudy flowers, and muslin flounces."

Johnny started by playing "Hail, Columbia," went on to the "Marseillaise," and ended with "God Save the King," thus covering all the national bases. Without any further ado, the dancing commenced and "mirth and joy abounded." The festivities would last until morning. Now it was Johnny who was fiddling, and the Young Gentlemen who were flying around the room with the buxom belles in their arms. Audubon found a place in the corner, next to an old gentleman, and watched with pleasure as the young people bounced around the dance floor. When glasses of pure rum were passed around, and downed by the women as well as the men "with evident pleasure," he was shocked, but tolerant. Cold climes, he figured, called for warm drink. Then he returned to the *Ripley* and to bed. "My young friends arrived towards daylight," he wrote, glad for their fun.[29]

After a few days more of being tossed on rough seas they were all "sick of sea-sickness, the sea and all its appurtenances," so Audubon decided they would leave the *Ripley* in Nova Scotia and travel overland to Eastport and on to New York.

Back on solid ground with his young charges, Audubon was in heaven: "The air felt deliciously warm, the country . . . perfectly beautiful, and the smell of the new-mown grass was the sweetest that ever existed. Even the music of the crickets was delightful." At Halifax, he had his beard cut, and he was ready to enter civilization once more.

To his surprise and delight, Edward Harris appeared at Eastport with letters from Lucy and his first news from the world without. In the next few days, as they traveled south, the Young Gentlemen went their separate ways, one by one, at the end of a fine adventure. Audubon was relieved to have delivered them home, all safe.

It had been an expensive journey, costing some two thousand dollars, but he believed it had been worth the money. To cover Labrador

and Florida had been grueling, but it gave him an edge over all other ornithologists: He now had a hundred species known to neither Wilson nor Bonaparte; this made him the indisputable authority on the birds of North America, a sweet vindication of his labors. Finally, on Saturday morning, September 7, Audubon and John arrived in New York and strode up the stairs to the Berthouds' house, where Lucy waited with open arms.[30]

"WE ARE A HOUSE FULL here . . ." Audubon wrote Victor, "not less than 18 in the family, which is *too bad.*" The crowded conditions at the Berthouds' did not deter him from the work at hand, which he hoped to complete in ten days.

He set Johnny to outlining the drawings from the Labrador trip; if the originals were lost at sea, the outlines, and the skins they had so scrupulously saved, would enable them to start the pictures over. He divided the drawings into two groups, sealed each in a tin case and enclosed that in a wooden box, insured each package for two thousand dollars, and shipped them off to England on separate packets to lessen the chance of losing both.

While Audubon was in Labrador, John Bachman had come to New York, visited Lucy, and used all his considerable charm to convince her that the Audubon family should spend the coming winter in Charleston as his guests. Audubon liked the idea. The mild climate would be good for Lucy, Johnny would appreciate the lively Bachman household, and he himself could get a good deal of work done on the second volume of the *Ornithological Biography* with Bachman's help. He was thinking of Maria Martin, as well; she had already supplied him with drawings of Southern plants, flowers, and insects, which he had included in some of the bird drawings, and she was able and eager to act as his assistant. While she was not as accomplished as either Mason or Lehman, she was quite good enough.

This plan depended on one factor: Victor. Audubon wrote to him, outlining his hope of spending another year in the United States and collecting not just the birds he needed but also fifty more subscribers—who, he was sure, were there if only he had time to pursue them. Audubon made it clear that this was his preferred plan of action. But, he wrote, he would follow it only if Victor agreed that he could carry on alone in England: "*Should you* call me to London, your demand will be promptly answered by my presence, and I shall not launch into the swamps or travel over the Prairies again without your answer on this important subject." [31]

Victor's letters, written in Audubon's absence, pleaded for guidance. In England, Waterton was on the offensive again, this time claiming in an article in Loudon's magazine that Audubon could not have written the *Ornithological Biography,* because its style was so different from that of the papers on the rattlesnake and the buzzard. In an astonishing appreciation of the book, Waterton wrote, "The correct and elegant style of composition, which appears throughout the *whole* of the *Biography* . . . cannot possibly be that of him whose name it bears."[32] To bolster his argument that someone else wrote the book, Waterton reported that Swainson had declined to work with Audubon on the *Biography,* because "Audubon insisted upon his unknown name being given to the world as author!"

Audubon had specifically directed his son to ignore these attacks, but Victor simply could not. He wrote a short, eloquent defense, saying that his father had most certainly written the Biography and intimating that Waterton was something of a cad to wait until his father was out of the country to attack him. Loudon's magazine published it, along with a statement from Swainson asserting that he was never asked to write his friend Audubon's book for him, but only to assist with the scientific details, and that it had never been suggested that his work be published under Audubon's name. Once Audubon read the exchanges, he wrote in high spirits to tell his son he was proud of him: "The copy of your reply to Mons Waterton is excellent," he said, "—that from Swainson ought to prove a death blow to the Demarara

Gent!" Audubon named a new warbler after Swainson, to show that he valued his friendship.

Audubon had reason to be proud of Victor. In what had to be a lonely year away from his family, he had done battle with Havell, too. The engraver was irritated about having to answer to a young American fresh off the frontier with no experience in engraving. Havell had also been threatening to raise his prices. Even so, the numbers that were done in Audubon's absence were strikingly good, and the father was happy to give the son credit. "I have examined Nos 32 and 33," Audubon wrote, "and must say that I look on these 10 plates as the best I ever saw of birds and that they do *Havell* and *yourself* my beloved son great Credit everything is better—the birds are Fac Simile of my Drawings—Soft and beautiful the colouring is clear transparent and true to nature—the plants are seriously better—I am delighted . . . If Havell goes on in this present style and principle, I will be bound that neither I or you will have a word of Complaint about his Works.—tell him this." [33]

Victor and Havell came to terms. From New York, Audubon wrote his son that he was glad the two seemed now to agree: "I am quite sure that your diligence at overseeing the work was a great source of discontent on his part but we have to look to and think of our own interest quite as much as any others in this Boistrous world of ours." [34]

If Audubon's old, tortured memory of the parrot and the monkey came to mind, the monkey had taken on a new guise: time. Audubon was forty-eight; his chestnut hair was streaked with gray now, and his body was less resilient than it had been. He was acutely conscious of ageing. Time was pressing on him, threatening the work. The schedule for completing the *Birds* would require seven more years—too long; he told Havell and Victor that they must finish quicker, work faster, perhaps by including more plates in each number. "I am growing old and will have to abandon the severe manner in which I have been obliged to travel in search of Birds . . . in a few more years.—The pleasure of seeing our vast undertaking completed would be to me the last furlough of my Life," he wrote his elder son.

Victor was already thinking of the future, planning for the time when the double-elephant folio was finished. He wanted to revive a plan to produce a smaller-sized edition of the *Birds,* one that most households could afford. Audubon had long felt that such a popular, affordable edition would be profitable, and Victor suggested that they get it under way. Audubon was cautious in his reply, discussing in detail various questions—the best size, how the books should be produced and where, if the text should appear alongside each plate. But he cautioned Victor that word of this edition must not get out before the double-elephant *Birds of America* was complete. Victor might confide in George Children, who could offer excellent advice, but no one else must know. Audubon could not risk upsetting current subscribers.

In Victor's spare time (his father wrote, and the son must have winced), he should send Edward Harris a gun exactly like the one he had sent his Uncle Billy in Louisville (which Victor might like to know now belonged to his Uncle Tom Bakewell). According to Audubon, it was the best gun Conway of Manchester had ever made, and Harris's gun must be every bit as good. He wanted Victor to include "a pair of extra Main Springs, Cocks and several pairs of Nipples," and to attend to this errand at once. As for Victor's two Kentucky uncles, Audubon had already told his son not to send them any more gifts; neither had bothered to answer Audubon's letters or to respond to requests he had made of them.

He could not wait in New York for Victor's reply; having put Johnny on a ship to Charleston with their heavy baggage, he and Lucy set out overland, planning to stop in Philadelphia and Baltimore to deliver some numbers to subscribers, collect money, and, Audubon hoped, sell some more subscriptions.

Philadelphia was to prove his bane once again. No sooner had they arrived than a warrant was issued for his arrest by old Henderson creditors, who were now following his rising career with more than a little interest. They figured that if he was famous, he must be rich. Bail was made, and Lucy and John Audubon left immediately for Washington.

At the capital, Audubon met with the secretary of war to see if he could be included in any expedition planned for the West. The secre-

tary was cool and Audubon left feeling discouraged. A large part of the
continent lay unexplored; he could not finish his great work without
somehow covering it, but all his efforts had been stymied. There was
nothing to do but move on—first to Baltimore, where Lucy's sister
Sarah's husband, Theodore Anderson, was helpful in searching out new
prospects for the *Birds;* four subscribers were added to the list.[35] They
then proceeded to Columbia, where Thomas Cooper, the president of
South Carolina College,* entered the rattlesnake controversy by assur-
ing Audubon that he himself had seen a rattler climb a five-rail fence
on his land. Audubon got him to put this on paper, then collected
$420 for a subscription for the State of South Carolina and, feeling
better, turned at last toward Charleston.[36]

Johnny had already been in residence long enough to know he
liked everything about the Bachman family, especially the eldest
daughter. Seventeen-year old Maria would soon become, in his letters,
"My Maria."

The Bachmans were fools for guests; they had been known to pack
as many as twenty-two people into their house (now there were but
fifteen). Audubon had his own quiet study on the ground floor, but
he enjoyed the rough-and-tumble of the lively house, children bob-
bing around, animals everywhere. Soon he, Maria Martin, and Johnny
were hard at work in the basement workshop, with Bachman join-
ing them whenever his other duties allowed. For her part, Lucy had
undertaken the laborious task of copying and organizing Audubon's
voluminous notes of the Florida and Labrador trips.[37] She had settled
in to be as good a guest as she knew how, though no doubt worrying
about Johnny and Maria Bachman. Neither father wanted to come
to terms with the romance that was obviously blossoming. Maria was
very young: They would have agreed on that. And Johnny had not yet
made his way in the world. (Lucy had been only seventeen when John
Audubon first set eyes on her, and his own father, and hers, had made
them wait.) On November 30, John marked his twenty-first birthday;

* [Now the University of South Carolina]

legally, he was now his own man. Pretty Maria smiled at him; they had all winter long to be together.

It was an idyllic interlude for father and son alike. Not only was Johnny in love, he was drawing birds that would appear in the *Birds* and his father was, in his more sanguine moments, talking of turning all of the drawing over to him. Audubon worked steadily on the second volume of the *Biography;* both Lucy and Bachman thought it better than the first.[38] Johnny was drawing a pair of adult American bitterns—one of ten of his drawings that would appear in *The Birds of America.* Then he was given the finch that his father had named for MacGillivray (now seaside sparrow); Maria Martin provided the white peacock butterflies to embellish it. Young Maria Bachman looked on admiringly as her Johnny worked with her aunt and namesake, whose work would ultimately appear in about twenty of the drawings.[39]

The house was a hotbed of creativity. Bachman was a respected naturalist in his own right, yet neither he nor Maria Martin seemed to care about credit, but only about art and science. Audubon wrote Victor: "Here . . . we are all comfortable & employed in writing, drawing, music, reading, & conversing from the moment we raise in the Morning until we retire to rest.—his [Bachman's] observations of the manners of the South birds with which he is *well* acquainted is a double source of enjoyment and use to me."[40] Each evening, Audubon and Bachman would sit together with a glass of claret and write at least one bird biography together. Occasionally, they rewarded themselves with a game of chess.

For exercise, Bachman had long made a habit of spending at least one day a week tramping through the woods with his gun, and Audubon was not averse to joining him. Bachman had christened his friend "Old Jostle," because of his grumblings about the rough rides he got in carriages on the crude country roads.[41] Seldom were two men so matched in enthusiasms and wit; seldom in the past ten years had Audubon found such a congenial mix of work and pleasure.

Bachman believed that America could afford a good many more subscriptions, if Audubon could take the time to seek them out. Not

only was the country becoming wealthy but also, according to Audubon, "subscribers in this Dear Country of ours do not drop off unless they die. They pay punctually on demand, and to have more of them in this land than in Europe is a thing that may prove of the greatest importance to *us.*"[42] He wrote to Victor: "If I could be spared from drawing birds and from going to England for 12 months . . . it was my opinion I could procure in that time and in our Country too, ONE HUNDRED additional subscribers." He would not, he said, leave Victor all alone, but would send Lucy and Johnny to England. Combing the United States would prove too exhausting for Lucy, who was, in any event, eager to return to England; since she wouldn't travel alone, Johnny must go with her.

The idea that he could stop drawing birds for a full year while he wandered the country in search of subscribers was wishful thinking, as Audubon must have known. He was even then urging Havell to push faster, to produce ten numbers every year rather than five. "It would be a great satisfaction to me," he wrote his engraver, "as I conceive myself growing old very fast . . . The Machine me thinks is wearing out." [43]

Waterton in England and Ord in Philadelphia continued to make nuisances of themselves by harping in print on the buzzard paper. The good-natured Bachman lost all patience and decided that to prove that the birds found carrion by sight, he would perform a modified version of the experiments Audubon and Bourgéat had done in Louisiana years before. Bachman called in several respected members of the faculty of the Medical College of South Carolina to observe his experiment, in case he should be accused of coming to a friend's aid with fraudulent data. Audubon painted a life-sized picture of a dead sheep as it might be viewed from the air; this was set out in an open area. The first vulture to overfly the picture wheeled and came to it. Putrid meat was put out, but hidden from view, and the vultures all but walked over it.[44] Bachman wrote a scholarly paper detailing each experiment and coming to the conclusion that buzzards find their food by sight, not smell. Audubon could not resist gloating over the effect this paper would have on Waterton and Ord, and he told Victor that he wished there were

more rattlesnakes around Charleston, so they could set "that Business" to rest. In fact, he should have been glad, because he was on shaky ground with his climbing rattlesnakes.

As November merged into December, Victor began to press his parents to return to England. He was becoming anxious about dealing with so many problems on his own, and even his father's friends felt that Audubon needed to return. Kidd had managed to get himself involved with men who were doing a book based on pirated material. Without Audubon's permission, Kidd had written an article about him, using information lifted from the *Ornithological Biography*, and had copied a portrait of Audubon to go with it. (Kidd wrote Victor that he hoped Audubon would take this as a compliment.) Victor was afraid Kidd might decide to publish the bird pictures he was copying from the originals before they could get out their "petite" book, as Audubon called their planned small edition of the *Birds*. Audubon told him not to fret, but to take the original studies away from Kidd as soon as he could. Audubon still had some hope of mounting a gallery exhibition of Kidd's oil copies of the birds.

Bachman, five years younger than Audubon, had suffered from tuberculosis since childhood, yet seemed to have great energy in his middle years—quite the opposite of Audubon. The minister's duties at St. John's Lutheran Church, where he had served since he was twenty-four, always came first, but his association with Audubon had kindled a new fire in him.[45] His primary interest was not birds, but quadrupeds. He wished to do for the mammals of America what Audubon had done for the birds. The friends talked about collaborating on the project; Audubon thought it a fine idea. He could not be actively involved until the *Birds* was complete, but after that he could turn his attention to this new challenge.

That is, he and the boys could do so: Audubon had always expected both of his sons to become artists, even while they pursued other activities. Johnny had the benefit of spending time with his father, who pushed him to excel, but Victor's artistic well-being was not ignored. That fall he wrote Johnny a long letter, explaining how he

was trying to improve his own skills at art and describing a lecture by the artist Cruickshank. Audubon was delighted with his son's efforts at self-improvement, and on the day before Christmas, wrote him: "Cruickshank is *right;* by *drawing* you are enabled to study the lights and shadows of bodies, again the beautiful mellowness with which, altho. all powerful in the *effect,* these blend themselves with each other. The *reflective power of bodies* will also strike your discerning attention, and when these combination of the true Material are well understood, the artist is a Master! Nature after all, has done all for us; she groups, and most beautifully, every thing that is presented to our eye or mind."[46]

Meantime, the drawings of waterbirds proceeded on schedule; Havell had worked on his own, with minimal supervision, for so long, and so well, that Audubon found he could send incomplete drawings with instructions for the engraver to put in a background here, add a butterfly there—in short, to finish the picture. At times Audubon cut and pasted, adding a bird drawn at some time in the past to a new one on the page. Miraculously, the drawings were getting ever better. Audubon was reaching the apex of his art; the faster he worked, the better he seemed to get.

From the moment he arrived in Charleston, he had expected the government to make available to him a ship that would take him south again, then west to Texas; but despite assurances, no government ship appeared. He knew he must go west; if he didn't go now, it would mean making yet another journey from England to America before the *Birds* could be complete. This he desperately wanted to avoid: Time was slipping away from him.

The new year had brought other annoyances: Nuttall was about to leave on an expedition west that would give him all the birds that Audubon so needed. Even more humiliating, the dogged Henderson creditors had tracked him down and had hired a Charleston lawyer to pursue their claims. Bachman's friend Judge Benjamin Dunkin agreed to represent Audubon in the case. All the while, Victor was urging him to return to England immediately.[47]

On January 14 Audubon wrote his elder son a thoroughly wasp-ish, petulant letter, saying that they would come to England as soon as possible, but that Victor had better have good reasons for pulling him back. It was against his better judgment to go, Audubon wrote, but "the die is . . . cast." He expected to be in London by the fourth of July; he couldn't make it any sooner because Lucy was in delicate health, and he wanted her to sail in the summer, when the seas were likely to be more calm. Like it or not, Victor was going to have to hold out for another six months.

It was March by the time the Audubons left Charleston. The parting was especially poignant for young John and Maria, who made it clear that they planned to marry. Their parents did not feel a formal engagement was necessary. There was plenty of time.

On the way to New York, Audubon went to pains to collect all the money owed him in America—not an easy chore, given the recent bank failures. In Philadelphia, he managed to collect twenty pounds that Victor had loaned Dr. Harlan in England, and to patch up a friendship which had taken a turn for the worse when Harlan failed as agent for the *Ornithological Biography*. True to form, Audubon did not hold a grudge; Harlan was having a difficult time financially, and besides, "he is as Kind as ever and I believe that is the best *portion* granted ever to poor Men," Audubon wrote to Bachman.

Before booking the best stateroom on the 650-ton packet *North America*, expected to depart April 16, Audubon made certain that John Bachman received an elegant leather-bound volume of the *Birds* (this was the copy he had taken to France as a sample), with a note that Bachman should accept it "from your old friend as part atonement for the troubles I have given you and the leatherings which you may yet receive at my hands at Chess!!!"[48]

Shortly before sailing, full of fear and foreboding as usual before a long sea voyage, Audubon wrote a soul-wrenching letter to Maria Martin. He recounted his nightmares of sinking and burning ships, of lost drawings and failed subscriptions. He considered her, he said, as dear a friend as his wife—he now referred to Lucy as "My Dear Old

Girl"—or Bachman. Maria, like Hannah Mary Rathbone, offered a kind of intimacy he could never resist: affection and understanding with no demands.

Audubon gave Johnny the job of writing to his brother in England to say how important it was to proceed with the work should the rest of the family perish. Johnny, who now had considerations of his own, added a personal request. Should the vessel go down, he wrote, Victor should make his way to Charleston and get to know the Bachman family, especially Maria. "Should you never hear of us more, you will be alone in the world, and a friend will cheer your solitary stay." If he didn't live to marry Maria, he thought Victor might like to. On the other hand, if he survived, "The lady I call my Maria is Miss Bachman and is, some day, if we prosper, to be your sister."[49]

In fact the journey was uneventful and took only twenty days. They arrived in Liverpool in the first week of May, 1834.

17

So you see . . . how lucky the "old man" is yet!
and why all this luck?—Simply because I have
laboured like a cart Horse for thirty years on a
Single Work, have been successful almost to
a miracle in its publication thus far,
and now am thought a—a—a (I dislike to write it, but
no matter here goes) . . . a Great Naturalist!!![1]

JOHN AUDUBON, TRAILING LUCY AND young John, paused in Liverpool only long enough to pay his respects to the Rathbones. Letters from the diligent Victor full of business details awaited them; there was work to be done, and John Audubon set about it with a fervor. On the way to London they stopped in Manchester, so the "Great Naturalist" could make the rounds of friends and subscribers—coaxing them, charming them, collecting their subscription fees—then went on to London and a poignant family reunion.

"We found Victor at home in the evening of our arrival," Audubon wrote. "I thought that the very sight of him was a restoration of life to me, and our happiness was as complete as it may ever be expected on this Earth."[2]

Victor had taken rooms for them at 73 Margaret Street, off Cavendish Square, and there the four settled down to a contented, industri-

ous existence. Lucy and John had produced sons in their own mold: loving, loyal, and competent. The boys studied music and worked to improve their art, John making black chalk portraits and Victor working on landscapes under the discerning eye of their father. Audubon was pleased with both his sons. He expected excellence from Victor, but John's progress amazed him. Lucy knitted socks and made shirts and, sometimes, read aloud to her menfolk as they all worked away. She had given up both brandy and her wig, her husband confided to Bachman approvingly, adding that she now "wears her own dear grey locks and looks all the better." Safe at last in the shelter of her immediate family, Lucy could afford to show her age.

Throughout the unusually long, hot London summer of 1834, John Audubon sat in the rooms on Margaret Street working on the *Biography*. In his spare time he dashed letters off to all of his friends— joking, cajoling, and begging them to send information, bird skins, or birds packed in barrels of cheap whiskey or rum. The biographies required great quantities of information, much of which he did not have and must somehow obtain. Since he could not go back and collect the birds he needed, he had to depend on his friends, and he kept after them mercilessly. He also needed his "Episodes" to enliven the text, and asked friends to send him interesting stories.

He pushed himself ruthlessly, writing so constantly that his hand swelled. London was quiet in the summer: "the Grandies are off shooting Partridges, Grous hares & Pheasants," he wrote Bachman. He hoped to return to the United States by the fall of 1835, to make the long-sought western journey—but there was much to be accomplished in Europe first.

Soon the family was dispersed again. Victor went off to Paris (where he saw Pitois, who had turned out to be a dependable agent after all) and to Couëron, where he visited his father's sister and her family.

Audubon's fame was now such that the newspapers in England, France, and America recorded his movements. Understanding the power of publicity, he had courted writers and editors from the begin-

ning—David Brewster and Robert Jameson of the *New Philosophical Review* became friends and began writing about Audubon in 1826; John Wilson of *Blackwood's Magazine* was a friend and chronicler of Audubon's life and work. As for American newspapers and magazines, friends like Bachman often sent them excerpts from Audubon's letters, or favorable reviews that had appeared in England. In 1831, Richard Harlan told Lucy: "Our newspapers announce the arrival . . . & progress of Mr. Audubon, as if he was an *Embassador*—and so he is, one of Natures's!"[3]

Now his French family could keep track of him through the newspapers. All these years, du Puigaudeau had been persevering in the matter of Sanitte's estate in Saint-Domingue. In 1825, the government there had finally compensated French planters for their assets, lost during the slave rebellion, but the settlement from Jean Audubon's property was being claimed by Sanitte's relatives as well.[4] Du Puigaudeau had hired lawyers to argue his wife's claim, and he wanted John Audubon to share in the legal costs, since any settlement in their favor would be divided between the two adopted children of Jean Audubon and Anne Moynet.

Victor returned from France with loving greetings from his aunt, uncle, and cousins. The family had been remarkably kind and hospitable to him; his aunt had sent a miniature of herself as a gift to his father. Victor also brought garbled reports on the state of legal affairs. He didn't fully understand the situation—and that was probably as his father wished, since it is quite likely that those challenging du Puigaudeau were Sanitte's children, his half sisters. But Audubon had neither the time nor the desire to pursue old debts. His thoughts and efforts were concentrated on the immediate future and the completion of his work, and other problems presented themselves. For one, he was forced to break his old promise to himself about drawing birds from life, never from stuffed specimens or skins. That year he would borrow thirty-three specimens from the Zoological Society to use as models.

Mostly, his mind was on the *Ornithological Biography.* As soon as he returned to London, he wrote to tell MacGillivray that he had a

mass of work to be edited and wished to continue their collaboration. MacGillivray responded eagerly, requesting that he be sent twenty-five bird descriptions at a time. Audubon complied promptly, and MacGillivray transcribed and corrected one a day throughout July. He was the perfect editor—cutting and trimming with elegant precision, reining in Audubon's literary excesses without stifling his enthusiasm or style, encouraging him continually while reminding him to be more concise.

Audubon had lived long enough to know that fame did not assure fortune. In London, continuing the search for subscribers, he took Johnny with him to the countinghouse of Nathan Mayer Rothschild, to whom he had a letter of introduction. Rothschild appeared, "a corpulent man, hitching up his trousers, and a face red with the exertion of walking." Without appearing to notice the father and son, the man Audubon called "the great usurer" took his seat, leaving them standing "hats held respectfully in our hands." (It was not his only derogative reference to Jews; Audubon was not immune to the pervasive anti-Semitism of the age.) Finally Audubon stepped forward, bowed politely, and handed over his letter. Rothschild looked up, but only to ask bluntly if he was there on business or only to offer "a mere letter of introduction."

Johnny was getting his first lesson in humility; he watched silently as his father swallowed his pride and told the rich banker that he would be honored to have his name on his subscription list for *The Birds of America.* Rothschild let him know that he did not put his name on subscription lists but then said that if sent a copy, he would pay for it. Audubon left, humbled but pleased. The first two volumes were dispatched, along with a bill for one hundred pounds. Rothschild took one look and announced that he had no intention of paying more than five pounds for any bird book, and with that sent the *Birds* back to the engravers.[5]

Audubon took this in stride; he considered suing Rothschild, but decided that would be too costly and too time-consuming. He had become inured to minor setbacks, and knew better than to waste time and energy on recriminations. Better to put Johnny to work copying

a drawing that he planned to sell outright. Money was needed, money must be had; Havell now required $450 a week to pay his workmen.

Audubon had several money-making schemes. Museums and collectors always wanted bird skins; he had returned with three hundred, some of which he had obtained himself and some he had purchased from professional hunters he thought he could trust. To his utter chagrin, the British Museum, which had bought seventy-five skins, discovered that a few were tampered with; though nothing was said to Audubon—he heard about the matter from a third party—the incident hurt his standing with this important institution.

Early that September, leaving Lucy in London with the boys, Audubon headed north to secure old subscribers and search out new ones. It was the old grind, all over again—trudging through muddy streets, calling on people who as often as not weren't at home. Letters of introduction in hand, Audubon pursued new subscribers with remarkable persistence, tracking one to the court where he was sitting as magistrate, and even turning up at a drinking house where another wealthy man was said to appear every day at the same time.

It rained incessantly; the artist, who had a "Shocking Cold," at times found himself waiting a full hour for someone who never showed up. He only shrugged, shaved, dressed, and went off to a dinner party to try to convince yet another family to subscribe. Day after day was spent like this; it was essential, he knew, and he tried not to complain. It was all part of being a Great Naturalist.

Trains had begun to make traveling faster and easier; Audubon took the evening train for Liverpool and Green Bank, where he knew he could rest and be restored. Yet even in that haven, trouble lurked. From the Rathbones, he learned of a rumor that Nicholas Berthoud's New Orleans business was on the verge of collapse. He wrote to ask the always trustworthy Edward Harris to make discreet inquiries, keeping the matter of course "quite *entre nous*." Berthoud was holding the Audubons' very considerable American funds; Audubon was concerned, and knew that Lucy would be beside herself if she should find out.

A few days later, he was back on the road to Leeds with letters of introduction to the four richest men in the area. One received Audubon coolly and didn't bother to introduce him to another guest, a member of Parliament. Another's steward led him to a back kitchen to wait, like a common peddler. And yet he did wait; his purpose was stronger than his pride.

In the end, each of the four said he would think about it. "This in plain English is translated thus.—I Shall not Subscribe," Audubon wrote Lucy. It didn't help to learn that the Marchioness of Hereford had papered the walls in one of her rooms with the birds from the first volume. Someone else had taken over the marchioness's subscription; Audubon, always one to look on the bright side, thought the new subscriber might want to replace the first volume. In all, he could see that subscribers were becoming much harder to come by in England. He wrote to tell Lucy not to expect him for another month: "I Must beat the Bushes a while."

Journey's end was Edinburgh, where Audubon saw at once that if he was to get the next volume out in time, he would need to go over bird biographies with MacGillivray for months, not weeks. Since the editor could not return with him to London, Audubon would have to stay in Edinburgh. He wrote to Lucy to come at once, and gave her a long list of things to bring.

While in Edinburgh, Audubon planned to confront Joseph Kidd. But, although Kidd had been slow in returning the original drawings to Victor, he now seemed chastened. Almost as soon as Audubon was back in the country Kidd sent him a letter filled with remorse and regret, assuring Audubon that his "speculations or publications have *stopt,* and thus I am now busy with nothing whatever but your pictures."[6] He all but begged Audubon to remain his friend and employer. Audubon quickly decided that the man was too poor and too much humbled by his disastrous adventure in publishing to do him any harm—besides which, Kidd was an excellent copyist and worked for very little money. Audubon gave him more drawings.

Audubon's thoughts seldom remained unspoken, which tended to get him into trouble. He had told the boys that if things worked

out with Kidd, he would bring him back to London to continue the copying and give them lessons in oils as well. The idea excited Johnny and Victor, who realized they needed more instruction if they were to play active roles in the creative part of the burgeoning family business. Their father's decision to have Lucy join him in Edinburgh while they remained in London put an end to that plan, and both Victor and Johnny were irritated. From their point of view, their father continued to put his own needs first; if they complained, they were told that everything he did was for them, for their comfort, for their future welfare.

Lucy joined her husband; through November and December they worked away in their rooms, he writing, she copying. Audubon wrote Bachman, "God preserve you, and save you the trouble of ever publishing Books on Natural Science! for my part I would rather go without a shirt or any inexpressibles through the whole of the florida swamps in musquito time than labour as I have hitherto done with the pen."[7] And their social life was curtailed: There were to be no happy evenings around the Lizarses' fireplace, sipping warm grog.

Lizars had produced the first ten plates of the Birds, which carried the legend "Engraved by W. H. Lizars, Edinr." Audubon owned the plates, so when the work went to Havell they went as well, along with some uncolored prints. Havell retouched four of the plates, using (as Lizars did not) the aquatint process, which created more subtle shading. Havell added his own name to these plates ("Retouched by R. Havell Junr."). Eventually, as more and more proofs were pulled, Lizars's legend disappeared altogether from the first ten plates, being replaced by "Engraved, Printed & Coloured by R. Havell Junr."[8] Audubon did not step in to protect Lizars's credit, and the engraver, feeling he deserved better, was understandably wounded. He kept his distance from the artist he had helped launch.

Sir William Jardine, having published some of Audubon's work without his permission, was also ruled out as an intimate. Old friends thus became adversaries and spoke out against each other, or gave fuel to such declared enemies as Waterton, who was still fuming and sputtering away.

By mid-December, the second volume of the *Ornithological Biography* was complete; Audubon made certain his editor friends got copies, and then he sat back and waited for the glowing reviews. They were quick in coming. One said that Audubon "has told what he has seen and undergone, not perhaps in the smooth nicely balanced periods of a drawing-room writer . . . but with . . . unstudied freedom, rising at times to eloquence . . . The work is full of the man."[9] Ord was just as quick to condemn these reviews as "miserable puffs."[10] And Waterton continued to make irritating noises, which bothered Bachman more than it did Audubon, who wrote his friend with earthy humor, "As to the rage of Mr. Waterton . . . I really care not a fig—all such stuffs will soon evaporate, being mere smoke from a Dung Hill."[11] The American edition of the Biography had been taken out of Harlan's hands and given over to George Parkman in Boston, where it was to be published.

By January, the intrepid couple was back in London with the boys. Audubon kept up his barrage of letters to friends in America, wheedling and cajoling them, flattering them—and begging them without mercy to send him information about particular birds. The letters were accompanied by lists that went on and on: "Make all enquires from good and true men and note down their sayings . . . 'do not put off until tomorrow what can be done to day!' . . . Find the nest of the Southern black capt Titmouse [common bushtit]—Watch the Habits of the Barn Owl & save one or two bodies in spirits . . ."[12] Bachman and Edward Harris bore the brunt of these demands and responded admirably—but never quite well enough or fast enough to suit their voracious friend, who had become obsessed with the need to work double time, to press everyone, to finish. "Do my dear friend exert yourself kindly for me as soon as you get this letter," he wrote Bachman; "write to many of your friends in the country—spur them up on the sea islands beg of the collector of the custom house to assist you— [write] to all the world my dear Bachman." At this point in the letter, Johnny inserted a wry "(just put an advertisement in all the papers of your city)" to his future father-in-law.

A letter from Maria Bachman came every ten days or so. Johnny planned to return to America with his father that fall of 1835, and the couple made it clear to their parents that they planned to marry. Audubon was not above using this connection in his pleas for help. He was anxious to finish his great work, he wrote, not for his own benefit but for the comfort of his sons and their families. *"You are a Member of My Familly,"* he wrote Bachman, "and some one besides under your roof, not mentioning our own Dearly beloved Sweet Heart and the children, and I know you all so well that I feel confident that your shoulder (and it is a good strong one) will willingly be applied to the wheel."

Maria Martin, whom he called his "Sweet Heart," was a no-nonsense, hardworking woman whose spinsterhood spared her the physical trauma of producing children year after year, as her sister Harriet had done. Maria was an accomplished artist, evidently delighted with the opportunity to provide botanical drawings for the celebrated work. And she did not badger Audubon for money or credit. Bachman depended on her as well, not only to tend his increasingly fragile wife, but to run his household and sometimes to help with his sermons. Both men learned they could count on Maria Martin; in their letters they lavished her with praise and—in Audubon's case—plenty of paper kisses.

Once back in London, Audubon took a hard look at the work that lay ahead of him and made a decision that sent Johnny and Maria reeling with disappointment: They must postpone their return to America for a full year. Now they would not leave before the first of April, 1836.

"I am almost mad with the desire of publishing my 3d Vol this year," Audubon explained to Bachman, "—I am growing old fast and must work at double quick time now." At the end of this letter, he could not resist inserting a little wheedling request: "I would give 5 Dollars for one egg of the Wood Ibis and a description of the nest, time of Breeding &c &c—Try your best for me."[13]

The Audubon ménage settled in for another bout of work, and the father's pen covered page after page in his sometimes illegible script. He could be irascible. Early in January 1835, he wrote the botanist

J. S. Henslow, who had become his agent at Cambridge, "Can you inform me why the Honble Revd G. N. Granville has discontinued his patronage to my Birds of America? I think that if he was aware that when finished (and that will be in two more years) one thousand pounds could not secure a Copy, he would probably be glad to possess so rare a Work. Inclosed I send three stamp receipts for the Subscribers at Cambridge and will feel obliged to you for a remittance at your convenience."[14]

Meanwhile, Victor and Johnny took over the family's social duties. Friends of the father became friends of the sons. Lord Stanley introduced them to Edward Lear, whose monograph on parrots was in Audubon's library.[15] Stanley was now Lear's patron.

Swainson was in London but did not come near the Audubons. His wife had died, his work had suffered, and he had allowed himself to become embroiled in a war of words with his critics, who were cutting him up. "He suffers his temper to run away with his good sense," Audubon wrote.

In fact, the great friends of Audubon's early days in England were being supplanted by the American contingent. Edward Harris and John Bachman were like brothers; America was his country, and he was beginning to yearn for the time when he could go home for good.

Audubon's manuscript grew; he worked on new drawings and supervised Havell. Now and then there were irritations to deal with. Bachman could be as blunt as Audubon was flattering. The Charleston minister had not been pleased by the praise Audubon had lavished on him in the second volume of the *Biography*. His own classical training and writings as a naturalist had established him in the scientific community; Audubon's frequent use of his name implied a responsibility that he was loath to assume, and he let the author know it. (Audubon, wide-eyed, seemed not to get the point. He answered dramatically, "Deny me the pleasure of expressing myself in gratitude if you dare not to cut the Jugular Vein that swells my neck," and went on to announce that for every word of praise for Bachman in the second volume, he was planning whole sentences in the third.)

More unsettling, Bachman wrote to tell Audubon that the law-yer representing him in Charleston advised him to settle the old Hen-derson debt out of court, and Bachman agreed. (Men who declared bankruptcy but then scrupulously paid off their debts were held in high esteem in an era of economic booms and busts, which may have influenced the conscientious Bachman.) Feeling harassed and "cheated anew," Audubon nonetheless directed Bachman to collect money from subscribers in Charleston and Savannah and pay the Henderson credi-tors. Thus he put that ugly chapter of his life behind him.[16]

That summer, he and Lucy headed back to Edinburgh to fin-ish the third volume of the *Biography*, while Johnny and Victor took themselves off on a walking tour of Wales. Edward Harris had hired an Indian boy to skin birds and find eggs for Audubon, and Harlan was sending barrels of birds preserved in whiskey which arrived at the docks at Leith. MacGillivray diligently dissected these, while Audubon looked on, making copious notes. He was sorry he had neglected this kind of minute detail during most of his career, and especially on the Florida trip. Now there was nothing to do but try to collect enough specimens to examine before the book was published.

Rain washed out the tramp through Wales, so the boys joined their parents in Edinburgh. It was cheaper to live in this Scottish city than in London (especially since fewer friends dropped in at mealtimes). They had brought their servant Betzy with them, so Lucy could devote herself to the work. The old days when Audubon was invited out to dinners almost every night were over. "We are a Working Familly," he declared. Lucy wrote to her cousin Euphemia Gifford, who was wealthy enough to subscribe, that "the expenses we are now obliged to defray make it a matter of necessity to consult economy," and she wasn't certain she would be able to afford to come to visit the old Bakewell homeplace in Derby.[17] "We have not paid one visit since we came, though we have many valuable acquaintances here, for the cor-rection of the proof sheets occupies all my husband's time."[18]

Still, Audubon understood that his sons needed a social life. He arranged for them to meet James Wilson of *Blackwood's,* who was

a longtime supporter of his and provided glowing reviews of each volume of the *Ornithological Biography*. Johnny and Victor fell in with the lively Wilson family and spent a good many evenings there. Lucy watched with pleasure as her handsome sons, born on the wild frontier and schooled by their mother in log houses, moved easily in Edinburgh's intellectual society.

Johnny had become adept at portraiture; by charging less than the going rate, he often found himself with as many as five sitters a day. The mayor and his wife sat for him, as did other city notables. By the end of the year he had completed fifty portraits; he was adding to the family coffers, he was becoming very good at painting, and his father was cheering him on. Victor handled the details of business, and took lessons in landscape painting.

By the close of 1836, Audubon and MacGillivray had finished the third volume of the letterpress, and Havell had engraved 350 plates. The original prospectus for the *Birds* promised four hundred plates, so the end seemed to be in sight. Those faithful subscribers who had stayed with Audubon from the first volume were beginning to heave audible sighs of relief.

After copying about a quarter of the *Birds* in oils, Kidd finally gave up on Scotland altogether and went to Jamaica, leaving the completed oils behind for Audubon to do with as he pleased. Audubon was neither surprised nor disappointed. The copies were good and had cost him little; he could always sell them for a fast profit.

By Christmastime, their work in Edinburgh complete, John and Lucy Audubon were back in Liverpool with the Rathbones, while the boys and the servant Betzy went by boat to London to prepare the way for them. Lucy looked forward to their return to London because the Gordons had taken a house on Sussex Place and she would have her sister for company. For Audubon, the city was always "Dirty London," but he was glad enough to return this time, to make ready for his departure that spring for America. The Audubons settled in at 4 Wimpole Street.

By the end of January, Havell was working on the first number of the last volume of the *Birds*. In the beginning, he had turned

out five numbers—or twenty-five folio sheets—each year; now he was doing ten numbers—fifty sheets—and at that rate, he promised to be finished within two years. "Unless *I* keep him back," Audubon wrote ominously.

The end of the great work was proving more difficult than the beginning. Now he needed certain very specific birds; they were hard to come by. And he was haunted by the thought of all the new birds that must exist in America's Far West, beyond the Rocky Mountains. How could his book be called *The Birds of America* when in fact he had scarcely looked beyond the Mississippi River? In the back of his mind he was wondering about Nuttall and John Townsend, a Philadelphia pharmacist who had gone with him. The two were even then trekking through the Columbia River country.

Such a trip would cost Audubon two years—the same two in which Havell planned to finish the work. He knew, in his heart of hearts, that he could not go so far or stay so long. In one of his unrestrained outbursts, he had written to Bachman that he wasn't certain where the "tremendous concluding journey" he was planning would take him, but probably he would "go through the 'Ever Glades' of Florida, then to the Mouth of the Sabine River and up it into the broad Prairies—I love the prairies! and then on to the Rocky Mountains and—So much for an old man!" [19] He was counting on Bachman to go with him; the minister's need to tend his flock did not seem to Audubon a particularly adequate excuse. He had never been one for organized religion.

Lucy complained of being unwell and said she was much more comfortable in the Wimpole Street house with servants Maria and Elizabeth than she could be in Eliza's crowded house in New York. [20] Happily, one of their neighbors was Dr. Benjamin Phillips, a member of the Royal Society (and a *Birds* subscriber, as well); he volunteered to look after Lucy. Whatever ailed Lucy didn't alarm her husband enough to cancel his trip. He even entertained the idea of taking Victor as well as Johnny; he thought his increasingly sophisticated elder son could use the rough-and-tumble of scrambling through canebrakes. But in the end, Victor stayed behind with his mother.

Maria and Johnny had expected their separation to last a year; now it was two, and they were counting the days until April, when Audubon Senior had promised that he and Johnny would depart. As usual, unforeseen events conspired against Audubon's plans. Fire had raged through New York City, destroying 530 buildings including the Berthoud warehouse where Audubon's library, personal effects such as bedding and drawing materials, and his guns were stored. It was the guns that presented a problem; Audubon would not leave England without new ones, and the manufacturer said none could be ready before the middle of May.

By then it would be too late to get to Texas in time for the migration. Audubon was worried, too, about what might await them in Florida. The Seminoles had been ordered to move west, beyond the Mississippi. They had answered with a savage attack on settlers, had killed U.S. troops, and were now engaged in a last, furious stand.

Audubon wrote Bachman that he greatly regretted the coming annihilation of the Indians, who had once been the "only Lords of the Land alloted to them by our God!" The good reverend did not share his friend's compassion for the Native Americans. Bachman answered: "Your Indian friends, the cutthroats, have scalped almost every woman and child south of St. Augustine, save those on Key West. They have burnt and plundered every plantation" and, he went on, would "make no bones of scalping an Ornithologist *secundum artem.*"[21]

Johnny probably argued that they could borrow guns when they arrived in America. No doubt he was miserable, and let his father know that he thought the delay unfair. Johnny must have insisted his father write an explanation to Bachman: "In John's Letter to Maria of this day he gives her further explanations than are necessary for me to enter in just now," Audubon began to his friend; "but as we are *fathers* and not precisely *Lovers in facto,* I repeat that I beg of you to represent to our own Dear Daughter to Consider her disappointment at Not meeting with her 'John' as one that is and must be common to all in this our Transient World.—As to My own self I feel most awfully disappointed, but what can I do?"[22]

The plan now had them arriving in New York in September of 1836. To assuage his son's disappointment—and to keep him occupied for the next several months—Audubon sent him and Victor off to the Mediterranean with their sketchpads and a stack of letters of introduction. Their purpose was ostensibly to search out new subscribers, but actually to see a little of the world while they could. In Rome, Charles Bonaparte took them to the opera and showed them around. For a time they considered going to Couëron to see the French relatives on their way back to London, but by mid-June the guns were done. Audubon sent word for his sons to return.[23]

He himself was working feverishly in London to finish as much as he could before leaving for America. He asked Maria Martin for fifteen or twenty drawings of plants and tree branches to be used in some of the smaller plates. He said it didn't matter which plants or trees, as long as they hadn't appeared in the first two volumes. And she needn't worry about how they would be used, he said. Victor would know how to piece them together with the bird drawings Audubon was leaving behind. The race to the finish was on; while he and Johnny were in America, Havell and Victor would be making the final decisions on the plates. If Audubon's drawings had reached new heights of excellence, Havell's artistry had kept pace; he was putting in new backgrounds, removing a bird from one drawing and putting it in another, adding and subtracting elements, and even rearranging, with an adeptness that Audubon depended upon and applauded.

The house on Wimpole Street was a blur of activity, with guests coming and going. Victor, not to be eclipsed in romance by his younger brother, was seeing the opera singer Adelaide Kemble, the younger sister of Fanny Kemble, who had met the Audubons in Boston. Vincent Nolte put in an appearance; he had lost one fortune, but had launched another. On his way to study in Paris, young George Shattuck stopped by for a short reunion with his compatriots of the Labrador adventure, and brought the unhappy news that the Boston edition of the *Ornithological Biography* had been lost in one of the deadly fires that swept through the city.

On August 1, 1836, Audubon and his younger son boarded the packet *Gladiator* with a menagerie of hunting dogs, some Manx cats, and 265 English birds. Audubon could give as well as take; the creatures were gifts for friends and museums. (When they landed in New York thirty-three days later, the dogs had multiplied. But only a few of the birds survived the crossing.)

The Berthoud household was brimming over as usual, but the two Audubons piled in. As Audubon's agent, Nicholas set about helping him add fifteen New York subscribers—one of them his wealthy son-in-law, whom Audubon quickly labeled "a delightful Man." (About him Audubon wrote to Victor: "Mr. Grimshaw wishes his Copy bound With Sheets *uncut* in plain Russia . . . without any gilding except the lettering on the back . . . He is a true connoisseur."[24]) Nicholas had also managed to collect $120 in insurance for folio sheets destroyed by a riot. Hard times had caught up with Berthoud; he knew now what it was to face financial ruin, and it made him more sympathetic to his old friend's early plight—especially since that old friend was now famous, free of debt, and relatively prosperous.

Johnny was for heading directly to Charleston, but that was out of the question for the moment: The city was in the grip of a cholera epidemic, and John Bachman was ill. They would have to wait until cooler weather to proceed to the South. Audubon was troubled as well by news of a flare-up of the Seminole War, in the Floridas. In Texas, General Sam Houston had defeated the Mexican Santa Anna and declared Texas an independent republic. Audubon realized the U.S. government would not be likely to provide an ornithologist artist with transportation to the war zone. Father and son were stuck in the North for the time being, though Audubon wrote to Bachman, "You cannot imagine how hard We both feel it, that we cannot go to Charleston at once, where we know we both could and would enjoy ourselves a thousand times [more] than any where else in America!"[25]

Balancing these setbacks was the truly thrilling news that Nuttall and Townsend's western exploration had turned up scores of new birds—Harlan said a hundred; others thought the total was more like

forty—and that the skins were even then at Philadelphia's Academy of Natural Sciences.

Audubon was beside himself; here were the birds of the West, which he so desperately needed to complete his book with integrity (though of course that would mean producing more than the four hundred folios he had initially promised, which would create other problems). If his was to be the definitive book on American ornithology, as he fervently wished, he simply could not ignore this new wealth of species. If only he could somehow manage to get his hands on the skins to study and draw them, and publish them as an appendix to *The Birds of America!* [26]

Audubon quickly discovered that neither Nuttall nor Townsend had returned, and with the skins at the Academy—which had helped finance the expedition and was the stronghold of his nemesis George Ord—he knew he was in for trouble. A quick trip to Philadelphia, where he stayed with Dr. Harlan, convinced him he was right. He got only a quick glimpse of the collection before the Academy threw up the first roadblock: Audubon would not be allowed to view the skins without Nuttall's personal approval. Fortunately Nuttall had always been friendly, so there was reason to hope.

Audubon rallied his own friends, explaining his dilemma to the loyal Edward Harris, and asking once more for his help. Then he went off to Boston to discuss the burned edition of the *Biography* with Parkman, visit subscribers, and collect three thousand dollars. With the help of some powerful letters of introduction from the likes of long-time admirers Daniel Webster and Edward Everett, he added twelve new names to his subscriber list. Every new subscriber was preceded by several futile attempts. One of these was in Salem, where he had a letter of introduction to a wealthy family of bluebloods. With the kind of humor he needed to get him through these selling forays, he described the first contact: "I called alone on a Miss Sitsby, a beautiful 'blue,' seven or eight seasons beyond her teens, and very wealthy. *Blues* do not knit socks, or put on buttons when needed; they may do for the parlour, but not for the kitchen. Although she had the eyes of a

gazelle, and capital teeth, I soon discovered she would be of no help to me; when I mentioned subscriptions, it seemed to fall on her ears, not with the cadence of the Wood Thrush or Mocking Bird does on mine, but as a shower-bath in cold January. Ornithology seemed to be a thing for which she has no taste; she said, however, 'I will suggest your wish to my father, sir, and give you an answer tomorrow morning.'"[27] He bowed, she curtsied, and so he was summarily dismissed by the young "blue" to whom he had turned out to be simply a salesman, beating the bushes.

Back in Boston and, as always, on the lookout for anyone who could be put to work as a foot soldier in the cause of ornithology, Audubon managed to meet young Thomas Brewer. He was recruited into the small army of naturalists who could supply information and fresh skins.

As luck would have it, Nuttall returned from California while Audubon was still in Boston. He immediately gave Audubon six new species he had with him, and said that "there [were] most positively fully 40 more new ones procured by himself and Townsend on both sides the Rocky Mountains . . . He assures me that they saw many more, among which were 3 species of Jays!"[28] Nuttall gave his permission for Audubon to see the collection in Philadelphia, though there was still a question of whether or not he would be allowed to examine and draw them. Audubon's long, rancorous experience with the Philadelphia Academy crowd had taught him to proceed with care, and he very wisely left the negotiating to his friends.

On October 23, in Philadelphia, Audubon wrote Bachman in high triumph, a letter filled with exclamation points and riddled with superlatives: With the amazing Edward Harris's invaluable help, he had managed to purchase ninety-three bird skins—duplicates of those in the Philadelphia Academy—from Townsend, and all for the bargain price of $184. "Such beauties! such rarities! Such Novelties! Ah my Worthy Friend how we will laugh and talk over them!"[29]

The cholera epidemic had abated, and Charleston was once more open to outsiders. In the beginning of that October 23 letter, Audubon

mentioned that Johnny had gone off to the New Jersey shore with a friend, but was expected back the following evening: "—and *perhaps* I will dispatch John to Charleston at once to see his beloved one!" Before closing, however, Audubon had already reversed himself: "Perhaps I will Keep John until I go along."

Maria would have to wait a bit longer while Johnny and his father stopped in Washington to have dinner with President Jackson, who was soon to be replaced by Martin Van Buren. "We spoke of olden times, and touched very slightly on politics," the carefully apolitical Audubon wrote.

The secretary of the treasury was kind enough to offer the Audubons a ride to Charleston on the cutter *Campbell*, but Audubon declined, explaining to Lucy in his journal, "The vessel is only fifty-five tons; and although Columbus crossed the Atlantic in search of a new world in a barque yet more frail, and although thy husband would go to the world's end after new birds on land, he would not like to go from Baltimore on such a vessel." Rather than risk being seasick, he would take his time, jostling over rough roads and rumbling along on the new railroad. At long last they arrived in Charleston, tired and dirty. It was the middle of November, 1836—two years and eight months since Johnny and Maria had parted. Both men were welcomed with open arms by the gathered Bachmans. It was a sweet homecoming.

Audubon and Johnny and Maria Martin settled down to work in the rooms set aside for them on the first floor. "I opened the box containing Dr. Townsend's precious series of birds," Audubon wrote, "and drew upwards of seventy figures of the species which I had procured at Philadelphia, assisted in the finishing of the plants, branches of trees, and flowers, which accompany these figures by my friend's sister-in-law Miss M. Martin." [30] The three of them plotted out each folio sheet, with Audubon or Johnny first drawing in the birds, and Maria filling in the plants and insects. "The insects she has drawn are perhaps the best I've seen," Audubon wrote Victor. [31]

Nuttall had given Audubon the tiny nest of a rufous humming-bird, along with the twig to which it had been fastened. Audubon drew

in the three small birds; Maria drew the nest, as well as the splashy spider-flower that is central to the drawing.[32] The rest of November and all of December and January were spent laboring over the treasury of skins and sending the drawings to Victor as they were completed. Nine were shipped on December 17, and on February 6 another nine by the *Superb* bound for Liverpool, insured for two thousand dollars.

Audubon was waiting for word on the cutter promised by the government, but the raging Indian war in Florida kept all ships engaged. He was anxious to get on with his western journey—as was Johnny, since it had been decided that he and Maria would marry on his return, and Maria would then go with the Audubons to England. John Bachman, already sad about the prospect of his daughter moving so far away, was in no hurry.

Finally, events began to favor the Audubon expedition. "The Florida War is at last ended," he wrote Lucy and Victor, ". . . they say that Osseloa (the rising Sun) has surrendered with the last 300 warriors under his command." Now he could expect a revenue cutter, and he had heard that an old friend, Napoleon Coste, who had been the pilot of the *Marion* on Audubon's tour of Florida five years before, was already on his way to New Orleans as commander of the cutter *Campbell.* Audubon wrote ahead to ask that he take them along the coast to the Sabine River and upriver into Texas. He planned to set out overland to join the cutter.

Bachman could not go. Audubon wrote: ". . . I would willingly give up one year of my Life *(hereafter)* to have you at my side Just Now."[33] Happily, on February 6, Edward Harris arrived in preparation for the journey and was immediately drawn into the welcoming family. The men managed to get in a deer hunt, and Harris made his first kill. To celebrate, his face was streaked with its blood, according to custom.

On February 17, 1837, in weather cold enough to produce morning ice, Audubon, Johnny, and Harris took the train to Augusta and then crossed Alabama in a coach. There they encountered a "Trail of Tears": expelled from their lands, the Indians were making a forced march to reservations, through swamps that were "shockingly bad,"

cold, and wet. Audubon knew that his friend Bachman had no sympathy for the Indians, but he could not keep himself from describing the awful scene to him. They had come upon a place, he wrote, "where 100 Creek Warriors were confined in Irons, preparatory to leaving for ever the Land of their births!—Some miles onward we overtook about two thousands of these once free owners of the Forest, marching towards this place under an escort of Rangers, and militia mounted Men, destined for distant lands, unknown to them, and where alas, their future and latter days must be spent in the deepest of Sorrows, afliction and perhaps even phisical want—This view produced on my mind an aflicting series of reflections more powerfuly felt than easy of description—the numerous groups of Warriours, of half clad females and of naked babes, trudging through the mire under the residue of their ever scanty stock of Camp furniture and household utensiles—The evident regret expressed in the masked countenances of some and the tears of others—the howlings of their numerous dogs; and the cool demeanour of the chiefs,—all formed such a Picture as I hope I never will again witness."[34]

Along the way they scoured the countryside for birds, and for mammals to be sent back to Bachman for the next great project. At Pensacola, one Commodore Dallas "received Friend Harris and I *quite well*" and promised to help them get a cutter for their scientific explorations. (He also gave them some "Copenhagen *snuff* that would make your nostrils expands with pleasure, and draw tears from your eyes—the stuff is so very potent.") At New Orleans, they headed for the house of Johnny's cousin Mary Berthoud Grimshaw, where they were made "snug and comfortable." The city itself had grown so large and was so much improved that "I can scarcely recognize one street from another." Sadly, most of their old friends, including young Mrs. Brand, were dead now, victims of the city's deadly fevers.

It was the first of April before the *Campbell* managed to leave New Orleans. They traveled through the Southwest Pass from the Mississippi River into the Gulf of Mexico, where they were joined by the schooner *Crusader*, which would act as their tender. Napoleon Coste,

Audubon wrote, was "full of the expedition." They took with them provisions for two months, enough to get them to Galveston and back.

By early April, as the *Campbell* skirted the marshes along the Louisiana coast, the skies were filled with migrating birds, moving north to their breeding grounds. Day after day, as the cutter's log noted, "Mr. Audubon & Company on shore shooting." Here was Audubon's chance to get the specimens he needed for study; the three hunters, sometimes with Napoleon Coste along, brought down hundreds of birds. The sandy islands that dotted the coast were alive with shorebirds and land migrants; Edward Harris counted 104 species shot in three days. In three days at a sugar-cane plantation, the bird collectors found ninety-seven different birds.[35]

For April 25, the logbook of the *Campbell* reads: "At 2 PM made Galviston Island. At 4 crossed the bar & anchored in the harbor in 4 fathoms water. At sunrise fired a Salute of 24 guns in Honor of the Texian Government. Was returned by the fort at Galviston. Also by the Texian Man of War Schnr Invincible. Mr. Audubon & Company on Shore Shooting."[36] Audubon went ashore and found Galveston to be miserable, full of poor Mexican prisoners and a population "both indolent and reckless."

Audubon was feeling the heat and the discomfort, not to mention the fatigue caused by plodding through mud in mosquito-infested marshes. His legs swelled "until they were purple," keeping him at times on board while Harris and Johnny went ashore to search out birds and mammals.

After scouring the area around Galveston for several weeks, they boarded the small tender *Crusader* to make their way up Buffalo Bayou to Houston, where the fabled Sam Houston, president of the new republic, was in residence. Audubon knew he was witnessing history.

The "city" was hardly impressive, with "houses half finished, and most of them without roofs" and only a liberty pole and a sorry-looking capitol to mark it as a place of importance. It had been raining hard, and the streets were so swamped that as they crossed to the "President's mansion" they were up to their ankles in water. "This abode of

President Houston is a small loghouse, consisting of two rooms, and a passage through, after the Southern fashion . . . The ground floor, however, was muddy and filthy, a large fire was burning, a small table covered with paper and writing materials was in the center, camp-beds, trunks, and different materials were strewn around the room. We were at once presented to several members of the Cabinet, some of whom bore the stamp of men of intellectual ability, simple though bold, in their general appearance." Soon enough President Houston received them. "He is upwards of six feet high and strong in proportion. But I observed a scowl in the expression of his eyes that was forbidding and disagreeable." Dressed in velvet and lace, Sam Houston received them hospitably in his inner chamber—which was not much better than the outer, Audubon noted—and, after a polite exchange, they were on their way.[37]

He had hoped to sail back to Charleston around the Florida peninsula, but that was not possible. Harris took a steamboat up the Mississippi, while Johnny and his father headed back through Mobile and Augusta, hating each oppressive mile of the way. By the time they reached Charleston Audubon was fifteen pounds lighter and completely exhausted.

No new birds had been found, but they had kegs full of specimens pickled in rum, plenty of skins, and a good deal of information. Most of all, he had been out in the field, exploring new country, reinforcing his reputation for having "drawn from nature." As he wrote Thomas Brewer: "There is, after all, nothing like seeing things or countries to enable one to judge of their peculiarities, and I now feel satisfied that through the want of these means many erroneous notions remain in scientific works that can not otherwise be eradicated. We found not one new species, but the mass of observations that we have gathered . . . had, I think, never been surpassed."[38]

Maria and Johnny, who had waited so patiently, were finally allowed to marry that May of 1837. It was a joyful occasion, binding the two families by marriage, but the Bachmans were saddened, too, at saying good-bye to their eldest and seeing her off on such a long voyage. The

three stopped at Washington to meet the new president (and learn that there was "some *talk* of a National Museum"). Then Audubon headed for Harris's home in Moorestown, New Jersey, while Johnny and Maria went to Niagara Falls on a honeymoon trip. They planned to meet in New York, and they would sail for England on July 17.

Maria proved a fresh breeze to her doting father-in-law. "Never in my Whole Life have I enjoyed travelling so much as I have with My beloved Daughter," he wrote her family. "Everything has been new to her senses—Hills and Dales—Trees & fruits, Bridges, Rail Carrs, and Highly fashionable Circles have danced before her alternately like so many novelties of nature and of the World, and her own descriptions of the feelings which have accompanied these transitions are so simple and meantime so truly Poetical and Just, that I have envied her situation a thousand times!" This letter was in large part to let the parents know that their daughter was happy and that he would take good care of her.

His ménage was growing; the family numbered five now. Victor would be next, though the affair with Adelaide Kemble had ended. Money was needed, money must be had—and at that moment in America, the economy was once again in convulsion. The times "were hard past reckoning," said Audubon. All of the Bakewell brothers and brothers-in-law were in trouble, except for Lucy's husband. In Cincinnati, Thomas had failed once again; in Louisville, Billy was barely hanging on. Alexander Gordon was close to bankruptcy. Nicholas Berthoud, who was in business with Gordon, was struggling as well. Nicholas assured Audubon he would be able to ride out the storm; Audubon need not worry about the money left in Berthoud's care.

Although Audubon had some difficulty, given the hard times, in making collections, he was able to take back with him a sum equal to £1,106, and to leave with Nicholas, acting as his agent, more than nine thousand dollars. Along with the collections to be made, this was more than enough to buy them a house when they returned for good in two years, if everything went as planned.

Before leaving, Audubon had the exquisite pleasure of hearing Berthoud tell him how much he envied him as "the Happiest

of Men—Free of debts, and having *available funds* and *Talents!*" [39]
Lucy's family was eating a little crow, and Audubon couldn't help but
enjoy it.

Maria and Johnny returned from Niagara "as Happy as if Angels
in heaven." On the seventeenth they boarded the splendid ship *Eng-
land,* on which, for $350, Audubon had reserved a room amidships for
the newlyweds, and a large stateroom for himself. They were carrying
ice enough for the whole journey, and "Sweet Daughter is tickled at
the Idea of Ice Cream and other good things . . . on board!" Maria's
high spirits, and Johnny's delight with his young wife, were infectious.
For once, Audubon was not plagued with morbid thoughts of death
at sea. As if in reward, calm seas went with them, and on August 5 the
three landed safely in Liverpool.

18

After all, I long to be in America again, nay,

if can go home to return no more to Europe,

it seems to me that I shall ever enjoy

more peace of mind, & even Physical comfort than I

can meet with in any portion

of the world beside.[1]

SUDDENLY EVERYTHING WAS GAY. LONDON was a whole new world for the vivacious Maria, and the Audubons set about showing it to her; her exuberant father-in-law watched in delight as her "mind and eyes filled with wonder." As soon as the papers announced the arrival of the Great Naturalist with his son and new daughter-in-law, friends began to call and invitations to arrive. A week after their return Audubon duly reported to Maria's father: "We have dined out twice, shewn her many a wonderful object, and even this morning took to the St. James Park, to View the Queen Palace and list to some exquisit Martial Music.—at 5 this afternoon we are going to Mr. Gordon to Dine, and afterwards to View . . . the Zoological Gardens."[2]

Maria wrote home: "My lucky star seems to shine brilliantly over me, for though separated for a time from so many dear friends, I am now surrounded by many who use all their endeavours to make me

happy and comfortable."[3] Her father responded with a gentle reproach, wondering why she had so much to say about plays and operas and dinner parties, and nothing at all about going to church.[4]

There were tense undercurrents. Soon after their return, Victor went off by himself to the seashore. This gave him a respite after a year of tending to business; perhaps he was also coming to terms with his younger brother's marriage to a charming nineteen-year-old. The boys were chafing to get on with their own lives, to take control, to be their own men.

Their father gave them responsibility, but never control. He checked on them, praised them lavishly when they did well, and chided them when they made mistakes. He was a good father, a loving father, but he would not let go. Audubon had always believed that theirs should be a family enterprise, that their futures should be inextricably tied to his. One thing was obvious: The money that supported all of them came primarily from his labors.

Johnny, at least, could pursue his portrait painting independently. He took a studio nearby. One of his first subjects was his new wife, her eyes steady and loving. He did two portraits of Maria; she sent the better one home to Charleston, writing to her Aunt Maria: "Dear Johnny sends a portrait of myself, which I hope you will all like on the other side of the water as much as we do on this. Many of our friends have seen it and . . . all agree in saying that it is the best and most finished head he has yet done."[5]

England was awash in bird books that year. John Gould, the one prolific ornithological artist whose books had made him rich, had finished yet another, *Birds of Europe*, and was about to begin *Birds of Australia*. (Audubon was understandably envious of Gould's financial success, and probably of the fact that Gould's very able engraver was also his wife.) Swainson had brought out what Audubon called "his incomprehensible Works," and there were, Audubon wrote, "about one thousand other niny tiny Works . . . in progress to assist in the mass of confusion already scattered over the World." Even MacGillivray had managed to publish the first volume of his British ornithology, which

he dedicated to Audubon. One reviewer said MacGillivray's writing style aped those of Izaak Walton and Audubon, "which being extremely peculiar, can only be relished in the Originals."[6]

The one thing nagging at the back of Audubon's mind was all the new birds Townsend was said to be bringing with him when he finally returned from the Far West. If he had forty new species, as he claimed, Audubon would need to represent them in some way, or his work would be out of date even as it came off the press.

There was reason to doubt the number of new birds Townsend said he had found. When Audubon had a chance to study the glorious cache of bird skins he had bought with such excitement in Philadelphia, he discovered there were only eight new birds, not the forty claimed. Some of the birds had, in fact, been named in the eighteenth century. Yet Nuttall and Townsend continued to claim amazing numbers of new birds; Audubon was skeptical but the West was vast, and he could not afford to dismiss Townsend's boast, not until he had a chance to see the skins for himself.

Meanwhile, life on Wimpole Street continued to be sparked by the young generation. Lucy was often ill and took to her bed, and the family rallied round, caring for her so well that she couldn't praise them enough. With his close family nearby, Audubon wrote primarily to Bachman. He discussed everything with him, often in a light and teasing tone that reflected Bachman's own witty, literate letters. When Bachman took Audubon to task for writing letters to Maria Martin that were too effusive, Audubon shot back, "I cannot think what you have to do with them—and I can assure you that I will continue to speak to her, to Kiss her, and to Love her as far as she may permit me to do without ever troubling myself as regards your thought on the subject." It did not seem to occur to Audubon that Maria Martin might be embarrassed by his endearments, probably because Bachman himself was capable of similar nonchalance, closing one letter to Audubon with: "Our Sweet-heart has grown fat hearty & saucy—she now says, she dislikes all old men that they are cross & take snuff—still I flatter myself she gives me the preference."[7]

Audubon's easy writing style offers tantalizing glimpses of life in the Audubon household: "Maria & John have gone to St. James' Theatre this evening. Lucy is Knitting across the round table—Victor is reading the last received number of 'Pickwick' and as you see I am driving a good old iron pen." In the middle of one letter, he described an interruption caused by a stray cat and Maria's pet bird, a grosbeak. "We heard a crash in the Dining room below . . ." Audubon wrote. Lucy went to see what had happened and found that a cat had knocked over the bird's cage. She cried the alarm, the men grabbed pokers, and the chase was on. The cat fled into the basement kitchen, the men in hot pursuit: "Doors all to in a crack.—Pussy like all other sinners much discomfitured—Under the tables, up towards the Windows—Would not do." Finally one of them grabbed the cat and threw it out onto the street. The story ended with Audubon declaring he had "passed a resolution that no cat shall poach on our grounds."[8]

Lucy continued to be ill, on and off, with nonspecific pains and weaknesses. Benjamin Phillips became both family doctor and confidant. During Audubon's absence he stopped by most days to check on Lucy; he refused all payment, which pleased Lucy's husband no end. (In thanks, Audubon had brought the good doctor's wife an elegant silk shawl from America.) Phillips was a zoologist and a member of the Royal Society; he fit perfectly into the Audubon set.

Autumn merged into winter; letters went out begging Bachman to "forward me in Rum one or more Flamingoes . . . Can you not procure a *Wood Ibis* in Rum?" In answer, letters arrived, packed with information, along with kegs of birds pickled in rum or whiskey. By the end of October, four hundred plates had been engraved. The end, however, eluded them. There were birds yet to be drawn; Audubon thought that twenty-five more plates should do it. His subscribers were grumbling; he was trying their patience and their pocketbooks.

Audubon realized he would have to crowd more species onto a plate than he liked, but the alternative was to leave them out altogether,

which was unthinkable. In fact, he was waiting for Townsend's birds. He wanted to complete the work, Havell wanted it done, and so did the subscribers—but Audubon couldn't let it go. Now he thought it should be finished by March.

He was distracted, and felt vaguely troubled, by a visit from Charles Bonaparte. His old friend had published a book on the birds of Mexico, and was turning once more to the birds of North America. His work was presented as a continuation and updating of Alexander Wilson's book. Audubon wrote Bachman, "He opened his eyes when he saw all our new species, and complimented me highly on my *Industry* and *perseverance.*" He added naïvely, "He Kissed me as if a Brother, and I really believe that he is My Friend."[9] Audubon was still in awe of the nephew of Napoleon, the Prince of Canino and Musignano. Bonaparte offered his six or seven new species in exchange for Audubon's new birds and information, and gave his word not to publish before him. Audubon agreed.

Over a matter of a month, Bonaparte appeared time and again, asking questions, taking notes, always probing for information. One evening he showed up after Audubon had gone to bed, woke him without ceremony, and sat by his bed for more than an hour, quizzing him. And "he is almost constantly with Gould, at the Zoological museum and Indeed every where, where there are bird Skins. Me thinks that he is over anxious to *pump me,*" Audubon told Bachman. Having grown suspicious of a man who would lean so heavily on the work of others, Audubon refused to give Bonaparte the information he wanted on the geographical distribution of birds and their migratory patterns. A few days later, Audubon declared, "Bonaparte is gone at last, and I am much relieved, for the days are very short and I have a great deal to do."[10]

In the last days of 1837, Audubon received a letter from Harris reporting that Townsend had returned to Philadelphia with twenty new species of birds. Good friend that he was, Harris bought duplicate skins for Audubon; he hoped to ship them on December 20. Audubon was beside himself. There was time yet. "Should the Birds come in time

I will of course publish the whole of the new species, and my Work will be *the* Work indeed!" he crowed to Bachman.

It seemed too good to be true, and it was. Initially, Townsend had planned to send a good part of the collection to Audubon, allowing him to buy what he wanted in exchange for selling the rest for him in England, where the skins were likely to bring a good price. Audubon readily agreed, and promised to credit Townsend along with Nuttall in the *Ornithological Biography.*

But upon his return from his long journey west, Townsend was deeply in debt. Pressed by creditors, and wanting to prevent the valuable skins from being seized and sold to pay his debts, he turned all of them over to the Philadelphia Academy.[11] He did not intend to deprive Audubon of the skins; Harris would just have to buy them from the Academy.

But in Philadelphia things were never quite simple where Audubon was concerned. Soon enough the "Philadelphia Sharks," as he called them, were flashing their teeth. George Ord saw no reason why Audubon should be given such an advantage. Why should the Academy allow him, and not someone else, to announce these new species to the world? Perhaps Townsend himself, or Bonaparte, should do so. Ord had to know that Townsend had no plans to publish any more than a small, cheap book on his journey, and that Bonaparte's book was already in press.

Audubon fumed. "If I do not figure the new species of Townsend, no one else will," he wrote Harris, "for it would not pay any one but me, and the Skins would be suffered to rot in the Public Institutions of Phila."[12]

He urged Harris to get a complete list of all the birds Townsend had observed on his western journey. "I want the dates, the names of Places, if few or abundant, if Periodical, accidental visitors, or permanently settled species." He also wanted every measurement Townsend had taken, every bit of information on habits and changes of plumage, any eggs, and permission to publish. Townsend would, of course, receive credit. If Townsend put his mind to it, he could do this work in two or three days, Audubon thought.

Havell was almost as exasperated with the delay, since work had come to a halt as they waited for the Townsend skins. Audubon wasn't sure how long he could hold his engraver off.

There were plenty of distractions in the busy household. The Philadelphia portrait painter Thomas Sully arrived in London with his daughter, Blanche; they became frequent guests at the Audubon house, where the boys and Maria made for lively company. Blanche wrote home about one evening at the Audubons': "All adjourned to the dining room where we spent the evening most merrily. I don't think I laughed so much as I did last night since we left home. At 10 P.M. Father called for me." Victor showed her around London, managing to provide her with a view from a friend's window of one of the many processions that marked the coronation of Queen Victoria. Father and daughter were to be in London for several months, while Thomas Sully painted the young queen's portrait. (Victoria suggested that when her head was drawn, Blanche should don her finery to pose for the figure.[13])

The young Queen Victoria was not the only one posing for portraits that spring. One of Sully's American students was so persistent that Audubon agreed to pose for him—but only in the evenings, by gaslight: He was not willing to sacrifice the daylight he needed for his own art. Getting a figure of such prominence to pose was considered a coup, as it would be for photographers in ten years' time.

Back in Philadelphia Harris had managed to work his usual magic, and with Townsend's help overcame the Ord-led resistance at the Philadelphia Academy. Townsend's bird skins were now in Audubon's hands, and he gave them his full attention. By mid-April he had finished a hundred new drawings, crowding several species together on a single plate and all but dispensing with the beautiful botanical drawings and backgrounds. The drawing for plate 424, for example, was crammed with seven birds representing six species. At this point, Audubon was in such a mad rush that he only penciled in the branch that supported all those birds, and painted only two of the finches, leaving the rest in pencil for Havell and his colorers to complete. Other

drawings had no backgrounds at all, but only birds perched in midair; Havell would complete them as well. The *Birds of America* was more of an artistic collaboration than anyone knew.[14]

Now Audubon was working almost entirely from skins and others' observations. He had harangued everyone he knew in the American South to ship him a flamingo in a barrel of rum, and finally some-one did. The spectacular bird, if drawn life-size, required a whole folio page, and even then it had to be depicted with its long neck curved to the ground. Havell added a simple background of mudflats and eight flamingoes in the distance. Now it seemed certain that they would make a June deadline.

In the midst of this frenzy of work Bonaparte's book came out. The prince had published all of the new material in spite of his promise not to do so. Audubon was so enraged that he declared Bonaparte persona non grata, and gave strict orders that he was not to receive the rest of the *Birds*. (This was not a great financial loss, since Bonaparte's pay-ments had always been difficult to collect.) "So much for a *Prince!*" he wrote Bachman.

Bachman and Audubon were about to become grandfathers. When Maria's baby was born that summer, they would be joined by blood, a fact which both noted with humor and pleasure. The two families were now inextricably bound, with the Bakewells on the periphery. After Alexander Gordon had paid a visit to Bachman in Charleston, Audu-bon felt comfortable asking his friend, "Tell me what do you think of that Gentleman—he is somewhat learned and Keen, and May be a Friend besides." "Somewhat" and "May": Audubon could forgive, but not forget, that Gordon had been less than helpful to him in the years of his need.

Early in June of 1838, Audubon took a drawing of two dippers to Havell; it was the last plate, number 435. On June 11, London was preoc-cupied with another event in the continuing pageant celebrating Victoria's coronation. Two days later, Maria gave birth to a baby girl, named Lucy for her paternal grandmother. It was, it seemed, a month for grand occa-sions and milestones. On the twentieth, Havell pulled the last engraving.

Now Audubon could turn his attention entirely to the *Ornithological Biography;* soon he was on his way to Edinburgh, to help MacGillivray piece together and expand the sparse information he was able to get from Nuttall and Townsend.

That summer John Bachman's congregation granted him a leave of absence to travel to Europe for six months. His health had not been good; he thought a sea voyage and the distraction of travel might be just what he needed. His destination was Germany, where he would speak to a gathering of naturalists, but his first and most important stop was England.

Traveling with him was fourteen-year-old Christopher Happoldt, a young member of his church, who would act as companion and general factotum. To ward off boredom, the boy kept a journal. His entry for Saturday, June 9, began: "Seasick." Even so, when somebody called out "Dolphin!" he could not resist getting up to see it. But the captain ordered his men to catch the dolphin; Christopher wrote: "Man is a distructful animal & is not long satisfyed with feasting his eyes on an interesting object, before he is determined to have it, dead or alive." [15] He was a boy after Audubon's heart. Audubon's feelings would not have kept him from eating the dolphin's roe, and neither did Christopher's; he found it "certainly very fine."

On July 5, at eight in the evening, they arrived at 4 Wimpole Street. John Bachman embraced Maria and got his first glimpse of baby Lucy. The family had already dined, but they found something for Bachman and young Christopher to eat, then tucked them in for a good night's rest. Bachman stayed only two days before taking a steamer to Edinburgh to see his old friend. Victor went with him but, given the choice, young Christopher elected to stay behind in London with the Audubons. Lucy was kind to him, and young Mr. John—Maria being occupied with the baby—was pleased to show him around. There was plenty of sightseeing in London to keep a boy busy. [16]

Christopher noted the routine of the house. "The dinner hour at Mrs. Audubon's is 5 OC; and very often as soon as we get up from

dinner, tea is ready which is only 7 OC P.M. The English are great wine bibbers, & never set down to dinner without a decanter of wine."

Bachman was to return in ten days, but extended his stay in Edinburgh to three weeks. Victor wrote home that the weather was cold, wet, and raw, that they had found lodgings for Bachman within a hundred feet of theirs, that he took his meals with them, and that Victor had been put to work at once reading proofs. "How does sister and the *chicken?*" he wrote teasingly. The baby was called "the little Cherub" and other endearing terms by the members of the family, all of whom had, as Lucy put it, made quite a pet of the babe.

The two old friends fell in together as if they had never been apart; they spent their days talking birds and mammals, walking all about Edinburgh. Afterward, Audubon wrote: "The days which we enjoyed together were few, but delightful; and when . . . my friend left us, I felt as if almost alone, and in the wilderness."[17]

Below the surface, a debate about Johnny's future preoccupied the family. Audubon was working so hard in Edinburgh that he scarcely took time out to answer letters, but on August 1 he felt compelled to write Lucy: "The reasons for this writing now is urged by the contents of our Dear John's Two last letters in which he mentions his wish to go to America at once. I hope that nothing whatever on our parts have brought this notion into his head, for he must be well satisfied that we are not tired of him or of our Dearest Maria. I think that perhaps the Idea of returning to America so unexpectedly as it were may have had a tendency to render her low of spirits just now, as thou speaks of this in rather significant words. Victor and I have thought that John would do better to remain about one Year longer in Europe, be it in France or *here* with us all or at all events until we all go back to America together, so by doing that he will become better master of his Art and enter on his career as a Portrait Painter . . . If him and Maria have the wish to go to Paris, well and good, give them the money and tell them to be careful and not extravagant—he may then derive great benefits by studying under good masters or copying first rate pictures, all of which he can easily procure access to in that country."[18]

Having said that, Audubon added that if they should choose to come to Edinburgh instead, there was plenty for Johnny to paint, and they could have the pleasure of all being together. It does not seem to have occurred to him that Johnny and Maria might want to be on their own.

Havell, with Victor's help, was delivering the outstanding folios and packing the plates and the originals for their journey back to America. The time when lapsed subscribers could complete their sets was over. Anyone who waited to purchase the *Birds*, thinking the price would go down, was out of luck. Several extra sets were pulled and colored, but they would be sold at full price.

It was time to make plans to go home; the boys were chafing at the bit, eager to get back to America and get on with their own lives. Audubon had one more volume of the *Biography* to write, and a synopsis.

Lucy packed their books and the accumulation of things they had collected during their years in Wimpole Street, and on August 8, a Wednesday, all of them—Johnny, Maria, and little Lucy included—left for Edinburgh. Perhaps Bachman had influenced the young couple; whatever the reason, the family would remain together, at least for the time being.

Bachman and Christopher moved into rooms at Leicester Square, near the Zoological Society of London, where Bachman would present a paper on the species of squirrels in North America. One of the species described by Bachman was named *Sciurus Auduboni* for John Woodhouse Audubon, who had found the specimen "at New Orleans on the 24th of March, 1837."[19] Bachman also gave the Society nine mammal skins.[20] His reputation as a mammologist among men of science was flourishing. His work at the Zoological Society complete, the older man and his young companion proceeded to Hamburg. Audubon wrote to ask, "Pray is my name Known in Germany???"

In September 1838, with the fourth volume of the *Biography* almost finished, Audubon took the family on a week's vacation in the Scottish Highlands. Maria, three-month-old Lucy, and Betzy went along. Then they all returned to a house on Alva Street, to finish what the father had started twelve years before.

During this time, Lucy wrote a somewhat complaining letter to her rich cousin Euphemia Gifford, explaining that her sons were doing as well as could be expected, "under their unsettled circumstances." They had moved to Edinburgh because it was less expensive, and they would be returning to the United States for the same reason. "My brothers," she wrote, "have had some pecuniary difficulties to contend with, but they have happily none of them had the trials we endured for about fifteen years." The old animosities were there, always. Though Audubon was financially secure—and famous—Lucy could not forget that her family had turned their backs on him and made her life miserable.

Audubon expected to finish the fifth, and last, volume of *Biography* and the synopsis by the spring of 1839. Victor would return to America early, to take care of business there and to scout out the best place for the family to settle. New York, Boston, Baltimore, and Philadelphia were in contention.

Late in October, Victor was sent south to London, making collections along the way. The plan was that he would sail for home six months or more in advance of the others. He just missed seeing Bachman, who had returned to London for a few days on his way back to Charleston. Audubon wrote a quick letter to Bachman in Liverpool, hoping it would reach him before he sailed. "We are all well just now, the Babe is grown very fat and lively, and my beloved Wife is certainly much better than she was last year . . . I hope . . . that on the first of May next, we will all go back to America, there to stay to the last days of our Lifes!"

Early in the new Year, 1839, Victor sailed for America. Now Audubon had to handle all of the business details, as well as finish writing the *Biography* and synopsis. By the middle of March, Havell had shipped the last number to the last subscriber. Audubon fretted over details: Had Euphemia Gifford's bankers paid the sixty pounds owed for her subscription? Had Havell remembered to pay for the insurance that would cover the copperplates? Would Havell please be more diligent in watching over the men employed to do the packing, because some had made gross mistakes? (A piece of beef was found stuck between folio sheets sent to Lord Kinnoul, and he had not been amused.)

When Audubon started, he had counted on finding two hundred subscribers. There had never been more than 175, but no one could be certain how many folio sheets had been pulled. Many subscribers had stopped along the way, others had been picked up, and many had received certain numbers but not all. It was all so confusing, and the records were so complex, that Audubon had long since lost track.

The *Birds* had given the Audubons an adequate, even comfortable, living, though Lucy fretted continually about their "pecuniary" situation. She had been scarred by want; in her mind, there was never enough money. Her husband was more confident in his approach to finances. Even now, Audubon was haggling with Havell to allow him to pay for the extra sets after he arrived in America. Havell resisted. He was taking his family to America and needed the money to make travel plans. In the end, he had no choice but to wait to collect until they were both in the United States.

In New York, Victor went about his father's business, then accepted John Bachman's invitation to come to Charleston for a visit. Victor was welcomed into the Bachman household like a member of the family. He moved to make the attachment even stronger by promptly falling in love with the Bachmans' second daughter, Eliza.

Victor had been assigned to consider where they might settle; not surprisingly, he decided they should all spend the winter in Charleston. On June 30, Lucy detected in her son's letter, written as he left Charleston, "a little depression of spirits." She assured him that many years of happiness lay ahead of them all. "Thy plan, as Papa agrees, of all going to Charleston for the Winter to be confined, to be *married*, to draw and write about quadrupeds and consider where our permanent abode should be, is a good one provided you find a roof to shelter us."[21] She did not intend to spend another winter in the clamorous Bachman household, where she had to share her husband's attentions with so many others. Nor did she wish to spend more than a night or two in the equally active Berthoud home, crowded with Eliza's large clan.

Johnny, Maria, the baby, and a nurse had been dispatched to France, and planned to come home separately. Maria was pregnant

again, and was to give birth that fall. Still, she did not want to miss Paris. "You seem surprised we sent on the young ones," Lucy wrote Victor, "but it was as Mr. Phillips said high time!" She ended the letter with, "Last night the Synopsis was done!"[22]

After thirteen long, arduous, and enormously productive years, Audubon at last was going home to stay. As if to signal the end of an era, the elder Mrs. Rathbone of Green Bank, whom he had affectionately dubbed the Queen Bee in his first, lonely months in England, died in the weeks before their departure.

Lucy and John Audubon boarded the packet *George Washington* on July 25, 1839. It would be John Audubon's last Atlantic crossing. He looked at Lucy, and at himself, and saw the toll time had taken. He was fifty-four, she two years younger, but their faces were lined, and he felt the approach of old age. By September 2, they were in New York.

<hr />

A WRITER FOR THE *North America Review* remarked,

It must have been with mingled and varied feelings that Audubon published his concluding volume. He was sure then that he had raised an imperishable monument to commemorate his own renown. All anxieties and fears which overshadowed his work in its beginning had passed away. The prophecies of kind but overprudent friends, who did not understand his self-sustaining energy, had proved untrue; the malicious hope of his enemies, for even the gentle lover of nature has enemies, had been disappointed; he had secured a commanding place in the respect and gratitude of men; he had secured a treasure of rich and glowing recollections, to warm his own heart in his declining years, and to kindle enthusiasm in his children's children. . . .

On the other hand he had lost an employment which for years had kept all the powers of body and mind in healthy though intense exertion; whatever else he might do, the great work of his intellectual life was finished . . .

His trumpet of victory at the result must have given an uncertain sound,
partly exulting in his success, and partly lamenting that his great work
was finished.[23]

The writer was, in part, wrong. The double-elephant folio of *The*
Birds of America, and the *Ornithological Biography,* were finished, but
the work was far from done. There was the small edition of the *Birds*
to bring out, as quickly as possible, and he planned to collaborate with
Bachman on *The Viviparous Quadrupeds of North America.*

They would not be going to Charleston for the winter: New York
was central to the work to be done and Audubon decided they must
settle there. Maria would not go home to have her baby, the family
would not be in Charleston to witness the wedding of Victor and Eliza,
and work on the *Quadrupeds* would have to wait until after the small
edition of the *Birds* could be launched. When Johnny, Maria, and the
baby arrived from France, the family settled into a house on White
Street big enough for all of them. Within a few weeks, Havell, his wife,
and their daughter arrived; they stayed with the Audubons for a short
time and eventually settled in the Hudson River Valley.

That fall Maria gave birth to a second daughter, named Harriet
for her maternal grandmother. Soon after, Victor got word that Eliza
was seriously ill, and set out in a panic for Charleston. On November
24, not long after his departure, Audubon wrote his son a letter spill-
ing over with distress and exasperation: "We here have been Kept on
Thorns until this morning when we had the fortune of receiving a let-
ter from our beloved friend Miss Martin, which has relieved us of all
further apprehensions connected with the attack of Dear Eliza; but you
may Judge of our situation for *Three Days* after your departure from
us when you Know that not one line came to us from Charleston, at
a period when we *ought* to have had *Three letters* in the mean time.
This extraordinary negligence, and the Knowledge of the Mental Suf-
ferings you must have endured during every moment of your hurried
and uncomfortable Journey disturbed our own minds day and Night
until this morning."

That dressing-down completed, Audubon turned to business. Maria Martin had let it slip that Victor was expected to spend the winter in Charleston, probably to spare the ailing twenty-year-old Eliza the rigors of a New York winter. Audubon, alarmed, reacted vehemently: "Since you left us I have been Stil more busy than ever, for now I have to perform all outward and inhome labour, John being constantly well employed at his Eazel." For Victor to spend the winter in Charleston was out of the question: "Now Such an event would prove far from pleasant to me, as I will in all probability be necessitate to travel during the greater part of this Winter, leaving Mamma and Maria under the Sole charge of John, who with his present work, and the appearance of more in Store for him could scarcely manage our other affairs besides.—That you Should remain a few Weeks at Charleston we would not object."

The Audubons had to know that the Bachmans did not want their daughter to leave. As a young man, Bachman had suffered from consumption; the family feared for Eliza, and wanted to care for her at home. In a postscript, Lucy added her voice to her husband's. Victor and Eliza should come along home "as we shall do badly without you . . . We have been terribly racked by the Silence of all at Charleston." She said she had to smile at Maria Martin's desire to keep Eliza near her, as if the Audubons couldn't offer "the best of medical aid and fine warm house." Lucy expressed sympathy for Mrs. Bachman, who would be parting with another child, but then pointed out rather insensitively that she still had plenty of daughters at home. Victor was to "write and write point blank and plain" what his own feelings were.

A spirited and determined Eliza Bachman got up from her sickbed to marry Victor, and then he bundled her up and brought her back to New York, as his father had all but demanded.

Audubon had not exaggerated the amount of work to be done. Bad economic times had cost them half their British subscribers by the time the double-elephant folio was done; now they must find another steady source of income. They were convinced that a miniature—a royal octavo—with material from the *Ornithological Biography* inter-

spersed would pay handsomely. After a thorough search, they had se-
lected a Philadelphia lithographer, J. T. Bowen. Johnny was already
busy with the camera lucida, reducing the bird figures to fit the smaller
format. Audubon was hastily adding birds that had been left out of
the large work and correcting errors that had come to light after pub-
lication. He and Johnny lost no time; the first numbers were in their
hands early in 1840. To try to stimulate sales, Audubon rented rooms
at the Lyceum on Broadway for a show of the original drawings. Ad-
mission was twenty-five cents; he lost fifty-five dollars and gave up on
exhibits forever, remarking sarcastically, "If I had an extra hog to show
and should place him in a large room on an elevated pedestal, with a
comfortable bed of straw, I could draw thousands from far and near."

Yet America was producing wealthy men and women who as-
pired to taste and learning, who were acquiring libraries and could
be counted on to buy the smaller book for a hundred dollars. (Most
books of the time sold for two dollars.)

Audubon already knew many of these people, and could easily get
introductions to the others. Victor thought his father's looks and repu-
tation alone would get them the subscribers they needed. Audubon
knew better. He was certain that the best plan was to get an influential
man in each town to make the rounds with him, house to house, to
sell the octavo. At the same time, he needed to make final collections
for the double-elephant folio, and to sell the two copies that were left.

Bachman had urged him to collect specimens for the *Quadrupeds;*
Audubon was just as interested in collecting subscriptions. He had
learned the hard way what it took to make a living from subscription
publishing. No matter how fine the product, it could never be success-
ful without dependable subscribers. His work was cut out for him: He
must sell, sell, sell. Early in December he was on the road again.

From Boston he wrote Bachman, with more pomp and flourish
than was usual between the two: "I wish to congratulate you as I con-
gratulate myself on the happy event which has taken place under your
roof last Wednesday last; when you acquired a second son and Valuable
friend, and myself a beloved and most Welcome second Daughter to

my heart's wishes.—Our Children though poor, will I feel assured be for ever happy, in as much as they are the possessors of most excellent hearts, and those Honorable principles which ever tend to augment the felicities of a married Life, unconnected with the pomp and grandeur of the World according to the common acceptance of these Words."[24]

His old friend was having none of this. On Christmas Eve Bachman replied: "Your congratulations about this double union in our families are all right and proper, no doubt—nor ought I to be so selfish as to wish to retain my children around me when their happiness requires a removal. But somehow the event which gives you so much pleasure has had a contrary effect on me, and I have on these two occasions looked forward to these happy events very much as a man to a funeral. I was glad, when Eliza left, that I was compelled to be absent and obliged to be preaching incessantly, twice a day, for a fortnight . . . When I came home, however, the holidays had scattered the rest of my little flock, and Jane and Catherine only were left. I was so lonely that my dyspepsia has given me strong warning of another social visit. So it is, and I cannot help it. The girls have good husbands who, I am sure, will take care of them, but to me I feel it to be a very great loss. However, I will try to put up with it as well as I can, and not complain about it, unless others wish me a joy which I do not feel and which I would be a hypocrite to acknowledge."[25]

From the moment that Eliza arrived in New York and regained her health, she delighted her father-in-law. "Rosy" was bright and spirited, and enlivened the household with her laughter and charm.

Audubon's first sweep through New England had garnered ninety-six subscribers for the octavo *Birds,* forty-one from the village of New Bedford alone. He now had a total of 160. New York, with Berthoud's active help, was proving a gold mine. The octavo, it seemed certain, would provide a good living for the expanding Audubon household—perhaps even make them wealthy. He admitted to Bachman that selling was a kind of purgatory, but that the more he did it the easier it became. (Indeed, five months after the Audubons' return from England, five octavo numbers were out and there were three hundred subscribers.)

After repeated contacts, he managed to sell one of the last full copies of the double-elephant folio and the *Ornithological Biography* to John Jacob Astor for $1,100 cash, and talked him into the octavo as well. Now Audubon could allow himself to think ahead to the *Quadrupeds*, and he began with his usual ferocious energy, full steam ahead. Bachman cautioned him to take his time and pay careful attention to scientific detail, but could slow him down only a bit. Audubon wrote back, "My Hair are grey, and I am growing old, but what of this? My spirits are as enthusiastical as ever, my legs fully able to carry my body for some Ten Years to come, and in about Two of these I expect to see *the Illustrations* out, and ere the following Twelve Months have elapsed, their Histories studied, their descriptions carefully prepared and the Book printed! Only think of the quadrupeds of America being presented to the World of Science, by Audubon and Bachman."

Although he and Bachman had been talking about a book on quadrupeds for some years, Bachman had never actually agreed to putting his name on the work; he was hesitant to take on such a large responsibility. His duties as pastor of a large congregation, father of a still-large family, and community leader kept him more than busy; but for one so fascinated with the world of nature, to publish the first definitive work on the quadrupeds of North America was a tantalizing prospect. To work with his great friend was another incentive. One thing was for certain: He wasn't about to have his name on a slapdash effort, as he worried that this might be. He knew Audubon's impulsiveness and his need to publish in order to support his family.

"Don't flatter yourself that this Book is child's play," he cautioned Audubon, "I have studied them all my life. We have much . . . to learn on this subject . . . Our work must be thorough." He said he would as soon write his name on a forged banknote as to have it used in connection with a *"soupe maigre"*—in other words, he wanted nothing to do with turning out a meatless soup. He was determined that the *Quadrupeds* offer its readers something of substance.[26]

Bachman's participation was critical, and he knew it. "You can not do without me in this business, I know well enough," he wrote with his

usual candor.[27] He had been studying quadrupeds since he was a young man, and was recognized as one of the country's leading experts on mammals. His fascination with the project equaled that of Audubon, who continued to cheer him on. Still, he wavered, perhaps because he sensed he would eventually be the one in charge, the one to see the work through to completion.

Finally he did consent to have his name on the book, but only with the understanding that all expenses, as well as all profits, would be the Audubons': "I am anxious to do something for the benefit of Victor and John, in addition to the *treasures* I have given them." That settled, he took up the reins with a passion, urging Audubon: "Employ yourself now in drawing every quadruped you can lay your hands upon. If you can find me a live Ermine, buy it in New York. I must once more examine and study its change of *pilage.*"[28] Now Bachman found himself in the role of the beseecher.

Soon after the Audubons returned to America, they received a letter from Gabriel du Puigaudeau, making one last effort to involve Audubon in what had turned out to be a ruinous attempt to claim the Saint-Domingue properties. Sanitte's heirs had won the long court battle. The fight left Gabriel and Rose in debt for the enormous sum of twenty thousand pounds. He was sixty-nine and ill, Gabriel wrote, and he did not want to leave his children burdened with such debt. Audubon had invested none of his own money in the long struggle over the Saint-Domingue property. Now his brother-in-law was asking him to renounce all claim to the property his father owned in France, so that he might sell it, pay his debts, and die in peace.[29] Audubon had been twenty-one when he last saw his sister and brother-in-law; that had been thirty-four years and a lifetime ago. As always, he was too involved in the present and the future to spend time lamenting the past. He gave du Puigaudeau what he wanted.[30]

The sisters were together again, but only for a few short months. Eliza was well, but Maria had never regained her full strength after baby Harriet's birth. On January 21, Eliza wrote home: "By this time

you will be aware of the indisposition of dear Ria . . . The poor girl has suffered from a sore mouth and a general weakness."[31] Soon after, Johnny took Maria home to Charleston for the rest of the winter. Harriet was left behind to be cared for by Lucy and Eliza, and presumably a wet nurse, but little Lucy—affectionately dubbed Lulu—went with her parents. There were plenty of aunts in Charleston to care for a twenty-month-old who was learning to sing "Yankee Doodle Dandy."

On February 10, 1840, Audubon left New York on what he called "a subscription gathering trip." He met up with Johnny, Eliza, and Lulu in Baltimore, on their way to Charleston. Johnny was taking equipment and supplies with him, and would set up work in the old basement rooms in the Bachman house. Audubon must have envied him; he had to spend a week at Baltimore, then move on to Washington, Richmond, Petersburg, Lynchburg, "and all other Burghs," drumming up new subscribers until ending his journey in Charleston, where he hoped to rest awhile.[32]

Baltimore had always been good to Audubon; this trip was no exception. He added 108 names in one week and decided to stay longer in hopes of adding another hundred.

The newspapers were paying attention to the new octavo. Bachman wrote about it for one journal; the story was copied by another; and the "puff," as both men called it, was on. Audubon sent a copy of the article to Victor with directions to "Have it repeated at New York in as many papers as you can, and quickly."

In Baltimore, as in Liverpool and Edinburgh in his early months in England, he was drawn into a worldly and sophisticated setting. After all this time and all his socializing, he still felt inferior and embarrassed. He wrote Lucy, "I have been to several parties, and some Dinners, where with all the friendliness and Kindness of the persons who did Invite me, I have felt as I always do on such occasions a Lost Sheep; Seeking for a Dark Corner to hide my want of that Knowledge which non education calls upon me to search." The Great Naturalist, famous now in his own country and in Europe, acknowledged by kings and heads of state, by great men everywhere, could never completely

convince himself of his own worth. He tended to blame these attacks
of self-doubt on his lack of a classical education.[33]

Soon, the number of subscribers had reached 520 and Audubon
was ecstatic. Such great success moved Victor to press his father about
making some investments, including a house for him and Eliza. Audu-
bon answered in alarm: "I will do all in my power to ennable you to
purchase a house pretty soon as well as to Collect our back debts, but
for your own Sakes and Mine, do not buy a single Share in *Any Stock
Whatever* until further advise from *me!* Think of the 2000$ We have
as dead in Kentucky Bank Stock,* Would not that Sum assist in the
purchase of a House?—No No Keep your Money at *Home.*"[34]

With Audubon on the road and Johnny in Charleston, Victor had
his hands full in New York. His bride had a lingering illness that was
worrying him. His father, always good at giving advice, told him to
make sure she got plenty of exercise and *"No Physic!"* On the second
day of spring, 1840, Victor wrote to Eliza's sister Jane, "My dear Eliza
is better than when I wrote last, and I think will overcome her cold in
a week or more, but it has been quite obstinate notwithstanding all we
would do."

That spring, the big Bachman house on Rutledge Street was filled
with worry. Maria was succumbing to tuberculosis, and no one seemed
to want to write to tell Audubon about it. Making his way south,
Audubon went to Richmond, Virginia, expecting to get another hun-
dred subscribers, but he was disappointed. He had to work hard to get
even twenty-nine, dining out every day, going to tea, talking talking
talking. That, along with a paucity of news from home, was making
him melancholy.

Finally, on April 17, he heard from John Bachman and answered
immediately: "I am extremely grieved at your account of Maria; but
surely the beautiful and gladening days of this season cannot but re-
store her." Audubon reached Charleston late that April to find Johnny
and Maria away in Aiken, where Maria was receiving treatment. When

* [Since the Kentucky banker the family knew best was Lucy's brother Billy, Audubon
was probably referring to a Bakewell investment gone bad.]

they returned two days later Audubon was unnerved by his daughter-in-law's appearance. With a heavy heart, he sat down to write Victor. "I look upon it as my bounden duty," Audubon wrote solemnly, "to speak of our beloved Maria's Situation.—Her Journey to Aiken instead of producing the effect sought for, has thrown her back, and She is now extremely feeble and so emaciated that it gives me pain to look at [her] face. John Bachman and Doctr Horlbeck went up to Aiken day before yesterday and made out to bring her home, by having a Car for herself and John, with a comfortable bed for her to lie on. That She may recover and return to us all is the Sincerest wish of every one of us, but her Situation is undoubtedly a very dangerous one. May God preserve her! It would be altogether impossible for her to travel, and Cruel in Dear John to leave her, until something decisif does take place and I may indeed think it my duty as her Father, to remain here a few days longer than I intended to see what will happen.—This is painful News to you all my dearest Friends but I have thought it proper not to conceal her situation to you any longer." He planned to be home, he said, by the first of June.

What happened in the weeks between, as Maria lay wasting away from the advancing tuberculosis, was the kind of clash that happens within families during times of terrible sorrow.

Evidently, Audubon made no effort to control his grief. "I go to town and return without scarcely seeing or caring about anyone," he wrote to Victor, "and when I return home, it is only to augment the pains of my poor heart." [35] He tried to ease those pains with whiskey, much to John Bachman's disgust. The minister, used to salving others' grief, now found himself drowning in his own. Full of a pain that he did not, perhaps, understand, he locked himself away in his study. After a while, Audubon went back to New York, but was so strangely silent about his friend that Victor wrote to Charleston to find out what had happened.

Bachman answered that on several occasions, Audubon had had too much to drink and had become "garrulous, dictatorial and profane." The ladies of the household had come to Audubon's defense.

John Bachman was filled with pain over his daughter's death, and, quite probably, his own part in sealing her fate. In his sorrow he lashed out at the Audubons. Bachman thought the father "too sanguine" and the son (and husband) "too desponding." Yet his letter to Victor ended on a note of reconciliation. He admitted that on one occasion, at least, he had chastised Audubon in haste. "Your father's name and memory are very dear to me . . . I pray God to direct us in the right way," he wrote, adding that Victor was to show the letter to his father whenever he thought it "seasonable and proper."[36]

While they were being buffeted by loss, the octavo's continued success buoyed them. By April 4, 650 subscribers had signed on, with more added every day. People were all but coming up to Audubon on the street to ask for subscriptions.

When he returned in June, Audubon found a letter waiting for him from fifteen-year-old Spencer Fullerton Baird, who had what he believed to be a new species of flycatcher, on which he wanted Audubon's opinion.[37] Audubon asked him to send one stuffed bird and another preserved in spirits. He also managed to enlist Baird in his army: "Being on the eve of publishing the Quadrupeds of our Country, I have thought that you might have it in your power to procure several of the smaller species for me, and thereby assist me considerably." Baird wrote back at once with a boy's enthusiasm, signing on to collect mammals for Audubon and help him in any way he could. He told him as well that he had read the "Episodes" in the *Ornithological Biography* "with the same motive of pleasure as I used to read a favorite novel." Audubon responded that it was his intention "as well as that of my friend, the Revd. John Bachman . . . to issue a work on the Mammalia of North America worthy of the naturalist's attention . . . Please to collect all the Shrews, Mice, (field or wood), rats, bats, Squirrels, etc., and put them in a jar in common Rum, not whiskey, brandy or alcohol, all of the latter spirites are sure to injure the subjects."

However strained their relationship just then, Audubon clearly expected Bachman to continue working on the *Quadrupeds*.

In July, Audubon was off again to New England, writing home regularly with all the business details. He was seasick all the way to Nantucket, "that truly curious Island," and all the way back again, but he had collected twenty subscribers. Now all his news from Charleston came through the family in New York. In response to one letter, he wrote, "The News from our beloved Maria and Johny are most extraordinary to me, and I am sadly grieved that both ever went to Charleston, but it was to be I Suppose— . . . I have Some pretty Shells for little Harriet and Lulu to play with." Now that he was away from his family, the old blue devils came back to haunt him. But he wasn't drinking now, "not a drop of anything but Water," he wrote Victor, and he was growing "thin as a Snake!"

On September 15, Maria Rebecca Bachman Audubon died at her father's house in Charleston. She was scarcely buried before Victor and Eliza left New York by ship, on their way first to New Orleans, then on to Cuba. The doctors had prescribed a warm climate for Eliza's stubborn "cold" and coughing, and the Audubons decided at once that she should not go to Charleston for the winter. The experience with Maria had been too painful for both families. The ship did stop in Charleston, and Maria Martin joined the young couple for the journey. She had helped raise the girls, she had nursed her namesake, and now—only a few short weeks after Maria's death—she turned her attention to Eliza. Thus, the good "Sweet Heart" of Audubon-Bachman correspondence stepped in as a bridge between the families.

By the first of November they were in New Orleans, at the home of Victor's cousin Mary Berthoud Grimshaw.[38] An exhausted Eliza was put to bed, while Victor went about the family business, collecting for the *Birds* and selling subscriptions to the octavo. Audubon had always regretted not going to Cuba to search out birds; now Victor could do it for him. Thus, both Eliza's health and the Audubons' business could be tended at once.

Young Johnny, a widower at twenty-seven, returned to New York with two-year-old Lulu, whom he turned over to his mother while he went out with his gun to seek solace in the woods. Lucy now had two

children to rear, girls very near the ages of her own little Lucy and Rose who had died more than twenty years ago.

From Philadelphia, the lithographer Bowen began to give them grief, first by eliminating some backgrounds to cut costs and then by making other demands. Audubon summoned the man to New York, where he told him that if he insisted on making such demands, he could take his pay and be done with the job right then. Audubon was not bluffing. He had someone waiting in the wings to take over the job, or he could send Johnny to London to hire skilled men to finish quickly. Bowen returned to Philadelphia chastened.

Victor, Eliza, and Maria Martin continued on to Cuba, and all that winter Audubon wrote to his son, a steady barrage of letters that ranged from affectionate to haranguing to lacerating and back again. He had been firm about Eliza going to Cuba, not Charleston, for the winter, and yet his letters complain, over and over, that he has not heard from Bachman, or anyone in Charleston. He did not seem to want to believe that Bachman was angry with him.[39] Johnny wrote to his brother in Cuba, "I suppose Mr. B. will never write to Papa."[40] Maria Martin was keeping the Bachmans well informed, but Victor was not doing his duty by his always-fretting father.

Typical of Audubon's complaining letters was one dated January 25, 1841. "My dear children and friends," he began, taking all of them in,

Your previous letter of the 3rd inst. we received a few days ago, and were indeed right glad to see that our beloved Eliza's having writ . . . a few lines, showing as we all hope a better state of health, as these very few lines have been the only ones re'cd from her since your arrival at the Havanna.

I must here tell Victor that it will not do for him to put off writing his letters to us, until the vessel by which he writes is under way. We all exceedingly regret that you should have remained in the infernal city *so long, instead of starting at once for the beauties of the interior of an island so far famed for all that is most congenial to ardent spirits. You say, however, that you are going in a few days to some place about 17 miles from Mataigas. Why not have [you] gone to the very interior of the island . . . and by the*

promise of a dry atmosphere still better suited to the state of health of our Eliza? I would have done so at once, for I feel assured that the beauties of nature in these high altitudes would have been preferable to all of you in every point of view. Here we all go on much as usual.

You, my dear Victor, would feel perfectly amazed were you here to see the numerous errors in your entries on our books. *All of which Johny and I have corrected & settled. This I can easily account for by the anxiety you felt for Eliza, but I assure you it have perplexed us not a little. Our total of subscribers exceed 1100 and we can have as many more as we can wish provided we can supply the demand and there is cash! . . .*

I finished yesterday morning a good drawing of 2 Beavers the size of Life

We have had what is called "an open winter" here, Rains in torrents. Short lapses of sharp cold. Some sun, and again rain. It is now quite mild and raining freely! I always guessed that your expenses in Cuba would prove great, and you must try to reduce them, by bringing back a great number of good sketches that you can turn to account on your return to us.

We do not know yet if we will remain at 86 White Street this year, but will know and inform . . . Why does not my Sweetheart write a very long letter to us? It seems to me as if you all were on the run to the very moment of the departure of each Vessel from the Havannah to the U.S. God bless you all.[41]

WHAT AUDUBON AND LUCY COULD not know, because no one had the heart to tell them, was that Eliza was dying. Victor brought his young wife home in the springtime, stopping at Charleston in the first week of May to say a last good-bye to her family. As his daughter sailed off with Victor on the ship *Calhoun,* a heartbroken John Bachman wrote ahead to warn the Audubons that the doctors in Charleston had pronounced her case hopeless and predicted she had no more than three weeks to live.[42]

Two weeks later Audubon wrote in the margin of a drawing: "I drew this Hare during one of the days of deepest sorrow I have felt

in my life, and my only solace was derived from my Labours. This morning our beloved Daughter Eliza died at 2 o'clock. She is now in Heaven, and may our God forever bless her soul!"[43]

John Bachman, father and man of God, was so numbed by this second terrible blow that he could write only a few perfunctory lines to Victor: "I do not know that I can add anything that will tend to alleviate your sorrow & comfort you under an affliction that has fallen on you in common with us all," he wrote dully. "You know our sympathies & we pray God to support you."

Maria had died at twenty-three, Eliza at twenty-two. Within eight months, Johnny and Victor had lost their much-loved wives, Bachman and Audubon their treasured daughters; and the fate of both families had changed irrevocably.

19

Minniesland for ever, say I![1]

MARIA AND ELIZA WERE DEAD, and Audubon's friendship with
Bachman was seriously damaged. Work was always the antidote—to
disappointment, to the blue devils, to the awful reality of death and loss.
Audubon kept busy by closely monitoring the business details of the
octavo edition and maintaining the large correspondence that would
yield the skins and information he needed for the drawings of the quad-
rupeds. He was drawing as he used to do, from earliest light until after
dark, day after day all through that spring and into the summer. By
August he had a hundred figures, thirty-six species in all.[2] Bachman was
impressed with his old friend's industry. Audubon had promised him
"the very best figures of all our quadrupeds that ever have been thought
of or expected," and he was producing exactly as he said he would.[3]

While Victor was still in Cuba, Johnny had written his brother
that his "most intimate friends" were Brooklyn merchant James Hall

and his family. Perhaps Victor read between the lines and realized that it was Caroline Hall, more than her father or brothers, with whom Johnny sought intimacy. Even though Johnny wasn't the most tactful of men (he accused Eliza and her aunt of rummaging through the drawers in his room to take letters he and Maria had written to each other), he did refrain from announcing his courtship of Caroline Hall while Eliza was still alive. They were married on October 2, 1841, a year after Maria's death, and four months after Eliza's. Johnny was getting on with his life; the Halls became part of the family, appearing at the ever-widening Audubon dinner table at holiday gatherings.

The octavo *Birds* was lithographed rather than engraved; it would fill seven volumes and include sixty-five more plates than the double-elephant edition had. *The Viviparous Quadrupeds of North America,* though smaller than the original *Birds,* was no pocket book: The plates measured twenty-two by twenty-eight inches. They would be issued in thirty numbers of five plates each, at ten dollars a number. The text would be printed separately. "Nature, truth and no humbug" was Bachman's motto; he kept a close rein on what he saw as his co-author's tendency to expedience and flights of fancy. Eventually there would be 150 hand-colored lithographs filling three volumes, with three separate books of text written entirely by Dr. John Bachman, D.D.

Bachman was a part of Audubon's life that had been pure pleasure; for many years the two had had the kind of rare friendship that engages both mind and heart. Audubon had once joked that while their sons and daughters were lovers, the two of them were lovers as well—of science— and it was true. They were excited about all the same things: birds, hunting and every aspect of nature, a game of chess, a lively argument.

The fire that was ignited when Audubon and Bachman were together had burned brightly for years, but the deaths of Maria and Eliza had all but extinguished it. The letters, and the work, continued—but the relationship was never the same.

Even so, John Bachman's name would appear on the title page with John James Audubon's. This was much more than Audubon had been willing to concede to any other collaborator.

The octavo edition was proving as profitable as Audubon always thought it could be, enough to underwrite not only the printing of the *Quadrupeds* but a move to the country as well. For Audubon, cities were all "hot bricks and pestilent vapors" full of "bustle, filth and smoke." The unhappiness that had plagued the family on White Street added to his wish to be out of the city. Most of all, he wanted to give Lucy a house of her own, to fulfill his promises and crown his success.

To keep his family together, Audubon would need to build a substantial house, ample enough to shelter them all in comfort. Edward Harris wanted him to buy a farm near his own in Moorestown, but Audubon elected to stay closer to New York. He bought twenty-four acres in the wooded countryside on the Hudson River, nine miles north of Manhattan.

"Minnie" was the endearing Scottish term for "mother," which the Audubon boys had adopted for Lucy, so the place was dubbed Minniesland. By February 1842 work was well under way on the main house, stables, and milk house. Victor spent that spring traveling on business to Philadelphia and New England—conferring with the lithographer, making collections, and selling subscriptions to both the octavo *Birds* and the *Quadrupeds*—but Johnny was at the home site almost every day. He had always been an outdoorsman, fond of shooting and hunting and good dogs. Farming appealed to him, and he was in his element, planning for poultry and pigs, for cabbage patches and orchards.[4] Two hundred trees would be planted, including pears, apples, quince, apricot, plums, nectarines, and Audubon's favorites, peaches.[5] The house was carefully placed in a grove of oaks, chestnuts, and evergreens on a slope above the river. Audubon could walk down to the water's edge, look out over the Palisades, hear the birds in his own fine old trees.

Though it had a lovely setting, the house at Minniesland was more spacious than palatial. Each floor was divided by a central hall; the first had the parlor and dining room on one side, and on the other a library, studio, and pantry. The second floor held bedrooms; the third included

the servants' quarters and guest rooms. The kitchen, according to the custom of the day, was in the basement.

On March 30, 1842, Lucy, the two "darlings," as everyone called Lulu and Harriet, and their new stepmother, Caroline, arrived to take up residence at Minniesland. For the first time since Henderson, Lucy was mistress of her own domain. Now she had a showplace for the good pieces of furniture they had collected, for the silver spoons her husband had sent her impulsively from England when he sold a large oil, for the fine china bought to replace her own mother's, lost all those years ago in Henderson, and for the hundreds of books they had accumulated.

Audubon had labored through the winter, working as much as fourteen hours a day on the Quadrupeds; now he took time out to settle in too.[6] He was more than pleased with his choice. After a trip down Chesapeake Bay he reported that he had seen no other spot he liked as well—"Minniesland for ever, say I!"[7]

The visitors who came to pay court had to thread their way through pens of fawns and elk, past dogs and turkeys and geese. In the workroom, an easel filled one corner; scattered about were elk antlers and stuffed birds, drawings of field mice and woodpeckers. A writer sent to interview Audubon reported him to be "a tall, thin man with a high arched and serene forehead, and a bright penetrating gray eye; his white locks fell in clusters upon his shoulders, but were the only signs of age, for his form was erect, and his step as light as that of a deer."[8]

For Lucy, Minniesland was the culmination of the dream; but her husband still had one aching need: He yearned to venture into that vast, still largely unexplored land beyond the Mississippi, the Indian lands, where few white men went. He dreamed of the Rockies, of Oregon, of California. There had never been the time, never the money, never a safe place to leave his family. Now he had all three, as well as a reason to go: research for the Quadrupeds. He made up his mind. He would go on "this grand and Last Journey I intend to make as a Naturalist."[9]

He began by going (despite the summer heat) to Washington, where he haunted the halls of Congress, searching out his friend Daniel Webster, now secretary of state, to try to collect money owed him and obtain letters of introduction that would make him welcome at military forts in the West. He came away with a little of the former, and plenty of the latter—letters not only from Webster but from President John Tyler, Secretary of War John C. Spencer, General Winfield Scott, and Lord Ashburton, the British treaty commissioner.

By fall, he was traveling nonstop, working feverishly to collect for the *Birds* and sell subscriptions to the new work, getting everything in order for an absence that might be as long as a year. He had four plates of *The Viviparous Quadrupeds of North America* to show.

Audubon canvassed through December, covering Connecticut, Rhode Island, Massachusetts, New York. He then swung north into Canada. Times were not particularly good, and the *Quadrupeds* was not proving as popular as the octavo *Birds*. Still he kept at it, writing dense three- and four-page letters home every few days, sometimes every day, sending lists of new subscribers and of specific details that Victor would need to take care of.* Lucy fretted and fussed at him to come home, to take care of himself, but he couldn't or wouldn't. He had to collect all the money he could, had to do everything in his power to make sure things would run smoothly while he was away.

In February 1843, Victor married Georgianna Mallory, one of Caroline's friends. By then, Audubon's plans for his western conquest were complete. Neither of the boys would be going, nor would Bachman, but Edward Harris—Audubon's "old and always true friend" who had been talking about such a trip for five years—had signed on, agreeing to pay his own way and more.[10] Audubon bought "several pairs of 6 barrelled revolving pistols," one pair for Harris. The two sent lists back and forth about supplies they would need—including India-rubber beds, mosquito nets, blankets, bullet molds, life preservers, butcher knives, and several boxes of the all-purpose James' Pills.[11]

* [Meanwhile, Johnny's Caroline had her first baby, a boy named John James; he lived only one day.]

Edward Harris was forty-three in the spring of 1843, Audubon was fifty-eight. The other members of the team were in their early thirties, young and strong: John Bell was hired to hunt and to skin the specimens; Isaac Sprague would be Audubon's artistic assistant, outlining and doing backgrounds; and a hardy, if rambunctious neighbor, Lewis Squires, would be a "kind of secretary" and general helper.

Audubon had tried his best—going so far as to offer to pay all expenses—to coax young Spencer Baird, who showed such promise as a naturalist, to go along as secretary. "I shall go towards the Rocky Mountains at least to the Yellowstone River, and up the latter Stream four hundred miles," Audubon wrote to tempt Baird, "and *perhaps* go to the Rocky Mountains. I have it in my power to proceed to the Yellowstone by Steamer from St. Louis on the 1st day of April next; or to go to the *'Mountains of the Wind'* in the very heart and bosom of the Rocky Mountains in the company of Sir William Drommond Stewart, Baronet who will leave on the 1st of May next also from St. Louis." In fact, Audubon had made up his mind not to go with Stewart, but the possibility had a romantic ring to it that he could not resist, nor could he quite give up the notion of being "in the very heart and bosom of the Rocky Mountains."

Baird wanted to go, but his mother felt the journey would be too dangerous. Audubon responded that he understood because "my own good Wife was much against my going on so long a Journey." Then he suggested that in fact the trip wouldn't be all that dangerous because they would be taking an easier route. Pierre Chouteau of the St. Louis Fur Company had offered Audubon and his group free passage up the Missouri River in a company boat, all the way to Fort Union in the Dakota territory.

Audubon wrote to Baird that traveling up the Yellowstone River in a good steamboat was perfectly safe: "The difficulties that existed some 30 years ago in such undertakings are now rendered as Smooth and easy as it is to go to Carlisle and return to N.Y. . . . Our difficulties (if any there are) will be felt on our return; when we must come back to St. Louis in one or 2 open boats in Sepr. and part of Octr next."[12] The

plan was to travel north and west in the springtime, spend the summer gathering specimens, and return in the fall, before cold weather set in.

But Baird was not with the group when it rendezvoused in Philadelphia early in March. They traveled overland in a snowstorm to Wheeling, where they boarded the steamboat *Eveline* for the trip down the Ohio. The river was full of ice; snow covered the countryside, and the weather was cold and blustery all the way to Cincinnati and on to Louisville. This part was a journey into Audubon's past.

The winter had been long and hard, and it was not yet over. They arrived in Louisville late on the evening of March 28; Audubon went directly to William Bakewell's house, while the others settled into a hotel. Audubon had always been fond of Billy, and had tried to talk him into joining the expedition. (Audubon told Flarris that his brother-in-law was "the very Nimrod of the West.")

Once more, hard times had shaken the Bakewell and Berthoud clans. The panic of 1837 had destroyed Thomas Bakewell's business; Billy had cosigned a loan for $125,000 for Thomas, so he had gone down with his brother. Both had had to declare bankruptcy. Even so, Audubon wrote Lucy, "William is in good spirits though deceived by his Brother." [13] Three of the seven Berthoud children were at Billy's, but Audubon missed seeing either Eliza or his old partner: Eliza was on her way to Pittsburgh to put her youngest daughter in school, and Thomas had gone with her "to try to get some money from Little Thomas to begin business anew." The Berthouds were moving to St. Louis, where Nicholas was starting over again in the general commission business.

Louisville had grown and changed enormously: *"The grass does not grow* in the street," Audubon wrote. He had some gossip to pass along about Georgiana Keats, who had been a sixteen-year-old bride when she and George Keats stayed with the Audubons in Henderson. George, who had become the social leader of Louisville (as well as a close friend of both Bakewell brothers), had died two years before. "Mrs. Keats is remarried with her 6 children tacked to her," Audubon wrote home. She was forty-one; her handsome new husband, John Jeffrey, was quite a bit younger. [14]

The elite of Louisville showed up to fête Audubon, and he rose to the occasion. At gatherings in his honor he managed to dance until past midnight, and William gave a grand dinner for eighteen. It was a rousing welcome for a hometown hero.

William and Alicia were all kindness, Audubon was quick to write his wife, but then he exclaimed, "but oh My Lucy what a difference within that House from the cleanliness of our dear Minniesland!"

Cold weather plagued them; ice in the rivers slowed navigation. It was not until March 24, one of the coldest days of the year, that they were able to board a steamer bound for St. Louis. "We passed several villages now called cities and so improved in size that I with difficulty recognized them," Audubon wrote about the changing face of the countryside.[15] What had been wilderness when he first saw it was now tamed. At ten that morning they passed Henderson, and he saw once again the "infernal" mill that had helped to shape his life. He also saw the steeples of two churches. Henderson was growing, too.

They were traveling on the steamer *Gallant,* which Audubon described as the filthiest, nastiest he had ever been on—a good initiation into the rigors of the Yellowstone, he reckoned, yet "we eat famously and sleep soundly." They passed Ste. Geneviève in Louisville; Audubon had heard that his erstwhile partner Rozier was separated from his wife; against his wishes, she had helped their eldest daughter elope with his young German clerk.

"Hie with us then to the West!" Audubon would write in the *Quadrupeds,* "let us quit the busy streets of St. Louis, once considered the outpost of civilization, but now a flourishing city, in the midst of a fertile and rapidly growing country, with towns and villages scattered for hundreds of miles beyond it."[16] But it was not all that easy to leave St. Louis in the spring of 1843: Both the upper Mississippi and the Missouri were locked in ice, and it would be another three weeks before they could possibly head north in the fur company's aptly named steamer *Omega.*

Audubon went to find Nicholas Berthoud, who had rented a house for the princely sum of five hundred dollars a year, and reported

to Lucy that it "will be comfortable to all appearance when carpeted &c."[17] Berthoud was expecting Eliza and the children at any moment. Hurt by the country's cyclical business failures, he told Audubon that he regretted ever going to New York and wished he had come to St. Louis instead. Meanwhile, he took Audubon in while Harris and the others headed across the Mississippi to Edwardsville, Illinois, where living was considerably cheaper and the hunting was said to be good.

The Chouteau family and their fur company had welcomed Audubon royally, but the *Omega* was in drydock, and there was some problem about paying the workmen, so the question of when they would leave was unsettled. In the meantime, Harris and the others hunted and Audubon visited old Mr. Chouteau on his farm, where the two caught what Audubon called pouched rats but which local folks referred to as gophers.

Letters arrived from home with news that all was well. "I have a letter from J. Bachman also this afternoon," Audubon wrote, "so that I feel light, comfortable and indeed Happy."

Captain Sire showed Audubon around the flat-bottomed *Omega;* the ladies' cabin would be set aside for his group. "My State room is so large that I will keep me a good Bed Sted and bed," he wrote home, to cheer Lucy.[18] The deck floor of the boat would be filled with a hundred or more trappers and hunters, who would be turned loose in the wilderness to collect furs for the company. These men, called *engagés,* were in the charge of Étienne Provost, a celebrated hunter who had been roaming the frontier for thirty years and was employed by the Chouteaus. After the trappers were delivered, Audubon planned to hire Provost (for fifty dollars a month), to help them collect specimens and return with them downriver in the fall.

Sir William Stewart, an English nobleman and adventurer who had already made two journeys to the Far West, arrived in St. Louis on the first of April for another expedition. Audubon and Harris went to call on him. "He is a rather tall, very slender person and talks with the lisping humbug of some of the English nobles," Audubon wrote home, not bothering to conceal his contempt. "He is most anxious

that we should join his party and offered us every kind of promises &c but it wont do for us. He has just too many people of too many sorts. He takes 16 days provisions only, and then depends on dried Buffaloe Meat for the rest of the Journey, excepting when they have opportunities of procuring fresh."[19] A few days later, Sir William came to call again and, according to Audubon, offered him five mules and a wagon if he would come along. "But I will not change my plans!" Audubon wrote. "No one knows his views, and he may *Winter* in the mountains, which to me is not quite as comfortable as Minniesland."[20] Audubon had no intention of subjecting himself to the rigors of an overland journey or a winter in wild, Indian country; he was ten years too old, and he had promised Lucy he wouldn't. Still, he was able to joke about Stewart: "No one *here* can understand that man, and I must say that in my opinion he is a very curious character. I am told that he would give a great deal that we should join him. If so why does he not proffer some $10,000; who knows but that in such a case I might venture to leap on a Mule's back and trot on some 7 or 8 thousand miles."

By the middle of April the weather had warmed; soon the river was high and the current, Audubon said, running like a millrace. Harris and the others had scoured the bottomlands across the river in Illinois for birds and quadrupeds, and brought back grouse, squirrels, snow geese, sandhill cranes, and about fifty small birds. They had had a few mishaps: Sprague tried crossing a pond on a log, fell in, and dropped his gun. Bell managed to fish it out for him, and after a good cleaning it was fine. Then Bell was kicked hard by a horse, but seemed to be all right after a few days. Harris was constipated but had taken some medicine, which had worked, and Audubon had lost his last remaining tooth, so he was going to have to soak his hard biscuits.[21] All such accidents and physical discomforts were to be expected and accepted; they were part of such a journey.

Finally, the *Omega* was loaded with provisions, including five hundred dozen eggs and fifteen dozen bottles of claret, and the Audubon entourage settled into its staterooms. On the day of departure, seven or eight Indians who were returning to their tribes upriver came aboard

and, with their usual unreadable patience, squatted to observe the tumult created by the 120 *engagés* as the *Omega* moved away from the dock. This was the *engagés'* last chance to get drunk, since it was illegal to take quantities of liquor into Indian country. Guns were fired at will, blast after blast into the air, as the steamboat moved out into the Mississippi and turned north. The thermometer hovered around seventy, spring had started to green the trees along the riverbanks, the promise of summer was in the air, and the important part of the last great journey had begun.

Audubon noticed with a certain chagrin that the men in charge of the fur trade were "all shockingly ignorant out of their course of Business.—Not one knows one animal from another beyond a Beaver, a Bear, a Raccoon or an Otter." But when the captain of the *Omega* invited the Indians to come look at Audubon's drawings, "the chiefs knew all of the animals except the Little Squirrels from the Oregon. Their signs were most significant, and the Interpreter told us of their delight and amasement," Audubon wrote.[22] Edward Harris described four of the Indians on board as belonging to a branch of the Sioux nation: "their costume is that of Adam & Eve immediately after the fall with the exception of a miserable blanket thrown over their shoulders."[23] Harris had brought along his dog Brag, a pointer, and he was soon sorry: "Poor Brag would be glad enough to be back to the old homestead," he wrote a friend; "he has been in a continual fright ever since he left home. Indians and trappers are his utter abomination, in fact he is a miserable traveller and I heartily wish he was safe at home again."[24]

It was a slow journey up the Missouri. The spring floods had made the waters high and swift, and even though the *Omega* had a flat bottom, she often caught on sandbars or was snagged by "sawyers," trees stuck upright in the river. The motion of the boat made it impossible for Audubon to draw during the day, and because they were on the river their chances to hunt were limited. Harris and the others were annoyed that "our opportunities for shooting do not come up to our expectations. Instead of stopping two hours before night to cut wood

as we had been led to believe, they stop whenever they can find that which is suitable no matter what time in the day."

On May 2, the *Omega* reached Independence. The day before they had stopped long enough to shoot some twenty-eight rabbits, two squirrels, and two marmots, as well as wild turkeys and pheasants for their dinner.

On the lower Missouri, great stands of timber had astonished the group; as they moved north, the trees grew smaller and sparse. Soon the view from the river was of prairies extending to the horizon. The farther north they went, the colder it became. The prairies were not yet in bloom, and the animal life the travelers sought did not make an appearance. So far, there was nothing to draw. They did discover what Audubon thought to be a fine new finch, and he promptly named it for Harris. (In fact, Nuttall and Townsend had already found it.) But it was quadrupeds that Audubon needed, and that Bachman expected from him.

On May 9, a little more than two weeks out of St. Louis, the *Omega* passed Council Bluffs. "We are now positively out of the *United States* boundaries Westward," Audubon wrote, "and now all the people we will see will be Indians, Indians, and nothing but Indians."[25]

As a young man in Kentucky, Audubon had traveled with Indians, hunted with them, admired their courage and stamina. He liked to say that in those old days of roaming the woodlands he had never been threatened by anything more than mosquitoes or ticks. Now, however, he wrote that the Indians were "squalid and miserable Devils," they were "beggars," they were "thieves." When the Indians on board disembarked, about eighty of their tribe were there "not to welcome them precisely but to eat all the eatables they had brought with them from St. Louis," Audubon wrote, adding, "The Rascals stole a good knife from us.—They are cunning beyond conception, and we will have to be on the alert when any of them 'call' on a visit!"[26] Harris echoed this disapproval, yet both men listened with sympathy to the terrible stories of how smallpox—brought upriver in a boat like the *Omega*—had all but eradicated the Mandans only four years earlier. Audubon believed that "civilization" had been disastrous for the Indians; he was sickened

by it, and sorry for it, but like most men of his age, he accepted it as
the inevitable toll taken by progress.

As they moved north, the land became more desolate. A late snow
on May fifth had killed off most of the buffalo calves; occasionally a
dead buffalo floated down the river, but they had yet to see a live one.
They did not see a single hare or a fox, though they caught glimpses
of some deer and one black bear, seen as it swam the river. Even the
wolves, which everyone knew were there, kept out of sight.

The captain, eager to set a speed record for the trip to Fort Union,
did not dawdle, so Audubon was almost glad when one of the boilers
blew and forced a two-day stop at Fort Pierre. He and the men "hunted
far and wide," but with little result. The Indian agent told them not
to worry, that before long they would see more deer and antelope than
they would know what to do with.

Squires was busy making a map of the river; Bell skinned every
bird and quadruped they managed to get their hands on; Harris was
keeping careful notes on the geology of the area for a report he had
promised the Academy of Natural Sciences; Sprague sketched; and
Audubon kept busy "driving his iron pen" across page after page of
the journal paper he kept in rolls that would fit into his pocket. Still,
he could not bring himself to write the complete notes that Bachman
needed. Instead, either through lack of interest or energy, he steadily
wrote letters home, hoping that a boat headed downriver would appear
and that someone on board her would take them to St. Louis.

Victor had orders to send excerpts of these dispatches to the news-
papers—the publicity couldn't hurt, and might be of some help in
selling the *Quadrupeds*. Audubon had long been news; now papers
throughout the United States began to run bulletins on his progress.
An interview he gave in St. Louis, which was picked up by the Buffalo
Courier, included a description: "His hair is white with age and some-
what thin; he combs it back from an ample forehead, his face being
sharp at the chin; has gray whiskers, an aquiline nose, and a hazel eye,
small, keen and indicative of great tranquility, and sweetness of temper,
cheerfulness and genius." The gullible writer went on: "He told me he

had not taken a particle of medicine for twenty years. He is capable of any fatigue; can walk thirty-five miles a day with ease, for months; can sleep anywhere in the open air; endure all climates; his principal food being soaked sea biscuits and molasses on account of having lost all his teeth, from which he suffers and is obliged to boil his meat to rags." Once more, Audubon had donned his American woodsman persona; it still made for good reading.

Soon the great herds of buffalo appeared. Audubon could see them by the thousands from his stateroom; they seemed to cover the landscape. For Harris, they were a depressing sight: "We have reached these wild, and to my eye, melancholy looking districts on which those countless multitudes of monstrous sized animals live, and die, more by the arrow and rifle bullet than even by drowning whilst attempting to cross the rapid Missouri. The shores are strewed with their carcasses, on which the wolf, the raven, and the vulture gorge themselves at leisure and unmolested, for hunters rarely if ever shoot at any of these." They saw elk, deer, wildcats, and bears, as well as antelopes and white wolves—though fewer than usual, according to the captain. Nor had many Indians been in evidence. The spring flood had diminished and the water was dropping, which meant the *Omega* caught on sandbars more frequently and had to struggle to get off. All of this was exasperating to Audubon, but it gave his group the chance to go ashore to explore such novelties as prairie-dog villages.

At a place where the river made a great loop, Audubon and his group got off to walk the three miles to the other side, where the boat would pick them up the next day. They hiked and hunted and explored the country before setting up camp under six cottonwood trees. One of the hunters shot a young deer, which they cooked over a great open fire—the most delicious supper they had had. Harris declared he had eaten enough for three days. It was a fine interlude, with beautiful clear weather. They blew up their India-rubber mattresses and arranged their mosquito nets to keep away the clouds of insects. Buffalo ranged all around, wolves howled close by, and when Audubon stood back to look at their campsite, he found it "sublime."

A few days after they were picked up, as the boat made its way quietly up the river, a small party of Santee Indians along the shore signaled for it to stop; when it didn't, the Indians began firing away. At least four balls hit the boat. Everyone on board seemed more surprised than frightened, and no one was hurt. The captain, who had been asleep, said he'd never heard of anything like it before, and was sure it wouldn't happen again. Audubon wrote home about the incident, in case an exaggerated version of the episode somehow made its way into the newspapers.[27]

At Fort Pierre, the *Omega* put ashore fifty men and half the cargo; now the boat would draw only 3¼ feet of water and their passage would be considerably easier. Honoré Picotte, the superintendent of the fort, presented Audubon with a necklace of grizzly-bear claws, an astonishing pair of elk horns, and a fine large elk skin to take home. Johnny was to get an Indian whip, and Audubon sent to Minniesland a disassembled teepee which he suggested they put up "on that sweet spot that overlooks the River" where Victor and his father-in-law might enjoy an after-dinner drink or a smoke.

By mid-June—after forty-eight days and seven hours—they reached their destination, Fort Union, on the eastern side of the Missouri near the confluence with the Yellowstone.[28] In spite of all the delays, they had made the trip in record time. The captain of the *Omega* quickly loaded on eight hundred packs of buffalo robes, thirty packs of beaver, and twenty-five of buffalo tongues.[29] He said good-bye to the naturalists and, the river being up, wasted no time in heading downstream, arriving in St. Louis fifteen days later.

Audubon and his group spent the summer at Fort Union. Situated on a high plain, the fort was constructed of twenty-foot-high walls; inside were dwellings, a warehouse to hold the buffalo robes and furs collected for the company, tinsmith and blacksmith shops, a powder magazine and cannons, and a store where Indians traded. The store was at the gate, so that the Indians could be controlled.

Alexander Culbertson, the superintendent, welcomed them, made them comfortable, and that afternoon gave them a Wild West welcome

with an astonishing display of hunting prowess. A white wolf was spotted from the high wall that surrounded the fort. Mounted on a beautiful Blackfoot mare, Culbertson set off at full speed. As Audubon and his group watched, Culbertson galloped after the wolf, fired at it, then reloaded again at top speed to fire again. Hunter and hunted vanished behind a rise, but a few minutes later Culbertson emerged with the dying wolf slung onto the saddle in front of him. The chase had taken little more than fifteen minutes. Audubon, Harris, and the young men were impressed. "I should like to see some of the best English hunting gentlemen hunt in the like manner," Audubon whooped.[30]

That night there was a ball, with Culbertson on the violin and Indian women dancing smartly. The only women at Fort Union were Indians, one of whom was Culbertson's "wife," Natawista, of the Blackfeet. (Fourteen years later, Culbertson married her legally.) Although appalled by the Indian women's "morals" (they passed no judgment on the white men's), Audubon and Harris admired their riding skills. Early one evening that summer, several of the best riders in the fort, including Culbertson, dressed as a Blackfoot chief, and Natawista, also in traditional dress, gave an exhibition of riding. Harris reported with wonder that the riders performed "some fine evolutions at full speed, the Squaws quite as much at their ease on the horses as the men."

Audubon's fame had gone before him, reaching even to this far outpost, and some legendary hunters of the frontier came to offer their services, for a fee. The hunt was on for antelope and deer, in fact for anything on four legs.

Audubon's group scoured the territory close to the fort for hares, bears, and, always, birds. In the weeks to come, the weather varied wildly, from cold and rainy to steaming hot. On wet days, when they could not go out, they sat around the fort and listened to stories, some of them tall (wolves caught with fishing lines), some unimaginably sad, and others continually reminding them of the unpredictability of the Indians of the region.

One Sunday afternoon Audubon took a walk with the fort's second-in-command, carrying "a bag and instruments to take off the head

of a three-years-dead Indian chief, called the White Cow." They found the coffin lodged in the branches of a tree, about ten feet above the ground, where the body would be safe from wolves. Audubon wanted the skull. The coffin was pulled down, the cover pried off, and "to my surprise, the feet were placed on the pillow, instead of the head, which lay at the foot of the coffin . . . Worms innumerable were all about it; the feet were naked, shrunk and dried up. The head had still the hair on, but was twisted off in a moment, under jaw and all." [31] In the interests of studying the anatomy of an Indian chief, John Audubon could revert to grave robbing.

Though, to avoid alarming Lucy, his letters home continually discounted danger from Indians, there was in fact reason for worry. Several times during his stay, word came that some incident had triggered trouble and that Audubon should not wander far from the fort. As if to underscore this concern, one evening a detachment from a war party of Assiniboin Indians came riding up to the fort, shouting what Culbertson said was the song of the scalp dance. Their faces were painted black, except for their leader, whose face was red. "They . . . looked more like infernal than human beings," Harris wrote. They sang their war song at the gate; inside, Indian women and their children joined in the singing and dancing, "making a most hideous uproar," Harris wrote. Audubon added, "The chief, to show his pride and delight at having killed his enemy, has borrowed a drum; and the company have nearly ever since been yelling, singing, and beating that beastly tambour."

At night, the men gathered on the battlements to watch for the wolves that roamed the countryside, and to shoot them when they could. Now and then hunters would send word that they had a bighorn for Mr. Audubon, or a yearling buck elk. Harris went out with Étienne Provost to find a doe by imitating the cry of a fawn. The ruse worked perfectly; a doe speeding to within ten feet was dispatched and taken back to the fort for Audubon to study, measure, and draw.

Buffalo were on everybody's mind. "It is *impossible to describe or even conceive* the vast multitudes of these animals that exist even now,

and feed on these ocean-like prairies," Audubon wrote before the summer was over.[32] "Wolves howling, and bulls roaring, just like the long continued roll of a hundred drums."[33] The buffalos' bellowing could be heard for miles.

Harris and the young men had been promised a buffalo hunt, and they were understandably nervous about how each would perform. (Audubon, at fifty-eight, knew his limitations and remained a spectator: "Alas! I am now too near seventy to run and load whilst going at full gallop."[34]) Squires, Audubon's rambunctious young neighbor, was certain he would do well. Harris was much more circumspect; at forty-three, he wasn't at all sure how well he would acquit himself, and so kept quiet.

When the day finally came, the hunters—Culbertson, Harris, Bell, and Squires—rode out over the prairie early in the morning. Audubon rode in a carryall. The sun rose hot; when it was almost directly overhead, Culbertson spotted four buffalo bulls—one for each hunter—grazing about a mile away. The chase was on.

Audubon mounted a rise to watch the action. The hunters moved carefully toward their prey. Squires described what took place on a such a hunt: "I observed, as we approached the Buffaloes, that they stood gazing at us with their heads erect, lashing their sides with their tails; as soon as they discovered what we were at, with the quickness of thought they wheeled, and with the most surprising speed, for an animal apparently so clumsy and awkward, flew before us. I could hardly imagine that these enormous animals could move so quickly, or realize that their speed was as great as it proved to be; and I doubt if in this country one horse in ten can be found that will keep up with them."[35]

The horses they rode that day could, and did, keep up. The buffalo divided by twos; Harris and young Squires galloped off after the left-hand pair. Harris described what happened then: "Knowing that Squires had the fastest horse I waited for him to choose, he fired into his bull and I crossed his track after the other." As Harris passed by, Squires's horse was running even with his bull; then the horse pulled up short and wheeled, sending Squires flying to the ground. Harris

checked his horse long enough to see that Squires was on his feet; then he went on in pursuit of his own game, "which I soon overtook and fired striking him in the middle of the thigh, a few strides more brought me directly opposite him and I shot him in the lungs just behind the shoulder. I rode along side of him reloading my gun, which I had just accomplished when I saw blood gushing in a stream from his mouth and nostrils in such a way that I knew he must soon fall." At that, Harris galloped off to get Squires's horse and bring it to him.

Harris's bull being down, the two galloped off after Squires's, intending "to avenge the mishap of poor Squires," as Harris reported. It was not to be; Squires's gun wouldn't fire, and when Harris gave him his, he managed to miss. Audubon had a grand view of the whole show; three of the four hunters came back with buffalo tails as trophies.

On the way back to camp, the carts filled with buffalo meat for the fort, they ran into another small herd of buffalo, all bulls. Only Squires wanted to pursue them, to redeem himself. Again Harris, Culbertson, and Bell each managed to kill a buffalo, and again Squires did not.

Harris, always thoughtful, began to feel pangs of conscience. "We now regretted having destroyed these noble beasts for no earthly reason but to gratify a sanguinary disposition which appears to be inherent in our natures," he wrote. "We had no means of carrying home the meat and after cutting out the tongues we wended our way back to camp, completely disgusted with ourselves and with the conduct of all white men who come to this country. In this way year after year thousands of these animals are slaughtered for mere sport and the carcasses left for the wolves."[36] (In fact, Harris had become mad for the hunt. He went out whenever he got the chance, up to the day in August when they were ready to leave for St. Louis.)

In 1843, immense numbers of buffalo covered the American plains; one of the principals of the fur company told Audubon it had taken him six full days to pass through the herds. If others thought the great herds would last forever, Audubon did not. He considered the bison to be a link to other huge American animals, now extinct, and

he predicted its demise. In the *Quadrupeds* he would write that the buffalo was "perhaps sooner to be forever lost than is generally supposed."[37]

Audubon made a few short forays out of the fort, usually riding in a cart or carryall. Sometimes they camped out overnight. While the others were hunting, Audubon stayed behind to fish, and if the hunters came back without any fresh meat for their dinner, three or four catfish would be waiting for them. On these one- and two-day trips, Audubon could see the countryside, glimpse its wildlife, live the rough life demanded in the wilderness. One night as they camped in view of the Badlands, with no wood for a fire in sight, Audubon and Harris collected dried buffalo dung, carrying it in great stacks under their chins, and laughed to think what friends back home might say, if they could see them now.[38]

Early in August, they built a mackinaw—a kind of flat-bottomed boat—forty feet long to take them downriver. In it they packed all the bird and quadruped skins collected over the summer. Audubon's group of five, along with Culbertson, his Indian wife, and their baby, as well as two hunters and four boatmen, climbed aboard, making it a tight fit. They left the fort on August 16.

While they were on their way downriver, back at Minniesland, Caroline Audubon gave birth to her second child, a daughter. She was named Maria Rebecca for Johnny's first wife.

The journey down the Missouri proved to be cold and uncomfortable, with wind and rain and at times water rough enough to send Audubon into convulsions of seasickness. They were wet and miserable, and Audubon notes "signs of Indians" often enough that his fear is almost palpable. One night they slept with their guns at the ready. It was a long time since Audubon had traveled the woods of Kentucky with Indian braves, sleeping easily at night by their fires, hunting with them early in the mornings.

On that downriver trip he wrote: "Distant thunder. Everything wet and dirty after a very uncomfortable night . . . wolves howling all about us, and owls hooting also." Finally, on October 20, they arrived in St. Louis; the last grand journey was over.

Georgianna Audubon, Victor's wife, described her father-in-law's homecoming at Minniesland on November 6, 1843. "It was a bright day, and the whole family . . . were on the piazza waiting for the carriage to come from Harlem . . . hearing wheels, some ran one way and some another, each hoping to be the first to see him; but he had left the carriage at the top of the hill, and came on foot straight down the steepest part, so that those who remained on the piazza had his first kiss. He kissed his sons as well as the ladies of the party. He had on a green blanket coat with fur collar and cuffs; his hair and beard were very long, and he made a fine and striking appearance."[39]

HE KEPT THE BEARD AND shoulder-length hair long enough for Johnny to paint his portrait in his green coat with the fur collar. Then he retired to his workroom—content to have Lulu and Harriet playing nearby—as he pushed to finish the drawings from his trip.

Only a week or so after his return, Bachman wrote to urge Audubon to come to Charleston with all the skins: "Your animals require an examination of three months. I cannot be spared from home for a single Sunday . . . I am quite sure that you will soon be here with all your treasures, and we will discuss these matters as men ought to do who are in earnest . . . Write on foolscap—fully—fearlessly . . . Out with your deeds and let us have an overhauling."[40]

But there was to be no overhauling, not yet. And Bachman's pleas for the books he needed for the text also went unheeded. There was simply not enough time to do everything. Audubon, his western journey out of his system, flew into action like a man possessed. Time was at his heels now, and he was running as fast as he could. The parrot Mignonne and the monkey beast were there still, lodged in his memory; there was no time to let up, no time to rest.

Even so, in many ways this was one of the happiest periods of his life. At Minniesland he was surrounded by his family and friends and admirers who came to call. There was laughter and warmth; he liked

to sing little French songs to his grandchildren, and to ramble along woodland paths.

"His habits were simple," Lucy later wrote. "Rising almost with the sun, he proceeded to the woods to view his feathered favorites till the hour at which the family usually breakfasted, except when he had drawing to do, when he sat closely to his work. After breakfast he drew till noon and then took a long walk." He had a favorite retreat on a well-wooded point overlooking the Hudson; from it he could watch the ships go by or scan the birds as they skimmed the water. He could fish from the docks, or study the quadrupeds kept in pens, or simply sit in the sunshine and contemplate his world.

The octavo *Birds* was progressing on schedule and—more than a thousand subscriptions having been sold—it was keeping the family solvent. But the seventh and last volume would be published in a year, and then that steady source of income would dry up. The *Quadrupeds* would have to take over, but subscription sales lagged.

Bachman was more than pleased with the number that came out that spring. The lithographs were "beautiful and perfect specimens of the art," he wrote, but there were some scientific mistakes for which he called Audubon to task.[41] The letters between the two men became cantankerous and taunting. Bachman needled his old friend about drinking too much, about taking snuff, about wasting time and effort on the Missouri River journey. Audubon had spent too much time on buffalo hunts, Bachman wrote, and too little searching out the small mammals they so badly needed. In Bachman's opinion, Audubon had lost sight of the purpose of the trip. He had come home with precious little new material, and what he had lacked scientific detail.

By spring, Audubon was on the road again—not to Charleston to see Bachman, but to New Bedford and Boston to sell subscriptions. That summer he tackled upstate New York, but found it not nearly so fertile a ground as New England.

At Minniesland, the boys were having trouble keeping a deer in its pen, but their gardens were producing well and they were earning money by selling vegetables in the neighborhood. Back from his New

York swing, Audubon settled into his routine: writing letters to beg for specimens for the *Quadrupeds*, drawing, playing with the children, walking on his favorite paths. Spencer Baird turned up at Minniesland one day with a live marten and some badly needed skins. Audubon had to depend on skins and, at times, even others' pictures, for his drawings. Now and then he ventured out with Victor to call on those individuals and societies who were behind in their payments.

In Charleston, Bachman was rising at four in the morning and working on the text of the *Quadrupeds* before breakfast and then on until three in the afternoon, if his pastoral duties allowed.[42] He was not at all satisfied with the Audubons' collaboration. (Both Johnny and his father worked on the animals; Victor filled in backgrounds.) Usually he couched his complaints in compliments: "The brush of my old friend Audubon is a truth-teller. I regard his drawings as the best in the world. Let us be very careful to correct any errors of description that have crept in . . . I see a few in the lettering . . ."

He tried coaxing: "Will not my old friend, Audubon, wake up, and work as he used to do, when we banged at the Herons and the fresh water Marsh-hens?" he wrote, reminding Audubon of his own considerable contributions to the *Birds*. Later Bachman became downright querulous when a "mutual friend" told him that Audubon had no intention of giving him credit for his part in the *Quadrupeds*. Audubon wrote that the so-called friend was absolutely wrong, adding that it saddened him that Bachman could possibly believe such a report from someone who "knew but very little of my feelings or actions or sayings as regards you." Then, wearily, he added: "The sooner forgotten, the sooner mended," smoothing things over before urging his old friend to come to Minniesland in the spring for a long visit.[43]

In the fall of 1845, Bachman did make the journey to Minniesland to visit his granddaughters, and to work with the Audubon men on the *Quadrupeds*. He found both Audubon and the boys hard at work and came away generally pleased with their progress. The visit did much to repair relations between Bachman and the Audubons. That same year Victor's wife, Georgianna, gave birth to their first child, a

girl they named Mary Eliza. John Bachman was moved beyond words by the graciousness both women showed in naming their firstborns for his daughters, and he opened his heart to them, drawing closer to the boys and to the rapidly growing family at Minniesland. Audubon finally got the grandson he wanted when Caroline gave birth to a boy, who was promptly named John James. By the end of 1845 there were five grandchildren—Johnny's Lucy, Harriet, Maria Rebecca, and John James; Victor's Mary Eliza.[44] Lucy, at seven, was the eldest.

During his visit, Bachman discussed at length the work on the *Quadrupeds* and watched with delight as Audubon painted Le Conte's mouse with undiminished skill. But it seemed to him that his friend was not quite as mentally acute as formerly.[45]

Victor had always been a Bakewell, but Johnny was unquestionably his father's son. Like his father, he was subject to periods of depression; he had also inherited his father's passion for the wilderness.[46] No one had searched the Southwest for mammals; Johnny proposed he make a trip to Texas. By November 1845—soon after the birth of John James—he was on his way, taking along as a companion one of the gardeners. At least one member of the family shared his passion, and cheered him on: "Push on to California," his father wrote him. "You will find new animals and birds at every change in the formation of the country, and birds from Central America will delight you."[47]

With Johnny away, Victor and Audubon had even more to do. Victor had promised to get Bachman the specimens and books he needed to complete the text, but he did not get around to it. As the weeks passed and the Audubons did not perform as promised, Bachman once more grew discouraged. On Christmas Eve, 1845, at his wit's end, he wrote to Edward Harris, and spilled out his frustrations. "Friend Harris," he began, "You can be of service to me, to the Audubons & the cause of science. I will tell you how." He recounted in some detail his complaints: "All they care about is to get out a No. of engravings in two months. They have not sent me one single book out of a list of 100 I gave them and only 6 lines copied from a book after having written for them for 4 years." Audubon had not sent him one

skin, and on many of the quadrupeds not one line; Bachman had none of the information from the Missouri River trip and had not received the journal. "I am willing to write every description and every line of the book," he went on. "I do it without fee or reward." But unless the Audubons gave him the specimens he needed, he intended to stop after the first volume was complete. This decision, he said, was the result of four years of "remonstrance, mortification, and disappointment."[48] Harris, a devoted friend of both men, worked a diplomatic wonder, and Bachman soon had the Missouri River journal in hand, along with what books Victor was able to find and as much detailed information as they could manage.

Of Johnny's trip to Texas—he did not "push on to California"—the best that can be said is that he returned safely. Texas was a mean place for a man, with murderous scoundrels and marauding Indians. Jack Hays, a celebrated Texas Ranger, gave Johnny much help, but the skins he brought back were badly done, and the proper measurements had not been made beforehand. As in the case of the Missouri River trip, the Audubons had invested a great deal of money without commensurate return. Johnny returned in April 1846, and on June 10 was dispatched to England with directions to draw "figures of those arctic animals, of which accessible specimens exist only in the museums of that quarter of the globe."[49] In this he could not fail.

In New York, Victor and his father worked as efficiently as they were able, drawing and selling and keeping after the lithographer. Chastened by the idea of losing their collaborator, for a time they managed to keep Bachman supplied, sometimes sending him skins that Audubon had not yet used, and asking that they be returned as quickly as possible.

Bachman was having his own share of sorrow; his wife, Harriet, died in the summer of 1846, and yet another of his daughters, Jane, was ailing. That fall, he brought her to New York for medical treatment and stopped at Minniesland. He could see that Audubon was failing physically, but did not realize how rapidly his old friend's powers were ebbing. Bachman continued writing the *Quadrupeds* (Maria

Martin acted as his assistant, often copying long sections for him) and haranguing the Audubons to send him "good, honest" material.

Some things simply were not said in letters, though now and then Victor hinted at his father's deteriorating condition. Once he wrote that Johnny should probably draw a pine vole—a rodent—because "my father's eyes are not quite so good as they have been."

Audubon's eyesight was indeed failing: Soon he would not be able to see well enough to draw. By 1846 he had completed half of the large illustrations for the *Quadrupeds,* but he could do no more. Still, he might have found some solace in his contributions to science. In the course of his career Audubon had described twenty-three new birds, and, with Bachman, he had introduced ten new mammals to the world.[50] With no fanfare, the task of completing the work passed from father to sons.

Audubon suffered either a series of small strokes or developed Alzheimer's disease. In any case, by the time Johnny and his family returned from England in May 1847, the change had been wrought, and the son had a terrible shock.

His father spent his days rambling around Minniesland, usually with someone by his side. He found solace in childish pranks—ringing the dinner bell, hiding eggs, pestering Johnny to feed the dogs or Lucy to feed him. He would not go to bed at night without a kiss from all of the women and children and a French song sung by one of his daughters-in-law who had an especially lovely voice. After some months this fussy stage was followed by silence and a kind of reverie, when Audubon seemed to withdraw from the world altogether. At last, the parrot and the monkey were banished from Audubon's memory, along with everything else that had engaged him for so many years.

The sons tried their best to keep their father's condition quiet, in part because the loss of the mind was viewed as shameful, in part because they felt that the news would damage sales of the *Quadrupeds.* They did not even confide in Bachman, who naturally continued his tirades, lashing out at both sons without mercy: "Is it not a shame—a disgrace—a sin that John should be so miserably careless as not to send

us the names of the species? All my writing and scolding do no good. Say to him I am as mad as Thunder at being treated so much like either a witch or a jackass."[51]

Audubon's last coherent letters were written in 1847. The following spring, Bachman visited Minniesland, was shocked by what he saw, and at last understood. He wrote home to Maria Martin: "Alas, my poor friend, Audubon, the outlines of his countenance and his form are there, but his noble mind is all in ruins."[52]

John Audubon lived now in a twilight world, free from all worries and fears. The life of the house swirled around him. New babies arrived as if on schedule, with both Caroline and Georgianna producing one almost every year. The patriarch, as the old man with the snow-white hair was called, sat in a chair in the parlor and said nothing.

Perhaps the worst consequence of his senility was the break in the close connection that had long existed between the Audubons and their sons. "Father, mother, and sons had always been most united, unusually so it seems," a granddaughter would write.[53] That alliance was now shattered.

From London, Johnny had written to say how much he missed the forests and rivers of America, how all he thought about was returning to Minniesland and never again leaving. He didn't mean that last. He returned from Europe eight months before gold was discovered in California. This event struck the world like an electric shock. "The fever," as it was called, attacked all sorts of otherwise rational men. John Woodhouse Audubon might have been able to fight it off had not some family friends asked him to act as second-in-command to a gold-prospecting company they were financing. The company would include about a hundred men and would be led by one Colonel Henry L. Webb, who had served in Mexico. Johnny consulted Victor, and the brothers—with the wild optimism of the day—decided that the twenty thousand dollars in gold that Johnny was certain to bring back would be worth his while, even if he had to be away for twenty months or so. At the very least, he would bring back a wealth of skins and information and sketches of western mammals for the *Quadrupeds*.

Victor approached Edward Harris about joining the company; his answer should have given the Audubons pause. He said he had experienced a bit of a gold rash, but that he had managed to ward off "the golden prospect and leave it to some more fortunate adventurer to build his castles." After the great buffalo hunts, Harris had married for a second time and was starting a family; his adventuring days were over.

Some two years after the death of his wife, Bachman announced his marriage to her sister, Maria Martin. The constant "Sweet Heart" was not only Bachman's wife, but—perhaps more important—his "nurse and scribe."[54]

The California-bound contingent left New York on February 8, 1849, with eighty men and capital of $27,000. The trip was an unmitigated disaster almost from the beginning. The company planned to travel through Texas and Mexico to San Diego, then north to San Francisco and the gold mines in the mountains to the east. In Texas, cholera struck, killing several of the group, among them Howard Bakewell, the son of Lucy's brother Thomas. Colonel Webb left the encampment, leaving Johnny in charge of nursing the sick. In the confusion, a large part of the company's money was stolen. After several more deaths, Webb deserted the group altogether and Johnny was asked to take charge.

The overland journey, through parched deserts and unbearable heat, was harsh beyond anything any of the men had ever known. Johnny himself fought off two bouts of cholera and was plagued by the blue devils. Mules and horses dropped dead or tumbled down mountainsides. Hunger and thirst and the fear of hostile Indians assailed the men. When they arrived in San Francisco—they were now only thirty-eight strong—Johnny had to draw on Victor for a thousand dollars to get them the equipment they needed. In the goldfields at last, they discovered they were too late. Men from every nation on earth were swarming over the hills; the trip had been a gamble, Johnny realized, and he had lost. He did not even have any sketches or specimens to show for his trouble. "My arsenic is broadcast on the barren clay soil of Mexico," he wrote, "the paper in which to preserve plants was used for

gun-wadding, and, though I clung to them to the last, my paints and canvases were left on the Gila desert of awful memories." In July 1850, he sailed for home.

His old father was waiting, silent now, with not even a glimmer of recognition in his face for those around him. It became obvious that his time was short. William Bakewell—who as a boy had been Audubon's favorite hunting companion at Mill Grove—came from Louisville that fall. He strode up to where Audubon sat, greeted him with his bluff Kentucky cheerfulness, and as everybody watched, astonished, Audubons old face cracked into a glow of recognition and he blurted, "Yes, yes, Billy! You go down that side of Long Pond, and I'll go this side, and we'll get the ducks."

Audubon the hunter was back in Henderson again, with a young Billy by his side, guns in hand, heading out for Long Pond when the ducks were in.

These were the last words John Audubon ever uttered. On January 27, 1851, he opened his eyes to take one last long look at Lucy and the boys, then closed them forever.[55] His life, possibly the greatest of all his works, was done.

MEMENTO MORI

On THE LAST DAY OF January, 1851, family, friends, neighbors, and a number of dignitaries braved a winter storm to follow the funeral cortège to Trinity Churchyard, which adjoined the Audubon property. There John Audubon was buried in a plot he had chosen himself.

Near the end of Audubon's life, before his mind dimmed, one of the many who came to pay homage said to him, "I have seen Audubon, and I am very thankful."

Audubon clasped the man's hand and told him the simple truth: "You have seen a poor old man."

He had never liked celebrity, never wanted to be a hero. He had dared to dream of creating a life's work that would prove both beautiful and instructive to the world at large. In *The Birds of America* he had accomplished that goal. By championing the parrot Mignonne and vanquishing the monkey beast, he made beauty and art triumph.

The second volume of *The Viviparous Quadrupeds of North America* was completed by his sons (young John did most of the artwork) with John Bachman's text, and published in the year of John James Audubon's death.

That spring, Lucy wrote to Maria Martin Bachman in Charleston: "I have been planting various favourite shrubs and creepers over the resting place of my poor old friend, who seems as quiet . . . in his cell as the mind can conceive, and all but the remembrance of him and his goodness to me is gone forever."[1]

BIBLIOGRAPHY
BOOKS AND PERIODICALS CONSULTED

Adams, Alexander B. *John James Audubon: A Biography.* New York: G. P. Putnam's Sons, 1966.

Arthur, Stanley Clisby. *Audubon: An Intimate Life of the American Woodsman.* New Orleans: Harmanson, 1937.

Audubon, John James. *Audubon's Birds of North America.* Secaucus, N.J.: The Wellfleet Press, 1990.

--------. *Audubon's Quadrupeds of North America.* Secaucus, N.J.: The Wellfleet Press, 1989.

--------. *Delineations of American Scenery and Character.* New York: G. A. Baker, 1926.

--------. *Letters of John James Audubon to J. S. Henslow.* San Francisco: Grabhorn Press, 1943.

--------. "Notes on the Rattlesnake." *Edinburgh Philosophical Journal,* April-October, 1827.

--------. *Ornithological Biography.* Five volumes. Edinburgh: A. Black, 1831-1839.

--------. *Selected Birds and Quadrupeds of North America.* Montreal: Optimum Publishing Co., Ltd., 1978.

--------, and John Bachman. *The Viviparous Quadrupeds of North America.* New York: n.p., 1846.

Audubon, John Woodhouse. *Audubon's Western Journal, 1849-1850.* Cleveland, Ohio: The Arthur H. Clark Company, 1906.

Audubon, Lucy, ed. *The Life of John James Audubon, the Naturalist.* New York: G. P. Putnam's Sons, 1873.

Audubon, Maria, ed. *Audubon and His Journals.* Two volumes. New York: Dover Publications, 1986; first published by Charles Scribner's Sons, 1897.

Bachman, Catherine L. *John Bachman.* Charleston, S.C.: Walker, Evans S. & Cogswell, 1888.

Bland, Desmond Sparling. *John James Audubon in Liverpool, 1826-1827.* Liverpool: University of Liverpool, 1977.

Buchanan, Robert. *Life and Adventures of Audubon, the Naturalist.* Edited, from material supplied by his widow. London: Sampson Low, Son, & Marston, 1869.

Burroughs, John. *John James Audubon.* Boston: Small, Maynard, 1902.

Chancellor, John. *Audubon: A Biography.* New York: Viking, 1978.

Coffin, Annie Roulhac. "Maria Martin (1796-1863)." *The Art Quarterly,* Autumn 1960.

Corning, Howard, ed. *Journal of John James Audubon Made During His*

Trip to New Orleans in 1820-1821.
Boston: Club of Odd Volumes,
1930.
--------. *The Letters of John James Audu-bon, 1826-1840.* Two volumes.
Boston: Club of Odd Volumes,
1930.
Dance, S. Peter. *The Art of Natural History: Animal Illustrators and Their Work.* London: Country Life Books, 1978.
Davidson, Marshall B., ed. *The Original Water-color Paintings by John James Audubon for "The Birds of America."* New York: American Heritage Publishing Co., 1966.
DeLatte, Carolyn F. *Lucy Audubon.* Baton Rouge: Louisiana State University Press, 1982.
Durant, Mary, and Michael Hargrove. *On the Road with John James Audubon.* New York: Dodd, Mead, 1980.
Ford, Alice. *John James Audubon: A Biography.* New York: Abbeville Press, 1988.
--------, ed. *The 1826 Journal of John James Audubon.* New York: Abbeville Press, 1967.
Fries, Waldemar. *The Double Elephant Folio: The Story of Audubon's Birds of America.* Chicago: The American Library Association, 1973.
Gordon, Esme. *The Royal Scottish Academy, 1826-1976.* Edinburgh: Gordon & McKay, n.d.
Greg, Mrs. Eustace, ed. Genealogical Table, *Reynolds-Rathbone Families, 1826-1840.* Liverpool: University of Liverpool, 1905.
Grierson, H. J. C., ed. *The Letters of Sir Walter Scott: 1787-1835.* London: Constable and Co., 1932-1937.
Hall, Basil. *Travels in North America in the Years 1827, 1828.* Three volumes. Edinburgh: Cadell & Co.,

1829.
Harwood, Michael. "In Search of the Real Mr. Audubon," *Audubon Magazine,* May 1985, p. 58.
Herrick, Francis Hobart. *Audubon the Naturalist: A History of His Life and Time.* Two volumes. New York: Dover Publications, 1968.
History of the Ohio Falls Cities and Their Counties, with Illustrations and Biographical Sketches. Volume 1. Cleveland: L. A. Williams & Co., 1882.
Johnson, Paul. *The Birth of the Modern: World Society 1815-1830.* New York: HarperCollins Publishers, 1991.
Johnston, J. Stoddard, ed. *Memorial Story of Louisville (from Its First Settlement to the Year 1896).* Volume 1. American Biographical Publishing Co., 1896.
Kirk, Naomi J. *The Life of George Keats.* Unpublished master's thesis, Columbia University, 1933. The Filson Club, Louisville, Ky.
Klauber, Laurence M. *Rattlesnakes: Their Habits, Life Histories, and Influence on Mankind.* Volume 1. Berkeley: University of California Press, 1972.
Low, Susanne M. *An Index and Guide to Audubon's "Birds of America."* New York: American Museum of Natural History and Abbeville Press, 1988.
McDermott, John Francis, ed. *Audubon in the West.* Norman, Okla.: University of Oklahoma Press, 1965.
--------. *Up the Missouri with Audubon: The Journal of Edward Harris.* Norman, Okla.: University of Oklahoma Press, 1951.
Murphy, Robert Cushman. *"John James Audubon (1785-1851): An Evaluation of the Man and His Work."*

New-York Historical Society Quarterly (October 1956).

Neuffer, Claude Henry, ed. *The Christopher Happoldt Journal.* Charleston, S.C.: The Charleston Museum, 1960.

Ridge, Davy-Jo Stribling. *A Load of Gratitude: Audubon and South Carolina.* Columbia, S.C.: Thomas Cooper Library, University of South Carolina, 1985.

Rourke, Constance. *Audubon.* New York: Harcourt, Brace & Co., 1936.

Sandburg, Carl. Abraham *Lincoln: The Prairie Years.* New York: Harcourt, Brace & World, 1926.

Sanders, Albert E., and Warren Ripley, eds. *Audubon: The Charleston Connection.* Charleston, S.C.: The Charleston Museum, 1986.

Simon, Charlie May. *Joseph Mason, Apprentice to Audubon.* New York: E. P. Dutton, 1946.

Sydnor, Charles S. *A Gentleman of the Old Natchez Region: Benjamin L. C. Wailes.* Westport, Conn.: Negro Universities Press, 1970.

Tocqueville, Alexis de. *Journey to America.* Ed. J. P. Meyer. Trans. George Lawrence. New Haven, Conn.: Yale University Press, 1959.

Webb, Allie Bayne Windham, ed. *Mistress of Evergreen Plantation: Rachel O'Connor's Legacy of Letters, 1823-1845.* Albany, N. Y.: State University of New York Press, 1983.

Welch, Margaret Curzon. *John James Audubon and His American Audience: Art, Science, and Nature, 1830-1860.* Unpublished Ph.D. dissertation, University of Pennsylvania, 1988.

Williams, Greer. *The Plague Killers.* New York: Charles Scribner's Sons, 1969.

Yater, George H. *Two Hundred Years at the Falls of the Ohio: A History of*

Louisville and Jefferson County. Louisville, Ky.: The Filson Club, 1987.

COLLECTIONS CONSULTED

American Philosophical Society Library, Philadelphia, Pa. John James Audubon Papers.

Audubon Museum, Henderson, Ky. Tyler Collection.

Charleston Museum, Charleston, S.C. Bachman Collection.

The Filson Club Historical Society, Louisville, Ky. Manuscript Department.

Princeton University Library, Princeton, N.J. John James Audubon Collection.

The Royal Scottish Academy, Edinburgh. Archives.

Tulane University, Howard-Tilton Memorial Library, New Orleans, La. John James Audubon Papers, Manuscripts, Special Collections.

Yale University, New Haven, Conn. Beinecke Rare Books and Manuscripts Library.

NOTES

FORWARD
1. John Francis McDermott, ed., *Audubon in the West*, pp. 67, 68.
2. Howard Coming, ed., *The Letters of John James Audubon*, 1826-1840, vol. 2, p. 54.
3. Robert Buchanan, *Life and Adventures of Audubon, the Naturalist*, p. vii.
4. Stanley Clisby Arthur, *Audubon: An Intimate Life of the American Woodsman*, p. 288.

CHAPTER 1
1. Stanley Clisby Arthur, *Audubon: An Intimate Life of the American Woodsman*, p. 120.
2. John James Audubon, *Ornithological Biography*, vol. 2, Introduction.
3. Maria Audubon, ed., *Audubon and His Journals*, vol. 1, p. 8.
4. Arthur, *Audubon: An Intimate Life*, p. 120: "Here it is well I should Mentioned, that I Landed in New York, took the Yellow Fever and did not reach Philadelphia for Three Months."
5. Greer Williams, *The Plague Killers*, p. 188.
6. Arthur, *Audubon: An Intimate Life*, *"Myself"* (from 1820 journal), p. 116.
7. Alexis de Tocqueville, *Journey to America*, p. 164.
8. Alice Ford, *John James Audubon: A Biography*, p. 15.
9. Alexander B. Adams, *John James Audubon: A Biography*, p. 18.
10. Ford, *John James Audubon*, p. 21.
11. The text of Dr. Sanson's bill appears in Francis Hobart Herrick, *Audubon the Naturalist: A History of His Life and Time*, vol. 2, pp. 314-27.
12. Arthur, *Audubon: An Intimate Life*, p. 471.
13. Herrick, *Audubon the Naturalist*, vol. 2, pp. 322-25.
14. Arthur, *Audubon: An Intimate Life*, p. 119.
15. S. Peter Dance, *The Art of Natural History: Animal Illustrators and Their Work*, pp. 89-91.
16. Maria Audubon, *Audubon and His Journals*, *"Myself,"* vol. 1, p. 12.
17. Ford, *John James Audubon*, p. 42.

CHAPTER 2
1. John James Audubon, *Ornithological Biography*, vol. 1, p. ix.
2. Alice Ford, *John James Audubon: A Biography*, p. 43.
3. Ibid., p. 40.
4. Robert Buchanan, *The Life and Adventures of John James Audubon, the Naturalist*, p. 9.
5. Durant and Harwood, *On the Road*, p. 1.

6. Buchanan, *Life and Adventures,* p. 16 (quoting William Bakewell).
7. John James Audubon, *Selected Birds and Quadrupeds,* "White-Headed or Bald Eagle," p. 5.
8. Basil Hall, *Travels in North America in the Years 1827, 1828,* vol. 3, p. 68.
9. Maria Audubon, ed., *Audubon and His Journals,* vol. 2, p. 524.
10. Ibid., pp. 524-25.
11. Ibid., p. 525.
12. Carolyn F. DeLatte, *Lucy Audubon,* p. 1.
13. Buchanan, *Life and Adventures,* p. 17. Buchanan quotes Billy Bakewell: "He had great skill in stuffing and preserving animals of all sorts. He had also a trick of training dogs with great perfection, of which art his famous dog Zephyr was a wonderful example."
14. DeLatte, *Lucy Audubon,* p. 10.
15. Stanley Clisby Arthur, *Audubon: An Intimate Life of the American Woodsman,* p. 120.
16. Ibid., p. 33.
17. DeLatte, *Lucy Audubon,* p. 7.
18. Ibid., p. 6.
19. Ibid., p. 9.
20. Arthur, *Audubon: An Intimate Life,* p. 37.
21. Ford, John James *Audubon,* p. 38.
22. Maria Audubon, *Audubon and His Journals,* vol. 1, p. 21.
23. Lucy Bakewell to Miss E. Gifford in Derbyshire, with addition by William Bakewell (n.d.), Princeton University Library, J. J. Audubon Collection.
24. Lucy Audubon to Miss Gifford: "Mr. Audubon who also sent a ring made of my Momma's hair" (n.d.), Princeton University Library, J. J. Audubon Collection.
25. Buchanan, *Life and Adventures,* p.

10. The version of "Myself" used here differs markedly from the original reproduced in Arthur, Audubon: An Intimate Life, p. 114 (where the incident does not appear at all), and from the more elaborate version offered in Maria Audubon's Audubon and His Journals, vol. 1, p. 119.
26. Francis H. Herrick, *Audubon the Naturalist,* vol. 1, p. 119.
27. Maria Audubon, *Audubon and His Journals,* "Myself," vol. 1, p. 23.
28. Three versions of Audubon's autobiography, "Myself," are quoted here. One is the bare-bones version that Clisby copied, word for word, from original material lent to him by an Audubon descendant, and that he published in his 1937 biography of Audubon. The second is from Buchanan, *Life and Adventures.* This material was quite probably polished by Audubon himself, by Lucy, and perhaps even by Mac-Gillivray, the excellent Scot who worked so well with Audubon on the *Ornithological Biography.* The third is from the journals as edited by Maria Audubon. Clearly, someone embellished these journals, adding a great deal of material (as one can see when comparing the three) and, what is worse, leaving out quite a lot. One of Audubon's granddaughters is said to have burned the original journals, preferring to substitute her own, sanitized version of her grandfather's life. I have quoted from each version, using the one that seemed best to illustrate a point.

CHAPTER 3

1. John James Audubon to William Bakewell (May 20, 1805),

Princeton University Library, J. J. Audubon Collection.

2. William Bakewell to E. Gifford (May 20, 1805), Princeton University Library, J. J. Audubon Collection.

3. Francis Hobart Herrick, *Audubon the Naturalist: A History of His Life and Time*, vol. 1, p. 127.

4. Alice Ford, John James *Audubon: A Biography*, p. 63.

5. Ibid., p. 68.

6. Maria Audubon, ed., *Audubon and His Journals*, vol. I, p. 41. Maria claims this story appeared in one of the burned journals, but Audubon did not include it in either version of "Myself."

7. Paul Johnson, *The Birth of the Modern: World Society 1815-1830*, p. 462.

8. Ford, *John James Audubon*, p. 64.

9. Robert Buchanan, *Life and Adventures of Audubon, the Naturalist*, p. 18.

10. Ford, *John James Audubon*, p. 66.

11. Ibid., p. 68.

12. John James Audubon to Jean Audubon (April 24, 1807), Howard-Tilton Memorial Library, Tulane University, John James Audubon Papers, Manuscripts, Special Collection.

13. John James Audubon to Mr. Rozier (May 30, 1807), ibid.

14. John James Audubon to Mr. Rozier (July 19, 1807), ibid.

John James Audubon to Mr. Rozier (July 19, 1807), ibid.

CHAPTER 4

1. John James Audubon, *Ornithological Biography*, "The Raven," vol. 2, p. 1.

2. Alice Ford, *John James Audubon: A Biography*, p. 54.

3. Ibid., p. 72.

4. Alexander B. Adams, *John James Audu-*

bon: *A Biography*, p. 88.

5. Carl Sandburg, *Abraham Lincoln: The Prairie Years*, vol. 1, p. 5.

6. Ford, *John James Audubon*, p. 73.

7. George H. Yater, *Two Hundred Years at the Falls of the Ohio: A History of Louisville and Jefferson County*, p. 33.

8. Sandburg, *The Prairie Years*, vol. 1, p. 20.

9. *History of the Ohio Falls Cities and Their Counties*, vol. 1, p. 488a.

10. Ford, *John James Audubon*, p. 437.

11. Lucy Audubon to E. Gifford (May 27, 1808), Princeton University Library, J. J. Audubon Collection.

12. Sandburg, *The Prairie Years*, vol. 1, p. 37.

13. Lucy Audubon to E. Gifford, Princeton University Library, J. J. Audubon Collection.

14. Carolyn F. DeLatte, *Lucy Audubon*, p. 49.

15. Sandburg, *The Prairie Years*, vol. 1, p. 19.

16. Ibid., p. 15.

17. Ibid., p. 14.

18. DeLatte, *Lucy Audubon*, p. 54.

19. Francis Hobart Herrick, *Audubon the Naturalist: A History of His Life and Time*, vol. 1, p. 205.

20. Ibid., vol. 1, p. 212.

21. Adams, *John James Audubon*, p. 105; Stanley Clisby Arthur, *Audubon: An Intimate Life of the American Woodsman*, p. 58.

22. Herrick, *Audubon the Naturalist*, vol. 1, p. 236.

23. Ibid.

24. Maria Audubon, ed., *Audubon and His Journals*, "Deer Hunting," vol. 2, p. 467.

25. Sandburg, *The Prairie Years*, vol. 1,

p. 30.

26. Arthur, *Audubon: An Intimate Life,* p. 120.

27. Robert Buchanan, *Life and Adventures of Audubon, the Naturalist,* p. 33; Arthur, Audubon: An Intimate Life, p. 114.

28. Arthur, *Audubon: An Intimate Life,* p. 114.

29. Maria Audubon, *Audubon and His Journals,* "Myself," vol. 1, p. 44.

CHAPTER 5

1. Stanley Clisby Arthur, *Audubon: An Intimate Life of the American Woodsman,* p. 121.

2. Arthur, *Audubon: An Intimate Life,* p. 121.

3. John James Audubon, *Ornithological Biography,* "Bird of Washington," vol. 1, p. 60.

4. Maria Audubon, ed., *Audubon and His Journals,* vol. 1, p. 218.

5. Maria Audubon, *Audubon and His Journals,* "A Wild Horse," vol. 2, p. 219.

6. Lucy Audubon to E. Gifford, Princeton University Library, J. J. Audubon Collection.

7. John James Audubon, *Ornithological Biography,* "The Carolina Turtle Dove," vol. 1, p. 91.

8. Alexander B. Adams, *John James Audubon: A Biography,* p. 140.

9. Ibid., p. 141.

10. Maria Audubon, *Audubon and His Journals,* "Earthquake," vol. 2, p. 234.

11. Ibid., p. 235.

12. Adams, *John James Audubon,* p. 142.

13. John James Audubon, *Ornithological Biography,* vol. 1, p. 461.

14. Maria Audubon, *Audubon and His Journals,* "The Ohio," vol. 2, p. 203.

15. Ibid., "Myself," vol. 1, p. 32.

16. Ibid., p. 33.

17. Carolyn F. DeLatte, *Lucy Audubon,* p. 71.

18. Ibid., p. 74.

19. Paul Johnson, *The Birth of the Modern: World Society 1815-1830,* p. 304.

20. Arthur, *Audubon: An Intimate Life,* p. 78.

21. John James Audubon, *Selected Birds and Quadrupeds of North America,* "The Wild Turkey," p. 50.

22. Maria Audubon, *Audubon and His Journals,* "Fishing in the Ohio," vol. 2, p. 212.

CHAPTER 6

1. Stanley Clisby Arthur, *Audubon: An Intimate Life of the American Woodsman,* p. 121.

2. Alice Ford, *John James Audubon: A Biography,* p. 91.

3. Arthur, *Audubon: An Intimate Life,* p. 79.

4. Ford, *John James Audubon,* p. 91.

5. Carolyn F. DeLatte, *Lucy Audubon,* p. 85.

6. Arthur, *Audubon: An Intimate Life,* p. 79.

7. Ibid., p. 80.

8. John James Audubon, *Selected Birds and Quadrupeds of America,* "The Passenger Pigeon," vol. 1, p. 281.

9. Ibid., p. 282. He was right; as the century wore on and the great forests were felled, depriving the passenger pigeons of food, their numbers decreased dramatically; the last of the species died in a zoo in 1914.

10. Arthur, *Audubon: An Intimate Life,* p. 79.

11. Ibid., p. 88.

12. DeLatte, *Lucy Audubon,* p. 90.

13. Ibid., p. 91.
14. Ford, *John James Audubon,* p. 477.
15. Carl Sandburg, *Lincoln: The Prairie Years,* vol. 1, p. 25.
16. Ibid., p. 32.
17. Sandburg, *The Prairie Years,* vol. 1, p. 50.
18. Francis Hobart Herrick, Audubon the Naturalist: A History of His Life and Time, vol. 1, p. 293.
19. Arthur, Audubon: An Intimate Life, p. 121.
20. Arrest Order for John James Audubon, Henderson Circuit Court. Susan S. Towles Collection, Manuscript Department, The Filson Club Historical Society, Louisville, Ky.
21. Naomi J. Kirk, *The Life of George Keats.*

CHAPTER 7

1. Stanley Clisby Arthur, *Audubon: An Intimate Life of the American Woodsman,* p. 129.
2. Ibid., p. 121.
3. Ibid., p. 120.
4. Alice Ford, *John James Audubon: A Biography,* p. 106.
5. Carolyn F. DeLatte, *Lucy Audubon,* p. 100, 101.
6. Arthur, *Audubon: An Intimate Life,* p. 121.
7. Ford, *John James Audubon,* p. 109.
8. Maria Audubon, *Audubon and His Journals,* vol. 1, p. 38.
9. Arthur, *Audubon: An Intimate Life,* p. 121.
10. Maria Audubon, *Audubon and His Journals,* vol. 1, p. 36.
11. Ford, *John James Audubon,* p. 109.
12. Alexander B. Adams, *John James Audubon: A Biography,* p. 190.
13. Ford, *John James Audubon,* p. 112.
14. Ibid., p. 113.
15. Adams, *John James Audubon,* p. 194.

16. Ibid., p. 195.
17. Howard Corning, ed., *Journal of John James Audubon Made During His Trip to New Orleans in 1820-1821,* p. 110.

CHAPTER 8

1. John James Audubon, *Ornithological Biography,* vol. 2, Introduction.
2. Marshall B. Davidson, ed., *The Original Water-Color Paintings by John James Audubon for The Birds of America,* vol. 1, Introduction.
3. Stanley Clisby Arthur, *Audubon: An Intimate Life of the American Woodsman,* p. 154.
4. Ibid.
5. Alice Ford, *John James Audubon: A Biography,* p. 122.
6. Ibid.
7. Alexander B. Adams, *John James Audubon: A Biography,* p. 230. The account of this adventure appears in manuscript pages torn from an Audubon journal and now in the papers of the American Philosophical Society. Entry May 1821, several months after event, in response to Lucy's request for more information. Her letter, dated April 1, 1821, in Princeton University Library, J. J. Audubon Collection.
8. Lucy Audubon to E. Gifford (April 1, 1821), Princeton University Library, J. J. Audubon Collection.
9. Adams, John James Audubon, p. 184.
10. Lucy Audubon to E. Gifford (April 1, 1821), Princeton University Library, J. J. Audubon Collection.
11. Adams, John *James Audubon,* p. 238.
12. Howard Corning, ed., *Journal of John James Audubon Made During His Trip to New Orleans in 1820-1821,* p. 193.
13. Ibid., p. 194.
14. Ibid., p. 192.

CHAPTER 9

1. Howard Corning, ed., *Journal of John James Audubon Made During His Trip to New Orleans in 1820-1821*, p. 200.
2. Ibid., p. 211.
3. Ibid., p. 214.
4. Charles S. Sydnor, *A Gentleman of the Old Natchez Region: Benjamin L. C. Wailes*, p. 129.
5. Alexander B. Adams, *John James Audubon: A Biography*, p. 254.
6. Natchez Mississippi State Gazette, Oct. 12, 1822, and Feb. 13, 1823.
7. Alice Ford, *John James Audubon: A Biography*, p. 139.
8. Carolyn F. Delatte, *Lucy Audubon*, p. 135.
9. Elisabeth Kilbourne Dart, historian of St. Francisville, La., personal communication to the author.
10. John James Audubon, *Ornithological Biography*, vol. 3, p. 371.
11. Stanley Clisby Arthur, Audubon: *An Intimate Life of the American Woodsman*, p. 267.
12. Ibid., p. 276.
13. Ibid., p. 279.
14. Ibid., p. 287.
15. Ibid., p. 298.
16. Ibid., p. 305.

CHAPTER 10

1. Alice Ford, ed., *The 1826 Journal of John James Audubon*, p. 105.
2. Ibid., p. 45.
3. Ibid.
4. Ibid., p. 20.
5. Ibid., p. 70.
6. Ibid., p. 61.
7. Ibid., p. 64.
8. Ibid.
9. Ibid., p. 81.
10. Ibid., pp. 81-82.
11. Ibid., p. 82n.
12. Desmond Sparling Bland, *John James Audubon in Liverpool, 1826-1827*, p. 4.
13. Alice Ford, *John James Audubon: A Biography*, p. 177.
14. Ford, *1826 Journal*, pp. 88-89.
15. Ibid., p. 89.
16. Ibid., p. 90.
17. Stanley Clisby Arthur, *Audubon: An Intimate Life of the American Woodsman*, p. 317.
18. Ford, *John James Audubon*, p. 179.
19. Ibid., p. 178.
20. Ford, *1826 Journal*, p. 94.
21. Ibid., p. 95.
22. Ibid., p. 96.
23. Ibid.
24. Ibid., p. 194.
25. Ibid., p. 100.
26. Ibid., p. 106.
27. Ibid., p. 111.
28. Maria Audubon, ed., *Audubon and His Journals*, vol. 1, p. 100; Bland, *Audubon in Liverpool*, p. 9.
29. Ford, *1826 Journal*, p. 111.
30. Ibid., p. 121.
31. Ibid.
32. Howard Coming, ed., *The Letters of John James Audubon, 1826-1840*, vol. 1, p. 4.
33. *Genealogical Table, Reynolds-Rathbone Families, with Catalogue of the Rathbone Papers.* See also Reynolds-Rathbone diaries and letters, 1753-1839, edited by Mrs. Eustace Greg, 1905, pp. 204-205.
34. Ford, *1826 Journal*, p. 151.
35. Ibid., p. 173.
36. Ibid., p. 176.
37. Ibid., p. 232.
38. Ibid., p. 262.
39. Ibid., p. 289.
40. Written on the back of *"A Robin Perched on a Mossy Stone,"* The

University of Liverpool, Special Collections, The University of Liverpool Art Gallery.

41. *Coming, Letters,* vol. 1, p. 5.
42. Ibid., p. 6.
43. Ford, *1826 Journal,* p. 123.
44. Ibid., p. 193.
45. Ibid., p. 207.
46. Ibid.
47. Ibid., p. 233.
48. Ibid., p. 246.
49. Ibid., p. 254.
50. Ibid., p. 259.
51. Ibid., p. 262.
52. Ibid., p. 269.
53. Ibid., p. 270.
54. Ibid., p. 289.
55. Ibid., p. 291.
56. Ibid., p. 292.
57. Ibid., p. 298.

CHAPTER 11

1. Alice Ford, ed., *The 1826 Journal of John James Audubon,* p. 346.
2. Ibid., p. 302.
3. Paul Johnson, *The Birth of the Modern: World Society 1815-1830,* p. 420.
4. Ford, *1826 Journal,* p. 305.
5. Ibid.
6. Ibid.
7. Ibid., p. 319.
8. Ibid., pp. 308-309.
9. Ibid., p. 309.
10. Sarah Bakewell married Theodore Anderson. The "Duck Killer" is Lucy's youngest brother, Billy, with whom Audubon often hunted.
11. Alexander B. Adams, *John James Audubon: A Biography,* p. 291.
12. Howard Coming, ed., *The Letters of John James Audubon, 1826-1840,* vol. 1, p. 8.
13. Ford, *1826 Journal,* p. 326.
14. Ibid.
15. Ibid., p. 327.

16. Ibid., p. 328.
17. Ibid., p. 329.
18. Ibid., p. 330.
19. Johnson, *Birth of the Modern,* p. 168.
20. Ibid., p. 895.
21. Ford, *1826 Journal,* p. 335.
22. Ibid., p. 340.
23. Ibid., p. 346.
24. Coming, *Letters,* vol. 1, p. 8.
25. Ford, *1826 Journal,* p. 364.
26. Ibid.
27. Ibid.
28. Ibid., p. 365.
29. The Symes portrait is now in the White House collections.
30. Ford, *1826 Journal,* p. 388.
31. Ibid., pp. 388-89.
32. Corning, *Letters,* vol. 1, p. 9.
33. Ibid., p. 15.
34. Ford, *1826 Journal,* p. 397.
35. Ibid., p. 419.
36. Coming, *Letters,* vol. 1, p. 13. This contradicts what he writes under the date of December 11 in his journal: that her letters of August 14 and 27 have just reached him. In the letter of December 21, he tells Lucy he has finally forwarded the money to Mrs. Middlemist.
37. Ibid., p. 6.
38. Ford, *1826 Journal,* p. 404.
39. Ibid., p. 406.
40. John James Audubon, "Notes on the Rattlesnake" (April-October 1827).
41. Laurence M. Klauber, *Rattlesnakes: Their Habits, Life Histories, and Influence on Mankind,* vol. 1, p. 494.
42. Ford, *1826 Journal,* pp. 408-409.
43. Ibid., p. 419.
44. Ibid., p. 421.
45. Ibid.
46. Ibid., p. 397.
47. Ibid., p. 205n.
48. Ibid., p. 426.
49. Ibid., p. 425.
50. Ibid., p. 426.

51. Ibid., p. 428.

CHAPTER 12

1. Howard Corning, ed., *The Letters of John James Audubon, 1826-1840*, vol. 2, p. 24.
2. Ibid., vol. 1, p. 27 (May 16, 1827).
3. Ibid., p. 17 (March 24, 1827).
4. Ibid., p. 17 (March 24, 1827).
5. Ibid., p. 25.
6. Ibid., p. 24.
7. Carolyn F. DeLatte, *Lucy Audubon*, p. 145.
8. John James Audubon to John Syme (January 16, 1827), Archives of the Royal Scottish Academy, Edinburgh; Esme Gordon, The Royal Scottish Academy, 1826-1976, p. 32.
9. Gordon, Royal Scottish Academy, 1826-1916, p. 32.
10. John Syme to William Nicholson, Secretary of the Academy (January 16, 1827), Archives of the Royal Scottish Academy, Edinburgh.
11. Alice Ford, *John James Audubon: A Biography*, p. 220.
12. Robert Buchanan, *Life and Adventures of Audubon, the Naturalist*, pp. 122-23.
13. H. J. C. Grierson, ed. *The Letters of Sir Walter Scott*, p. 476.
14. Francis Hobart Herrick, *Audubon the Naturalist: A History of His Life and Time*, vol. 1, p. 370.
15. Paul Johnson, *The Birth of the Modern: World Society 1815-1830*, p. 221.
16. Maria Audubon, ed., *Audubon and His Journals*, vol. 1, p. 210.
17. Ibid., vol. 1, p. 204.
18. Ibid., vol. l, p . 218.
19. Ibid., vol. 1, p. 231.
20. Ibid., vol. 1, p. 239.

21. Corning, *Letters*, vol. 1, p. 26.
22. Ibid.
23. Maria Audubon, *Audubon and His Journals*, vol. 1, p. 251.
24. Corning, *Letters*, vol. 1, p. 31.
25. Maria Audubon, *Audubon and His Journals*, vol. 1, p. 252.
26. Paul Johnson, *The Birth of the Modern: World Society 1815-1830*, p. 445.

CHAPTER 13

1. Howard Corning, ed., *The Letters of John James Audubon, 1826-1840*, vol. 1, p. 31.
2. Maria Audubon, ed., *Audubon and His Journals*, vol. 1, p. 256.
3. John James Audubon to Lucy Audubon (June 20, 1827), Princeton University Library, J. J. Audubon Collection.
4. Stanley Clisby Arthur, *An Intimate Life of the American Woodsman*, p. 358.
5. Corning, *Letters*, vol. 1, p. 29.
6. Ibid., vol. 1, p. 31.
7. Arthur, *Audubon: An Intimate Life*, p. 356.
8. Ibid., p . 359.
9. Maria Audubon, *Audubon and His Journals*, vol. 1, p. 258; Corning, Letters, vol. 1, p. 39.
10. Arthur, *Audubon: An Intimate Life*, p. 361.
11. John James Audubon to Victor G. Audubon (Sept. 21, 1827), American Philosophical Society, John James Audubon Papers.
12. Corning, *Letters*, vol. 1, p. 45.
13. Ibid., p . 42.
14. Ibid., p. 48.
15. Ibid., p. 54.
16. Ibid., p. 56.
17. Maria Audubon, *Audubon and His Journals*, vol. 1, p. 272.

18. Corning, Letters, vol. 1, p. 57.
19. Maria Audubon, *Audubon and His Journals*, vol. 1, p. 278.
20. Ibid., p. 278.
21. Ibid., p. 279.
22. Ibid., p. 283.
23. Ibid., p. 289.
24. Ibid., p. 290.
25. Corning, *Letters*, vol. 1, p. 65.
26. Maria Audubon, *Journals*, vol. 1, p. 294.
27. Ibid., p. 297.
28. Ibid., pp. 298-99.
29. Corning, *Letters*, vol. 1, p. 67.
30. Basil Hall, *Travels in North America in the Years 1827, 1828*, vol. 2, p. 20.
31. Francis Hobart Herrick, *Audubon the Naturalist: A History of His Life and Time*, vol. 1, p. 410.
32. Ibid., vol. 2, p. 409.
33. Maria Audubon, *Audubon and His Journals*, vol. 1, p. 307.
34. Ibid., p. 315.
35. Ibid., p. 317.
36. Alice Ford, *John James Audubon: A Biography*, p. 243.
37. Maria Audubon, *Journals*, vol. 1, p. 325.
38. Ibid., p. 329.
39. *History of the Ohio Falls Cities and Their Counties*, vol. 1, p. 488a.
40. Coming, *Letters*, vol. 1, p. 72.
41. Ibid., p. 77.

CHAPTER 14
1. Howard Corning, ed., *The Letters of John James Audubon, 1826-1840*, vol. 1, p. 81.
2. Ibid., p. 82.
3. Alice Ford, *John James Audubon: A Biography*, p. 256.
4. Corning, ed., *Letters*, vol. 1, p. 80.
5. Stanley Clisby Arthur, *Audubon: An Intimate Life of the American Woodsman*, p. 379.

6. Ford, John James *Audubon*, p. 259.
7. Corning, *Letters*, vol. 1, pp. 84-85.
8. Charles Bonaparte to William Swainson (July 30, 1829), Linnaean Society, London.
9. Coming, Letters, vol. 1, p. 81.
10. Ford, John James Audubon, p. 264.
11. Arthur, Audubon: An Intimate Life, p. 382.
12. Ibid.
13. Maria Audubon, ed., Audubon and His Journals, vol. 2, p. 312.
14. Ibid.
15. Corning, *Letters*, vol. 1, p. 91.
16. Ibid., p. 97.
17. Ford, *John James Audubon*, p. 262.
18. Ibid., p. 264.
19. Francis Hobart Herrick, *Audubon the Naturalist: A History of His Life and Time*, vol. 1, p. 422.
20. Corning, *Letters*, vol. 1, p. 88.
21. Ibid., p. 93.
22. Ibid., p. 99.
23. Ibid., p. 96.
24. Herrick, *Audubon the Naturalist*, vol. 1, p. 426n.
25. John James Audubon, *Ornithological Biography*, "The Great Pine Swamp," vol. 2, p. 321.
26. Herrick, *Audubon the Naturalist*, vol. 1, p. 426; Corning, *Letters*, vol. 1, p. 96.
27. Herrick, *Audubon the Naturalist*, vol. 1, p. 427.
28. Ford, *John James Audubon*, p. 268; Corning, *Letters*, vol. 1, p. 93.
29. Arthur, *Audubon: An Intimate Life*, p. 386; Herrick, *Audubon the Naturalist*, vol. 1, p. 435.
30. Basil Hall, *Travels in North America in the Years 1827, 1828*, vol. 1, p. 349.
31. Herrick, *Audubon the Naturalist*, vol. 1, p. 435; Ford, *John James Audubon*, p. 269.

CHAPTER 15

1. Howard Corning, ed., *The Letters of John James Audubon, 1826-1840,* vol. 1, p. 161.
2. Francis Hobart Herrick, *Audubon the Naturalist: A History of His Life and Time,* vol. 1, p. 437.
3. Corning, *Letters,* vol. 1, p. 108.
4. Ibid., p. 111.
5. Alexander B. Adams, *John James Audubon: A Biography,* p. 370.
6. Ibid., p. 373.
7. Corning, *Letters,* vol. 1, p. 122.
8. Adams, *John James Audubon,* p. 376.
9. Herrick, *Audubon the Naturalist,* vol. 1, p. 438.
10. Ibid., p. 447.
11. Ibid., p. 448n.
12. Alexis de Tocqueville, *Journey to America,* p. 136.
13. Corning, Letters, vol. 1, p. 149.
14. Maria Audubon, ed., *Audubon and His Journals,* vol. 2, p. 352.
15. Basil Hall, *Travels in North America in the Years 1827, 1828,* vol. 3, p. 145.
16. Corning, *Letters,* vol. 1, p. 143.
17. Ibid.
18. Ibid., p. 145.
19. Claude Henry Neuffer, ed., *The Christopher Happoldt Journal,* p. 47.
20. Ibid., pp. 38-39.
21. Mary Durant and Michael Hargrove, *On the Road with John James Audubon,* pp. 337-38.
22. Herrick, *Audubon the Naturalist,* vol. 2, p. 8.
23. Durant and Hargrove, *On the Road with John James Audubon,* p. 331.
24. Tocqueville, *Journey to America,* p. 260.
25. Corning, *Letters,* vol. 1, p. 144.
26. Ibid., p. 147.
27. Ibid., p. 148.
28. Ibid., p. 147.
29. Ibid., p. 150.
30. Neuffer, Happoldt *Journal,* p. 42.
31. Maria Audubon, *Audubon and His Journals,* vol. 2, p. 333.
32. Ibid., p. 354.
33. Coming, *Letters,* vol. 1, pp. 163, 153.
34. Ibid., p. 156.
35. Ibid., p. 154.
36. Ibid.
37. Ibid., p. 159.
38. Ibid., p. 161.
39. Ibid., p. 179.
40. Maria Audubon, *Audubon and His Journals,* vol. 2, p. 358, "St. John's River in Florida."
41. Coming, *Letters,* vol. 1, p. 187.
42. Ibid., p. 191.
43. Ibid., p. 194.
44. Albert E. Sanders and Warren Ripley, eds., *Audubon: The Charleston Connection,* p. 74.
45. Ibid., p. 75.
46. Maria Audubon, *Audubon and His Journals,* vol. 2, p. 369.
47. Ibid., p. 366.
48. Stanley Clisby Arthur, *Audubon: An Intimate Life of the American Woodsman,* p. 415.

CHAPTER 16

1. John James Audubon to Richard Harlan (March 20, 1833), The Filson Club.
2. Howard Coming, ed., *The Letters of John James Audubon, 1826-1840,* vol. 1, p. 196.
3. Alice Ford, *John James Audubon: A Biography,* p. 302.
4. Coming, *Letters,* vol. 1, p. 276.
5. John Woodhouse Audubon, *Audubon's Western Journal, 1849-1850,* Biographical memoir by Maria R. Audubon.
6. Alexis de Tocqueville, *Journey to America,* p. 183.

7. Francis Hobart Herrick, *Audubon the Naturalist: A History of His Life and Time,* vol. 2, p. 29.
8. Ford, *John James Audubon,* p. 302; p. 450, n. 23.
9. Corning, *Letters,* vol. 1, p. 233.
10. Maria Audubon, ed., *Audubon and His Journals,* vol. 2, p. 391.
11. Corning, *Letters,* vol. 1, p. 198.
12. Ford, *John James Audubon,* p. 302, n. 12.
13. John James Audubon to Richard Harlan (March 20, 1833), The Filson Club.
14. Claude Henry Neuffer, ed., *The Christopher Happoldt Journal,* p. 44.
15. John James Audubon to Richard Harlan (March 20, 1833), The Filson Club.
16. Ibid.
17. Corning, *Letters,* vol. 1, p. 198.
18. Ibid., p. 205.
19. Ibid., p. 200.
20. Ibid., p. 201.
21. Ibid., p. 200.
22. Ibid., p. 213.
23. Ibid.
24. Ibid., p. 227.
25. Ibid., p. 226.
26. Ibid., pp. 242, 243.
27. Ibid., p. 242.
28. Ibid., p. 239.
29. Maria Audubon, *Audubon and His Journals,* vol. 2, p. 428.
30. Ibid., p. 441.
31. Corning, *Letters,* vol. 1, p. 257.
32. Alexander B. Adams, *John James Audubon: A Biography,* p. 415.
33. Corning, *Letters,* vol. 1, p. 247.
34. Ibid., p. 246.
35. Ford, *John James Audubon,* p. 312; Corning, *Letters,* vol. 1, p. 261.
36. Lucy Audubon, ed., *The Life of John James Audubon, the Naturalist,*
pp. 379-80.
37. Corning, *Letters,* vol. 1, p. 269.
38. Ibid., vol. 1, p. 265.
39. Marshall B. Davidson, ed., *The Original Water-color Paintings by John James Audubon for "The Birds of America,"* vol. 1, p. xxxi.
40. Corning, *Letters,* vol. 1, p. 264.
41. Neuffer, Happoldt *Journal,* p. 53.
42. Herrick, *Audubon the Naturalist,* vol. 2, p. 59.
43. Corning, *Letters,* vol. 1, pp. 267-68.
44. Ibid., p. 272.
45. Neuffer, *Happoldt Journal,* p. 55.
46. Herrick, *Audubon the Naturalist,* vol. 2, p. 61.
47. Ibid., p. 59.
48. Corning, *Letters,* vol. 2, p. 16.
49. Ford, *John James Audubon,* p. 321.

CHAPTER 17

1. Howard Corning, ed., *The Letters of John James Audubon, 1826-1840,* vol. 2, p. 136.
2. Francis Hobart Herrick, *Audubon the Naturalist: A History of His Life and Time,* vol. 2, p. 125.
3. Margaret Curzon Welch, *John James Audubon and His American Audience: Art, Science, and Nature, 1830-1860,* p. 120.
4. Paul Johnson, *The Birth of the Modern: World Society 1815-1830,* p. 320.
5. Lucy Audubon, ed., *The Life of John James Audubon, the Naturalist,* p. 381.
6. Alice Ford, *John James Audubon: A Biography,* p. 325.
7. Corning, *Letters,* vol. 2, p. 50.
8. Susanne M. Low, *An Index and Guide to Audubon's "Birds of America,"* p. 24.
9. Stanley Clisby Arthur, *Audubon: An Intimate Life of the American Woodsman,* p. 429.

10. George Ord to Charles Waterton (April 17, 1835), American Philosophical Society, John James Audubon Papers.

11. Corning, *Letters*, vol. 2, p. 77.

12. Ibid., p. 57.

13. Ibid., p. 63.

14. John James Audubon, *Letters of John James Audubon to J. S. Henslow.* Henslow was a Cambridge professor whose most noted student was Charles Darwin. Teacher and student were so often together that young Darwin became known as "the Man who walks with Henslow." It was Henslow who secured a place for Darwin on the *Beagle* expedition.

15. Corning, *Letters*, vol. 2, p. 69.

16. Ibid., p. 72.

17. Alexander B. Adams, *John James Audubon: A Biography*, p. 428.

18. Ibid., p. 427.

19. Coming, *Letters*, vol. 2, p. 71.

20. Ibid., p. 141.

21. Catherine L. Bachman, *John Bachman.*

22. Corning, *Letters*, vol. 2, p. 118.

23. Ford, *John James Audubon*, pp. 341-42.

24. Corning, *Letters*, vol. 2, p. 128.

25. Ibid., p. 132.

26. Ibid., p. 131.

27. Arthur, *Audubon: An Intimate Life*, p. 431.

28. Corning, *Letters*, vol. 2, p. 134.

29. Ibid., p. 136.

30. Annie Roulhac Coffin, "Maria Martin (1796-1863)," quoting John James Audubon, *Ornithological Biography*, vol. 4, p. xiii.

31. Ibid., quoting Francis Hobart Herrick, *Audubon the Naturalist: A History of His Life and Time*, vol. 2, p. 61.

32. Ibid., quoting John James Audubon, *Ornithological Biography*, vol. 4, p. 556; Susanne M. Low, *An Index and Guide to Audubon's "Birds of America,"* p. 162.

33. Corning, *Letters*, vol. 2, p. 156.

34. Ibid., p. 145.

35. Arthur, *Audubon: An Intimate Life*, p. 440.

36. Mary Durant and Michael Hargrove, *On the Road with John James Audubon*, p. 520.

37. Adams, *John James Audubon*, p. 437.

38. Herrick, *Audubon the Naturalist*, vol. 2, p. 165.

39. Corning, *Letters*, vol. 2, p. 169.

CHAPTER 18

1. Francis Hobart Herrick, *Audubon the Naturalist: A History of His Life and Time*, vol. 2, p. 125.

2. Howard Corning, ed., *The Letters of John James Audubon, 1826-1840*, vol. 2, p. 175.

3. Albert E. Sanders and Warren Ripley, eds., *Audubon: The Charleston Connection*, p. 54.

4. Claude Henry Neuffer, ed., *The Christopher Happoldt Journal*, p. 64.

5. Sanders and Ripley, *Charleston Connection*, p. 49.

6. Corning, *Letters*, vol. 2, p. 177.

7. Neuffer, *Happoldt Journal*, p. 64.

8. Corning, *Letters*, vol. 2, pp. 180-81.

9. Ibid., p. 182.

10. Ibid., pp. 186; 195.

11. Alice Ford, *John James Audubon: A Biography*, p. 353.

12. Corning, *Letters*, vol. 2, p. 197.

13. Ford, *John James Audubon*, p. 356.

14. Susanne M. Low, *An Index and Guide to Audubon's "Birds of America,"* p. 31.

15. Neuffer, *Happoldt Journal*, p. 121.

16. Ibid., p. 135.

17. Ibid., p. 66.

18. John James Audubon to Lucy Audu-

bon (August 1, 1838), Princeton University Library, John James Audubon Collection.

19. John Bachman, "Monograph of the Species of Squirrels Inhabiting North America," from *Proceedings of the Zoological Society of London* 68 (1838): 85-103.

20. Albert E. Sanders and Warren Ripley, eds., *Audubon: The Charleston Connection*, p. 105. Albert E. Sanders and W. D. Anderson Jr., *Deep Runs the Heritage: The Story of Natural History Investigations in South Carolina.* In press.

21. Lucy Audubon to Victor Audubon (June 30, 1839), Princeton University Library, John James Audubon Collection.

22. Ibid.

23. Herrick, *Audubon the Naturalist,* vol. 2, p. 201.

24. Corning, *Letters,* vol. 2, p. 226.

25. Ford, *John James Audubon,* p. 372.

26. Herrick, *Audubon the Naturalist,* vol. 2, p. 211.

27. Ford, *John James Audubon,* pp. 372, 373.

28. Herrick, *Audubon the Naturalist,* vol. 2, p. 211.

29. Ford, *John James Audubon,* p. 371.

30. Robert Buchanan, ed., *The Life and Adventures of John James Audubon, the Naturalist,* p. 3.

31. Albert E. Sanders and Warren Ripley, eds., *Audubon: The Charleston Connection,* p. 54.

32. Corning, *Letters,* vol. 2, p. 231.

33. Ibid., p. 240.

34. Ibid., p. 247.

35. Ford, *John James Audubon,* p. 376.

36. Ibid.

37. Spencer Fullerton Baird grew up to become secretary of the Smithsonian Institution.

38. John James Audubon to Victor Audubon (Nov. 1 and Nov. 8, 1841), American Philosophical Society Library, John James Audubon Papers.

39. John Audubon (Johnny) to Victor Audubon (April 22, 1841), American Philosophical Society Library, John James Audubon Papers.

40. John Audubon (Johnny) to Victor Audubon (Nov. 1, 1840), American Philosophical Society Library, John James Audubon Papers.

41. Tyler Collection, Audubon Museum, Henderson, Kentucky.

42. John Bachman to John James Audubon (May 8, 1841), Charleston Museum Collection.

43. Ford, *John James Audubon,* p. 385.

CHAPTER 19

1. John James Audubon to Victor Audubon (July 17, 1842), American Philosophical Society Library, John James Audubon Papers, Philadelphia.

2. Francis Hobart Herrick, *Audubon the Naturalist: A History of His Life and Time,* vol. 2, p. 229.

3. Howard Corning, ed. *The Letters of John James Audubon, 1826-1840,* vol. 2, pp. 229-30.

4. Herrick, *Audubon the Naturalist,* vol. 2, p. 235.

5. Ibid., p. 245.

6. Ibid., p. 236.

7. John James Audubon to Lucy Audubon (July 17, 1842), American Philosophical Society Library, John James Audubon Papers.

8. Herrick, *Audubon the Naturalist,* vol. 2, p. 237.

9. Ibid., p. 250.

10. John James Audubon to Charles Bonaparte (Feb. 26, 1843), American Philosophical Society Library,

John James Audubon Papers.

11. John Francis McDermott, ed., *Up the Missouri with Audubon: The Journal of Edward Harris,* p. 9.

12. Herrick, *Audubon the Naturalist,* vol. 2, p. 252.

13. John Francis McDermott, ed., *Audubon in the West,* p. 25.

14. Ibid., p. 26.

15. Ibid., p. 31.

16. John James Audubon, *Audubon's Quadrupeds of North America,* p. 174.

17. McDermott, *Audubon in the West,* p. 37.

18. Ibid., p. 45.

19. Ibid.

20. Ibid., p. 53.

21. Ibid., p. 63.

22. Ibid., p. 73.

23. McDermott, *Up the Missouri,* p. 18.

24. Ibid., p. 26.

25. McDermott, *Audubon in the West,* p. 85.

26. Ibid., p. 89.

27. Ibid., p. 94.

28. Maria Audubon, ed., *Audubon and His Journals,* vol. 2, p. 29.

29. McDermott, *Up the Missouri,* p. 99n.

30. Lucy Audubon, ed., *The Life of John James Audubon, the Naturalist,* vol. 2, p. 33.

31. Alexander B. Adams, *John James Audubon: A Biography,* p. 458.

32. Maria Audubon, *Audubon and His Journals,* vol. 2, p. 146.

33. Ibid., p. 154.

34. Ibid.

35. Ibid., p. 58.

36. McDermott, *Up the Missouri,* p. 149.

37. John James Audubon, *Quadrupeds of North America,* p. 174.

38. McDermott, *Up the Missouri,* pp. 159, 167.

39. Maria Audubon, *Audubon and His Journals,* vol. 2, pp. 175n., 176n.

40. John Bachman to John James Audubon (Nov. 12, 1843), Charleston Museum, Bachman Collection.

41. John Bachman to John James Audubon (Feb. 8, March 24, 1844), Charleston Museum, Bachman Collection.

42. Herrick, *Audubon the Naturalist,* vol. 2, p. 262.

43. Ibid., p. 267.

44. Ibid., p. 294.

45. Ibid., p. 268.

46. John Woodhouse Audubon, *Audubon's Western Journal, 1849-1850,* p. 35.

47. Ibid., p. 41.

48. Herrick, *Audubon the Naturalist,* vol. 2, p. 269.

49. Ibid., vol. 2, p. 273.

50. Albert E. Sanders and Warren Ripley, eds., *Audubon: The Charleston Connection,* pp. 125, 128-29.

51. Charleston Museum Library, Bachman Collection.

52. Herrick, *Audubon the Naturalist,* vol. 2, p. 289.

53. John Woodhouse Audubon, *Western Journal,* p. 35.

54. Charleston Museum Library, Bachman Collection, Dec. 18, 1848. Lucy Audubon, *The Life of John James Audubon, the Naturalist,* p. 442. Lucy says it was a Thursday morning at five, but in 1851, January 27 was a Monday. In Maria Audubons biographical sketch of her grandfather, published in Audubon and His Journals, she says it was five on a Monday afternoon, at sunset. Alice Ford, *John James Audubon: A Biography,* p. 429, uses Victor's version, according to which Audubon died at five in the evening. At least all parties agree on the date.

MEMENTO MORI

1. Albert E. Sanders and Warren Ripley, eds., *Audubon: The Charleston Connection*, p. 121.

INDEX

ABOUT THE AUTHOR

SHIRLEY STRESHINSKY is a novelist, journalist, and travel essayist. Her husband was photographer Ted Streshinsky. They have three grown children: David, Mark, and Maria. She lives in Northern California.

CPSIA information can be obtained at www.ICGtesting.com
Printed in the USA
BVOW08s1523050913

330416BV00001B/1/P